ASSASSIN'S CREED

THE ESSENTIAL GUIDE

TITAN BOOKS

ASSASSIN'S CREED: THE ESSENTIAL GUIDE
TABLE OF CONTENTS

FOREWORD

Nearly fifteen years ago, a Montreal development team that had just achieved a resounding success with the revitalization of the Prince of Persia license was given the ambitious mandate to redefine the adventure game for the next generation of consoles. After a few years of development, the team was ready to reveal its new game.

Like many players, I will always remember the moment I discovered the Assassin's Creed franchise. For me, it was through a video presentation. The bewitching music, the white silhouette paused in the crowd, the close-up shot on a hand with a missing finger, and suddenly the secret blade that springs from under the wrist of the hero...

As more information began to circulate, I was seduced by the aesthetics, the intoxicating environment, and the historical context (which offered us a chance to embody an Arab hero during the Crusades, a truly atypical story).

To say it was vastly different from the hyper, frenzied video game trailers we'd become so accustomed to is no understatement. The game already had a unique atmosphere, it had a real identity, a soul, and I knew what I wanted most at that time was to join the talents behind this project.

Fate waited until a few months after the release of that first opus. This was when I joined the team that would continue the franchise, including introducing a new period and a new hero. The change of era would become a core element of the brand. This is now one of the most important pillars of Assassin's Creed and it leads to the question we hear the most:

"When and where will the next title be set?"

It's a question that is repeated upon the release of every new game. When the first rumours or announcements circulate, search engines and online encyclopedias go crazy, the fantasy machine is activated, and players around the world start to imagine what the next game could be, who the next Assassin will be, which historical characters they will next meet.

Assassin's Creed uses history as a playground.

The protagonists are immersed in pivotal moments that have helped shape humanity, and this connection to our origins resonates with everyone involved in our adventures. Specifically, it's not a time machine, which would change the plot of history... instead we explore our genetic memories, our roots, in order to learn more about ourselves. These experiences allow us to become better. I think it is a message that resonates even more strongly today.

You are now holding in your hands a summary of the work of thousands of passionate people, made over a decade. We open the doors of our universe to you: the heroes, the antagonists, the places, the time periods... and we hope that with all this information, you will learn to appreciate our stories even more.

I would like to use this opportunity to thank all the Ubisoft staff who, through their talent, time, and passion, have made, and continue to make, Assassin's Creed.

I can't conclude, of course, without thanking you, the fans, our second family. Thanks to your passion and support, we were able to create a magnificent epic. We still have a lot of stories to tell.

See you soon in the Animus!

Aymar AZAÏZIA
Head of Content for Assassin's Creed

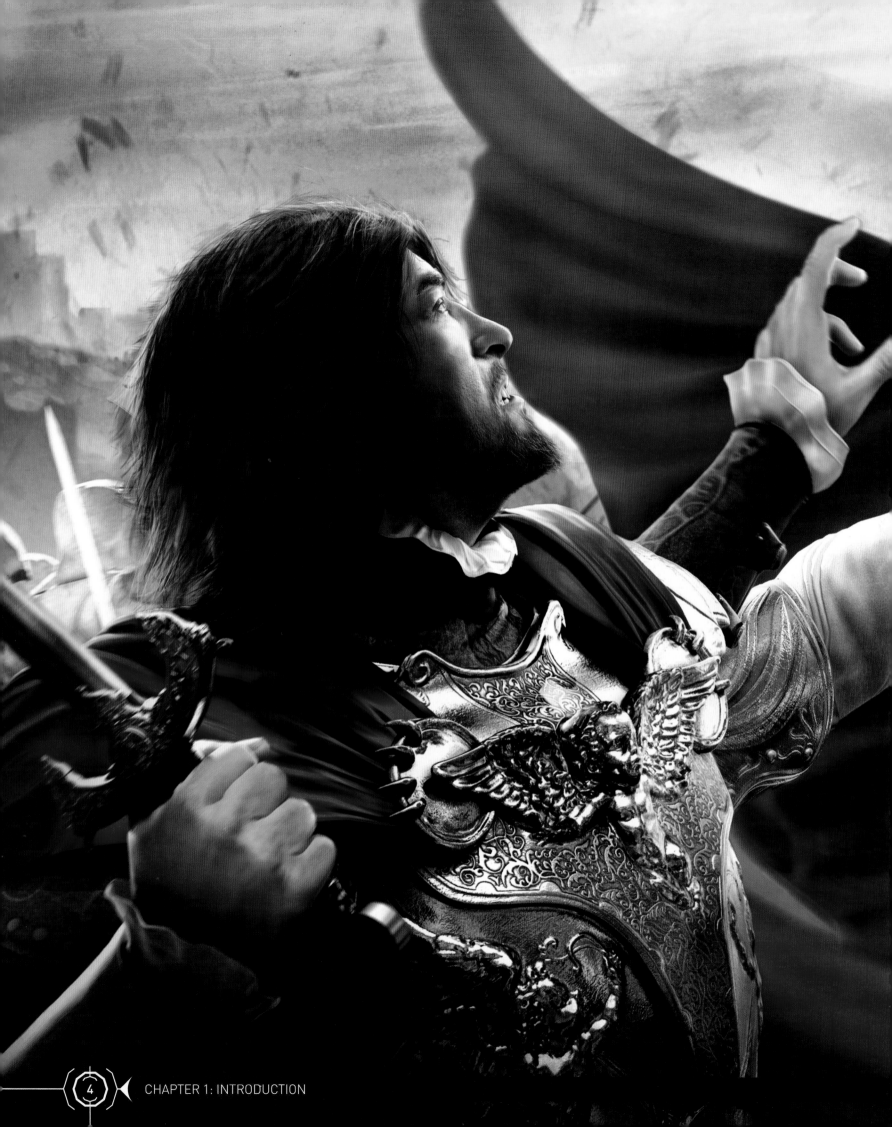

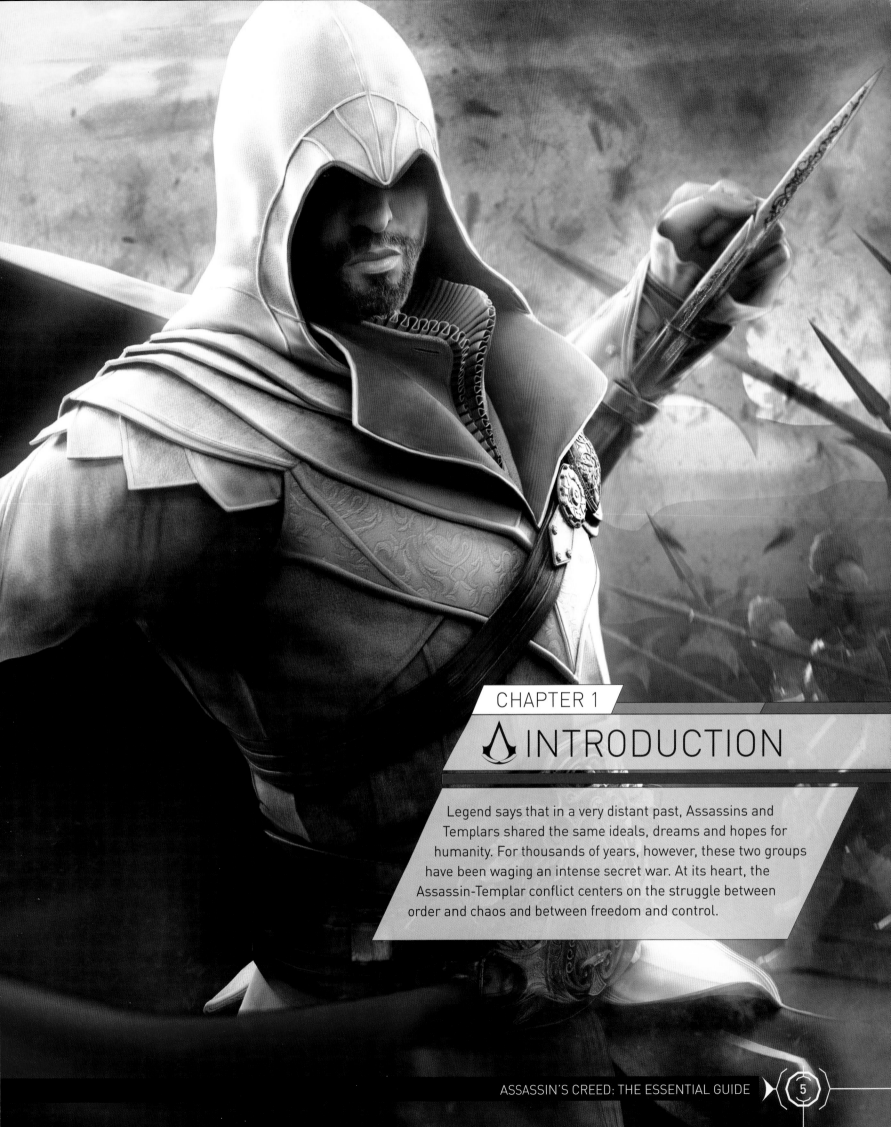

CHAPTER 1

⟁ INTRODUCTION

Legend says that in a very distant past, Assassins and Templars shared the same ideals, dreams and hopes for humanity. For thousands of years, however, these two groups have been waging an intense secret war. At its heart, the Assassin-Templar conflict centers on the struggle between order and chaos and between freedom and control.

THE ASSASSIN BROTHERHOOD

The Assassin Brotherhood is an organization dedicated to protecting the free will of humankind, and ensuring the freedom to live peacefully and without interference. They fight on behalf of those who do not have the opportunity to change society or speak out against the abuse of power, working strategically to neutralize or remove oppressors and tyrants.

The Assassins oppose the Templars, who use manipulation of the masses to control the course of history.

The Brotherhood's values were born in Ancient Greece, and the predecessor to their organization was founded in Egypt near the end of the Ptolemaic Kingdom under the name of the Hidden Ones. The Assassin Brotherhood is still active in modern day society.

THE CREED
The Brotherhood's philosophy centers on three main tenets:
1. Stay your blade from the flesh of an innocent.
2. Hide in plain sight.
3. Never compromise the Brotherhood.

This strong set of values should govern any Assassin's conduct.

"You cannot know anything. Only suspect. You must expect to be wrong, to have overlooked something." — Malik Al-Sayf

At the heart of the Assassins' ideology lies the principle that no one person can know the objective truth of a situation. Assassins must gather as much information about a situation as possible, and do their best to make an informed, objective decision before acting. No single rule can be universally applied across a set of different circumstances; each must be taken as a unique position and examined as a unique entity. To apply one rule to every situation is to risk becoming blinded by dogma, and the Brotherhood strives to remain open to every possibility and to encourage the diversity of thought.

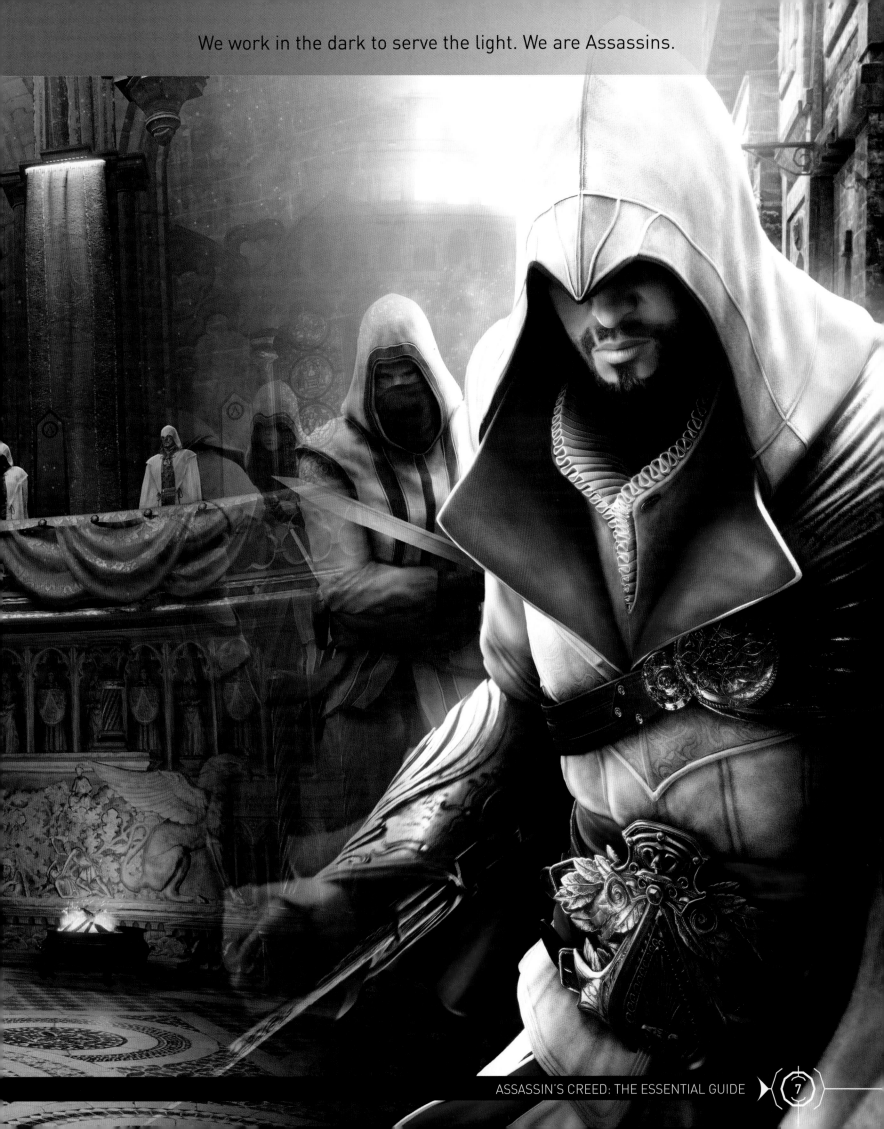

We work in the dark to serve the light. We are Assassins.

THE TEMPLAR ORDER

The Templar Order began as a secret society known as the Order of the Ancients. The group was established millennia ago, and rose to power in Persia, Egypt, and beyond. When Kassandra weakened and eventually took down the chaotic Cult of Kosmos in the fifth century BCE, she unknowingly made way for the Order of the Ancients to gain influence in Greece. In the Middle Ages, the Templar Order was openly endorsed as a religious order, but subsequently returned to secrecy after being discredited. The next public face of the Templar Order would be a corporate entity in the twentieth century: Abstergo Industries.

The Templars seek to create a perfect world by imposing order and a set, defined paradigm upon the world at large. Purpose, discipline and control typify their approach, which sets them at odds with the methodology of the Assassin Brotherhood.

The Templar Order supports centralized leadership and government, working behind the scenes to transform and influence society while manipulating uprisings and revolutions to their benefit. Free will and uncontrolled development are considered chaotic; only through careful guidance can the world achieve equilibrium and peace.

ORDER, NOT CHAOS

Templar ideology centers on the idea that structure and order allows humankind to transcend its baser violent tendencies, and that free will and too much autonomy creates a chaotic, unharmonious society. Essentially, the unwashed masses cannot be trusted to govern themselves; more enlightened individuals must guide and corral it for them to ensure a functional society and to aspire to the greater good. Like the Assassins, the Templars are ultimately in pursuit of peace; it is their means of achieving that goal which differ.

ABSTERGO INDUSTRIES

The corporate front of the Templar Order in the twentieth and twenty-first centuries is Abstergo Industries. Founded in 1937, Abstergo was created as a public face to facilitate Templar influence on the world economy, and in the twenty-first century operates within several business sectors, including pharmaceuticals and communications. Abstergo has been responsible for the majority of corporate research and development in the modern Western world, genuinely contributing to the technological and economic development and advancement of civilization. By investing in foreign governments and funding important corporations, Abstergo has quietly strengthened its influence over the dissemination of information and the collection of data that helps support the Templar Order's goals.

PRECURSOR RESEARCH

One main focus of Templar research is the Precursor civilization, also known as the Isu. This civilization predates humankind, and the information the Templars have uncovered about it reveals that it was a very structured, analytical, and orderly society, which focused on intelligent design. The Templar Order uses the Animus technology developed by Abstergo to uncover as much information and as many artifacts related to the Precursor civilization as possible. The Templar Order seeks to locate Pieces of Eden created by the Precursors in order to use their powers to impose their will upon humanity.

THE ANIMUS

The Animus is one of the most important tools available to both the Assassin Brotherhood and the Templar Order. By accessing genetic memories, information regarding the Pieces of Eden, powerful technological artifacts dating from the Precursor civilization, can be uncovered, as well as information regarding the location of Precursor sites. The Templars seek to use these artifacts and information to enforce their ideal of an orderly, structured society; the Assassins strive to keep them out of the hands of the Templars in order to preserve humankind's independence.

It has now been confirmed that, as theorized, the Animus technology was initially based on Precursor technology.

At its most basic, the Animus technology allows the user to read a subject's genetic memory, casting it onto a screen in three dimensions, immersing the user in the memory experience.

Abstergo's current VR and entertainment technology, which encourages the public to consider history as their playground, and Helix, a cloud-based software using the Animus technology, allow anyone to experience the memories of the historical figures made available on the platform. Beyond the use of this well-established technology for entertainment, however, the fields of research and analysis have been enriched by the use of more complex applications. Recent staggering advances in the technology include the development of portable Animus models that can use damaged or even incomplete DNA to reconstruct genetic memories. With the latest technology that allows for the scanning of historical material sources in order to reconstruct or project probable paths to fill in gaps more accurately, the possibilities are now limitless.

ΛNIMUS⏴

Powered by Abstergo®

MAIN ANIMUS COMPUTER UNIT

HIGH DENSITY FOAM

> "Our DNA functions as an archive. It contains not only genetic instructions passed down from previous generations, but memories as well. The memories of our ancestors."
>
> — Warren Vidic

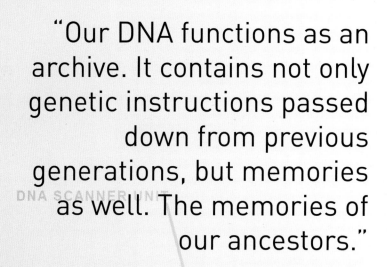

DNA SCANNER UNIT

DIALYSIS UNIT

DNA READER UNIT

ANIMUS OCULARS

THERMA-GEL / BODY TEMPERATURE REGULATOR

TIMELINE:
KEY EVENTS OVERVIEW

431-406 BCE: The Peloponnesian War between Athens and Sparta was the foreground of the secretive manipulations of The Cult of Kosmos, a group of people looking to control the course of history. The Spartan mercenary Kassandra, the granddaughter of King Leonidas, managed to bring down the powerful Cult, destroying the Precursor artefact they had used to sway the balance of powers in their favor.

Unknown [BCE]: The Isu genetically modify existing species to create the human race.

Circa 75,000 BCE: The Toba Catastrophe occurs. The earth is struck by a massive solar flare, and both populations are severely diminished. Few members of the Isu survived, and as a result, they gradually become extinct. What remained of humankind successfully managed to build new civilizations across the globe.

Circa 75,010-75,000 BCE: The Human-Isu war takes place.

Circa 75,010 BCE: The Isu Saturn is murdered by a human, the first public act of the uprising that launches the Human-Isu War. His death seals his daughter Juno's hatred for humanity, and she swears to destroy them.

Circa 75,010 BCE: Eve steals an Apple of Eden from an Isu. She awakens Adam with the Apple, setting in motion a chain-reaction leading to the mass uprising of the humans against their creators.

480 BCE: Betrayed by the mysterious Cult of Kosmos, Leonidas, King of Sparta, is killed during the battle of Thermopylae, his final stand against the invading Persian army. Leonidas' broken spear, a Precursor artifact, is passed down to his daughter Myrrine.

465 BCE: King Xerxes I of Persia, supported by the predecessors of the Templar Order, is killed by Darius in the first recorded use of the Hidden Blade.

47 BCE: Bayek of Siwa and Aya found the Hidden Ones, an organization of people committed to the ethics of working in the shadows to block or remove those who would control humanity's free will. Bayek forms a group in Memphis, while Aya travels to Rome to establish a bureau there.

40 BCE: Bayek and Amunet realize that an ally of the Hidden Ones in Egypt's Sinai region has manipulated them in his drive to create martyrs to inspire people to join the rebellion against Roman forces. They agree that the Hidden Ones must hide in plain sight to keep their identities secret, and that their activities should never endanger the lives of innocents, forming the foundations of the Assassin's Creed as we know it.

30 BCE: With the end of Ptolemaic Egypt inevitable, Amunet offers her former friend Cleopatra an honorable way to decide her own fate and end the war that is destroying Egypt and its people. Cleopatra accepts, calls for the retreat of Egyptian forces, and dies after willingly drinking the poison Amunet had given her.

1129 CE: The Order of the Knights Templar is publicly recognized during the Council of Troyes, with Hugues de Payens serving as the first public Grand Master.

Circa 47 BCE: The Order of the Ancients arrange an alliance between Caesar and Cleopatra, which unites the two powerful empires of Rome and Egypt under their control.

15 March 44 BCE: Aya, together with Brutus and Cassius, orchestrates the murder of Julius Caesar. The chaos after Caesar's public execution convinces Aya that working from the shadows should be the preferred course of action for the Hidden Ones. In the following days, she changes her name to Amunet, "the Hidden One," to be a reminder and pledge.

1257-69 CE: Niccolò and Maffeo Polo train under Assassins Altaïr Ibn-La'Ahad and his son Darim. They establish Assassin Guilds in Constantinople and Venice, the first Guilds in the West.

1307 CE: The Knights Templar are branded heretics by King Philip IV of France and their Temple in Paris is besieged. Over sixty Templars are arrested, including Grand Master Jacques de Molay.

1090 CE: Under the leadership of Hassan-i Sabbāh, the Assassin Brotherhood no longer conceals its presence in order to inspire others to fight oppression, although the rites and practices remain secret.

April 1937: In the midst of the Spanish Civil War, the Assassin Ignacio Cardona and Templar and Black Cross Albie Bolden collaborate to retrieve the powerful Koh-i-Noor artefact from Instrument of the First Will Rufus Grosvenor. They left the artefact buried in a mass-grave under the ruins of a church in Spain.

1-2 September 2012 CE: Desmond Miles is abducted by Abstergo to relive the genetic memories of his ancestor Altaïr Ibn-La'Ahad.

1512 CE: Ezio Auditore unlocks Altaïr Ibn-La'Ahad's secret library in Masyaf and views Jupiter's message about the Toba Catastrophe, and his suggestion to go to the Grand Temple in Turin, New York.

1980 CE: The Animus Project is formally launched by Abstergo Industries under the direction of Dr. Warren Vidic, with the goal of exploring genetic memories to gather information about the Assassins and the Pieces of Eden.

1977 CE: Assassin William Miles steals the Abstergo blueprints for the Animus and passes them to an Assassin cell to use in constructing their own version of the Animus.

1314 CE: Jacques de Molay, the last publicly recognized Grand Master of the Knights Templar, is burned at the stake. De Molay's last command sends nine of his most trusted men across the known world to continue the Order's objectives underground.

1937 CE: Abstergo Industries is founded by the Templar Order as a public front.

October 1943: Project Rainbow, also known as the Philadelphia Experiment, was a desperate attempt by the Assassins and Templars to use a proto-Animus device, Die Glocke, in order to alter the past and prevent the horrific events that would take place during World War II. The experiment failed, but the scientific knowledge behind the development of Die Glocke would become instrumental to the later development of the Animus.

2000 CE: Daniel Cross, a Templar sleeper agent, kills the global Mentor of the Brotherhood. The Templar Order initiates the Great Purge, a global operation designed to eradicate the Assassin Brotherhood, using information gathered by Daniel Cross. The only Assassin cells to survive are those whose existence are unknown to Cross.

2016 CE: Ascendance Event: A group of teens with special lineage prevent rogue Templar and former Instrument Isaiah from using the Trident of Eden to start a new era of humans with godlike powers.

2017 CE: After illegally modifying an Animus to be used in the field with raw DNA from the mummies of Bayek and Aya, Layla Hassan discovers the Hidden Ones and the Order of the Ancients, important elements in the history of the Brotherhood and the Templar Order. Desmond Miles invites Layla to join the Assassin Brotherhood.

2018 CE: Atlantis, a repository of invaluable Isu knowledge tended by Kassandra, is located by Layla Hassan in Greece. There, Kassandra, who has remained alive for centuries by holding the Staff of Hermes, passes the artifact to Layla, imploring her to restore balance to the world.

2012 CE – Present: After his son's death, William Miles disappears and leaves Gavin Banks in charge of rebuilding the now scattered Brotherhood. As of today, the remaining Assassin cells have gone deeper into hiding but still fight to try to break the Templars' control.

8-9 September 2012 CE: After escaping and meeting with the Assassins, Desmond uses their Animus to relive the genetic memories of his ancestor Ezio Auditore, including the message about the upcoming Second Disaster that Ezio received from Minerva.

21 December 2012 CE: Desmond Miles opens the Grand Temple in upstate New York. Against the wishes of Minerva, he touches the pedestal activating the device created to stop the Second Disaster, and dies in the process. This saves the world from the Second Disaster, but also releases Juno from her imprisonment, where she had been trapped by the Precursors to prevent her from acting against them and humankind in her own interests.

2018 CE: Elijah —Sage, son of Desmond Miles, and pawn of the Instruments of the First Will—vanishes in the Australian desert while in possession of the Koh-i-Noor, a powerful Piece of Eden.

2018 CE: The Assassins and Otso Berg retrieve the Koh-i-Noor in Spain, only for the artefact to be taken from them by the Instruments of the First Will. Juno, a powerful Isu, is finally given human form thanks to the Phoenix Project, but is stabbed by Charlotte de la Cruz when her body is incarnated, and dies. Templar and Black Cross Otso Berg oversees the complete destruction of the Phoenix Project, and the eradication of the Instruments of the First Will.

CHAPTER 2: THE PRECURSOR CIVILIZATION

CHAPTER 2

 THE PRECURSOR
CIVILIZATION

In the distant past, an ancient race of precursor beings
known as the Isu created humanity, only to perish following
a devastating catastrophe. The Isu legacy would live on for
millennia in various myths and legends, becoming the basis
of many religious ideals. And most of all, the powerful Pieces
of Eden they created became the objects of an endless quest
for both the Templars and the Assassins.

 CHAPTER 2: THE PRECURSOR CIVILIZATION

THOSE WHO CAME BEFORE

THE TOBA CATASTROPHE

After centuries of enslavement, the human race revolted against their Precursor masters. The humans had the advantage of numbers, while the Precursor civilization had the advantage of superior technology. The ten-year war between the two races was cut short by the Toba Catastrophe, a cataclysmic coronal mass ejection circa 69,000-77,000 BCE that essentially wiped out the Precursor civilization, despite the methods they explored or implemented to prevent the disaster. The human race, engineered for survival by the Precursors themselves, rebuilt their society and flourished, while the few surviving Isu gradually died out over the next millennia, unable to maintain their civilization.

The Isu were an ancient and advanced species of humanoids that were native to Earth before the human race was created. Variously called the First Civilization, Those Who Came Before, and the Precursors, the Isu were a highly advanced race with sophisticated scientific knowledge.

THE PRECURSORS: QUICK FACTS

- Advanced species of humanoid predating the human race on earth
- Anatomically similar to humans, taller with larger skulls
- Possessed six senses and triple-helix DNA
- Classified as Homo sapiens divinus by Abstergo Industries

THE PRECURSOR RACE AND HUMANKIND

The Precursor civilization used their extensive scientific knowledge to genetically engineer the human race, accelerating the natural evolutionary process and extensively transforming the existing genetic makeup. The resulting race, ostensibly created in the image of the Precursors, had a shorter lifespan and only five senses, and was designed to flourish in challenging conditions. This resilience, which was not present in the Isu, is what enabled humans to adapt to its environment and survive. Evidence suggests that the Precursor civilization deliberately limited the potential of the newly created human race in order to keep them as a compliant workforce, and the Pieces of Eden were created to guarantee their obedience. The less-complex humans considered the Isu to be gods.

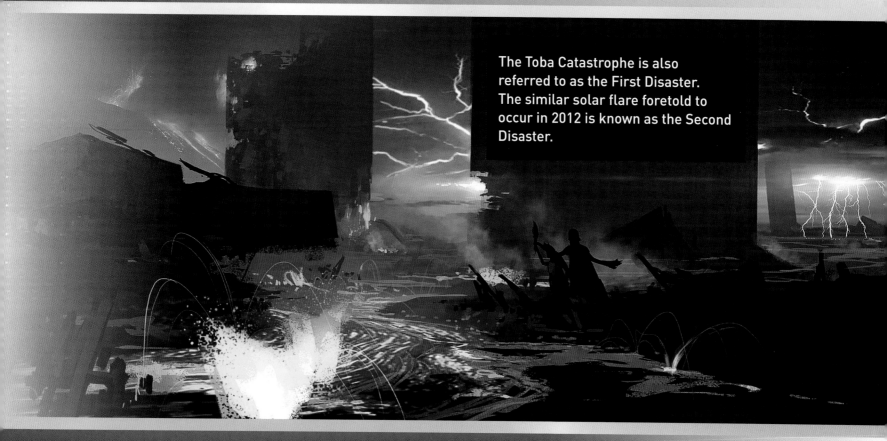

The Toba Catastrophe is also referred to as the First Disaster. The similar solar flare foretold to occur in 2012 is known as the Second Disaster.

"But something larger than the Assassins and Templars is approaching. Bigger than all of us. And if we can't find a way to stop it — these next few weeks will probably be our last. **Everyone's** last." — William Miles

The Capitoline Triad: The Capitoline Triad consisted of Precursor scientists Minerva, Juno, and Jupiter. In search of methods to avert or cope with the incoming natural disaster that would become the Toba Catastrophe, they worked in the underground Grand Temple for years in vain to research and test various potential solutions that were developed in a network of secondary temples or vaults.

The Precursor Influence: Even as they slowly vanished, the Isu influenced the burgeoning human civilization, reflected in thematically similar mythologies from different cultures across the globe.
This society is sometimes referred to as the First Civilization, although it is impossible to prove if the Precursor civilization was in fact the first on earth.

Knowledge of the Precursor civilization is not limited to the Assassin Brotherhood and Templar Order; a few people outside these organizations have also come into contact with Precursor artifacts and information.

Cults Dedicated to the Isu: The Cult of Kosmos in Ancient Greece was a splinter group from the Pythagorean cult, formed around a Precursor artefact in the shape of a pyramid that could predict possible futures. They manipulated the Oracle of Delphi, and used the artefact to deliver prophecies that guided the population toward the Cult of Kosmos' preferred outcomes.

The Hermeticists were a cult that followed the teachings of Hermes, an Isu who passed his Staff of Eden that held the key to life's mysteries to Pythagoras. Pythagoras was a philosopher and mathematician who believed that there existed a perfect number that could establish balance between order and chaos. Centuries later, the Hermeticists had evolved into a cult devoted to the pursuit of mathematics that could control the world.

The Instruments of the First Will, sometimes referred to as the Juno cult, was a secret group drawn from Templars, Assassins, and civilians devoted to Juno and her quest to re-establish the Isu race. The Instruments co-opted the Phoenix Project's goal of creating a physical Isu body for Juno to inhabit. At the last moment of Juno's incarnation, Charlotte de la Cruz stabbed the Isu body, killing Juno.

KNOWN PRECURSORS

JUNO

Juno's actions throughout the years alternately supported or opposed both Templar and Assassin activity. Her subversion of individuals on both sides of the conflict to serve her own needs made her one of the most dangerous entities involved in the ongoing struggle between order and chaos in the world.

Juno was an Isu scientist, and a member of the Capitoline Triad alongside Jupiter and Minerva. Her hatred of humanity was sealed by seeing her father, Saturn, murdered by a human slave at the beginning of the Human-Isu war. Driven by this hatred and an argument with Minerva about the great potential the human race held for becoming equals of the Isu, Juno began to make her own plans to take over the world after the Toba Catastrophe, which resulted in the imprisonment of her consciousness in the Grand Temple throughout the millennia of human civilization that followed the Toba Catastrophe.

Juno reached out to several humans over the years, winning them to her cause of self-liberation through promises, guile, or the use of Pieces of Eden. She also encouraged the creation of the Instruments of the First Will, a cult devoted to her quest to re-establish the Isu as the dominant race and humanity as their slaves. Her consciousness was freed from the Grand Temple through Desmond Miles' sacrifice to protect the world from a repeat of the Toba Catastrophe in December 2012. Juno's consciousness used the equipment the Abstergo team brought into the Grand Temple as a stepping-stone, enabling her to leave the Grand Temple and enter the Web, inhabiting and communicating via digital networks in her continuing quest to find a physical host. The Instruments of the First Will turned their efforts to finding or creating a new body for her consciousness to inhabit, as well as locating a powerful Piece of Eden known as the Koh-i-Noor to bring Juno's goal of seizing control of the world to fruition.

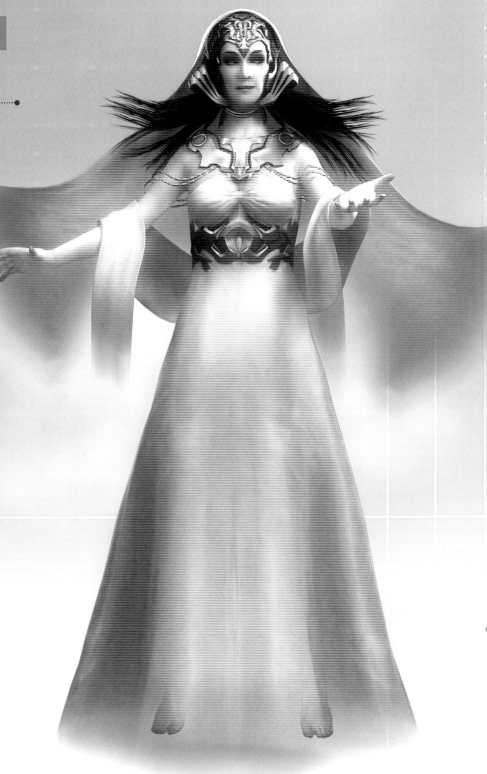

At her moment of incarnation in the Isu body constructed by the Phoenix Project, a moment of great triumph for her, Juno was killed by Charlotte de la Cruz, bringing to an end a long, dangerous saga of manipulation and self-serving actions that threatened the safety and integrity of the human race.

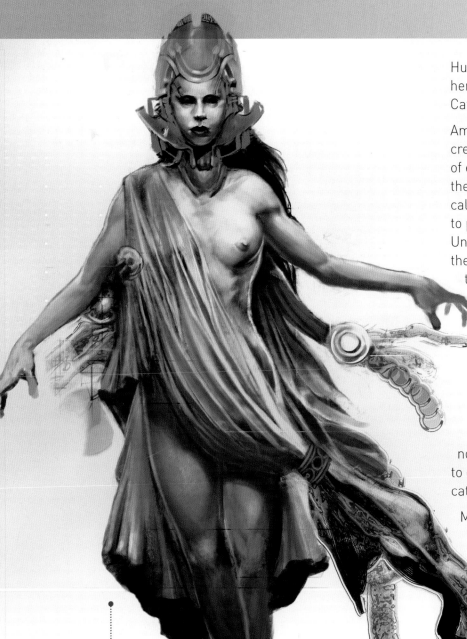

Human-Isu war, Minerva upheld this belief, and devoted herself to helping humanity rebuild after the Toba Catastrophe.

Among other projects at the Grand Temple, Minerva created the Eye, a device capable of identifying patterns of existence to comprehend, and even manipulate, the calculations of time itself. She realized, through her calculations, that any corrective action was destined to fail to prevent the First Catastrophe from happening. Understanding that patterns of existence repeat themselves, Minerva then dedicated herself to using the Eye to aid in preventing the next catastrophe from occurring by guiding Desmond towards the location of technology that had been automated to develop a solution after the passing of the last remaining Isu.

When Minerva and Jupiter discovered Juno had tampered with the Eye to further her own objectives for the future, they destroyed the device and sealed Juno within the Vault located inside the Temple, but not before they used it to send messages through time to guide Desmond Miles towards preventing a second catastrophe from occurring in December 2012.

Minerva and Jupiter lived on for centuries after the Toba Catastrophe, and she eventually created a second Eye, allowing her to look through time once again before her own death, to see if her messages to Desmond had worked. Minerva reached Desmond one last time on December 21st, 2012. Minerva and Jupiter had intended for Desmond to avert the Second Catastrophe, but when Minerva realized that Juno had managed to connect her consciousness to the Temple's Vault, and had been able to reach out to Desmond as well, she implored Desmond to from refrain touching the pedestal that would activate the technology within the Temple, and release Juno.

In addition to her efforts to guide Desmond, Minerva was also instrumental in aiding Owen Meyers and his fellow teenagers involved with the Ascendance Event to block the rogue Templar Isaiah from using the reassembled Trident of Eden to destroy the world. Minerva had been able to foresee probable futures, including one that exposed the threat Isaiah would pose to humanity. She created a genetic time capsule, inserting strength and the power to resist the Trident when required into the DNA of certain individuals that would be passed down to their genetic lines, ending with the adolescents who she had foreseen could be united to destroy the power of the Trident of Eden.

MINERVA

One of the Capitoline Triad devoted to researching methods to prevent the First Disaster, Minerva survived the Toba Catastrophe. She worked to create the best odds for the continuation of the human race and the world itself, knowing that the Second Disaster would come eventually.

Moments before Saturn's death at the hands of a slave, and the start of the human uprising, Minerva had argued for the potential the human race held, urging Juno to recognize that if the Isu gave them the tools, the humans could become truly great. Despite the devastating

KNOWN PRECURSORS

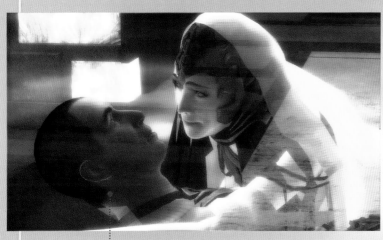

AITA •·······

An Isu scientist and Juno's husband, Aita designed the Observatory and supervised the program that created the Pieces of Eden. As the Toba Catastrophe approached, Aita volunteered to test one of the methods being researched by the Capitoline Triad to survive the disaster, the transference of Isu consciousness into an artificial body. The experiment failed, and Aita was left trapped inside the surrogate body, his mind degrading and failing. Juno was unable to heal or rescue him, and was forced to euthanize him.

Before doing so, Juno secretly preserved his genetic material, which she subsequently inserted into human DNA in order to create the Sages. By means of this project, Aita was reincarnated in a series of humans through the next millennia, each Sage echoing his physical appearance and his ingrained opinions concerning the inferiority of the human race. Aita's goal is to manifest Juno in physical form so that they may be reunited. Only one Sage has proved capable of resisting Aita's influence and controlling the Isu's DNA: Elijah, the son of Desmond Miles.

JUPITER •·······

Also called Tinia, Jupiter was the Precursor who spearheaded the Isu commitment to preventing or surviving the Toba catastrophe, leading the Capitoline Triad in their quest to gather and test information to prevent the Toba Catastrophe.

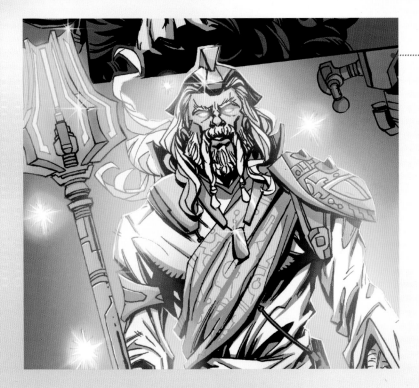

SATURN

Saturn was a high-ranking Isu leader, and the father of Juno. He wielded the Scythe, a powerful Piece of Eden. Unlike his daughter, Saturn did not despise the human race. While Juno mocked humans and said they were just aping their betters, Saturn agreed with Minerva's point of view that the humans were capable of art and could possibly someday achieve equality with the Isu.

Tragically, Saturn's more liberal mindset would not inspire Juno. Saturn was murdered at that moment by one of his human servants, who shouted that the uprising had begun. Enraged, Juno used the Koh-i-Noor to channel Saturn's Scythe and destroy all the humans around them with its power. This was one of the incidents that signaled the beginning of the Human-Isu War, and an incident that sealed Juno's hatred for humans. She announced that she would save the human race from itself by ending it.

CONSUS

Also called Prometheus, Consus was a Precursor scientist and creator of some of the Pieces of Eden. He assisted Hephaestus in making the Swords of Eden, and when the war generated the need for medical equipment he designed the Shroud of Eden, a device intended to scan a body and reconstruct it, healing damage and returning it to a predetermined state. The designs for his original Shroud were used to create other Shrouds, to be used by Isu as a sort of highly advanced medical field kits. Death being the one state the Shroud could not heal, near the end of his natural life Consus transferred his consciousness into the original Shroud in order to cheat death. While the transfer was successful, Consus found himself trapped in the artifact, which was subsequently forgotten.

Found by Juno during the Capitoline Triad's research into methods of averting or surviving the impending Toba Catastrophe, Juno used Consus' knowledge to experiment with transferring Isu consciousnesses into artificial bodies, an attempt which failed.

Consus has temporarily possessed various users of the original Shroud throughout the centuries, providing guidance and counsel. When the Shroud was destroyed in 2014, Consus' consciousness was apparently destroyed as well.

However, various individuals such as Charlotte de la Cruz were able to interact with the information Consus had seeded throughout history to help them fight Juno in the modern era.

In late 2015 a second Shroud was located in the Precursor Vault beneath Buckingham Palace. Álvaro Gramática used this Shroud for his Phoenix Project, and the creation of a new body for Juno. During this process, which was finalized in 2018, Juno's DNA and the Shroud blended together, and Consus was able to communicate with Juno, telling her she had underestimated the human Charlotte de la Cruz. Juno's dismissal of the human potential proved to be her final, fatal mistake.

KNOWN PRECURSORS

DURGA

A statue of Durga was discovered under the ruins of the summer palace of Maharajah Ranjit Singh. The statue held two recognizable Pieces of Eden, an Apple and a Staff, as well as the Koh-i-Noor, the Piece of Eden rumored to be capable of combining the power of other Pieces of Eden.

APHRODITE

In a vision by Kyros of Zarax, Aphrodite was seen hiding three apples behind the main altar of a temple of Aphrodite. Awakening from the vision, Kyros looked behind the altar and found a single Apple of Eden. He used this in his race against Atalanta, the Apple acting upon her to slow and confuse her, allowing him to win the contest and marry her.

HERMES

An Isu revered as a god of magic and alchemy by Ancient Greeks and Egyptians, a cult dedicated to Hermes known as the Hermeticists was founded.

In the sixth century BCE, Hermes met Pythagoras and his protégé Kyros of Zarax in the desert, where they had felt drawn to explore. Hermes passed his Staff of Eden to Pythagoras, naming him his successor. Pythagoras would go on to live much longer than the normal human lifespan, thanks to the influence of the artefact.

ALETHEIA

When Kassandra retrieved all four Atlantis artifacts, she and Pythagoras received part of a message from Aletheia. The Isu acknowledged that Pythagoras' efforts to understand the very equations of reality had brought him further than any other human, but at a cost to his mind.

She noted that her fellow Precursors should have never shared their knowledge with humans, as they were not ready for it. Aletheia expressed her belief that other Precursors were manipulating humans for their own selfish ends, not letting them truly be free.

Finally, the Isu spoke directly to Layla, who was experiencing Kassandra's genetic memories in the Animus. Aletheia was aware of the simulated nature of the reality Layla was experiencing, and reflected on them both being 'rebels' who could defy the rules and status quo. With this message transferred across the ages, Aletheia indicated that she and a group of fellow Precursors intended to defy the status quo within their own present reality.

HEPHAESTUS

Creator of many of the Pieces of Eden, but mainly weapons, Hephaestus was an Isu scientist who was known as "the maker" among the Precursors. Consus apprenticed with him to create weapons during the War of Unification, notably the Swords of Eden and the Spear of Eden, at his Forge. Having witnessed the sheer level of destruction and suffering the weapons could cause, Consus was inspired to devote himself to creating a healing Shroud instead.

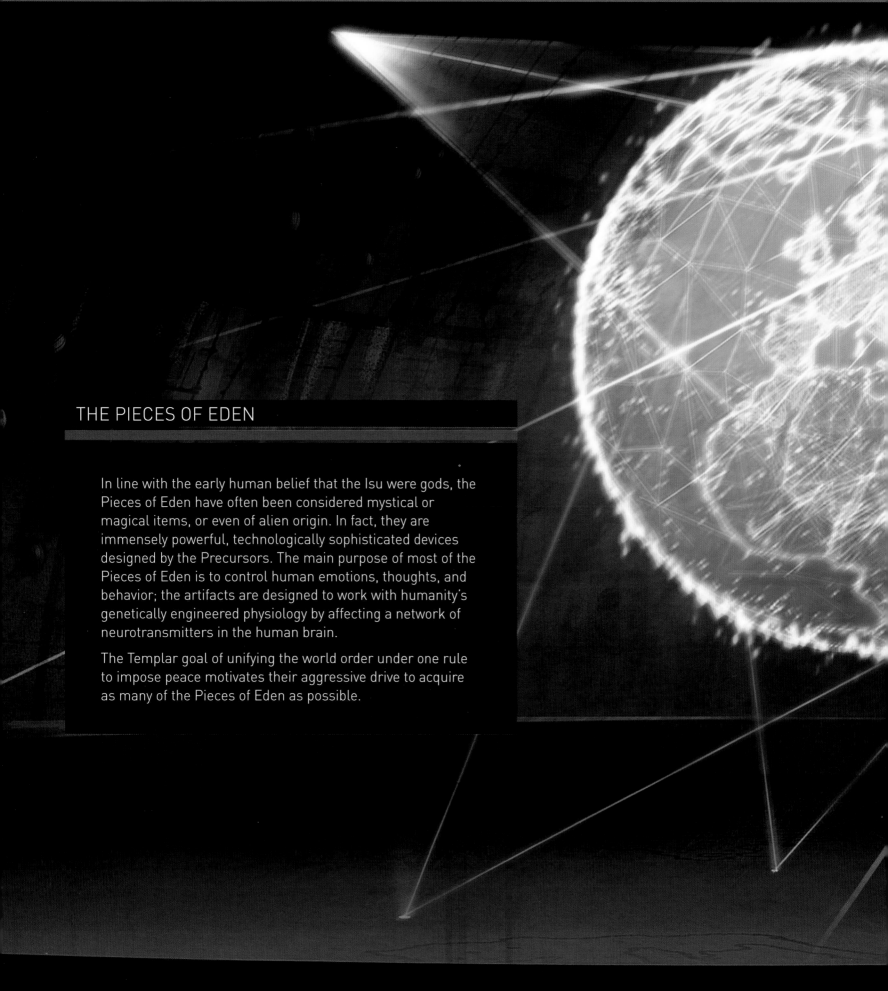

THE PIECES OF EDEN

In line with the early human belief that the Isu were gods, the Pieces of Eden have often been considered mystical or magical items, or even of alien origin. In fact, they are immensely powerful, technologically sophisticated devices designed by the Precursors. The main purpose of most of the Pieces of Eden is to control human emotions, thoughts, and behavior; the artifacts are designed to work with humanity's genetically engineered physiology by affecting a network of neurotransmitters in the human brain.

The Templar goal of unifying the world order under one rule to impose peace motivates their aggressive drive to acquire as many of the Pieces of Eden as possible.

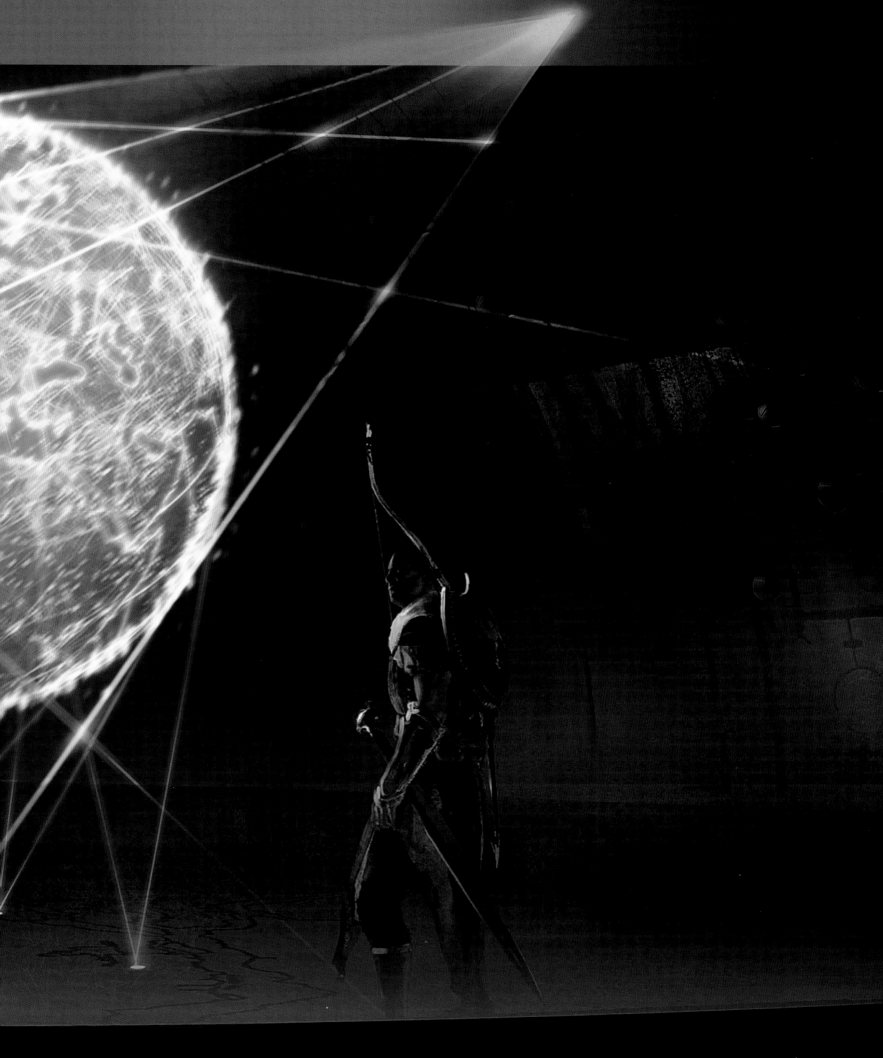

APPLES OF EDEN

The Apples of Eden are spherical technological devices designed by the Precursors to ensure humanity's obedience to them. With their genetic makeup designed to respond to the power of the Apples, the human race is particularly susceptible to the effects of these artefacts.

In circa 75,010 BCE , the Isu-human hybrid Eve, who was able to resist the mind-controlling powers of an Apple of Eden thanks to her mixed DNA, stole one of the artifacts. Together with Adam, she released other humans from its enslaving powers; an act that would lead to a human uprising against its creators, and eventually the widespread Human-Isu war. Eve and Adam's act of defiance gave rise to the human legend that they were cast out of the Garden of Eden for partaking of forbidden fruit.

The powers of the Apples of Eden can be applied towards different purposes. They can, for instance, be used to create reality through thought. The Isu unsuccessfully tried to use this power when they launched an Apple of Eden into the Earth's orbit to influence humans into believing the planet would be safe from the incoming Toba Catastrophe, and making that belief come to pass.

The artefacts can also be used as archival devices, containing a large amount of Precursor information. Some also possess the capability of tracking the location of other Pieces of Eden in the world, which increases their value to both the Templar Order and the Assassin Brotherhood.

As of the twenty-first century, the existence of multiple Apples of Eden has been confirmed.

APPLE 1

Taken by Arno Dorian from the Saint-Denis Temple in northern Paris. Napoleon acquires it and becomes Emperor of the French thanks to its power. The Apple passes into the hands of the magician Harry Houdini. The Templars eliminate him and retrieve the Apple.

Known owners: Suger of Saint-Denis, Arno Dorian, Napoleon, and Harry Houdini

Uses: By Napoleon to become emperor; assassination of John F. Kennedy

Current status: In the hands of the Templars

APPLE 2

Bayek recovered this Apple of Eden from the Order of the Ancients and hid it in Aya's hideout in Alexandria. In the 12th century, the Apple was held by Al Mualim, the old Mentor of the Assassins of Masyaf, before Altaïr exposed him as a traitor and took possession of it. In the 16th century, the Apple fell into the hands of Elizabeth I of England. Later it was owned by Gandhi, who was assassinated by the Templars who took the artifact. The Apple was destroyed in an accident at an Abstergo facility located beneath Denver International Airport in 2011.

Known Owners: Bayek, Al Mualim, Altaïr, Elizabeth I, and Gandhi

Current Status: Destroyed

APPLE 3

Brought by European Freemasons to the New World, where, in the 18th century, it came into the possession of George Washington. Haunted by dreams of totalitarian tyranny made possible by the Apple, he gave it to Assassin Ratonhnhaké:ton (Connor) so he could throw it into the sea. In the 20th century, Franklin D. Roosevelt had it recovered, and passed it down to his successors until it reached John F. Kennedy, who would be assassinated by the Templars.

Known owners: George Washington, Ratonhnhaké:ton (Connor), Franklin D. Roosevelt, and John F. Kennedy

Current status: Unknown, probably in the hands of the Templars

Human study of the Pieces of Eden has led to several technological and scientific breakthroughs.

APPLE 4

The earliest known depiction of this Apple dates back to 10th-century China. In the 19th century Nikola Tesla found the Apple, and later aimed to use the artifact's energy to create free electricity for the entire world. The Templar Thomas Edison gained possession of it, blocking Tesla's goals. The Apple fell into the hands of Mark Twain, followed by Henry Ford, who used it to manipulate the workers on his mass-production assembly lines, ensuring the triumph of Capitalism. In 1933, following the instructions of the Templars, he sent the Apple to Adolf Hitler so that he could take power in Germany and start a world war favorable to Templar industry and influence. Years later, the Templars kidnapped Nikola Tesla and used the Apple to create and power a proto-Animus called Die Glocke. In 1943, the Templars set up a temporary alliance with the Assassins to use the Apple and Die Glocke for 'Project Rainbow', a failed attempt to turn back time to prevent the atrocities of World War II.

Known owners: Nikola Tesla, Thomas Edison, Henry Ford and Adolf Hitler

Current status: Unknown, probably owned by the Assassins

APPLE 5

The Capitoline Triad, Isu Jupiter, Juno, and Minerva, sent this Apple of Eden, among several other similar artifacts, into space in an attempt to prevent the Toba Catastrophe. The Apple crashed into the Moon, where it was recovered on July 20th, 1969, during NASA's Apollo 11 mission.

Known Owners: Precursors, and NASA

Current Status: Probably in the hands of NASA

APPLE 6

In the 15th century, Sultan Mehmet II used the Apple to conquer Constantinople. In 1501, Leonardo da Vinci was forced by the Templars to study the Apple and create war machines for them. Later, the Italian Assassin Ezio Auditore found the Apple and used it to defeat the forces of Cesare Borgia. Together with Machiavelli, Ezio hid the Apple in the First Civilization vault under the Colosseum. In 2012, Desmond retrieved the Apple hidden by Ezio from the Colosseum Vault. He used it to open the Grand Temple in New York.

Known owners: Sultan Mehmet II, Rodrigo Borgia, Ezio Auditore, Caterina Sforza, Girolamo Savonarola, Mario Auditore, Cesare Borgia, Leonardo da Vinci, and Desmond Miles

Current status: In the possession of William Miles

APPLE 7

In the 19th century, the British Templar Cavanagh used the construction of the world's first underground railway as a cover for the attempts to find this Apple of Eden. Eventually Cavanagh did obtain the Apple, but he was killed by rival Templar and Grand Master Crawford Starrick, who ordered scientist David Brewster to unlock its powers. The Apple was destroyed, and Brewster killed, on February 10, 1868, during an experiment in his laboratory in Croydon.

Known owners: Charles Pearson, Cavanagh, Sir David Brewster

Current Status: Destroyed

AGUILAR'S APPLE

The first recorded location of this Apple of Eden was in the possession of Muhammad XII of Granada, who traded it to Tomás de Torquemada and the Templar Order in 1492 in exchange for his son's life. The Assassin Aguilar stole it from Torquemada and gave it to the Brotherhood's ally Christopher Columbus, who sailed with it to the New World. Columbus kept the Apple safe until his death; the Apple was brought back to Spain with his remains and buried with him.

In 2016 the Templar Order located the Apple by viewing the genetic memories of Callum Lynch, and retrieved it. Abstergo Industries CEO Alan Rikkin was assassinated by Callum Lynch in London where the Apple was being presented to the Council of Elders, and Callum escaped with the Apple.

Known owners: Muhammad XII, Tomás de Torquemada , Aguilar de Nerha, Christopher Columbus, Alan Rikkin

Current status: In the possession of Callum Lynch

AKHENATEN'S APPLE

The first known holder of this Apple was Akhenaten in the 14th century BCE, who believed it to be a physical form of Aten, an aspect of the great sun god. He and his wife Nefertiti bequeathed it to their son, Tutankhamun, who then entrusted it to the priesthood of Amun. The High Priests of Amun kept it safe for centuries, until Isidora, the highest-ranking priestess of Amun known as the God's Wife of Amun, used it to revenge herself on the robbers who desecrated her mother's tomb. Bayek assassinated her and gave the Apple to Sutekh, a smuggler and descendant of Pharaoh Ramesses II, to hide.

Known owners: Akhenaten and Nefertiti, Tutankhamun, High Priests of Amun, Isidora, Bayek of Siwa, Sutekh

Current status: Unknown

STAVES OF EDEN

Pieces of Eden in the form of sceptres, the Staves of Eden reflect authoritative power, usually underscored by the concept of sovereignty. A Staff represents the power to command or administrate, and is designed to control men's minds and bodies. Powers ascribed to a Staff of Eden include the ability to conceal the bearer's presence, and levitation; whether these are actual, physical effects or achieved via manipulation of the viewer's perception is unclear. The end of a Staff of Eden can also be used as a spear.

Four staves have been documented.

Rumors are that the **Scythe of Eden,** which once belonged to the Isu Saturn, functioned as a powerful weapon, capable of mass destruction. It also had a different set of powers, however, capable of being used as a tool to counter illusions and reveal truth and hidden reality. It is not known whether anything remains of the Scythe of Eden after Saturn's death and the Toba Catastrophe.

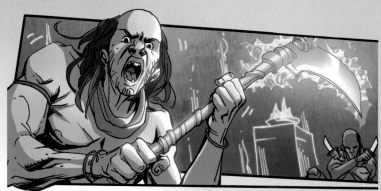

The **Staff of Hermes Trismegistus** was carried by the Isu Hermes, who passed it to Pythagoras. The Staff granted him extended life, although the mental burden of carrying the Piece of Eden and of spending many decades obsessing over the Isu's equations of the universe taxed his mind. Pythagoras then passed the Staff to Kassandra. The Staff is currently in the posession of Assassin Layla Hassan, who received the Staff from Kassandra in 2018, when they met in Atlantis.

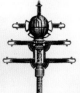

The **Papal Staff** held a cradle in its headpiece where an Apple of Eden could be placed, in order to enhance its mind control effects. When combined with an Apple of Eden, it also unlocked the Vatican Vault, one of the Precursor temples.

The **Scepter of Alexander the Great** was a Staff of Eden, given to Alexander by the Order of the Ancients to help him secure control of Macedonian region, and establish an empire far beyond its borders. At his death the Staff was buried with him in Alexandria, where it was stolen in 47 BCE by Flavius and Septimius, members of the Order of the Ancients, to use in conjunction with an Apple of Eden to open an Isu vault in Siwa. Septimius brought the Staff to Rome and gave it to the local Order of the Ancients, before being killed by Aya.

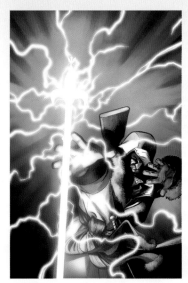

The **Russian Imperial Scepter** was in use by 1888. At some point, the original was stolen by Rasputin and replaced with a replica; the original was then brought to the Templars. Assumed destroyed in the Tunguska explosion in 1908, a piece of the Scepter survived as a Shard of Eden, and was used by Rasputin to control the Tsarina. In 1917 Rasputin's body was exhumed and the Shard retrieved by Assassin Nikolaï Orelov.

"We must fix the mistakes we've made. Use the staff. Repair the rift in the universe." — Pythagoras

SWORDS OF EDEN

Created by the Precursor scientist Hephaestus, the Swords of Eden are carried to enhance power and leadership. A known power associated with the Swords is the ability to direct energy blasts. The existence of three Swords of Eden has been confirmed.

Deimos was the brother of Kassandra, whose birthname was Alexios. The Cult of Kosmos gave him a Sword of Eden to wield as he was raised to be their champion and living weapon. With it, he became an all but an unstoppable force.

The Grand Master of the Knights Templar, Jacques de Molay, had a Sword of Eden before his arrest. This Sword was enhanced by a small red stone called the Heart, which de Molay hid. Joan of Arc found the Heart and kept it in a pouch around her neck, where it functioned as a special power source for the Sword she later obtained, adding to the artifact's inherent powers. The Heart was again lost after Joan's execution when her executioner threw it into the Seine. During the French Revolution this Sword was badly damaged during a battle between Grand Master François-Thomas Germain, Arno Dorian, and Élise de la Serre, likely due to the absence of the Heart. Centuries later, the Sword was displayed in the office of Master Templar and CEO of Abstergo Indutries, Alan Rikkin. Simon Hathaway, Inner Sanctum member and Head of Abstergo's Historical Research department, used the Animus to locate and retrieve the Heart from the Seine, and restore power to the Sword of Eden. The Sword was handed back to Alan Rikkin, but after his death at the hands of the Assassin Callum Lynch, it joined the Templar Order's collection of artifacts.

Many of the swords carried by heroes and conquerors throughout history have been Swords of Eden, including swords belonging to Attila the Hun and Genghis Khan.

THE SPEAR OF LEONIDAS

An artefact and powerful weapon created by the Isu Hephaestus, capable of showing those with Isu blood past events from their own lives, and those of their ancestors.

Leonidas, the legendary king of Sparta, held the spear until his death at the Battle of Thermopylae in 480 BCE. Broken during battle, the Spear was passed on to his daughter Myrrine, who eventually gave it to Kassandra.

Kassandra wielded the Spear in her battles against the forces of the Cult of Kosmos, but once they were defeated, she decided to move on without it.

In 2018, the Spear was found by Assassin Layla Hassan. The traces of DNA found on the Spear were used, in combination with the lost book of Herodotus, to enable the Animus to reconstruct the genetic memories of Kassandra, eventually leading Layla to Atlantis.

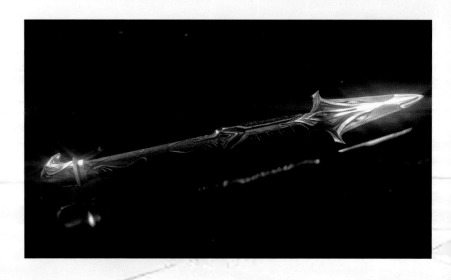

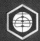

THE PYRAMID

The Pyramid is an Isu artifact that is made up of many regular triangular segments. The Pyramid can access past memories for a user who touches it, assuming they have a high enough concentration of Isu DNA to activate it. It can also compute possible futures, using the Isu ability to manipulate relativity through the calculation of potentials.

Originally in the possession of the followers of Pythagoras, the splinter group calling itself the Cult of Kosmos stole it to use in their pursuit of the ability to manipulate reality through the calculation of possibilities. In order to use the artifact, the Cult abducted and raised a child from a special bloodline. Through Deimos, the Cult's champion and living weapon, the Cult gained access to the full potential of the Pyramid.

The Cult of Kosmos set up the Pyramid under the Temple of Apollo at Delphi, where the Oracle sat, co-opting her freedom. When a querent came to the Oracle, the Pyramid would calculate potential futures. The Cult would then choose the future that best suited their goals, then transmit the prophecy to the Oracle to help lead into that future.

The Pyramid was eventually destroyed by Kassandra, but not before she and former Cultist Aspasia both received different messages from the artefact, urging them onto diverging paths.

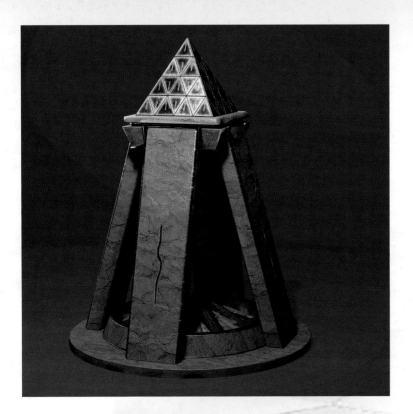

ATLANTIS ARTIFACTS

Designed as keys to mechanisms in Atlantis that reveal secret knowledge of the Precursors, these four Pieces of Eden were powerful and, in the words of Pythagoras, "possess a will to defend themselves." Like other Pieces of Eden, they could consume the minds of weaker humans.

Unlike other Pieces of Eden, these four keys possessed the ability to roam. It is unknown if these keys were originally designed this way, but it has been suggested that an Isu somehow modified these Pieces of Eden, merging them with biological creatures to create monstrous hybrids in the mythological forms of a sphinx, a minotaur, a medusa, and a cyclops. These monsters served as protectors of the artifacts, and the knowledge they could offer access to.

Long after the Precursor civilization disappeared from the world, any human not of Isu lineage who would attempt to hold one of these artifacts would be consumed by it, their appearance transforming into a reflection of the artifact's original protector: An eye, a snake, a horn, and a feather.

When Kassandra obtained the artifacts, they would reveal their original shape and form, which was a round orb very similar to the Apples of Eden. Kassandra was able to resist their consuming force, thanks to her Isu lineage and mental strength, and brought the artifacts back to Atlantis, where they unlocked a hidden message from the Isu Aletheia.

TRIDENT OF EDEN

The Trident of Eden was a very powerful artifact once held by Alexander the Great, who wielded multiple artifacts throughout his lifetime. After his death, the Trident of Eden was broken into thirds; it was believed that no single human should again possess the complete power of the Trident at once. The prongs scattered in various locations around the world. Nevertheless, even the single prongs were used to cause great suffering and domination by those who possessed them, such as the fearsome Mongol leader Möngke Khan and Spanish Conquistador Hernán Cortés.

According to legend, each Trident's prong has a different power or effect on those exposed to it: one prong causes an intense feeling of fear, the second arouses overwhelming devotion or admiration, while the third inspires blind faith.

The existence of the Trident was discovered by a teenager named Owen Meyers, through exploration of ancestral memories via the Animus technology. A rogue Templar named Isaiah used the genetic memories of Owen and a group of other teenagers to seek all three prongs of the Trident in an effort to reassemble it and bring about the end of the world in order to create it anew.

The Trident was rendered powerless by Minerva, who was able to shut it down in collaboration with the group of teens. The seemingly useless relic is currently in the possession of Monroe, who plans to study it, while keeping it out the hands of both Assassins and Templars.

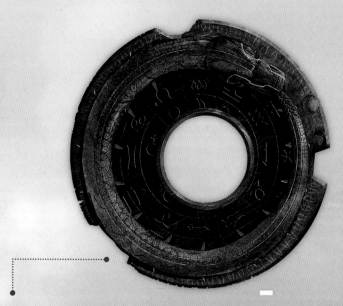

GRAND TEMPLE KEY

An amulet-like Piece of Eden, the Grand Temple Key opened the inner gate of the Grand Temple located in New York. The Key features an ourobouros design, a serpent consuming its own tail, a symbol associated with cycles and infinity. Other symbols decorating it include the twelve astrological signs of the Western zodiac, the symbol of Venus, and other incomplete symbols which likely denote other classical planets.

KOH-I-NOOR

This Piece of Eden, possessed by many dynasties of the Indian subcontinent, takes the form of a diamond. It is rumored to hold such an immense amount of power that it could unite all of the other Pieces' powers. Crafted specifically for a female Isu to wield, the Koh-i-Noor could channel energy from other Pieces of Eden, as well as cast powerful illusions. Male Isu could use it for brief periods of time, but at limited capability, and at great cost to their health. Over the centuries, certain humans have shown to be capable of using the Koh-i-Noor, specifically women with a high level of First Civilization DNA. A few men with high concentrations of Isu DNA have been able to wield it, but again, for a limited time, accessing only limited power, and at tremendous danger to themselves.

Juno wielded the Koh-i-Noor at the beginning of the Human-Isu War, channeling the destructive power of the Scythe of Saturn to kill the humans who had murdered her father at the onset of the uprising. Later the Koh-i-Noor came into the possession of the Isu Durga, whose consciousness imprinted upon the Piece of Eden.

The Koh-i-Noor passed through the hands of several people in the nineteenth century, during which time Templars and Assassins both tried to retrieve it. The Piece of Eden ended up in India, in possession of Ranjit Singh, founder of the Sikh Empire, who placed it in an Isu temple below his Summer Palace. Stolen in 1839 by Assassin Arbaaz Mir, it was eventually given to Pyara Kaur, Singh's granddaughter. The Koh-i-Noor was activated when Pyara was attacked by a Templar while fleeing the palace after her grandfather's murder, unlocking a message from Durga who spoke of the fragmentation of humanity, the mutual need to remain free, and a warning to hide the Koh-i-Noor until humanity united to fully recognize the entwined history of the human and Precursor races.

By the early twentieth century the Piece of Eden was once again in Templar hands. It was manipulated into the possession of the Assassin Ignacio Cardona, who had a high percentage of Isu DNA. Cardona successfully unlocked it, but was then almost destroyed by the artifact. The Koh-i-Noor was subsequently buried during the collapse of a church, in a mass grave of victims of the atrocities committed during the Spanish Civil War.

In 2017 and 2018, The Instruments of the First Will, a cult devoted to Juno and the restoration of the Isu as masters of the human race, raced an Assassin-Templar alliance to prevent them from locating the Koh-i-Noor for Juno's use. The Instruments took it from Charlotte de la Cruz as she found it in Spain, guarded by protectors trained by Cardona and Albie Bolden. At Juno's rebirth in Álvaro Gramática's lab, Charlotte used the Koh-i-Noor to cast illusions and distract Juno before killing her with her Hidden Blade. Elijah disappeared with the Koh-i-Noor; he's missing but presumed deceased by the Assassins.

SHROUDS OF EDEN

Designed by the Precursor Consus and shaped like cloth, these Pieces of Eden are capable of restoration and healing. The original Shroud was crafted by Consus, and thereafter several copies were made.

Consus's own consciousness was stored in the original Shroud of Eden, and copies of it in other Shrouds, resulting in his ability to temporarily possess the body of the user when the Shroud was activated. The original was described as a white, bloodstained cloth with the faint image of a man imprinted on it, kept in a plain wooden box. The image was said to change throughout history. The most famous owner of a Shroud of Eden was Jesus of Nazareth, who used the Shroud before his death to heal many followers. Other Shrouds throughout history include the Golden Fleece of myth, and Joseph's multicolored coat.

The Shrouds of Eden are soothing artifacts that heal wounds or reverse defects. They can also enhance healing ability and strength as long as they are in contact with an individual. While their abilities are staggering, they cannot reverse death; they can heal and reanimate bodies for a brief period, but it cannot truly restore life. The Shrouds can also destroy; use of them has been known to drive individuals mad, or physically tear them apart.

According to Abstergo research, the Shrouds scan for damage when applied to a body, then commence reconstruction on a cellular level, even on partially decomposed organisms. This led to further research into the possibility of reconstructing actual Precursor individuals from existing DNA samples. Álvaro Gramática used a Shroud of Eden and DNA harvested from a human with a high percentage of Isu DNA to construct a physical Isu body; he unraveled the Shroud to weave its strands in with the DNA to construct Juno's body.

BLOOD VIALS

Blood Vials are small crystalline cubes designed to contain a blood sample. The cube is then used in the Observatory in conjunction with a Crystal Skull to observe the donor in real time, reproducing visual and audio information experienced by the donor by virtue of the connected DNA.

Born with severe malformation and defects, Giovanni Borgia would have died had Perotto Calderon not wrapped the newborn in Consus' original Shroud of Eden. Giovanni was healed physically, but the encounter with the Shroud altered his mind permanently. As a result, Giovanni maintained a preternatural relationship with Consus throughout his life and was particularly attuned to Pieces of Eden.

CRYSTAL SKULLS

Discovered in Central and South America, the Crystal Skulls functioned as Precursor communication devices. Three categories of Skulls have been discovered: one type function as direct communication device, requiring both individuals to possess a Crystal Skull; a second type is a recording and playback device that can send recorded messages to another Crystal Skull; and a third is a monitoring device, receiving information from an individual linked by a Blood Vial. Due to their scarcity, communication between the Crystal Skulls is highly secure.

The Crystal Balls are similar artifacts that allow a user to access the Nexus. Communication with Precursor individuals is possible this way, as well as with humans in the past or future. They are similar in size and design to the Apples of Eden.

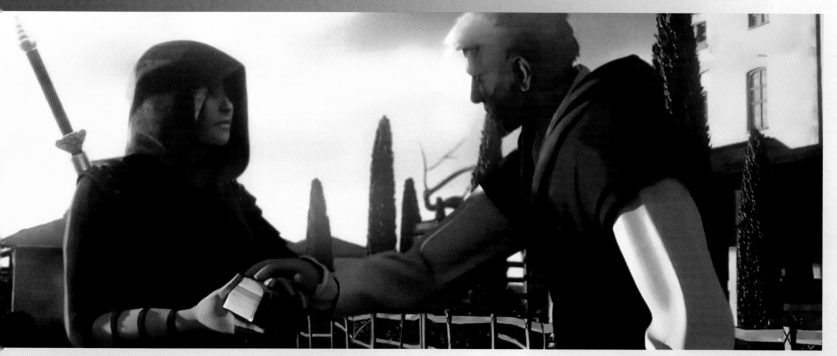

PRECURSOR BOXES

Precursor Boxes are artifacts used in conjunction with other Pieces of Eden to trigger certain effects. When activated, boxes have been known to imprint memories of previous owners onto users, as well as decipher Precursor writing and project holograms of maps. While the Precursor Boxes are intended to be used with another Piece of Eden or Isu manuscript, it is possible to activate the artifact with high doses of electricity, although the risk of damaging the artifact exists if this method is used.

In 1524, Ezio Auditore gave a Precursor Box to Shao Jun, a Chinese Assassin who had traveled to Italy to seek his advice. Over the centuries since then, this Box has resurfaced many times, switching between Assassin and Templar hands, including those of eventual Templar Shay Cormac.

In 2016, Templar and scientist Álvaro Gramática used the same Precursor Box to help him better understand the workings of the Shroud of Eden in his possession in order to advance his Phoenix Project.

Multiple Precursor Boxes have been in existence, although it is not known how many exactly still remain.

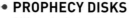

PROPHECY DISKS

Although their ultimate purpose is unclear, the Prophecy Disks are capable of recording audio-visual messages and separating into two parts, requiring an amulet to activate them. Two shards of one such disk were located in the Precursor ruins beneath the Mayan city of Chichen Itza by Assassin Aveline de Grandpré; the pieces were united and activated by the amulet known as The Heart of the Brotherhood.

Shards of Eden: Shards of Eden are leftover fragments of Precursor technology that still hold traces of power.

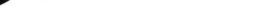

PRECURSOR RELICS

There are many other Precursor relics, such as the Memory Seals used by the Capitoline Triad to record several messages, and the Masyaf Keys used by Altaïr Ibn-La'Ahad. While they do not possess the controlling and influencing powers of the Pieces of Eden, they have nonetheless been the focus of Templar and Assassin research and exploration, as have long-lost Precursor sites.

Not rightfully Precursor technology, but highly sought after by both factions, are human transcriptions of Precursor knowledge and information, such as the Voynich Manuscript and Nicholas Flamel's two-part Book of Abraham, written by Abraham of Würzburg. These manmade relics still require unlocking or translation with some kind of key, such as a Precursor Box.

PRECURSOR LOCATIONS

Certain sites have been identified as the location of important Precursor activity or artifacts. The Temples, underground sites also referred to as Vaults, are found all over the world, with a disproportionate number located in and around Rome, Italy. Built by Precursors who recognized that the Toba Disaster was a larger threat than the Human-Isu conflict, they were centres of research and planning, their goal to explore methods of preservation of the world and its people in the face of the impending Toba Catastrophe. They were built underground so as to be removed from the war on the surface, as well as to be more secure in the event that the disaster was not averted.

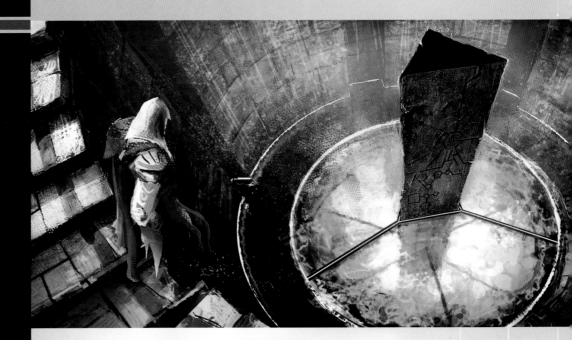

GRAND TEMPLE

Located in present-day below Turin, New York, the Grand Temple was the central complex of the Precursor Vaults, where the theories and solutions developed in the Secondary Temples to stop or survive the incoming First Catastrophe were reviewed and tested by the Capitoline Triad. The Grand Temple had three areas: a section for sleeping quarters, a section for a research facility, and a section for computer servers. The location was marked by a statue of the Triad, until its destruction in the Toba Catastrophe. The Grand Temple was also the location of the Eye, a device designed to prevent the Second Disaster and to communicate information about the Isu and the First and Second disasters to future descendants, and where Juno was kept imprisoned.

SEISMIC TEMPLES: The Seismic Temples (Port-au-Prince, Arctic, and Lisbon Temples) were created as a separate network. Each Temple contained a piece of Precursor technology (erroneously assumed to be Pieces of Eden) that, if disturbed, triggered large-scale seismic events. This network of temples may have been designed to stabilize the earth's crust, or as a defense mechanism.

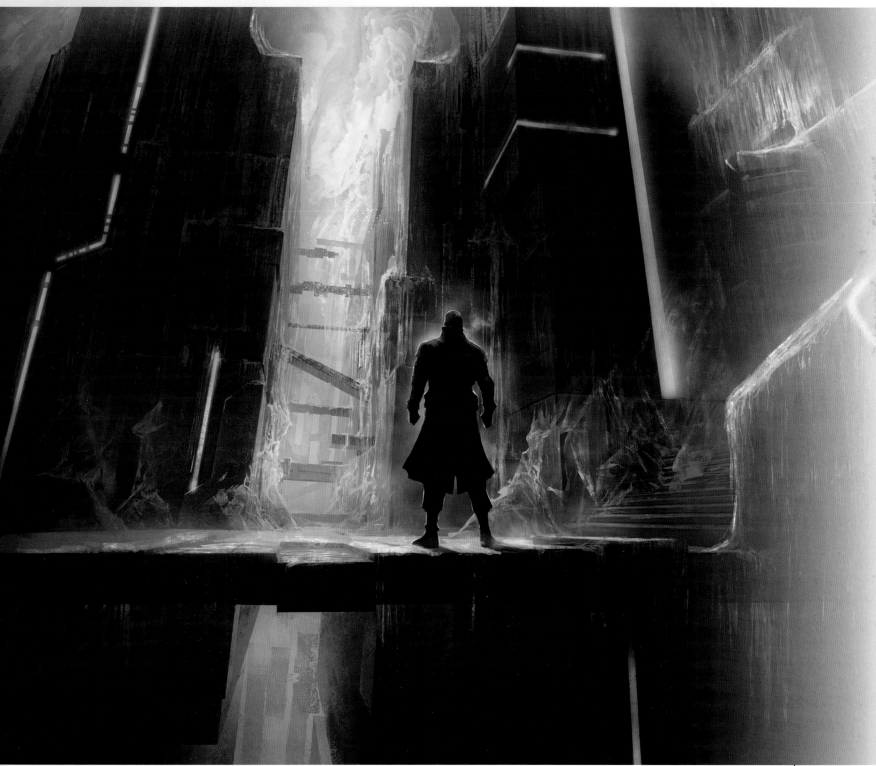

OTHER TEMPLES

The other Temples, also referred to as Vaults, were the location of lower-level research, sourcing ideas and brainstorming possible solutions to send to the Grand Temple.

1. JERUSALEM VAULT: The Jerusalem Vault is located under the ruins of Solomon's Temple, and contained the Ark of the Covenant, which featured an Apple of Eden set in it.

2. COLOSSEUM VAULT: Located in Rome, Italy, under the Basilica Santa Maria in Aracoeli, this vault is accessed via a lift secretly placed in the Basilica that could only be activated by a person with a high concentration of Precursor DNA.

3. VATICAN VAULT: Located beneath the Sistine Chapel, the Vatican Vault could only be opened by combing two Pieces of Eden, an Apple and a Staff. However, while Ezio Auditore was able to perform this feat in 1499, Rodrigo Borgia could not replicate it, even using the identical Pieces of Eden. This Vault contained a hologram of the Precursor Minerva, who communicated the entwined history of her race and humanity to Ezio, revealing that the Temples were part of the Precursor efforts to protect against the recurrence of the First Disaster.

4. THE OBSERVATORY: Located in Long Bay, Jamaica, the Observatory was constructed as a surveillance center, enabling remote viewing of individuals via a Blood Vial and a Crystal Skull. When activated, images and audio transmitted from the individual being viewed would be projected on the walls. Rows of seats surround the central altar housing the Crystal Skull. The corridor leading to this main viewing chamber served as a storage for Blood Vials.

5. SAINT-DENIS TEMPLE: Located under commune Saint-Denis in France, this vault held an Apple of Eden within a lantern called the Head of Saint-Denis. This artifact projected illusions when powered by the Apple, although when the Apple was removed it became an ordinary lantern. The Precursor knowledge contained within the Apple of Eden was used by Abbot Suger in the twelfth century to craft a powerful sword called the Eagle of Suger, which created blinding flashes of light when it struck an enemy.

6. SIWA VAULT: Located under the Temple of Amun, the location of the Oracle of Siwa, the Siwa Vault was opened with a combination of an Apple and the Staff of Eden stolen from the tomb of Alexander the Great. Inside was a holographic map of the world highlighting several locations, doubtless other Isu vaults and temples with technology or information in them.

7. FORGE OF HEPHAESTUS: An Isu location where Hephaestus was said to have created some of his most powerful weapons, such as the Swords and Spears of Eden. The Forge also features the ability to upgrade the Spear of Leonidas, using fragments of Isu technology to power the improvement.

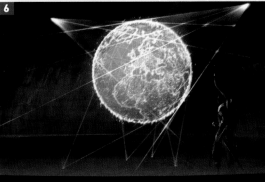

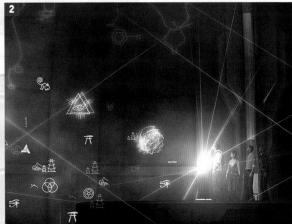

8. PYTHAGOREAN VAULT: This small chamber with a pedestal is located inside the Pythagorean Temple in Rome, Italy. A series of letters and numbers were encoded inside the pedestal, unlocked by Ezio Auditore's Precursor DNA; centuries later, this was revealed to be latitude and longitude coordinates denoting the location of the Grand Temple in New York. In the 1530s, Assassin Giovanni Borgia also accessed this Vault and activated the pedestal, which triggered a possession by Consus.

9. ALAMUT TEMPLE: Located under the Assassin fortress of Alamut in Iran and discovered in the thirteenth century, this Temple was used to store a number of Memory Seals.

10. CHICHÉN ITZÁ TEMPLES: A pair of temples located in caverns beneath the Mayan city of Chichén Itzá, in the Yucatán region of Mexico. Discovered in the eighteenth century, each temple housed one half of a Prophecy Disk.

11. AMRITSAR TEMPLE: Located under the summer palace of Maharajah Ranjit Singh in India, this Temple contained the Piece of Eden known as the Koh-i-Noor. The Temple was destroyed during an altercation between Master Templar William Sleeman and Assassin Arbaaz Mir.

12. HERAT TEMPLE: The location of the Herat Temple in Afghanistan was discovered by Templars in the nineteenth century by using the Koh-i-Noor.

13. ATLANTIS: Created by the Isu to be a city where humans and Isu could live side-by-side as well as an indestructible repository of their knowledge, Atlantis was meant to be an imposing and awe-inspiring demonstration of their achievements. Pythagoras, his life extended by the Staff of Eden given to him by Hermes, resided in an upper section of Atlantis to devote himself to researching the vast knowledge contained within the place, to the point he became obsessed with it. He considered himself to be Atlantis' guardian and defender, anxious to keep it from being breached by people bent on using its secrets for destructive ends. Eventually, Pythagoras agreed to pass on his Staff to Kassandra, and he died shortly after doing so. With the Staff of Hermes, Kassandra lived on for many centuries, fighting in wars through the ages in an effort to restore the balance between order and chaos in the world. In 2018, the Assassin Layla Hassan discovered the entrance to Atlantis on Thera, an island in Greece, and encountered Kassandra there, who handed her the Staff with the task to continue her quest for balance and peace.

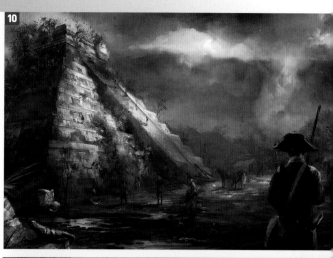

"There is knowledge in this place. Powerful knowledge. In the wrong hands, its secrets could bring about the downfall of humanity. We cannot allow others to discover this place. We must find a way to seal it from the world forever." — Pythagoras

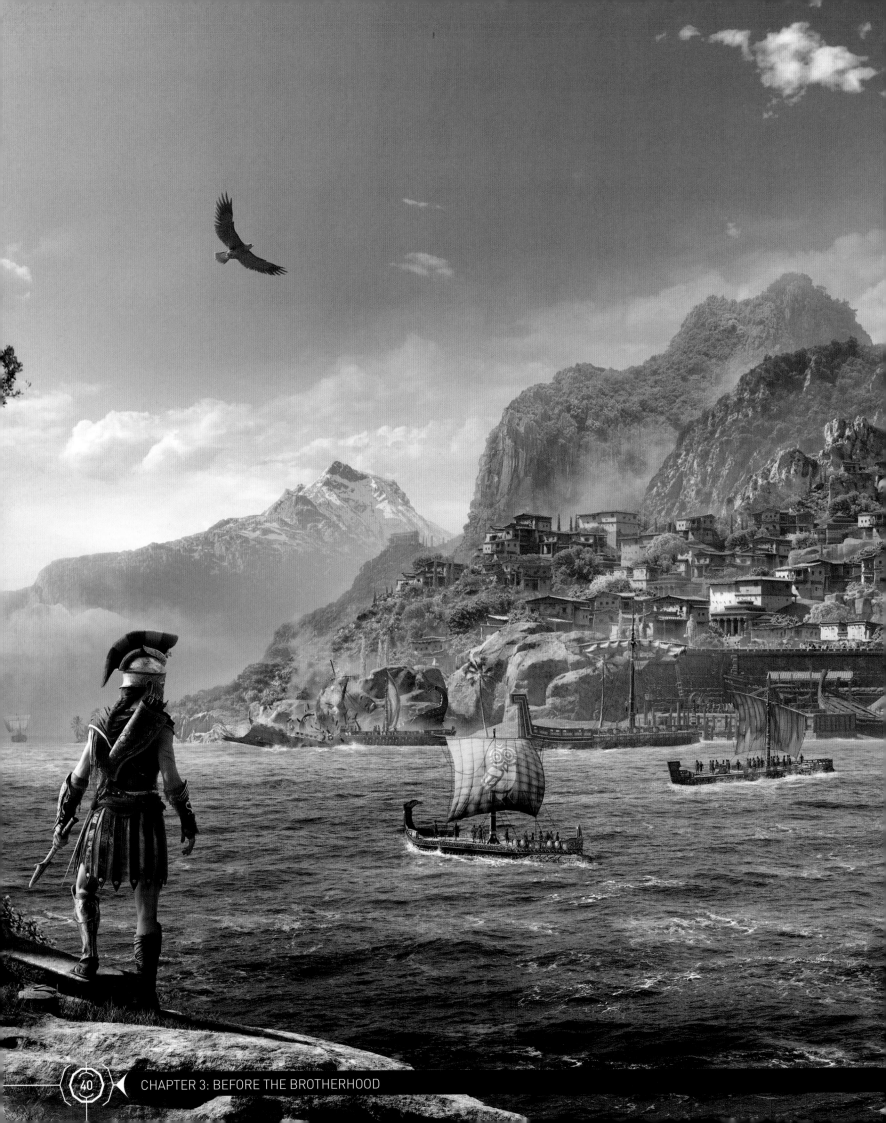

CHAPTER 3: BEFORE THE BROTHERHOOD

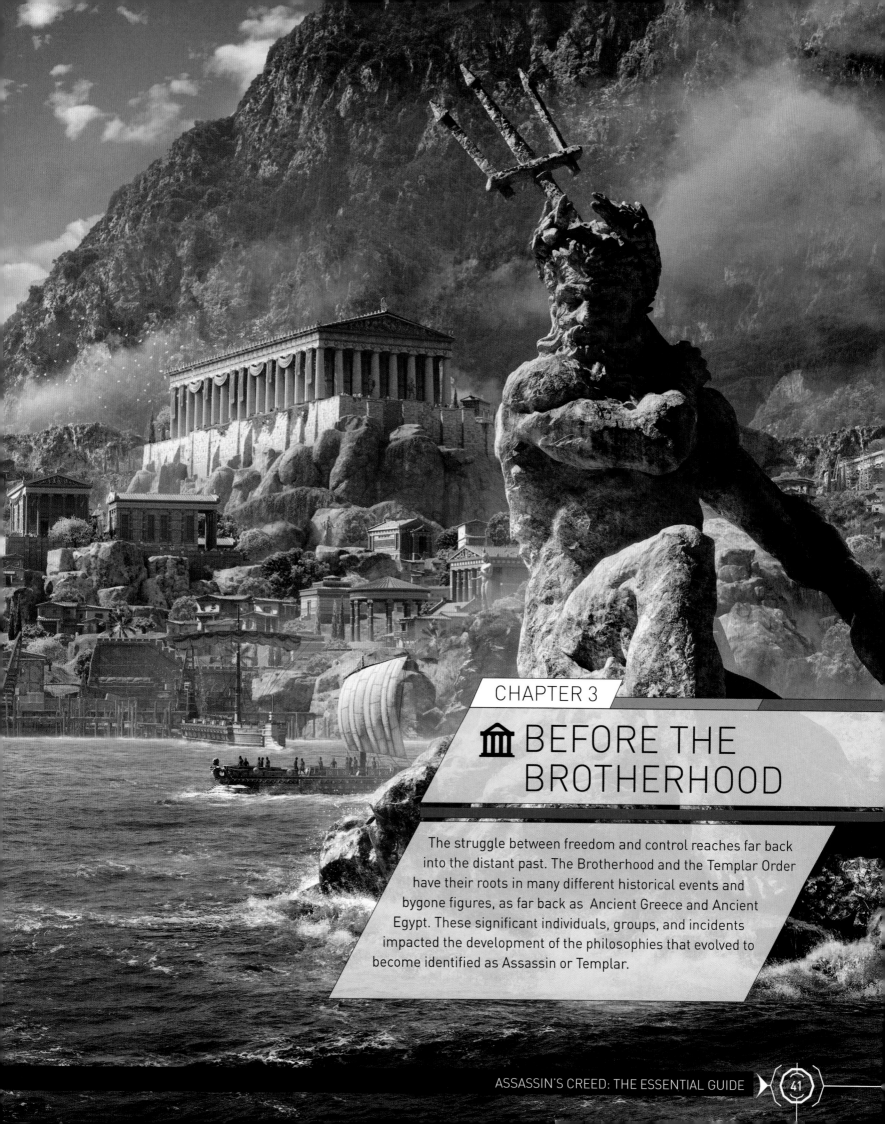

CHAPTER 3

🏛 BEFORE THE BROTHERHOOD

The struggle between freedom and control reaches far back into the distant past. The Brotherhood and the Templar Order have their roots in many different historical events and bygone figures, as far back as Ancient Greece and Ancient Egypt. These significant individuals, groups, and incidents impacted the development of the philosophies that evolved to become identified as Assassin or Templar.

THE END OF THE GOLDEN AGE

There is a conflict between order and chaos that has always existed; one needs the other, and it is a delicate balance.

The earliest known suggestion of the roots of the values and actions that would lead to the formation of the Brotherhood can be traced back to approximately 465 BCE with Darius, a Persian assassin. Darius killed King Xerxes I using a blade strapped to his forearm that could extend and retract into a sheath, the first known use of what would become the Hidden Blade.

Taking place over the course of several decades in the later half of the 4th century BCE, the Peloponnesian War set the stage for another key moment in the Brotherhood's ancestry. The struggle between the Delian League of Athens, fighting for democratic reforms and change, and the Peloponnesian League of Sparta, defending the oligarchic control they had over their territory and pushing back against the rising power of Athens, consumed the region and countless allied city-states.

Below the surface of these events, the secretive Cult of Kosmos was operating to continue the war, as the widespread chaos enabled them to spread their power. By using a Precursor artefact to predict possible futures, the Cult was able to control the Oracle of Delphi and direct the profound influence of her predictions.

The Spartan mercenary Kassandra fought to eradicate the deep-rooted influence of the Cult, defending the right of the people to choose their own direction without interference from a corrupting force. Over the years, Kassandra learned of the existence of the Precursors, and the powerful artefacts they left behind. This knowledge solidified her belief that the Cult should be destroyed before it could come into the possession of additional artefacts and knowledge and become all-powerful. She realized too late that by doing so the roots of an even darker order managed to take hold. Kassandra dedicated the rest of her life to protecting the freedom of people who were suffering oppression, and trying to restore balance in the world.

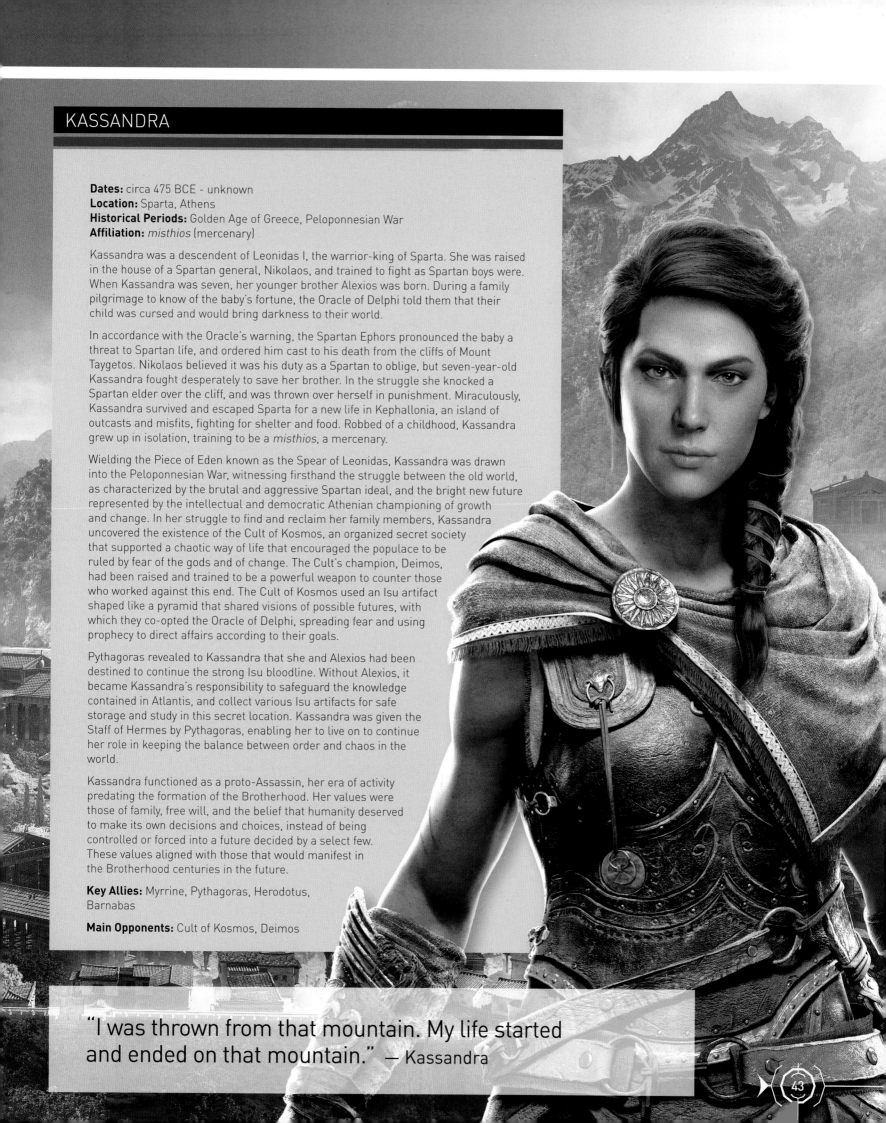

KASSANDRA

Dates: circa 475 BCE - unknown
Location: Sparta, Athens
Historical Periods: Golden Age of Greece, Peloponnesian War
Affiliation: *misthios* (mercenary)

Kassandra was a descendent of Leonidas I, the warrior-king of Sparta. She was raised in the house of a Spartan general, Nikolaos, and trained to fight as Spartan boys were. When Kassandra was seven, her younger brother Alexios was born. During a family pilgrimage to know of the baby's fortune, the Oracle of Delphi told them that their child was cursed and would bring darkness to their world.

In accordance with the Oracle's warning, the Spartan Ephors pronounced the baby a threat to Spartan life, and ordered him cast to his death from the cliffs of Mount Taygetos. Nikolaos believed it was his duty as a Spartan to oblige, but seven-year-old Kassandra fought desperately to save her brother. In the struggle she knocked a Spartan elder over the cliff, and was thrown over herself in punishment. Miraculously, Kassandra survived and escaped Sparta for a new life in Kephallonia, an island of outcasts and misfits, fighting for shelter and food. Robbed of a childhood, Kassandra grew up in isolation, training to be a *misthios*, a mercenary.

Wielding the Piece of Eden known as the Spear of Leonidas, Kassandra was drawn into the Peloponnesian War, witnessing firsthand the struggle between the old world, as characterized by the brutal and aggressive Spartan ideal, and the bright new future represented by the intellectual and democratic Athenian championing of growth and change. In her struggle to find and reclaim her family members, Kassandra uncovered the existence of the Cult of Kosmos, an organized secret society that supported a chaotic way of life that encouraged the populace to be ruled by fear of the gods and of change. The Cult's champion, Deimos, had been raised and trained to be a powerful weapon to counter those who worked against this end. The Cult of Kosmos used an Isu artifact shaped like a pyramid that shared visions of possible futures, with which they co-opted the Oracle of Delphi, spreading fear and using prophecy to direct affairs according to their goals.

Pythagoras revealed to Kassandra that she and Alexios had been destined to continue the strong Isu bloodline. Without Alexios, it became Kassandra's responsibility to safeguard the knowledge contained in Atlantis, and collect various Isu artifacts for safe storage and study in this secret location. Kassandra was given the Staff of Hermes by Pythagoras, enabling her to live on to continue her role in keeping the balance between order and chaos in the world.

Kassandra functioned as a proto-Assassin, her era of activity predating the formation of the Brotherhood. Her values were those of family, free will, and the belief that humanity deserved to make its own decisions and choices, instead of being controlled or forced into a future decided by a select few. These values aligned with those that would manifest in the Brotherhood centuries in the future.

Key Allies: Myrrine, Pythagoras, Herodotus, Barnabas

Main Opponents: Cult of Kosmos, Deimos

"I was thrown from that mountain. My life started and ended on that mountain." — Kassandra

CULT OF KOSMOS

A secret society from Ancient Greece organized around the retrieval, protection, and control of Pieces of Eden in order to obtain power and manipulate the course of history in their favor. The Cult of Kosmos was initially formed by past members of the group that followed the famous mathematician and scholar Pythagoras, who dedicated himself to studying the numbers and formulas that could explain the mysteries of the universe.

Pythagoras learned of the incredible Isu artefacts and the traces of knowledge left behind by the First Civilization, and was granted the Staff by the Isu Hermes himself, allowing his lifespan to be extended. Aware of the power that could be obtained by controlling Isu artefacts, Pythagoras was rigorously disciplined and expected the same level of self-control from his followers. As a number of people within the group became more and more obsessed with the idea of power without bounds, they established their own organization.

The symbology of the Cult of Kosmos is based on the myth of Python, a giant, ancient snake said to guard a stone at the center of the world. Apollo slew the snake, and the Oracle of Delphi was housed in the Temple of Apollo built on that location. The Cave of Gaia, an ancient site beneath the Temple of Apollo, is where the forty-two members of the Cult of Kosmos met to consult the artefact they referred to as the Pyramid, and to perform their sacred rituals once a year during the Dark Symposium. Highly secretive, the members of the Cult wore dark, oversized robes and Greek theatre masks with red and gold highlights to preserve their anonymity, even from each other.

The pyramid can show visions of past, present, and future with the possibility to manipulate what the viewer is seeing based on how it shows the order of the events. This happens rarely, but we see this happen with Deimos, who gets to see Kassandra's memories of what happened the night he was tossed off Mount Taygetos but in a different order from how it happened. The pyramid can also use voices from memories to call people from the bloodline to it. We see this when it uses Myrrine's voice to draw Kassandra in. The pyramid only works for people who are descendents of the Precursors. The Cult of Kosmos controlled the populace via superstition, fear, and aggression. The cultists aimed (and succeeded) to take power of Athens by removing the ruler Perikles, and putting Cult member and warmonger Kleon in his place.

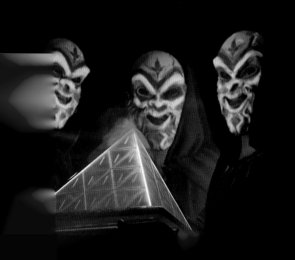

While the Cult of Kosmos relied on people's belief in the destiny, using the predictions of the Pyramid to control their decisions, former Cult-member Aspasia had a different vision. Knowing that the Cult had become weak and corrupted, Aspasia helped Kassandra to bring them down. Rather than rely on chaos and destruction like the Cult did, Aspasia believed what the world needed to achieve peace was a unified front led by control and order. Praying not to the gods but to the 'Father of Understanding' for guidance, Aspasia foresaw a new order built on logic, one republic led by one supreme ruler – a philosopher-king. While she had hoped Kassandra would join her cause, they parted ways realizing their paths lead in opposite directions.

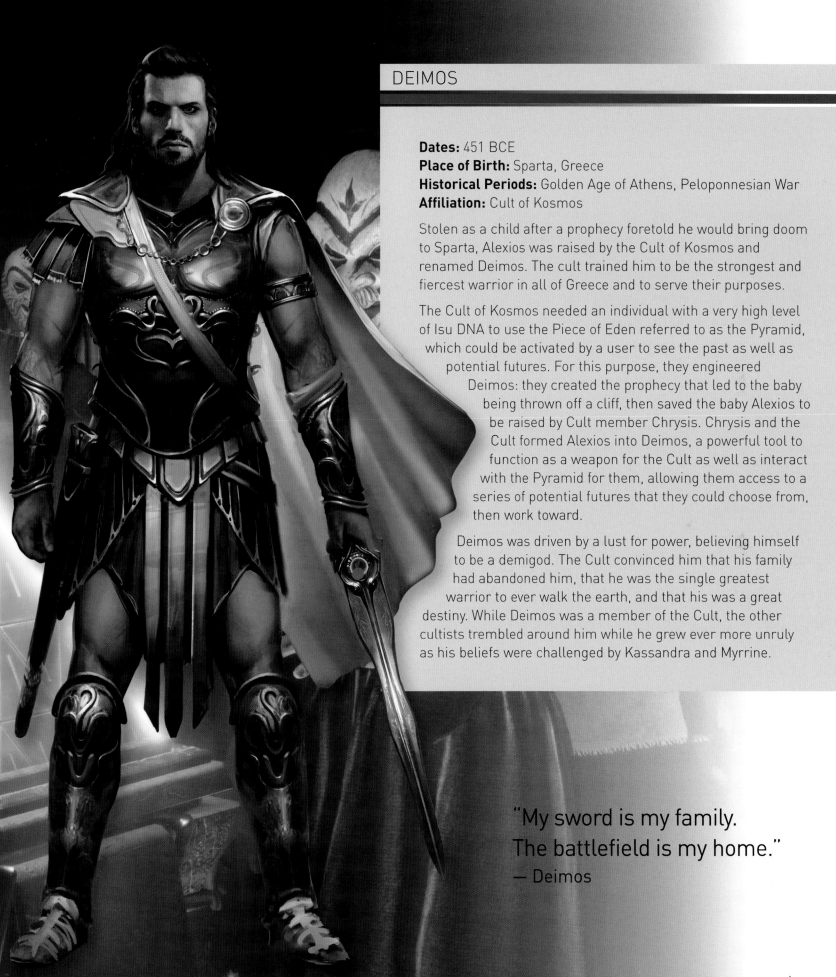

DEIMOS

Dates: 451 BCE
Place of Birth: Sparta, Greece
Historical Periods: Golden Age of Athens, Peloponnesian War
Affiliation: Cult of Kosmos

Stolen as a child after a prophecy foretold he would bring doom to Sparta, Alexios was raised by the Cult of Kosmos and renamed Deimos. The cult trained him to be the strongest and fiercest warrior in all of Greece and to serve their purposes.

The Cult of Kosmos needed an individual with a very high level of Isu DNA to use the Piece of Eden referred to as the Pyramid, which could be activated by a user to see the past as well as potential futures. For this purpose, they engineered Deimos: they created the prophecy that led to the baby being thrown off a cliff, then saved the baby Alexios to be raised by Cult member Chrysis. Chrysis and the Cult formed Alexios into Deimos, a powerful tool to function as a weapon for the Cult as well as interact with the Pyramid for them, allowing them access to a series of potential futures that they could choose from, then work toward.

Deimos was driven by a lust for power, believing himself to be a demigod. The Cult convinced him that his family had abandoned him, that he was the single greatest warrior to ever walk the earth, and that his was a great destiny. While Deimos was a member of the Cult, the other cultists trembled around him while he grew ever more unruly as his beliefs were challenged by Kassandra and Myrrine.

"My sword is my family.
The battlefield is my home."
— Deimos

SHIFTING ALLIANCES: FRIENDS AND FOES

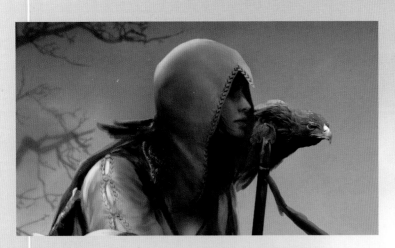

IKAROS: To any civilian of the ancient Greek world, a misthios with an eagle ever-perched on their shoulder could be no less than a demi-god. So too thought Barnabas when he was rescued by Kassandra, an Eagle Bearer blessed by the gods. Ikaros, Kassandra's constant companion, flew by her side since he was a mere eaglet at the bottom of Mount Taygetos. They forged a bond so strong that they learned to live and work in sync – as though they shared the same mind. Ikaros would assault Kassandra's enemies from the sky, while Kassandra connected with Ikaros's sight to view the world from his lofty perspective.

It wasn't until she met her birth-father Pythagoras that Kassandra discovered the truth of her eagle. As Ikaros sailed over to Pythagoras, landing comfortably on his shoulder, it was revealed Pythagoras had sent him to watch over Kassandra as a guardian.

BARNABAS: An ex-soldier, Barnabas was a mercenary and a charismatic storyteller. He travelled throughout Greece on his trireme *Adrestia*, learning about gods and their worship throughout the land. In this way he became a deeply spiritual man, while still being jovial and enjoyable company for Kassandra. After an encounter with one of Poseidon's "pets" left him half-blind and nearly dead, he gave up the life of a mercenary and followed a more spiritual path. Barnabas's knowledge of the gods on both land and sea made him a valuable and trusted friend to Kassandra.

LEONIDAS: [Circa 540 BCE—480 BCE] A Legendary king of Sparta, Leonidas led the Greek forces in battle against the invading Persian forces of Xerxes I in the famous Battle of Thermopylae. The Spartan army was victorious on the first two days of the battle, but was then betrayed by an ally who allowed the Persian forces to flank the Greek army. Leonidas sent away all but his Spartan troops and fought the Persians. When he died, the Spartans fought back the Persian forces multiple times in order to retrieve his body and spear. There were few Greek survivors. He also defied the Cult-controlled Pythias who didn't want Sparta to go to war. If it weren't for Leonidas defying the Cult, they would have surrended the entire Greek world to one ruler: the Persian King Xerxes.

He is also Myrrine's father, Kassandra's grandfather.

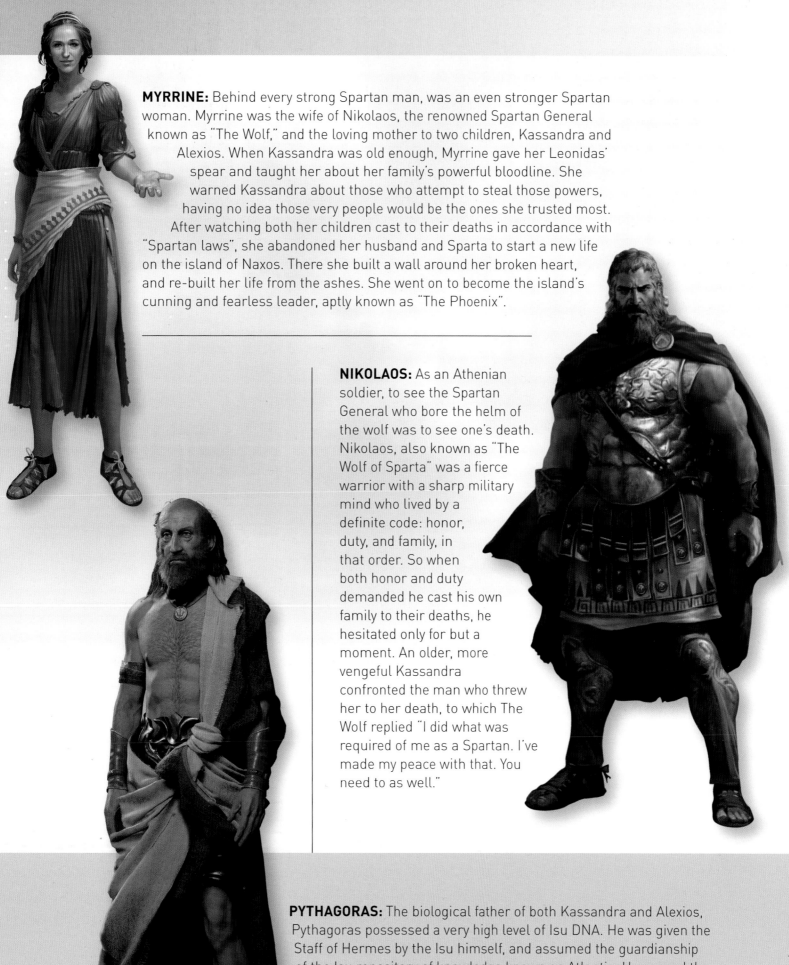

MYRRINE: Behind every strong Spartan man, was an even stronger Spartan woman. Myrrine was the wife of Nikolaos, the renowned Spartan General known as "The Wolf," and the loving mother to two children, Kassandra and Alexios. When Kassandra was old enough, Myrrine gave her Leonidas' spear and taught her about her family's powerful bloodline. She warned Kassandra about those who attempt to steal those powers, having no idea those very people would be the ones she trusted most. After watching both her children cast to their deaths in accordance with "Spartan laws", she abandoned her husband and Sparta to start a new life on the island of Naxos. There she built a wall around her broken heart, and re-built her life from the ashes. She went on to become the island's cunning and fearless leader, aptly known as "The Phoenix".

NIKOLAOS: As an Athenian soldier, to see the Spartan General who bore the helm of the wolf was to see one's death. Nikolaos, also known as "The Wolf of Sparta" was a fierce warrior with a sharp military mind who lived by a definite code: honor, duty, and family, in that order. So when both honor and duty demanded he cast his own family to their deaths, he hesitated only for but a moment. An older, more vengeful Kassandra confronted the man who threw her to her death, to which The Wolf replied "I did what was required of me as a Spartan. I've made my peace with that. You need to as well."

PYTHAGORAS: The biological father of both Kassandra and Alexios, Pythagoras possessed a very high level of Isu DNA. He was given the Staff of Hermes by the Isu himself, and assumed the guardianship of the Isu repository of knowledge known as Atlantis. He passed the Staff to Kassandra, telling her of her destiny to restore balance in the world.

SHIFTING ALLIANCES: FRIENDS AND FOES

ELPENOR: A rich and powerful businessman from the Greek island of Kirrha, and a member of the Cult of Kosmos. When Kassandra met Elpenor on Kephallonia, he promised her a large sum of money in exchange for killing a Spartan general called 'The Wolf'. Elpenor proclaimed that The Wolf would be capable of conquering Athens, ending a war he was keen to see continued, reflecting the Cult's practice to thrive off the opportunities and confusions caused by the chaos of war.

Before he died at Kassandra's hands, Elpenor revealed to Kassandra she was hunted by the Cult.

ASPASIA: Independent and resourceful, admired and respected, Aspasia ruled the intellectual scene of Athens the way her partner Perikles ruled the political scene. Her piercing intellect and resourcefulness meant that many people felt estranged by the breadth and depth of her ideas and discourse. Originally a member of the Cult of Kosmos, Aspasia left when the Cult's methods and expression became too fanatical and their goals turned to controlling the future instead of using the Piece of Eden to guide the present.

KLEON: Kleon pitted himself fiercely against the intellectual and aristocratic Perikles and his allies, arguing that democracy was a weak option when war was so much more likely to result in a positive outcome for Athens. His goal was to make Athens (and thereby himself) the most powerful by physically dominating other states. His ideas and arguments drew the lower classes and regular people of Athens towards him in the changing political climate. A member of the Cult of Kosmos, Kleon's plans benefit them, as well.

CHRYSIS: Chrysis was a priestess of Hera, and a member of the Cult of Kosmos, raising the children that were left at the temple to become soldiers for the Cult, agents of chaos. When Myrrine took baby Alexios to the temple in a desperate attempt to save his life, Chrysis let her believe he was dead. Chrysis raised Alexios to become the Cult's champion, molding him into the ultimate weapon, Deimos. However, she did her job with Deimos too well; he became too wild and hateful for the Cult of Kosmos to control.

PERIKLES: Aristocratic, wealthy, and privileged, Perikles championed a visionary new world of intellect, philosophy, and democracy. This golden age was under attack, however, by Sparta outside Athens' city walls, and by his political nemeses within. Perikles' influence is instrumental in developing Kassandra's political savvy.

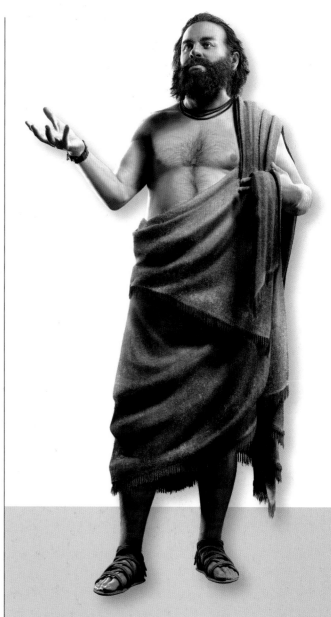

HERODOTUS: A traveling historian who encountered Kassandra when they both visited the Oracle at Delphi. With the help of Herodotus, Kassandra learned more about her heritage. Herodotus was inspired to support Kassandra and to record her story, realizing that it would impact and sow key elements of change across history and civilization. He pursued this despite the Oracle at Delphi's warning not to.

SOKRATES: The most popular philosopher in Athens, Socrates was still not completely convinced that he had pinned down the nature of reality and the mind of humanity. He pursued the definitions of truth, justice, and what constituted a good life. Socrates taught Kassandra the power of persuasion, and she knew to turn to him to help explore her own concepts of purpose, morality, and destiny.

MEDJAY OF EGYPT

"As a Medjay you are not just charged with preserving and promoting those principles, you are those principles. Do you understand?" — Nitokris, High Priestess of Thebes

Between the eighteenth and twentieth dynasties (the New Kingdom era), the Medjay of Egypt functioned as a scouting and peacekeeping force protecting the pharaoh's interests, such as capital cities and tombs. The Medjay were bloodline-based and itinerant, travelling to where they were needed, serving as scouts, palace attendants, temple employees, and soldiers, among other things. By the time of the Ptolemaic dynasty, the Medjay had mostly been phased out, replaced by a pharaoh-specific Roman-style military force. The Medjay's code directed them to save whoever may need help and to kill those who were lawless. The Medjay swore to protect innocents, to not compromise the Medjay, and to not betray the gods and all that was right. With the alliance of Egypt and Rome and Cleopatra's dismissal of Bayek from his duties, the time of the Medjay was formally past. Its ideals would form one of the seeds of the Brotherhood's philosophy.

AMUNET: Our tenets need to be passed on to those who have taken our oath, so they have a true creed to study.

BAYEK: The Hidden Ones will pass onto Petra and towards Judea. And forever. The Creed must live beyond any one.

THE HIDDEN ONES

Aya saw Cleopatra's alliance with Rome as disloyalty to what Aya herself held precious: the safety and freedom of Egypt and its people. She saw that the evil represented by the Order of the Ancients, the secret cabal who worked behind the scenes to manipulate power instead of working to the good of the people of Egypt, was present also in Rome and beyond.

Aya and Bayek's bitterness led them to encapsulate their purposes—freedom for the people, resistance against dictators—and define them as a concrete goal. Together, Aya and Bayek's commitment to their goals and their personal ethical choices about how they intended to go about achieving their aims led them to establish a new organization. This group would be based on shared ideals: the Hidden Ones, the organization that would be codified and eventually develop into the Brotherhood of Assassins.

Aya relocated to Rome to work with like-minded people such as Brutus and Cassius. Their assassination of Caesar, done publicly as Brutus insisted against Aya's instincts, initiated a disastrous outcome: the people of Rome panicked, rather than felt liberated, when their dictator was killed. The chaos that followed Caesar's death reinforced Aya's conviction that secrecy and work in the shadows was the best avenue for dealing with those who would abuse power, which would become confirmed as one of the central tenets of the Hidden Ones. Anonymously removing oppressors would better allow the population to choose their own path. To symbolize this commitment to secrecy and invisibility, she took on the name Amunet, after the Egyptian goddess of invisibility.

Amunet and Bayek realised that they needed to properly define the objectives they set out for the Hidden Ones, to help guide members to keep secret the knowledge of their group and its goals and to keep them focused on protecting innocents, and not be corrupted by the allure of power themselves. They knew that as the group grew, the Hidden Ones would expand into other countries; in order to keep the various groups on the same path, Amunet and Bayek codified the basic philosophy and goals of the group they had founded.

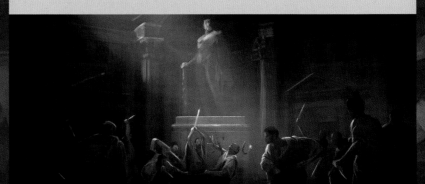

BAYEK AND AYA

Dates: Circa 80 BCE – unknown
Location: Egypt, Rome
Historical Periods: Ancient Egypt, Ancient Rome
Guild Affiliation: The Hidden Ones

Bayek and Aya's personal ethics and morals shaped the creation of organization devoted to justice known as the Hidden Ones, which would later evolve into the Brotherhood of Assassins.

A Berber-Egyptian born and raised in Siwa, a remote oasis near the Egyptian-Libyan border, Bayek was the last of the Medjay, the protectors of the old kingdom of Egypt, its temples, its people, and its way of life. He married Aya of Alexandria, who learned the way of the Medjay with him, although she was not of the formal Medjay bloodline.

When soldiers arrived demanding access to a sacred temple of Siwa, Bayek's refusal led to the murder of his young son, and in their grief Bayek and Aya separated. Deep inside, Bayek hoped that eliminating each of the men involved in his son's murder would somehow restore his life, allowing him to reunite with Aya and to return to an easier existence. When his task led him back to Aya in Alexandria, she convinced him to look beyond his own goals again to the larger picture. Aya believed Cleopatra to be the key to free Egypt of oppression, and she was willing to do everything to help her gain her throne back. Bayek agreed to join her in working for Cleopatra, hunting down the Order of the Ancients. However, as he progressed, Bayek realized that the people of Egypt had the right to choose their own path, and needed champions to fight the growing oppression caused by an unjust regime. His drive for personal vengeance slowly evolved into a drive to see right championed for its own good.

Cleopatra elected to ally with Caesar, who was being directed by the shadowy Order of the Ancients, and dismiss Aya and Bayek. Aya saw Cleopatra's choice not as a personal betrayal so much as disloyalty to what Aya herself held precious: the safety and freedom of Egypt and its people. Despite her personal pain, Aya remained committed to her overall goal: to free Egypt from oppression, and to fight tyrants, dictators, and manipulators everywhere. If this meant moving against Cleopatra's allies, then so be it.

Having given everything to Cleopatra and her struggle against the Order of the Ancients, Bayek and Aya's bitterness led them to encapsulate their purposes—freedom for the people, resistance against dictators—and define them as a concrete goal. They knew that pursuing this personal quest would also benefit Egypt at large, striking a blow against the Order of the Ancients.

Bayek and Aya established a new organization based on shared ideals instead of a bloodline, one that would endure for millennia... the Hidden Ones, the organization that would become the Brotherhood of Assassins. Aya, who chose to change her name to Amunet, would go on to become honored by the Brotherhood as one of their most famous Assassins.

Key Allies: Phoxidas, Brutus, Cassius, Hepzefa, Apollodorus, Tahira

Main Opponents: Order of the Ancients, Julius Caesar, Flavius Metellus, Lucius Septimius, Martellus, Bion

THE ORDER OF THE ANCIENTS

Established millennia ago, The Order of the Ancients rapidly gained influence and control in ancient Persia, Ancient Egypt, and eventually in Greece during and after the Peloponnesian War in the fifth century BCE. During the period of the Ptolemaic dynasty in Egypt, the Order of the Ancients held the reigns of power behind the scenes. A secret, sinister group of political and social figures, the Order of the Ancients sought to control Egypt and beyond. To do this, they attained key positions in the state and military apparatus of the pharaoh, as well as other powerful positions such as temples and within other countries' governments. They worked to maintain peace and order via controlling the political, social, religious, and economic oppression of Egyptians. The Order manipulated the weak, easily influenced pharaoh Ptolemy XIII, but when he was dethroned by his sister Cleopatra, backed by Julius Caesar, the Order shifted their manipulative tactics to their side.

One method of consolidating their power involved in the collection of sacred objects of power. The mystery of the Temple at Siwa was an enigma rumoured to contain information about controlling time and somehow harnessing the power of the human mind, making the Temple at Siwa a prime target for their attention. They were committed to their goals, and killed anyone who stood in their way.

Members of the Order of the Ancients wore masks when they met, a symbolic demonstration of their loyalty. The leading members of the Order of the Ancients had code names based on Egyptian animals such as Hippo, Ibex, and Crocodile. The symbol the Order used as an organization was a snake, and the Order was therefore generally referred to as "the Snake."

Snake
(The organization)

Scarab Lion Jackal Ibis Hyena Crocodile

Vulture Hippo Heron Lizard Scorpio Ram

"Do you know The Order? Has word of our work reached you? [...] We are a society growing in strength and stature. Our aim is to usher in a new, more modern society. One that moves away from the old established ways."

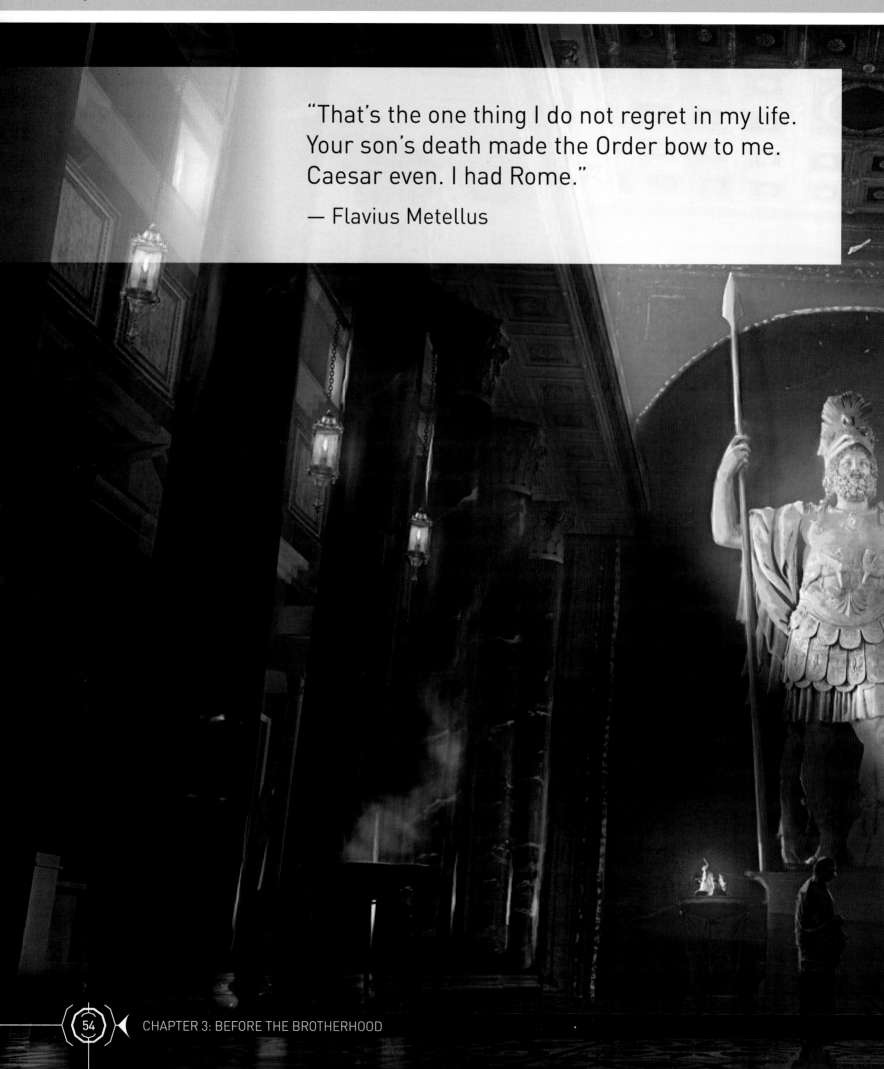

"That's the one thing I do not regret in my life. Your son's death made the Order bow to me. Caesar even. I had Rome."
— Flavius Metellus

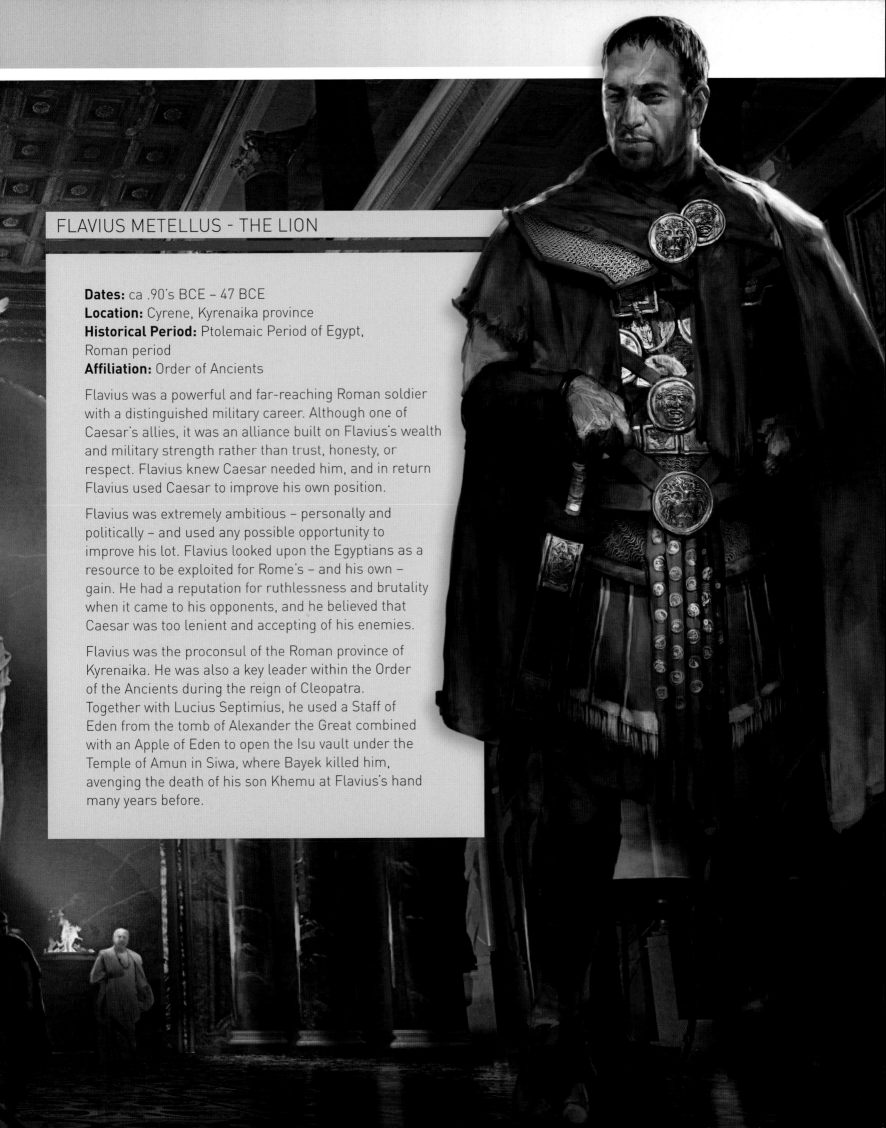

FLAVIUS METELLUS - THE LION

Dates: ca .90's BCE – 47 BCE
Location: Cyrene, Kyrenaika province
Historical Period: Ptolemaic Period of Egypt,
Roman period
Affiliation: Order of Ancients

Flavius was a powerful and far-reaching Roman soldier
with a distinguished military career. Although one of
Caesar's allies, it was an alliance built on Flavius's wealth
and military strength rather than trust, honesty, or
respect. Flavius knew Caesar needed him, and in return
Flavius used Caesar to improve his own position.

Flavius was extremely ambitious – personally and
politically – and used any possible opportunity to
improve his lot. Flavius looked upon the Egyptians as a
resource to be exploited for Rome's – and his own –
gain. He had a reputation for ruthlessness and brutality
when it came to his opponents, and he believed that
Caesar was too lenient and accepting of his enemies.

Flavius was the proconsul of the Roman province of
Kyrenaika. He was also a key leader within the Order
of the Ancients during the reign of Cleopatra.
Together with Lucius Septimius, he used a Staff of
Eden from the tomb of Alexander the Great combined
with an Apple of Eden to open the Isu vault under the
Temple of Amun in Siwa, where Bayek killed him,
avenging the death of his son Khemu at Flavius's hand
many years before.

SHIFTING ALLIANCES: FRIENDS AND FOES

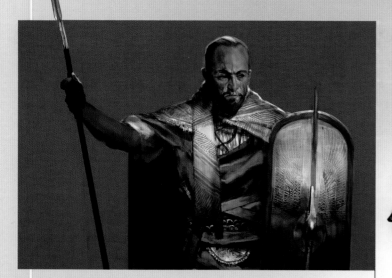

APOLLODORUS: [c. 90 – 47 BCE] Apollodorus was Cleopatra's chief counsellor and advisor, and also served as her head of intelligence. He created a network of informants across Egypt to keep him apprised of the comings and goings of local Ptolemaic sympathizers; his informants were mostly commoners and merchants under oppression from the official regime under Cleopatra's brother Ptolemy XIII. A loyal supporter of Cleopatra since her youth, Apollodorus was cautious, played his cards close to the chest, and had a secretive nature that was difficult to penetrate, although as a court official he was also capable of projecting charm and competence to win allies.

PHOXIDAS: [88 BCE – unknown] A strong and rugged man, Phoxidas preferred the outdoors and the open ocean to the backroom dealings of court. He was a soldier in his youth, but retired into great wealth and used this money to fund his fleet of ships. A mercenary leader in Cleopatra's navy, Phoxidas hated how the politicians manipulating the court of young Ptolemy came to dominate Egypt and its people. Stoic but with a razor-sharp wit, Phoxidas was cool under pressure and could relieve stressful situations with well-placed black humor. He inspired confidence and loyalty in his sailors, thanks to his honest leadership and stern hand. After Cleopatra's death, he transported Amunet and Cesarion, Cleopatra's son, away from Egypt to safety after Octavian's invasion.

BRUTUS AND CASSIUS: Roman senators who perceived Caesar's power as a threat to the Roman republic, Marcus Junius Brutus and his brother-in-law Gaius Cassius Longinus worked with Aya to remove Caesar. Once Caesar's ally, Brutus became distrustful of Caesar's continual acquisition of power. Caesar's increasingly king-like behaviour led Brutus and Cassius to conspire with other Senators to assassinate him, seeing his behavior and policies as detrimental to the future of the Republic of Rome. After experiencing visions of future chaos, Brutus pushed for Caesar's public death in the grand tradition of spectacle that was the style of Rome, against Aya's preference for a quiet, private death to remove Caesar from power. Brutus later recognized that calling for the public death of Caesar had initiated the very chaos he had seen in the visions. In an attempt to avoid the disaster, assuming it was due to Caesar's actions, he had in fact caused it to come into being. Brutus and Cassius left Rome to continue the work of the Hidden Ones, but later returned to rescue Aya from death while in the custody of Mark Anthony. Before Brutus departed for Crete, Aya gave him the dagger he had once offered her for Caesar's assassination, and which had broken when she had prevented him from killing Mark Antony.

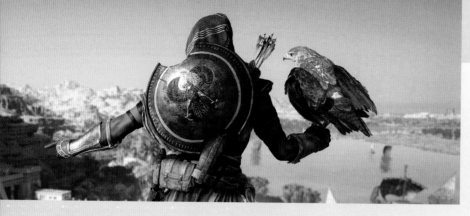

SENU: Senu was Bayek's eagle companion, linked spiritually with the Medjay-trained warrior. Wounded and lost during the battle for the Temple of the Oracle of Amun, Senu was nursed back to health by one of Bayek's allies in Siwa. Senu remained in the vicinity of the oasis, waiting for Bayek to return. When he did, she rejoined him as if no time had passed. A Bonelli's Eagle, Senu was a fairly large bird at 55–65 cm in length and a wingspan of about 150 cm. Her coloring was mostly brown and buff with off-white and black accents. Senu worked closely with Bayek; his finely-honed awareness and spiritual link with Senu allowed him to see through her eyes, making her a valuable asset during reconnaissance.

PHANOS THE YOUNGER: One of the first members of the Hidden Ones, Phanos the Younger was Aya's cousin, working as an actor and playwright in Alexandria. He was targeted by the authorities for his work, which was critical of the Ptolemy XIII administration. When Aya was being pursued in Alexandria and needed refuge, he put her in contact with Apollodorus, who in turn brought her to Cleopatra.

TAHIRA: (unknown – 38 BCE) An old acquaintance of Bayek, Tahira worked to protect Egyptian wildlife around the Nile Delta. She was one of the first members of the Hidden Ones. Tahira was charged with setting up and leading the Hidden Ones bureau in Sinai, supporting the Nabatean rebels against the Romans in 38 BCE. She was severely injured in one of the battles against Roman forces, but before dying she urged Bayek to not allow the creed of the Hidden Ones to fade.

SABU AND AHMOSE: Sabu held the position of Medjay of Siwa before Bayek. He knew his son was expected to follow in his footsteps, but after a mercenary gang attacked Siwa when Bayek was merely six years old, Sabu became reluctant to train and guide Bayek as a Medjay, the violence having created in him a fear for his family's safety and survival. Conversely, Ahmose, Bayek's mother, strongly supported her son's training after she herself was forced to defend and kill during the same attack on Siwa. Nevertheless, she could not convince Sabu to overcome his fears and continue Bayek's training as a Medjay alone, and had to ask others to provide similar training for Bayek until his father agreed.

GAMILAT: (unknown – 38 BCE) Gamilat lead the Nabatean rebels fighting the Romans in Sinai, where he was an ally of the Hidden Ones. Sometime in 38 BCE, Gamilat heard of a plot to invade Egypt and sent word to the Hidden Ones, who stopped the invasion. Unbeknownst to the Hidden Ones, Gamilat had been deliberately sparking battles with the Romans in villages throughout Sinai, recruiting people bent on avenging the death of their loved ones to his rebel forces. Bayek had to end his life, with regret.

SHIFTING ALLIANCES: FRIENDS AND FOES

GAIUS JULIUS RUFIO: (unknown-38 BCE) Rufio was a Roman general in command of Roman forces in Egypt, as well as a member of the Order of the Ancients. Rufio sought to undermine Cleopatra and Mark Antony's rule in Egypt and claim the throne for himself. Rufio was a true believer in the Order's cause and had unshakeable faith that it would survive long after his death. Despite this, he was fascinated by the Order's new opponents, the Hidden Ones, who seemed to have similar goals to the Order. However, he was confident the Order's faith and conviction would ultimately prove far stronger than the Hidden Ones'.

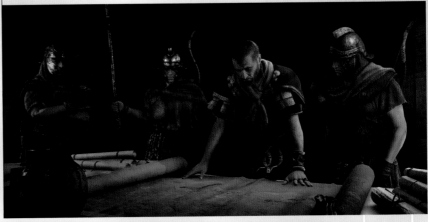

MARK ANTONY: (83-30 BCE) A Roman general and politician, Mark Antony joined forces with Caesar's heir Octavian to hunt down the rebellious senators who had worked with Aya to assassinate Caesar. Mark Antony would go on to become embroiled in a struggle for control over Rome with Octavian. He became romantically involved with Cleopatra, uniting with her to battle Octavian and support his own claim to Rome; in exchange, Cleopatra sought the return of the eastern lands that had formerly belonged to Egypt.

LUCIUS SEPTIMIUS - THE JACKAL: (circa 90s BCE-44 BCE) A Roman Military Tribune stationed in Alexandria, Septimius was among the Roman soldiers who were permanently stationed in Alexandria to protect the Ptolemaic kings and queens. During this time he fell in with influential men of the court who sought to manipulate the pharaoh. Physically he was a giant man—muscular and tanned, and athletic in every way. Septimius was a master manipulator, who was also suspicious; he tended to paranoia. He only felt at ease when he was in the company of those he knew to be his allies and co-conspirators; otherwise, he could be brooding, sarcastic, and aloof.

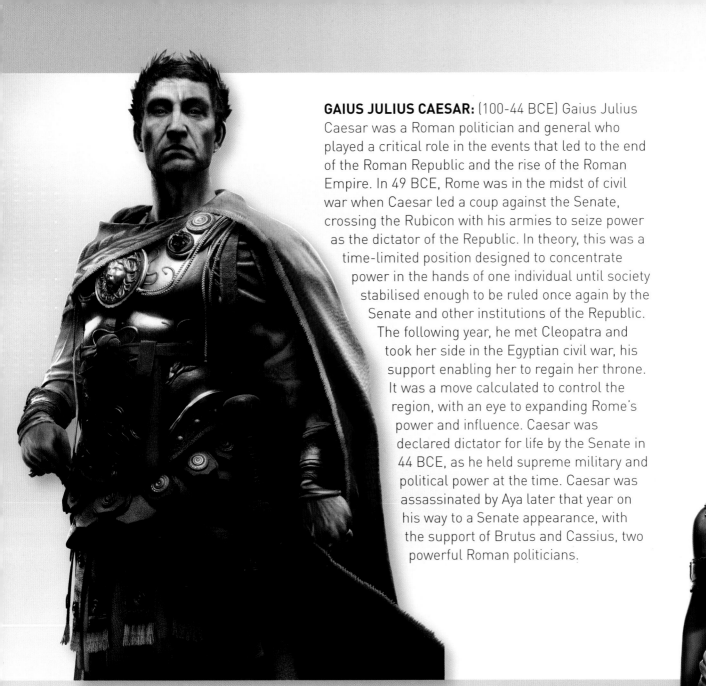

GAIUS JULIUS CAESAR: (100-44 BCE) Gaius Julius Caesar was a Roman politician and general who played a critical role in the events that led to the end of the Roman Republic and the rise of the Roman Empire. In 49 BCE, Rome was in the midst of civil war when Caesar led a coup against the Senate, crossing the Rubicon with his armies to seize power as the dictator of the Republic. In theory, this was a time-limited position designed to concentrate power in the hands of one individual until society stabilised enough to be ruled once again by the Senate and other institutions of the Republic. The following year, he met Cleopatra and took her side in the Egyptian civil war, his support enabling her to regain her throne. It was a move calculated to control the region, with an eye to expanding Rome's power and influence. Caesar was declared dictator for life by the Senate in 44 BCE, as he held supreme military and political power at the time. Caesar was assassinated by Aya later that year on his way to a Senate appearance, with the support of Brutus and Cassius, two powerful Roman politicians.

CLEOPATRA: [69-30 BCE] Fiercely intelligent, extraordinarily charismatic, and highly educated, Cleopatra was one of the most intelligent and educated women of her time. She was a shrewd politician and possessed a deep understanding of the economy and resources of her country, which made her a powerful negotiator when dealing with her primary client and protector, Rome. Knowing that Rome's goal was the assimilation of Egypt, Cleopatra requested support from Caesar for her claim to the Egyptian throne. She and Caesar allied, and with her brother defeated she took her position as pharaoh. The Order of the Ancients, who had supported her weaker brother, cunningly altered their tactics, leading to influencing Cleopatra through Caesar, whom they recruited to their cause. Years later, Amunet pleaded with Cleopatra to yield to Octavian to prevent more Egyptians from dying and to preserve what was left of the country. Cleopatra gracefully agreed to poison herself to end the war, but not before she made Amunet promise her to take her son Caesarion with her, and train him as a Hidden One.

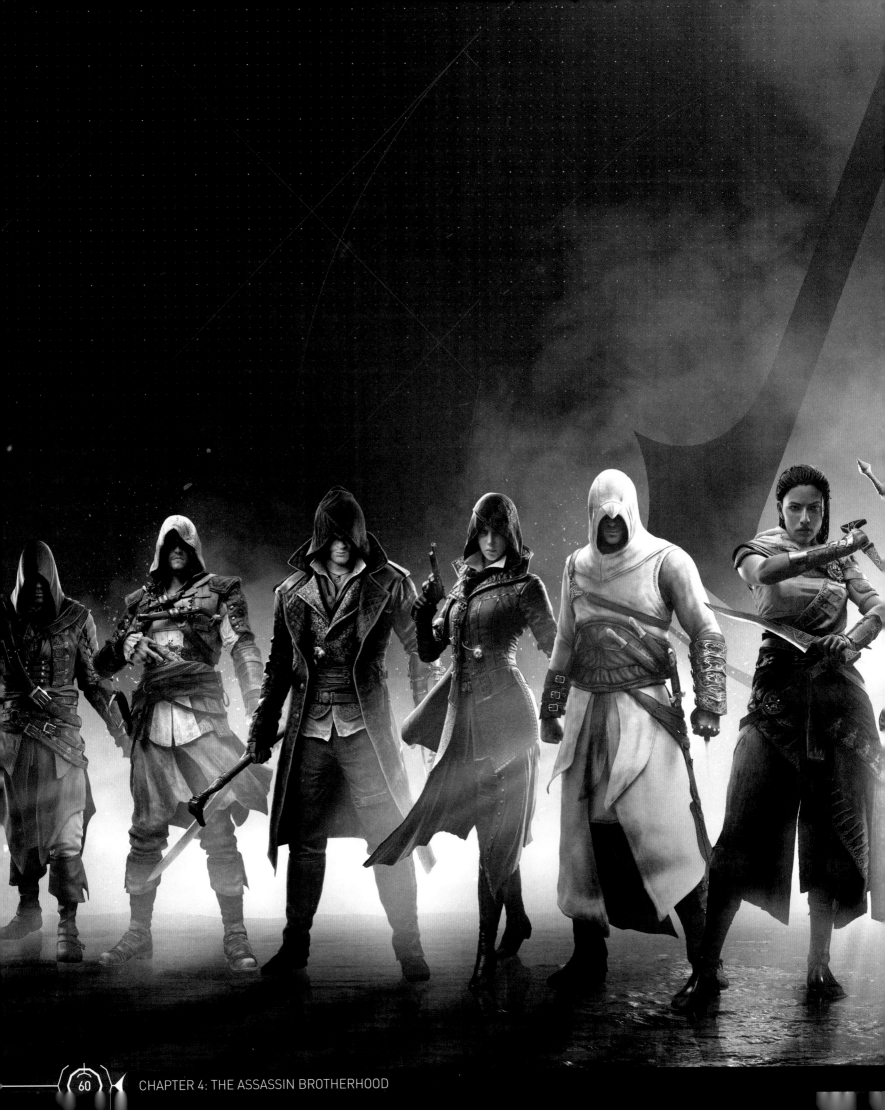

CHAPTER 4: THE ASSASSIN BROTHERHOOD

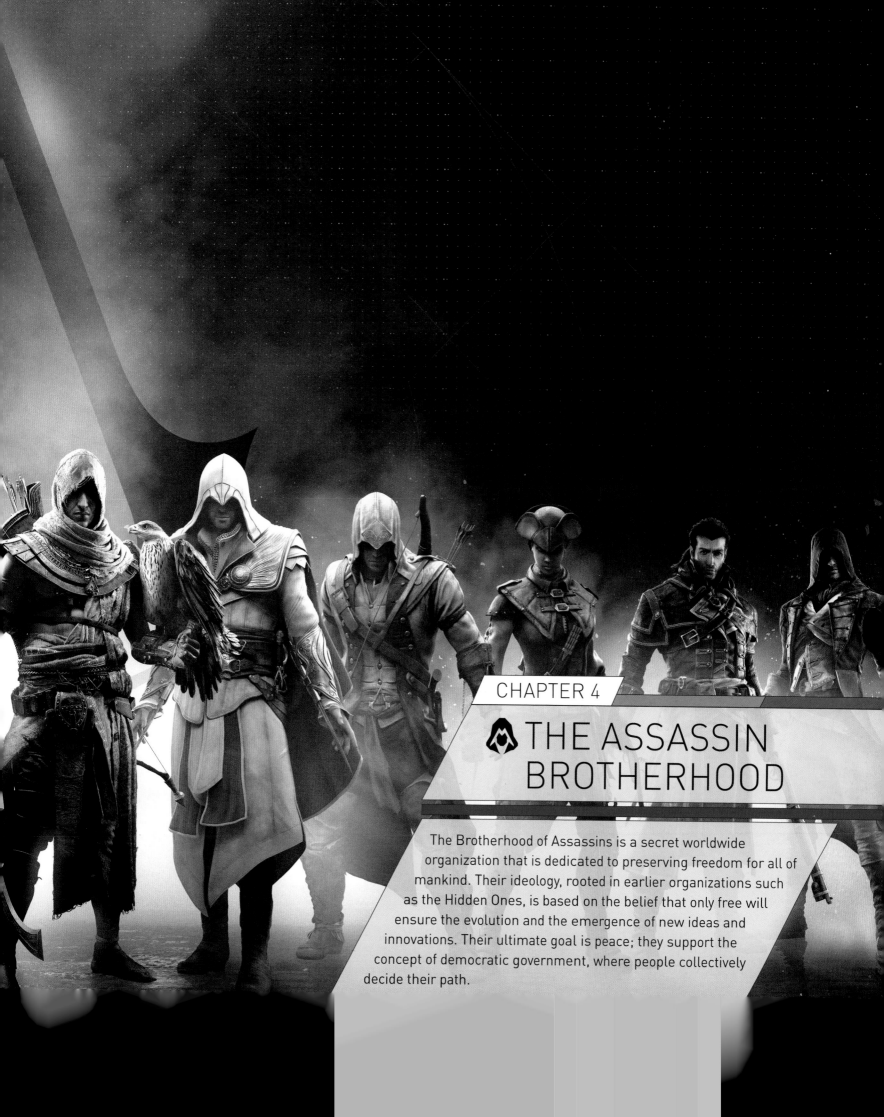

CHAPTER 4

THE ASSASSIN BROTHERHOOD

The Brotherhood of Assassins is a secret worldwide organization that is dedicated to preserving freedom for all of mankind. Their ideology, rooted in earlier organizations such as the Hidden Ones, is based on the belief that only free will ensure the evolution and the emergence of new ideas and innovations. Their ultimate goal is peace; they support the concept of democratic government, where people collectively decide their path.

E BROTHERHOOD
ROUGH THE AGES

Although the roots of the ideals that would eventually give rise to the Brotherhood can be traced back to antiquity, the origins of the organized Brotherhood and its Creed were established in Ancient Egypt, with the formation of the Hidden Ones by Bayek of Siwa and Aya of Alexandria.

Another notable individual the Assassin Brotherhood claims as an ancestor is Iltani of Babylon, who assassinated Alexander the Great in 323 BCE.

SHAPING HISTORY

The Brotherhood had key influence in various revolutions and uprisings throughout history, including the American Revolution, the French Revolution, and the Russian Revolution. By influencing events leading up to and during these key historical moments, the Brotherhood was able to shape the world in such a way as to allow humankind to determine its own path, free of tyranny or autocratic Templar direction.

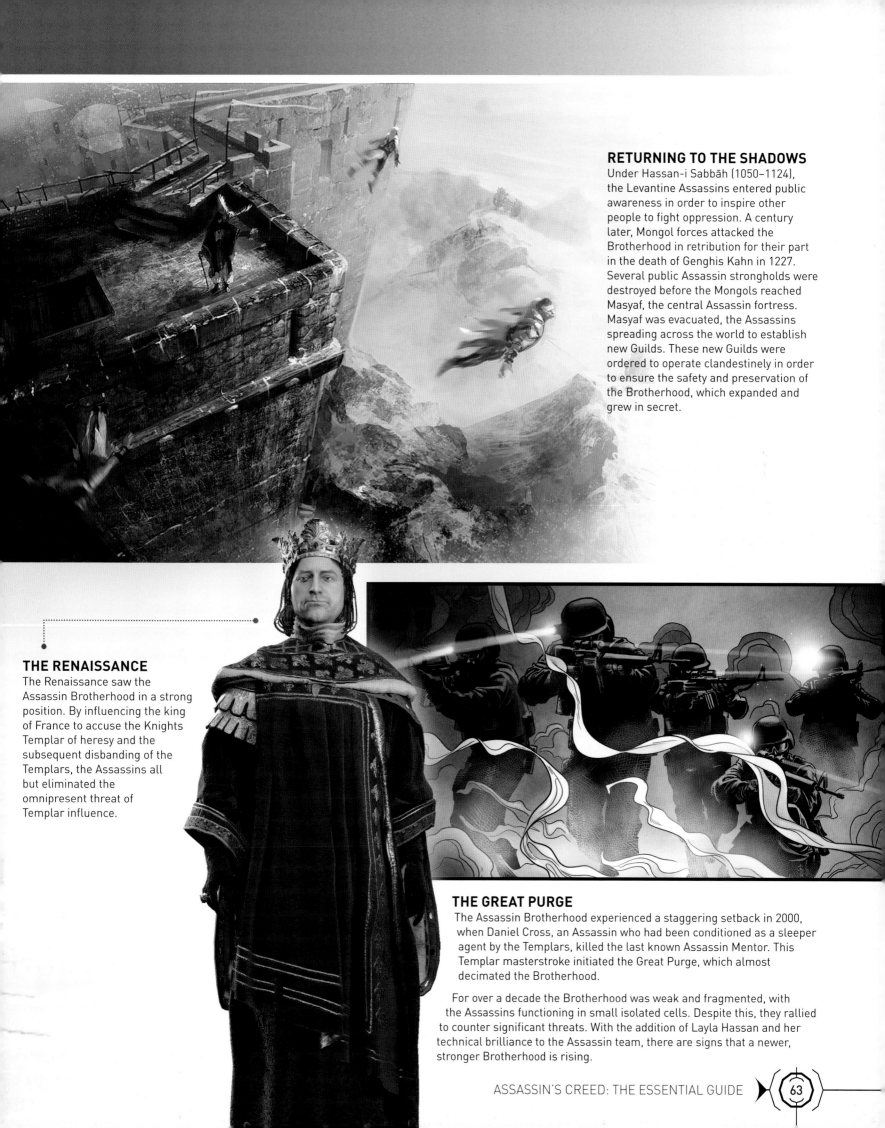

RETURNING TO THE SHADOWS

Under Hassan-i Sabbāh (1050–1124), the Levantine Assassins entered public awareness in order to inspire other people to fight oppression. A century later, Mongol forces attacked the Brotherhood in retribution for their part in the death of Genghis Kahn in 1227. Several public Assassin strongholds were destroyed before the Mongols reached Masyaf, the central Assassin fortress. Masyaf was evacuated, the Assassins spreading across the world to establish new Guilds. These new Guilds were ordered to operate clandestinely in order to ensure the safety and preservation of the Brotherhood, which expanded and grew in secret.

THE RENAISSANCE

The Renaissance saw the Assassin Brotherhood in a strong position. By influencing the king of France to accuse the Knights Templar of heresy and the subsequent disbanding of the Templars, the Assassins all but eliminated the omnipresent threat of Templar influence.

THE GREAT PURGE

The Assassin Brotherhood experienced a staggering setback in 2000, when Daniel Cross, an Assassin who had been conditioned as a sleeper agent by the Templars, killed the last known Assassin Mentor. This Templar masterstroke initiated the Great Purge, which almost decimated the Brotherhood.

For over a decade the Brotherhood was weak and fragmented, with the Assassins functioning in small isolated cells. Despite this, they rallied to counter significant threats. With the addition of Layla Hassan and her technical brilliance to the Assassin team, there are signs that a newer, stronger Brotherhood is rising.

THE ASSASSIN'S CREED

The heart of the Brotherhood's philosophy is encoded in the Three Tenets of the Assassin's Creed, founded on the rules laid out for the Hidden Ones by Bayek of Siwa and Aya (Amunet).

THE THREE TENETS

1. Stay your blade from the flesh of an innocent.

2. Hide in plain sight.

3. Never compromise the Brotherhood.

At their most basic, the Three Tenets are designed to highlight the importance of working for the safety of innocent people caught up in the machinations of government and tyranny; for the ideal of peace both in the world at large and within the Assassin's heart; and to preserve the anonymity of the Assassin and the Brotherhood. In theory, abiding by these rules would guide an Assassin to do the right thing when faced with a choice of actions. While the Tenets are upheld today, the interpretation of how best to apply them in guiding the Assassins can lead to differences of opinion, as has happened throughout the centuries.

The Tenets appear simple, but they are in fact a complex and challenging set of ethical puzzles that an Assassin must continually struggle with. Being philosophical guidelines, the Tenets cannot be applied as blanket rules. This forces the Assassin to examine each situation as objectively as possible, independent of historical or contemporary situations. Doing so can lead to decisions that appear hypocritical or that contradict previous or concurrent choices, and create cognitive dissonance. It is no easy thing to be an Assassin and follow the Tenets.

There is an unofficial value that is often quoted by Assassins that also guides them: the idea of working in the dark to serve the greater good. An Assassin does not seek glory or external recognition. They work in the dark, for their own protection and for that of others.

FREE WILL, NOT CHAOS

Free will does not imply the absence of consequence or morality. On the contrary; the Tenets require a deep level of self-discipline and ethical consideration, as well as respect for other cultures, viewpoints, and beliefs, and acceptance of one's fallibility.

"The Creed of the Assassin Brotherhood teaches us that nothing is forbidden to us. Once, I thought that meant we were free to do as we would. To pursue our ideals, no matter the cost. I understand now. Not a grant of permission. The Creed is a warning. Ideals too easily give way to dogma. Dogma becomes fanaticism. No higher power sits in judgement of us. No supreme being watches to punish us for our sins. In the end, only we ourselves can guard against our obsessions. Only we can decide whether the road we walk carries too high a toll. We believe ourselves redeemers, avengers, saviors. We make war on those who oppose us, and they in turn make war on us. We dream of leaving our stamp upon the world... even as we give our lives in a conflict that will be recorded in no history book. All that we do, all that we are, begins and ends with ourselves."

— Arno Dorian

THE THREE IRONIES

In light of this dissonance, Altaïr created the Three Ironies, a corollary set of statements that reflect on the Three Tenets.

1. Here we seek to promote peace, but murder is our means.

2. Here we seek to open the minds of men, but require obedience to a to a master and set of rules.

3. Here we seek to reveal the danger of blind faith, yet we are practitioners ourselves.

With these statements, Altaïr underscores the inherently contradictory nature of being an Assassin. As Altaïr's Codex points out, Assassins bend their own rules in order to accomplish their work for the greater good. Many Assassins find it challenging to operate within such a paradoxical structure, which can give rise to rebellion and dissatisfaction.

The contradictory nature of being an Assassin and following the Tenets means that assumptions about the correct way to do things should never be made. Indeed, beliefs should constantly be challenged in order to make sure the right path is being followed for the right reasons. This conflict continues in the present day.

RESPECT

Selective murder may be the means by which the Brotherhood achieves their goals, but an Assassin is dissuaded from rejoicing in the death of an opponent; respect for life must be taken into account at all times.

"Requiescat in Pace" — Ezio Auditore

STRUCTURE

During the Third Crusade, the most prominent Brotherhood was based in Masyaf, until Altaïr commanded it to disband in the thirteenth century and reform into separate Guilds based in cities across the globe. Each Guild was under the supervision of a Master Assassin, and had slightly different ranks that reflected an initiate's progression from a recruit through apprenticeship to a confirmed and initiated Assassin.

The modern Brotherhood is organized into smaller groups of Assassins known as cells, usually one per major or strategically-located city; the concept of more central guilds has been discarded. Cells function more like isolated groups of freedom fighters, in contrast to the highly structured Templar organization. Some cells are isolated compounds, communities of Assassins living and training off the grid, away from urban centers where Templars have a stronger presence, such as the settlement where Desmond Miles grew up.

The leader of the Brotherhood is called the Mentor. At one time, each Guild had its own Mentor; however, by the twentieth century the entire Brotherhood was overseen by a single Mentor. The identity and location of the Mentor was kept secret, even from the Assassins. In 2000, the Mentor was located and murdered by sleeper agent Daniel Cross in Dubai.

Gavin Banks and William Miles shared the responsibilities of the Mentor after the Great Purge while the Brotherhood struggled to recover and to re-establish itself in the wake of the Templar Order's decimating blow. Since 2015, William has served as the new Mentor of the worldwide Brotherhood of Assassins.

Assassin Dens — Throughout history the Assassins have used safehouses — or dens — to hide from their enemies or to meet with fellow brothers.

Assassin Councils — Branches of the Brotherhood often assemble a Council as a governing body. Composed of selected Master Assassins, the Council advises the Mentor, or functions in place of a Mentor if a suitable Assassin cannot be appointed.

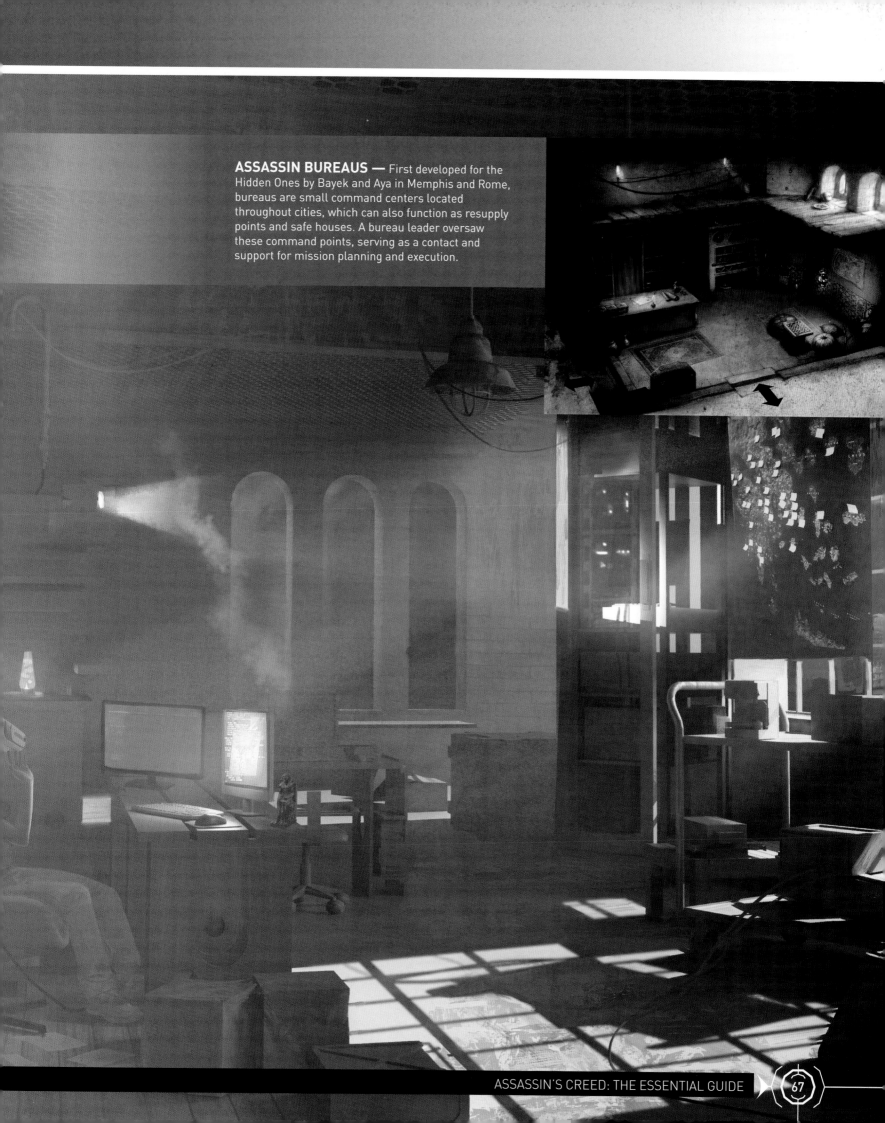

ASSASSIN BUREAUS — First developed for the Hidden Ones by Bayek and Aya in Memphis and Rome, bureaus are small command centers located throughout cities, which can also function as resupply points and safe houses. A bureau leader oversaw these command points, serving as a contact and support for mission planning and execution.

TRAINING

An apprentice undergoes rigorous training while learning to be Assassin.

Part of an Assassin's training is learning **observation**. This entails more than just watching something or someone; it means taking note of the context of the situation, absorbing as many details as possible, and collecting information via espionage. Being well informed means being able to make the best possible decision.

Stealth and concealment are among an Assassin's greatest assets. Being able to reach a target, deal with it, then slip away without being noticed is essential to an Assassin. Trainees practice the art of hiding in plain sight. They learn how to move through crowds quickly and efficiently, without being noticed. This also entails being able to move the way people in a crowd are moving, and mimicking their way of dress. Assassins are masters at blending in. Trainees are taught to take advantage of shadows and alternate paths, such as rooftops and walls.

A trainee undergoes extensive weapons and combat training, specifically with bladed weapons. While the original Medjay background of Bayek and Aya influenced how they trained the Hidden Ones and inspired a certain style of moving that can still be recognized in modern Assassin movement, no specific style of fighting identifiable as typical of the Brotherhood exists; other than the use of the Hidden Blade, an Assassin makes use of what he or she personally excels at. Combat styles can also reflect cultural and geographic influences.

Not all Assassins are trained to be fighters, although there is a basic level of physical and self-defense training that is universal. A good leader recognizes that some Assassins are more valuable in other more specialized roles, such as **research, espionage, or technical engineering**.

Freerunning is a key element of an Assassin's training. An acrobatic form of movement that involves navigating fluidly through an urban or natural landscape, freerunning involves scaling vertical surfaces such as walls, leaping horizontally or vertically, diving, vaulting, swinging from handholds, dropping, and rolling. While equipment is not required, various gear has been developed over the years to enhance an Assassin's ability or facilitate various freerunning moves. Tools such as hooked blades, whips, and the grappling hook/rope launcher extension to the Assassin gauntlet have all been used by various Assassins to aid freerunning.

MODERN TRAINING

Knowledge of a variety of subjects is useful. A trainee is often encouraged to develop their own interests into strengths that benefit the Brotherhood, such as history, engineering, hacking, or combat.

A chosen fighting style is often reflective of an Assassin's cultural or geographic location, but much physical training is also born of necessity; the old style of teaching trainees all the same moves is no longer possible in the twenty-first century. Many initiates learn on the go from personal mentors and their fellow Assassin teams, in the midst of do-or-die situations.

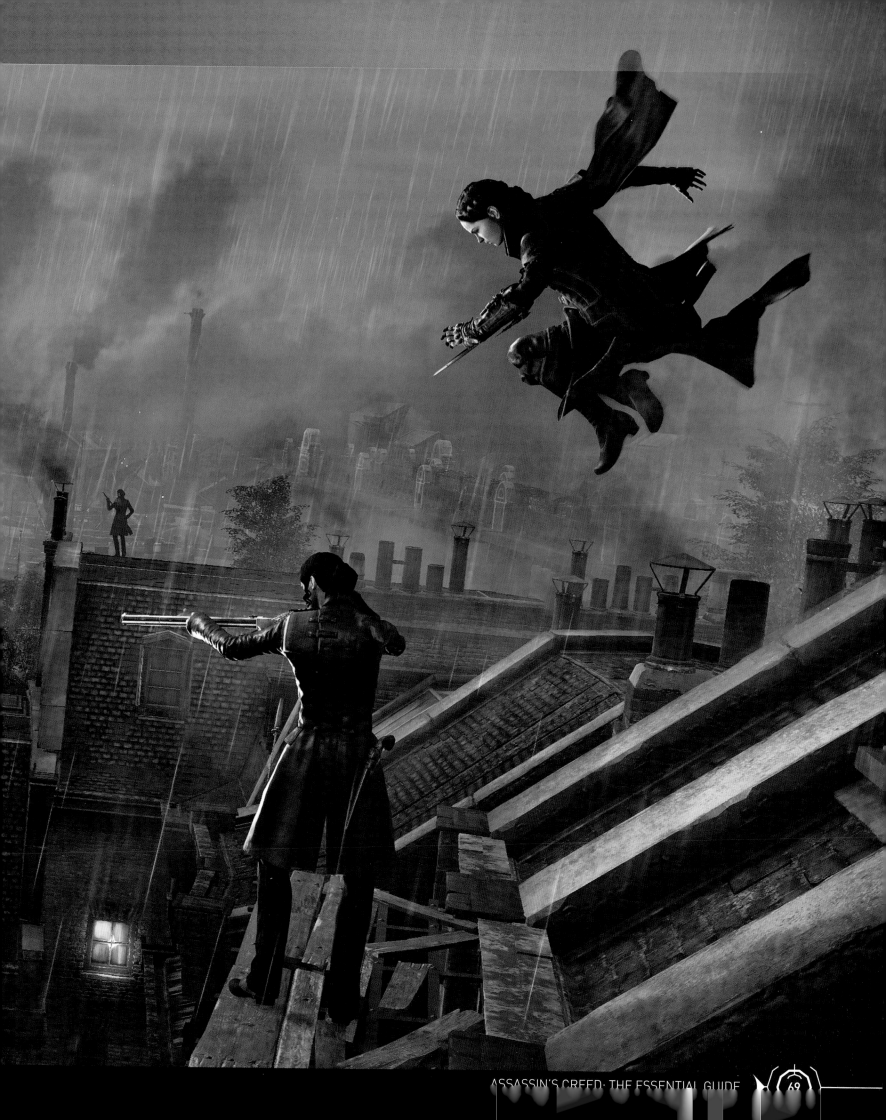

ICONIC ABILITIES

The Brotherhood's roots are in the hybrid race created when the Precursors crossbred with humans. Modern-day Assassins can access abilities that are rooted in this bloodline if the concentration of Precursor DNA is high enough.

Eagle Vision is a sixth sense that is encoded in human DNA, partially as a result of genetic engineering on the part of the Precursors, and partially due to interbreeding between the two races. Eagle Vision allows an individual to intuit or sense how people and objects relate to them in various ways. Sigils, colors, auras, words, and other forms of input have all been recorded as being part of the Eagle Vision ability; the medium may depend on the skill level of the user, or the method of processing information the individual Assassin subconsciously prefers. Assassins have used this ability to locate hidden passageways, to identify illusion from truth, and to locate and track targets.

As the bloodline becomes further diluted, the ability has become rarer and rarer. Eagle Vision is now a relatively uncommon ability; the majority of Assassins do not have it. The higher the concentration of Precursor genes within an individual's DNA, the more likely the ability is to be present.

In theory, anyone can potentially learn how to use Eagle Vision, as the ability is latent within human DNA. The Bleeding Effect, a side effect of Animus use, can also awaken the ability. Consequently, not everyone who possesses the ability is an Assassin.

EAGLE VISION is not limited to visual input; auditory input has also been used in place of (or as a complement to) visual input.

A SPECIAL BOND
Bayek of Siwa had a special bond with his beloved eagle Senu, through whose eyes he could survey activity and gather valuable information. Very few other Assassins demonstrate the ability to bond or otherwise connect with an eagle and see through their eyes. Kassandra possessed this capability with Ikaros, the eaglet she raised; Io:Nhiote also demonstrated this skill, to the joyful amazement of Ratonhnhaké:ton, her father. It is likely that Eagle Vision and Eagle Sense is a form of, or derived from, this extraordinary ability.

Eagle Sense is a more refined and advanced use of Eagle Vision. This ability allows an individual to use a more heightened, precise, and detailed method of sensing. Some users have been able to refine this further into being able to sense a target's next move.

The Leap of Faith is an acrobatic freerunning move wherein an Assassin leaps vertically off a tall freestanding structure, tucks into a flip head over heels in mid-air, and lands unharmed in a pile of hay, water, or other soft material. It has also been performed by stepping off a wall or beam, or by leaning the whole body forward from a standing position. Once performed by newly made Assassins to celebrate their new rank, it can also been used to escape from danger.

Although the use of the Leap of Faith decreased in the twentieth century, it has been performed by modern Assassins such as Charlotte de la Cruz. Present-day Assassins have also adapted the Leap of Faith for modern use by using equipment and technology such as wingsuits to alter the Leap's capabilities and function.

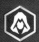

ICONIC WEAPON: THE HIDDEN BLADE

The signature weapon of an Assassin, bestowed upon the completion of training, the Hidden Blade is a concealed narrow blade controlled by a mechanism on the Assassin's wrist, often set into a bracer or gauntlet. Aya received the Hidden Blade used by Darius to assassinate Xerxes, and gave it to Bayek, acquiring her own new one later. The Hidden Blade became the weapon of choice for the Hidden Ones.

Unlike distance weapons or weapons of mass destruction, the Hidden Blade requires the Assassin to use stealth and concealment to locate, follow, and personally remove a target without calling attention to the act. Use of a Hidden Blade sends a very specific message to the target's colleagues and followers: No one is safe.

It is not unusual for an Assassin to have unique, personal modifications to their Hidden Blade. Alternate and unique designs have included two or more blades, a hook, a rope launcher, folding or swivelling blades, and the inclusion of explosive devices.

Some Assassins are capable of equipping two Hidden Blades, one on each arm, but this is very rare, especially in modern day. Most Assassins equip the Hidden Blade on the left arm, but some are experienced enough to switch sides temporarily or permanently.

> "The Hidden Blade has been a constant companion of ours over the years. Some would say it defines us, and they would not be entirely wrong."
>
> — Altaïr Ibn-La'Ahad

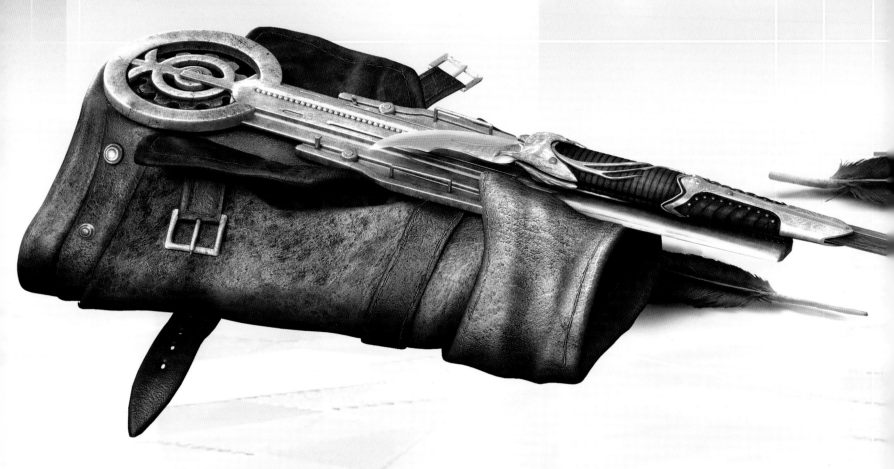

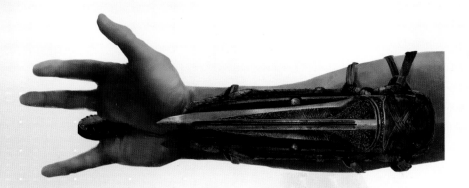

The first recorded use of a Hidden Blade was in the fifth century BCE, in the assassination of King Xerxes I by Darius, a predecessor of the Assassins.

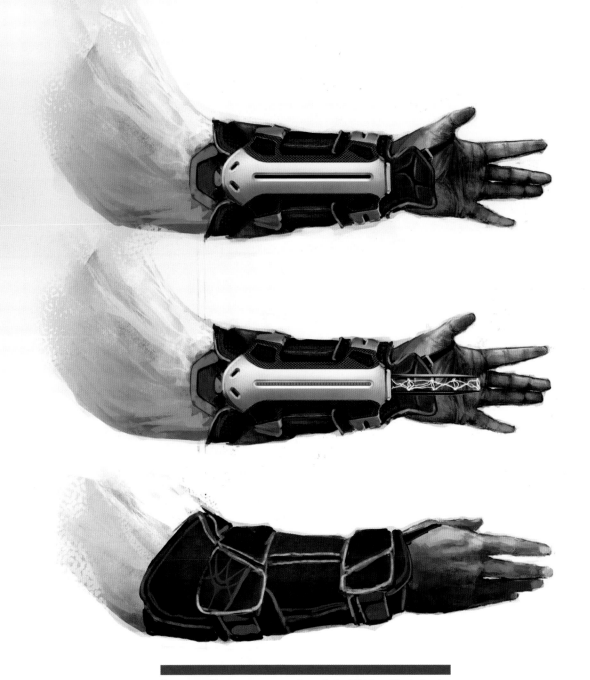

A twenty-first century version of the Hidden Blade is the Shock Blade, a two-pronged component that discharges electricity when stabbed into the flesh of an enemy.

JOINING THE BROTHERHOOD

The process of joining the Brotherhood varies across the world and has evolved over time. However, it is always regarded as a lifelong commitment.

The ancestor organization to the Brotherhood, known as the Hidden Ones, was a coming together of like-minded people who fought for the same ideals; it was less formalized, and initiation rituals weren't important. As the organization evolved into a more formal and codified Brotherhood, ritual became more significant

At the height of its formal practice, an initiation ceremony marked the passing of an apprentice to a full member of the Brotherhood. At this ceremony the Assassin would be given the iconic weapon of an Assassin, the Hidden Blade, and a full set of traditional garb, including the beaked hood. As the Guilds further fragmented through the eighteenth and nineteenth centuries, formal initiation ceremonies once again became a thing of the past.

An Assassin is either born into a family already present within the Brotherhood, or is recruited from outside. If born into an Assassin family, a trainee begins Assassin-focused education at a young age. Sometimes individuals are recruited by an Assassin because of their potential or connections. Novices operate under supervision before being confirmed as full members of the Brotherhood.

With the Brotherhood's fragmentation by the Great Purge, there has been a lack of ceremony that some say reflects the Brotherhood's loss of purpose and direction. Instead, the modern Brotherhood recruits much like the Hidden Ones did, by finding like-minded people and either allying with them or bringing them into the Brotherhood. It is a pragmatic approach, focused on secret recruitment and training for the mission at hand. It is, in a sense, a return to the Brotherhood's roots.

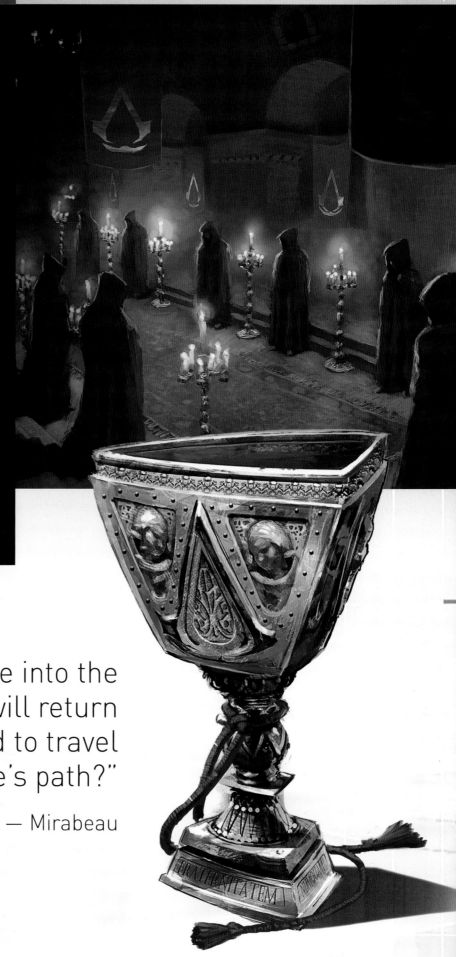

"Out of the dark, you come into the light. From the light, you will return to the dark. Are you prepared to travel the eagle's path?"

— Mirabeau

THE EAGLE

The eagle is a bird of prey with keen eyesight, and a symbol that is strongly associated with the Assassin Brotherhood. From the soaring Leap of Faith to the traditional Assassin's beaked hood to the Assassin Crest, the imagery of the eagle is repeatedly evoked. There is a spiritual connection between Assassins and the eagle, going so far as to manifest as a personal connection with a physical bird, such as the relationship between Kassandra and Ikaros, or Bayek and Senu, although this is extremely rare.

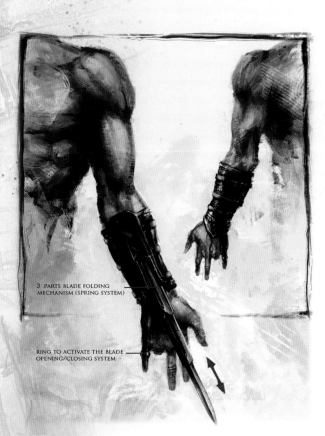

3 PARTS BLADE FOLDING MECHANISM (SPRING SYSTEM)

RING TO ACTIVATE THE BLADE OPENING/CLOSING SYSTEM

THE CREST

The iconic stylized A that forms the basis of the Brotherhood insignia was inspired by the shape of the eagle skull necklace that Bayek dropped at Aya's side at the beach as she left for Rome.

The crest has essentially held the same basic shape throughout the ages, although many Guilds have slightly different variations. Cultural variations also exist, reflecting the local style of art and embellishment of the Guild using it. The crest has decorated armor, tombs, banners, and other Assassin equipment. Some modern Assassins wear the symbol as a tattoo or jewelry.

THE FINGER BRAND

The early use of the Hidden Blade entailed cutting off a finger to enable the blade to extend. Severing the finger in this way was sometimes part of the initiation ceremony, recalling Bayek's loss of a finger the first time he experimented with the Hidden Blade of Darius. Altaïr redesigned the Hidden Blade to avoid such sacrifice and to keep Assassins from being identified by the missing finger. Despite that, some Assassins chose to continue the ritual, while others decided to tattoo or brand a finger instead to mark their commitment.

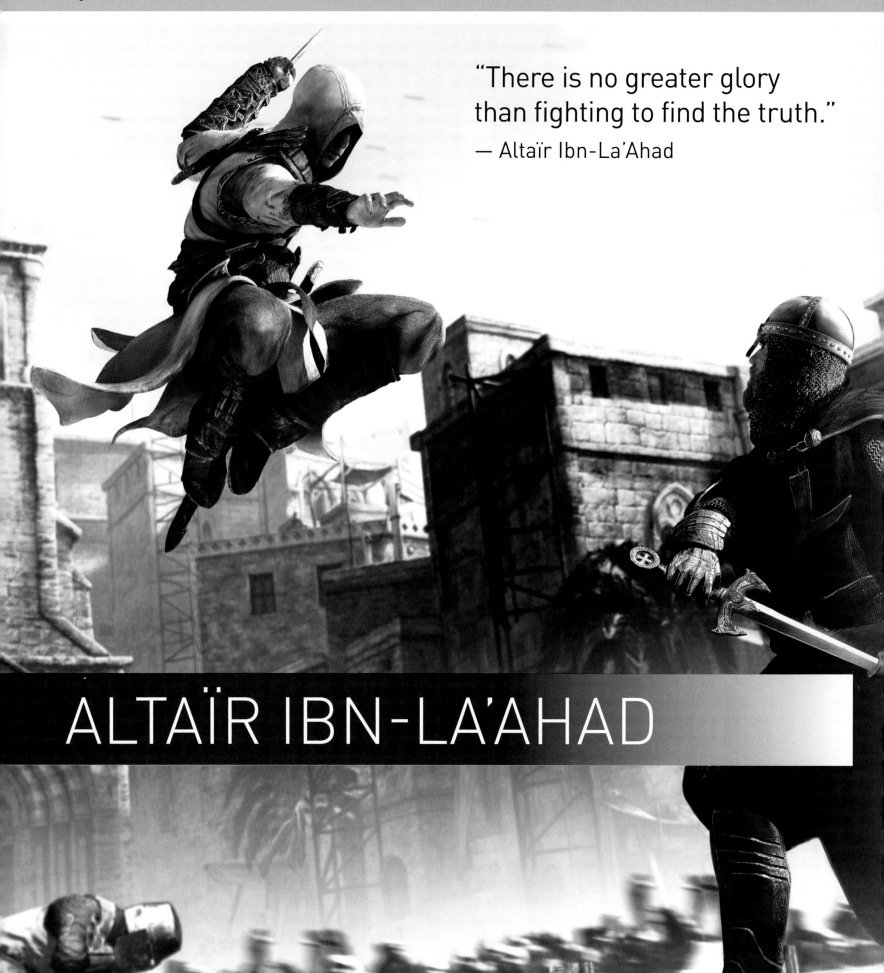

"There is no greater glory than fighting to find the truth."
— Altaïr Ibn-La'Ahad

ALTAÏR IBN-LA'AHAD

MAIN ASSASSINS

Dates: 1165–1257
Born: Masyaf, Syria
Historical Period: Third Crusade
Guild Affiliation: Levantine Brotherhood

Altaïr was born into an Assassin family and achieved the rank of Master Assassin at twenty-five, the youngest to attain that rank at the time. During the Third Crusade, Altaïr was tasked with obtaining an Apple of Eden in Jerusalem, known as the Templar Treasure.

After arrogantly breaking all three tenets of the Creed and exposing the Assassin community in Masyaf to a Templar attack in pursuit of the Apple, Altaïr was demoted to the level of Novice. To redeem his honor, he was assigned the task of playing the Saracens and Crusaders against one another in order to prevent the Templars taking control of the Holy Land.

While doing this he discovered that his Mentor, Al Mualim, was working with the Templars with the intention of using the Apple for his own purposes. Altaïr assassinated Al Mualim and retrieved the Apple, which revealed the locations of other Pieces of Eden scattered around the world. It also communicated a significant amount of Precursor history and a warning of the Second Disaster to come.

Older and wiser when he became the Mentor of the Levantine Brotherhood, Altaïr implemented several reforms and improvements, making the Brotherhood more egalitarian and less insular. He spent time redesigning equipment and studying the Apple. Altaïr also wrote his Codex, an encoded collection of wisdom and information gleaned from his life, including the knowledge obtained from the Apple of Eden.

Key Allies: Maria Thorpe (wife), Darim and Sef (sons), Malik Al-Sayf

Main Opponents: Robert de Sablé, Abbas Sofian, Al Mualim , Gengis Khan

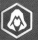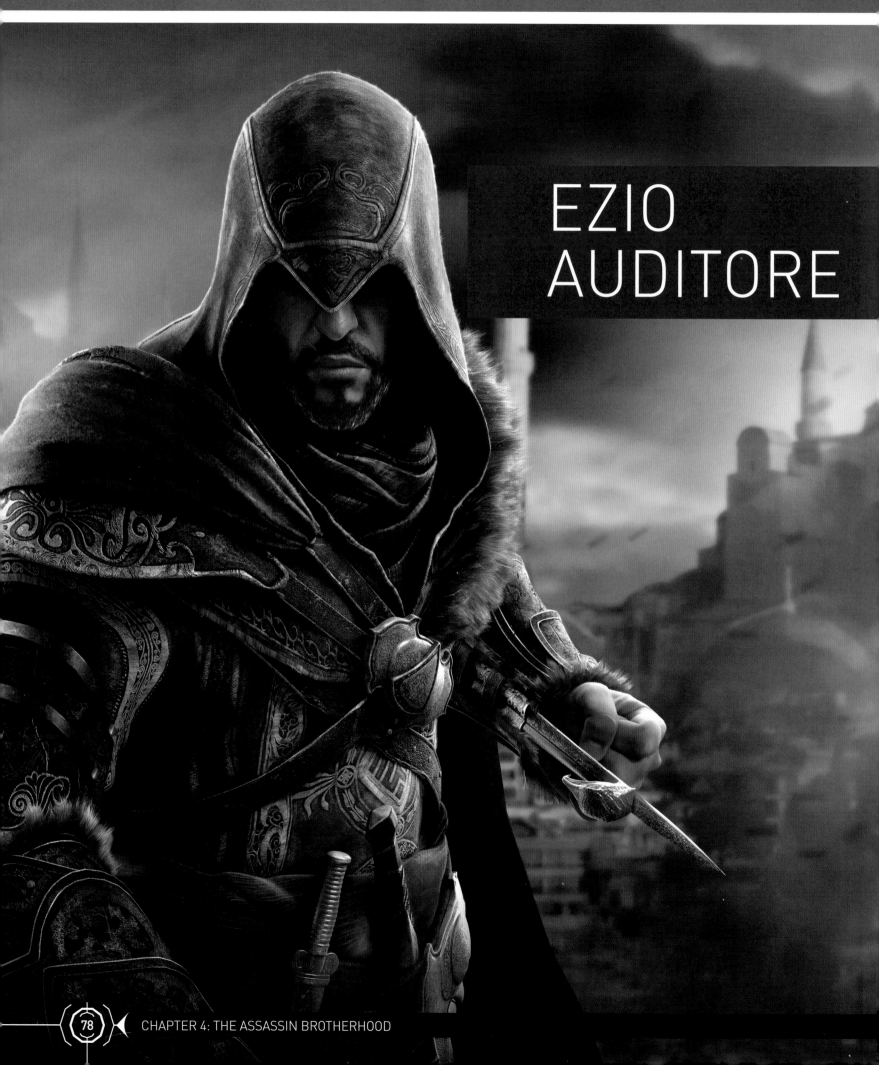

EZIO AUDITORE

Dates: 1459–1524
Location: Italy
Historical Period: Italian Renaissance
Guild Affiliation: Italian Brotherhood

Ezio Auditore da Firenze's passion drove him from being a carefree, irresponsible youth to an accomplished Assassin leader.

Born into an Assassin family but not privy to the existence of the Brotherhood, Ezio only learned of his family's heritage upon the execution of his father and older brothers, when Ezio was seventeen.

His uncle Mario took him in and taught him the ways of the Assassins in Monteriggioni. When a Templar attack killed his uncle and stole the Apple of Eden his family possessed, Ezio assembled a group of trusted people who helped him oppose the Templar corruption in Rome.

Ezio worked for many years to defeat the Borgias. He also worked to locate and reassemble pages of Altaïr's Codex, seeking to improve the Brotherhood's techniques and technology.

Eventually Ezio was led to the Middle East, where the Assassins and Templars raced to locate Altaïr's lost library and the treasures thought to be inside. When Ezio entered the library in 1512, he found no books, only Altaïr's remains, the Apple of Eden, and a Memory Seal encoded with Altaïr's final memories.

When activated, the Apple revealed a message from the Precursors, and Ezio learned that he was to be a conduit between the Precursors and a future Assassin. Ezio recorded his experience and the Precursor message in the Prophet's Codex.

Ezio chose to retire from the Brotherhood when he returned from the Masyaf library, marrying Sofia Sartor and raising a family.

Key Allies: Mario Auditore, Claudia Auditore, Sofia Sartor, Leonardo da Vinci, Bartolomeo D'Alviano, Niccolò Machiavelli, Caterina Sforza, La Volpe, Yusuf Tazim, Lorenzo de' Medici, Suleiman I, Piri Reis

Main Opponents: Rodrigo Borgia, Cesare Borgia, Juan Borgia, the Pazzi family, the Barbarigo family, Prince Ahmet, Manuel Palaiologos.

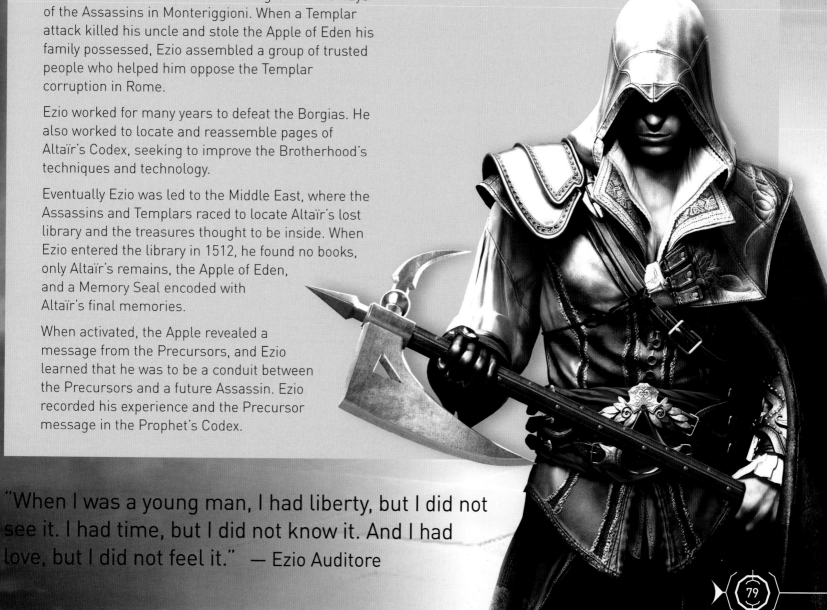

"When I was a young man, I had liberty, but I did not see it. I had time, but I did not know it. And I had love, but I did not feel it." — Ezio Auditore

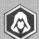
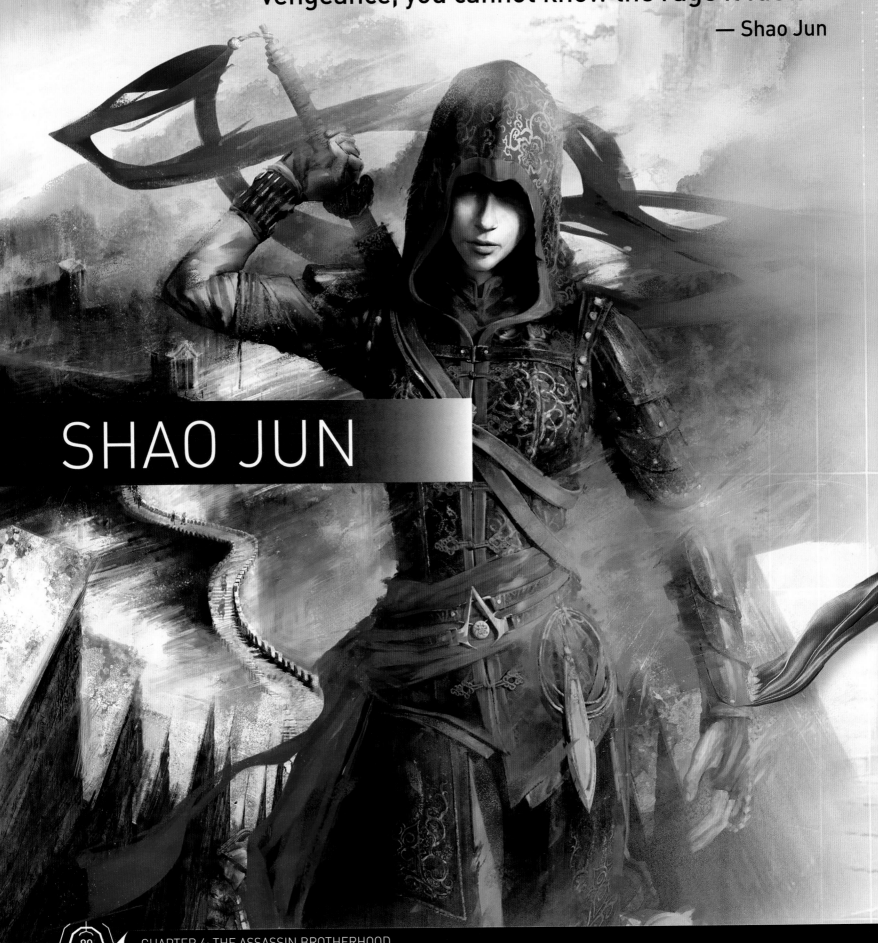

"Until you have experienced the thirst for vengeance, you cannot know the rage it fuels."

— Shao Jun

SHAO JUN

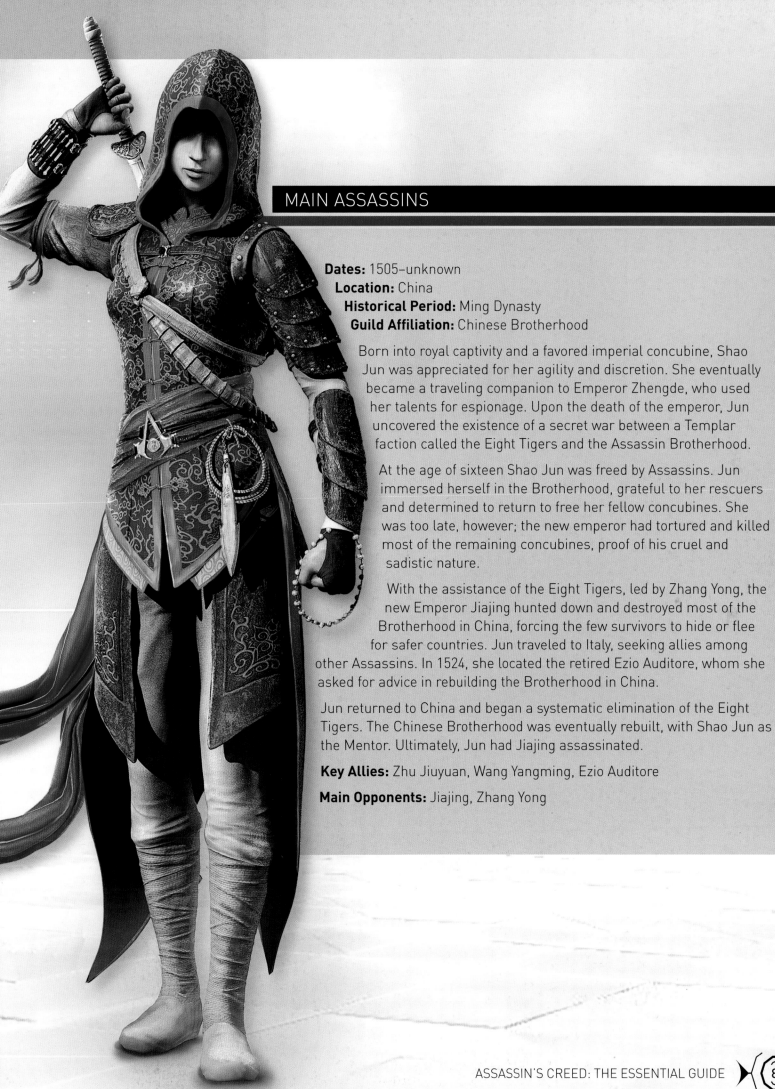

Dates: 1505–unknown
Location: China
Historical Period: Ming Dynasty
Guild Affiliation: Chinese Brotherhood

Born into royal captivity and a favored imperial concubine, Shao Jun was appreciated for her agility and discretion. She eventually became a traveling companion to Emperor Zhengde, who used her talents for espionage. Upon the death of the emperor, Jun uncovered the existence of a secret war between a Templar faction called the Eight Tigers and the Assassin Brotherhood.

At the age of sixteen Shao Jun was freed by Assassins. Jun immersed herself in the Brotherhood, grateful to her rescuers and determined to return to free her fellow concubines. She was too late, however; the new emperor had tortured and killed most of the remaining concubines, proof of his cruel and sadistic nature.

With the assistance of the Eight Tigers, led by Zhang Yong, the new Emperor Jiajing hunted down and destroyed most of the Brotherhood in China, forcing the few survivors to hide or flee for safer countries. Jun traveled to Italy, seeking allies among other Assassins. In 1524, she located the retired Ezio Auditore, whom she asked for advice in rebuilding the Brotherhood in China.

Jun returned to China and began a systematic elimination of the Eight Tigers. The Chinese Brotherhood was eventually rebuilt, with Shao Jun as the Mentor. Ultimately, Jun had Jiajing assassinated.

Key Allies: Zhu Jiuyuan, Wang Yangming, Ezio Auditore

Main Opponents: Jiajing, Zhang Yong

EDWARD KENWAY

" I'm not an easy man
to call a friend, am I?"
— Edward Kenway

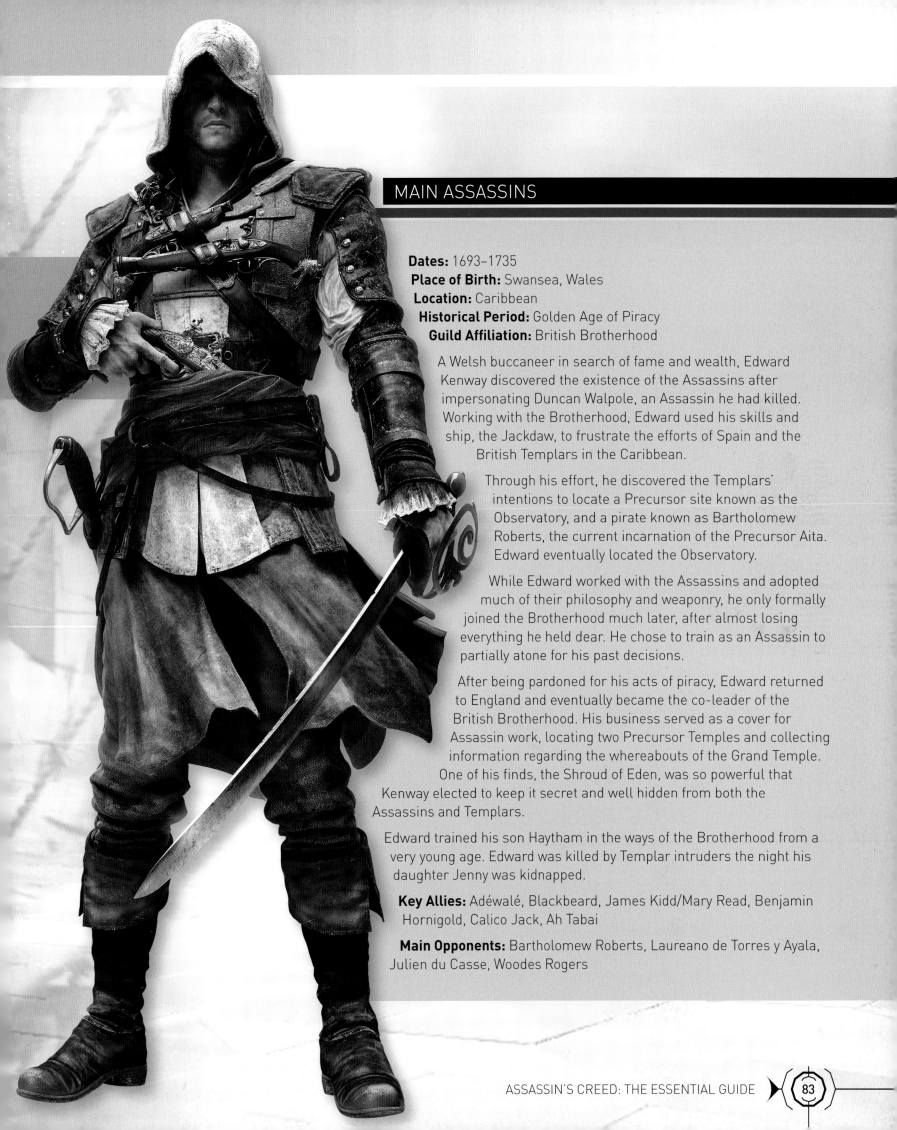

MAIN ASSASSINS

Dates: 1693–1735
Place of Birth: Swansea, Wales
Location: Caribbean
Historical Period: Golden Age of Piracy
Guild Affiliation: British Brotherhood

A Welsh buccaneer in search of fame and wealth, Edward Kenway discovered the existence of the Assassins after impersonating Duncan Walpole, an Assassin he had killed. Working with the Brotherhood, Edward used his skills and ship, the Jackdaw, to frustrate the efforts of Spain and the British Templars in the Caribbean.

Through his effort, he discovered the Templars' intentions to locate a Precursor site known as the Observatory, and a pirate known as Bartholomew Roberts, the current incarnation of the Precursor Aita. Edward eventually located the Observatory.

While Edward worked with the Assassins and adopted much of their philosophy and weaponry, he only formally joined the Brotherhood much later, after almost losing everything he held dear. He chose to train as an Assassin to partially atone for his past decisions.

After being pardoned for his acts of piracy, Edward returned to England and eventually became the co-leader of the British Brotherhood. His business served as a cover for Assassin work, locating two Precursor Temples and collecting information regarding the whereabouts of the Grand Temple. One of his finds, the Shroud of Eden, was so powerful that Kenway elected to keep it secret and well hidden from both the Assassins and Templars.

Edward trained his son Haytham in the ways of the Brotherhood from a very young age. Edward was killed by Templar intruders the night his daughter Jenny was kidnapped.

Key Allies: Adéwalé, Blackbeard, James Kidd/Mary Read, Benjamin Hornigold, Calico Jack, Ah Tabai

Main Opponents: Bartholomew Roberts, Laureano de Torres y Ayala, Julien du Casse, Woodes Rogers

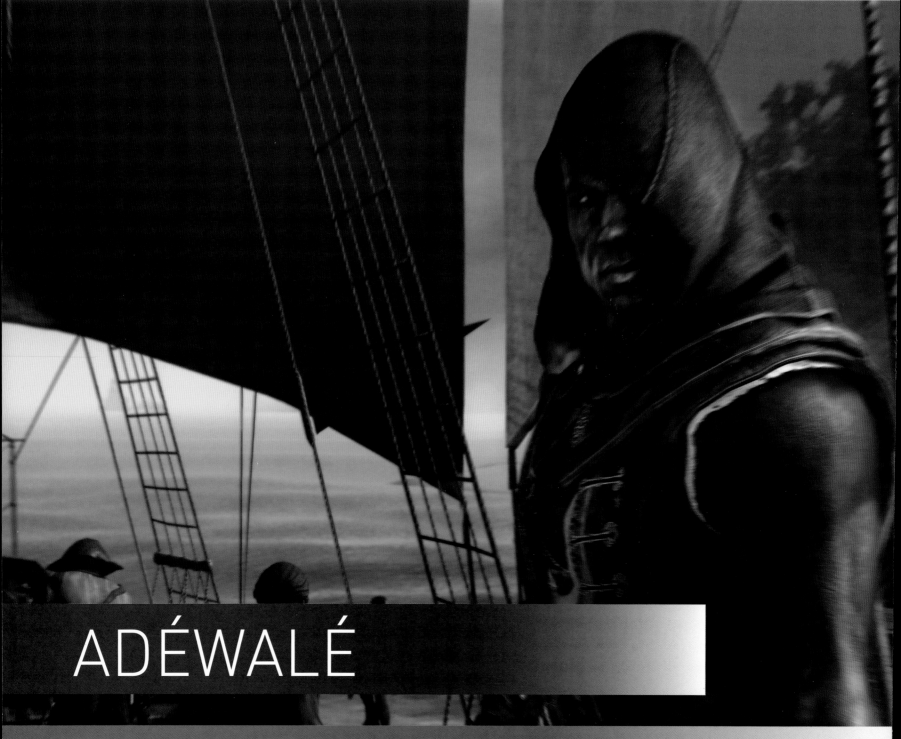

ADÉWALÉ

"That's Adéwalé. He was a slave who freed himself and hundreds of his brothers in the West Indies. That man's a living incarnation of the Creed."

— Liam O'Brien

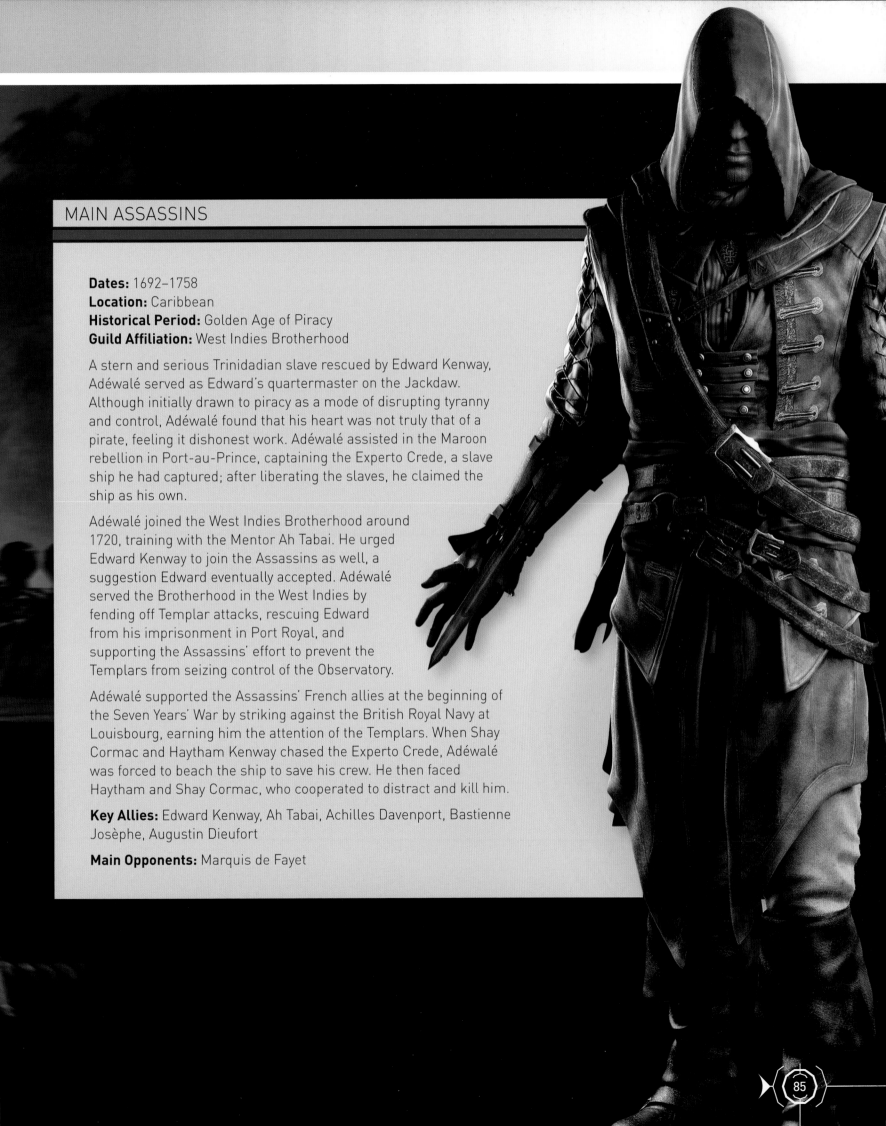

MAIN ASSASSINS

Dates: 1692–1758
Location: Caribbean
Historical Period: Golden Age of Piracy
Guild Affiliation: West Indies Brotherhood

A stern and serious Trinidadian slave rescued by Edward Kenway, Adéwalé served as Edward's quartermaster on the Jackdaw. Although initially drawn to piracy as a mode of disrupting tyranny and control, Adéwalé found that his heart was not truly that of a pirate, feeling it dishonest work. Adéwalé assisted in the Maroon rebellion in Port-au-Prince, captaining the Experto Crede, a slave ship he had captured; after liberating the slaves, he claimed the ship as his own.

Adéwalé joined the West Indies Brotherhood around 1720, training with the Mentor Ah Tabai. He urged Edward Kenway to join the Assassins as well, a suggestion Edward eventually accepted. Adéwalé served the Brotherhood in the West Indies by fending off Templar attacks, rescuing Edward from his imprisonment in Port Royal, and supporting the Assassins' effort to prevent the Templars from seizing control of the Observatory.

Adéwalé supported the Assassins' French allies at the beginning of the Seven Years' War by striking against the British Royal Navy at Louisbourg, earning him the attention of the Templars. When Shay Cormac and Haytham Kenway chased the Experto Crede, Adéwalé was forced to beach the ship to save his crew. He then faced Haytham and Shay Cormac, who cooperated to distract and kill him.

Key Allies: Edward Kenway, Ah Tabai, Achilles Davenport, Bastienne Josèphe, Augustin Dieufort

Main Opponents: Marquis de Fayet

AVELINE DE GRANDPRÉ

"I seek liberty and freedom, not for myself, but to those to whom such fundamental rights are denied. I am their shield, their sword and their only hope."

— Aveline de Grandpré

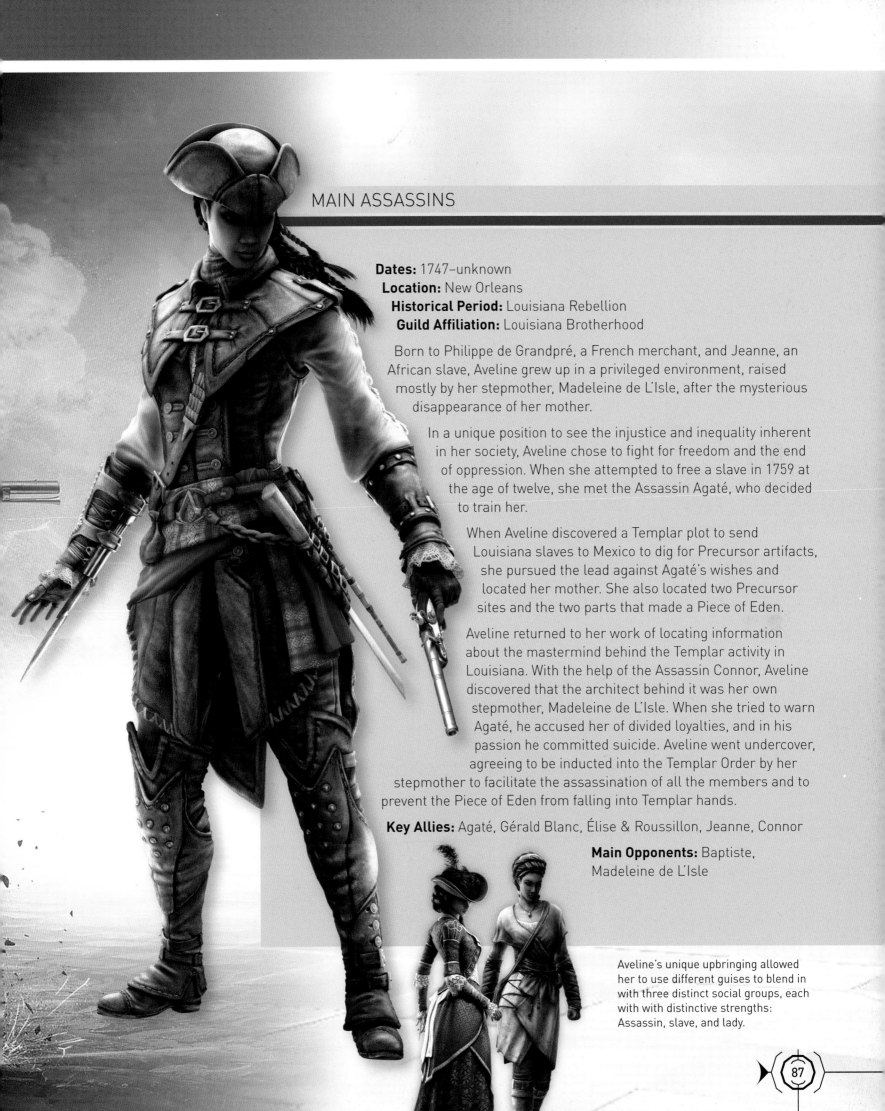

MAIN ASSASSINS

Dates: 1747–unknown
Location: New Orleans
Historical Period: Louisiana Rebellion
Guild Affiliation: Louisiana Brotherhood

Born to Philippe de Grandpré, a French merchant, and Jeanne, an African slave, Aveline grew up in a privileged environment, raised mostly by her stepmother, Madeleine de L'Isle, after the mysterious disappearance of her mother.

In a unique position to see the injustice and inequality inherent in her society, Aveline chose to fight for freedom and the end of oppression. When she attempted to free a slave in 1759 at the age of twelve, she met the Assassin Agaté, who decided to train her.

When Aveline discovered a Templar plot to send Louisiana slaves to Mexico to dig for Precursor artifacts, she pursued the lead against Agaté's wishes and located her mother. She also located two Precursor sites and the two parts that made a Piece of Eden.

Aveline returned to her work of locating information about the mastermind behind the Templar activity in Louisiana. With the help of the Assassin Connor, Aveline discovered that the architect behind it was her own stepmother, Madeleine de L'Isle. When she tried to warn Agaté, he accused her of divided loyalties, and in his passion he committed suicide. Aveline went undercover, agreeing to be inducted into the Templar Order by her stepmother to facilitate the assassination of all the members and to prevent the Piece of Eden from falling into Templar hands.

Key Allies: Agaté, Gérald Blanc, Élise & Roussillon, Jeanne, Connor

Main Opponents: Baptiste, Madeleine de L'Isle

Aveline's unique upbringing allowed her to use different guises to blend in with three distinct social groups, each with with distinctive strengths: Assassin, slave, and lady.

RATONHNHAKÉ:TON (CONNOR)

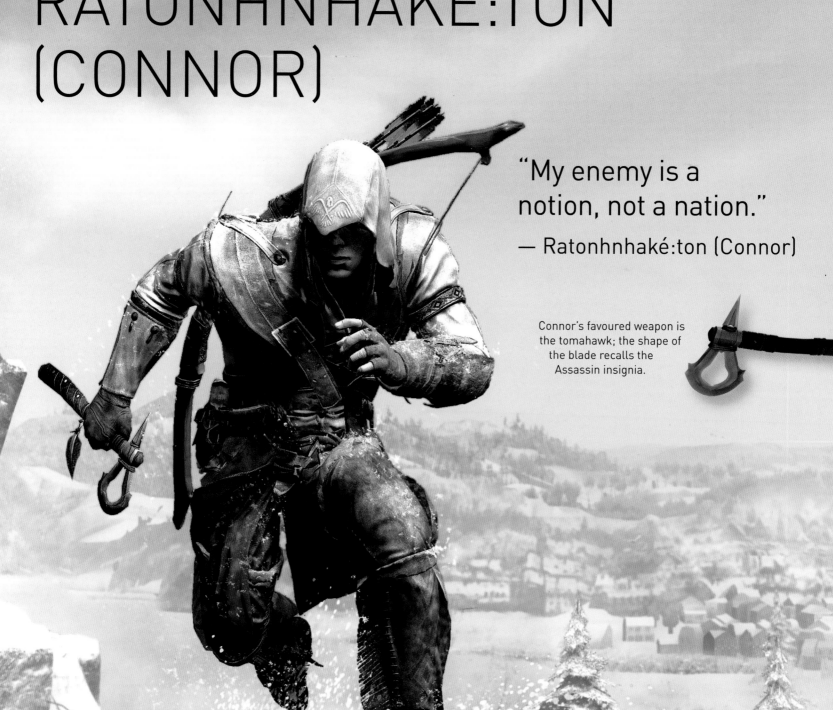

"My enemy is a notion, not a nation."
— Ratonhnhaké:ton (Connor)

Connor's favoured weapon is the tomahawk; the shape of the blade recalls the Assassin insignia.

Dates: 1756–unknown
Location: Mohawk Valley, North America
Historical Period: Colonial America, American Revolution
Guild Affiliation: Colonial Brotherhood

Son of Haytham Kenway, a British Templar, and Kaniehtí:io, Ratonhnhaké:ton believed the Templars to be behind the destruction of his village and the death of his mother during the Seven Years' War.

As a teenager Ratonhnhaké:ton encountered a Piece of Eden, a Crystal Ball that triggered a vision in which he soared like an eagle and was instructed to seek a special symbol. The vision convinced him that his village was a sacred place that must be kept safe at all costs, and Ratonhnhaké:ton devoted himself to stopping the Templar drive to dominate North America.

Searching for the symbol, Ratonhnhaké:ton tracked down a former Assassin leader, Achilles, and insisted Achilles train him so that he could oppose the Templars and fight to keep America free from their control. In 1770, Ratonhnhaké:ton completed his training and was made a full Assassin, taking a new name: Connor.

Connor worked hard to rid the new nation of Templars, supporting the Patriots in their revolutionary efforts to overthrow British rule. His relationship with George Washington was troubled; he worked with Washington until he became disillusioned by the general's treatment of Native peoples. He offered an alliance to his father Haytham Kenway, the Grand Master of the Colonial Rite, hoping that their differences could be put aside in favor of working together for the benefit of everyone in the new nation. In the end, however, fundamental differences forced Connor to assassinate his own father.

Connor's work ensured that the Revolution guaranteed political rights for men and women free from immediate Templar control, but ultimately felt his struggle to be a failure, for the same rights were not secured for minorities and indigenous peoples. His faithful adherence to the Creed meant that the majority of people were saved, at the expense of a few.

Despite Abstergo's attempts to portray Connor as a failure, he went on to enjoy a happy marriage, and fathered three children. Despite his tribe's disapproving views regarding the training of women in certain areas, Connor chose to teach his youngest daughter, Io:nhiòte, to track and hunt, for he recognized in her the same gift of keen sensory perception that he himself possessed.

Key Allies: George Washington, Benjamin Franklin, Achilles Davenport, Samuel Adams, Marquis de Lafayette

Main Opponents: Haytham Kenway, Charles Lee

ARNO DORIAN

"All that we do, all that we are,
begins and ends with ourselves."
— Arno Dorian

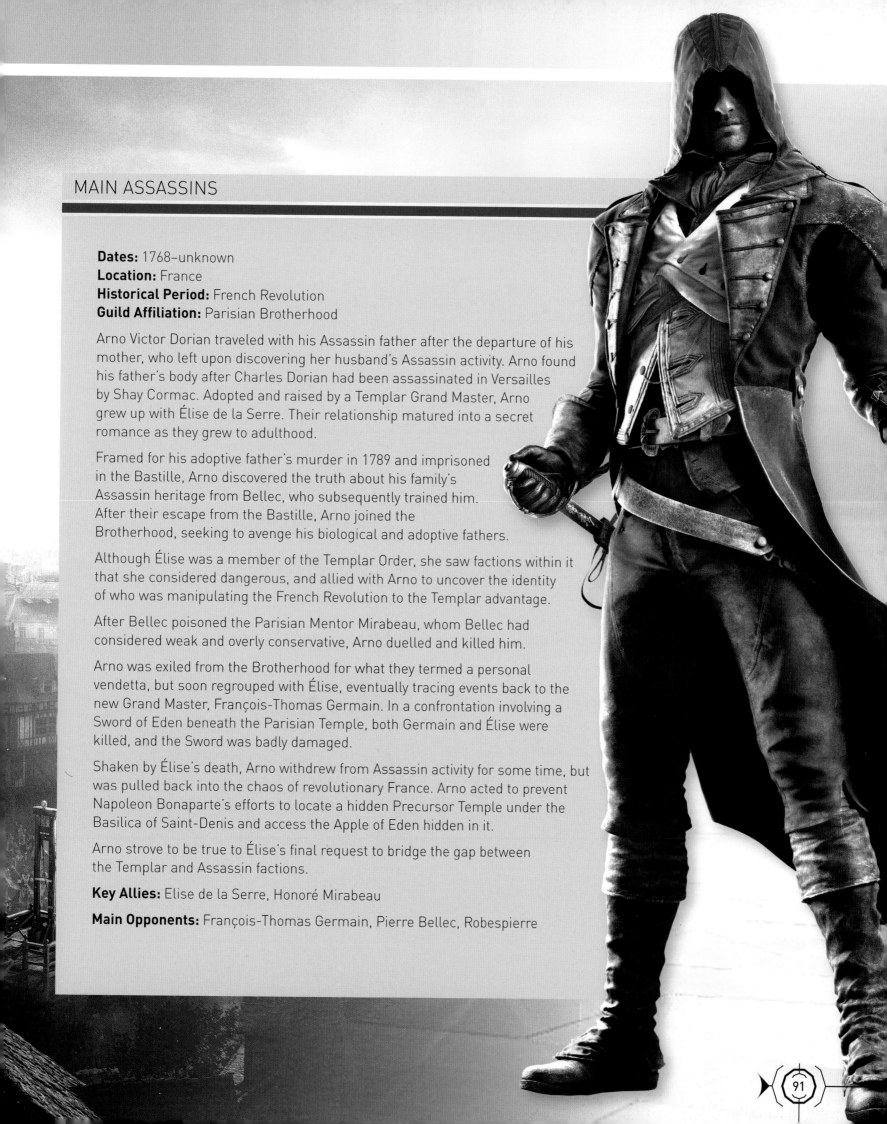

MAIN ASSASSINS

Dates: 1768–unknown
Location: France
Historical Period: French Revolution
Guild Affiliation: Parisian Brotherhood

Arno Victor Dorian traveled with his Assassin father after the departure of his mother, who left upon discovering her husband's Assassin activity. Arno found his father's body after Charles Dorian had been assassinated in Versailles by Shay Cormac. Adopted and raised by a Templar Grand Master, Arno grew up with Élise de la Serre. Their relationship matured into a secret romance as they grew to adulthood.

Framed for his adoptive father's murder in 1789 and imprisoned in the Bastille, Arno discovered the truth about his family's Assassin heritage from Bellec, who subsequently trained him. After their escape from the Bastille, Arno joined the Brotherhood, seeking to avenge his biological and adoptive fathers.

Although Élise was a member of the Templar Order, she saw factions within it that she considered dangerous, and allied with Arno to uncover the identity of who was manipulating the French Revolution to the Templar advantage.

After Bellec poisoned the Parisian Mentor Mirabeau, whom Bellec had considered weak and overly conservative, Arno duelled and killed him.

Arno was exiled from the Brotherhood for what they termed a personal vendetta, but soon regrouped with Élise, eventually tracing events back to the new Grand Master, François-Thomas Germain. In a confrontation involving a Sword of Eden beneath the Parisian Temple, both Germain and Élise were killed, and the Sword was badly damaged.

Shaken by Élise's death, Arno withdrew from Assassin activity for some time, but was pulled back into the chaos of revolutionary France. Arno acted to prevent Napoleon Bonaparte's efforts to locate a hidden Precursor Temple under the Basilica of Saint-Denis and access the Apple of Eden hidden in it.

Arno strove to be true to Élise's final request to bridge the gap between the Templar and Assassin factions.

Key Allies: Elise de la Serre, Honoré Mirabeau

Main Opponents: François-Thomas Germain, Pierre Bellec, Robespierre

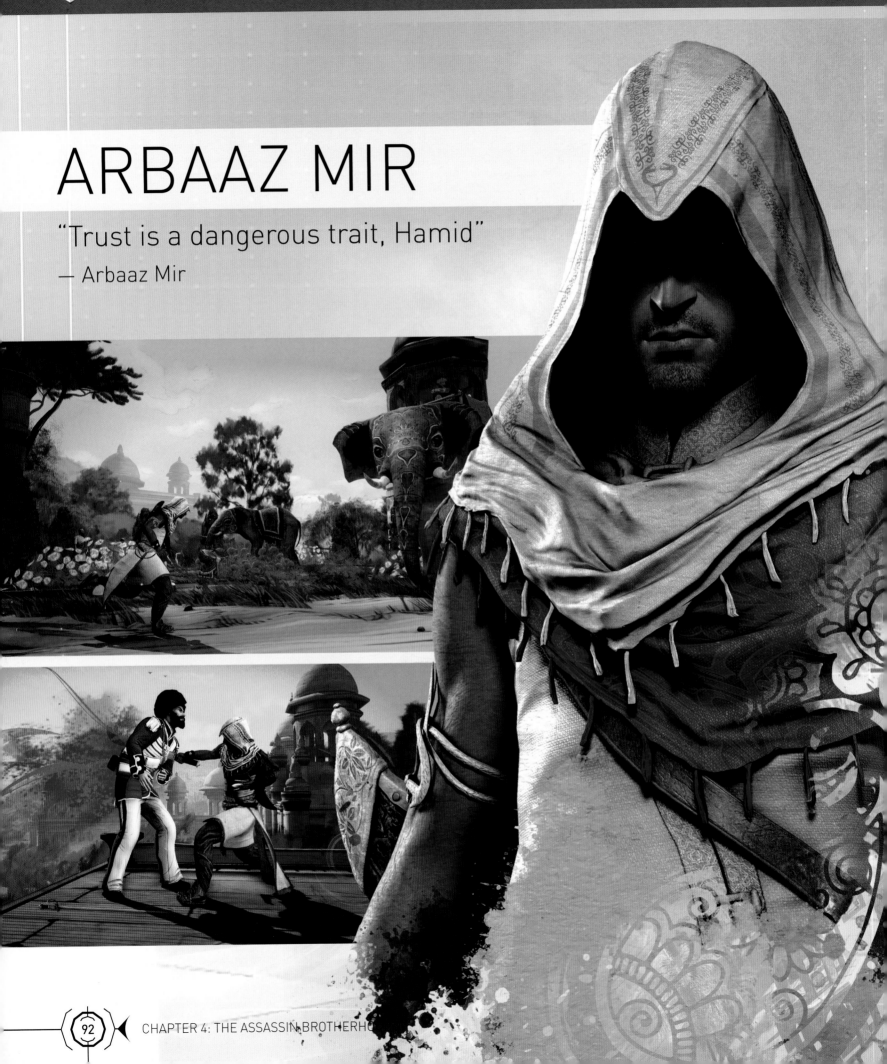

ARBAAZ MIR

"Trust is a dangerous trait, Hamid"

— Arbaaz Mir

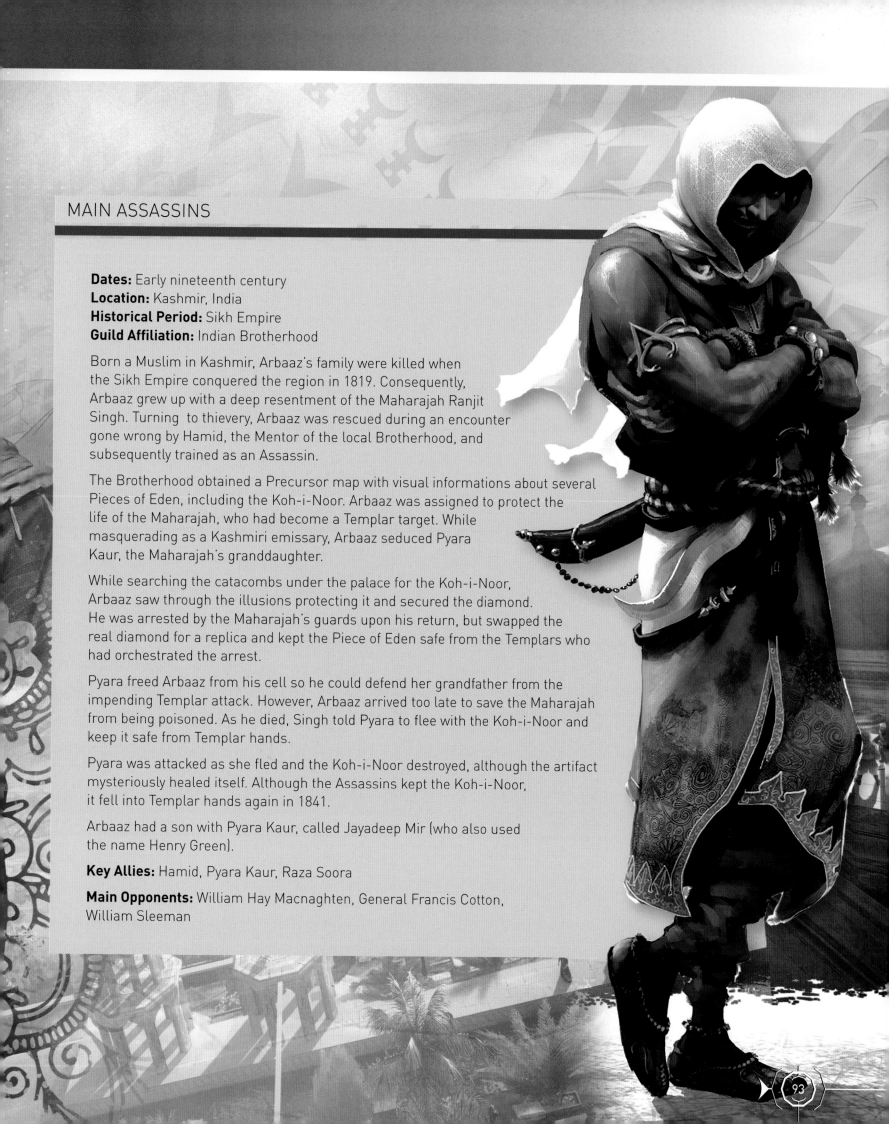

MAIN ASSASSINS

Dates: Early nineteenth century
Location: Kashmir, India
Historical Period: Sikh Empire
Guild Affiliation: Indian Brotherhood

Born a Muslim in Kashmir, Arbaaz's family were killed when the Sikh Empire conquered the region in 1819. Consequently, Arbaaz grew up with a deep resentment of the Maharajah Ranjit Singh. Turning to thievery, Arbaaz was rescued during an encounter gone wrong by Hamid, the Mentor of the local Brotherhood, and subsequently trained as an Assassin.

The Brotherhood obtained a Precursor map with visual informations about several Pieces of Eden, including the Koh-i-Noor. Arbaaz was assigned to protect the life of the Maharajah, who had become a Templar target. While masquerading as a Kashmiri emissary, Arbaaz seduced Pyara Kaur, the Maharajah's granddaughter.

While searching the catacombs under the palace for the Koh-i-Noor, Arbaaz saw through the illusions protecting it and secured the diamond. He was arrested by the Maharajah's guards upon his return, but swapped the real diamond for a replica and kept the Piece of Eden safe from the Templars who had orchestrated the arrest.

Pyara freed Arbaaz from his cell so he could defend her grandfather from the impending Templar attack. However, Arbaaz arrived too late to save the Maharajah from being poisoned. As he died, Singh told Pyara to flee with the Koh-i-Noor and keep it safe from Templar hands.

Pyara was attacked as she fled and the Koh-i-Noor destroyed, although the artifact mysteriously healed itself. Although the Assassins kept the Koh-i-Noor, it fell into Templar hands again in 1841.

Arbaaz had a son with Pyara Kaur, called Jayadeep Mir (who also used the name Henry Green).

Key Allies: Hamid, Pyara Kaur, Raza Soora

Main Opponents: William Hay Macnaghten, General Francis Cotton, William Sleeman

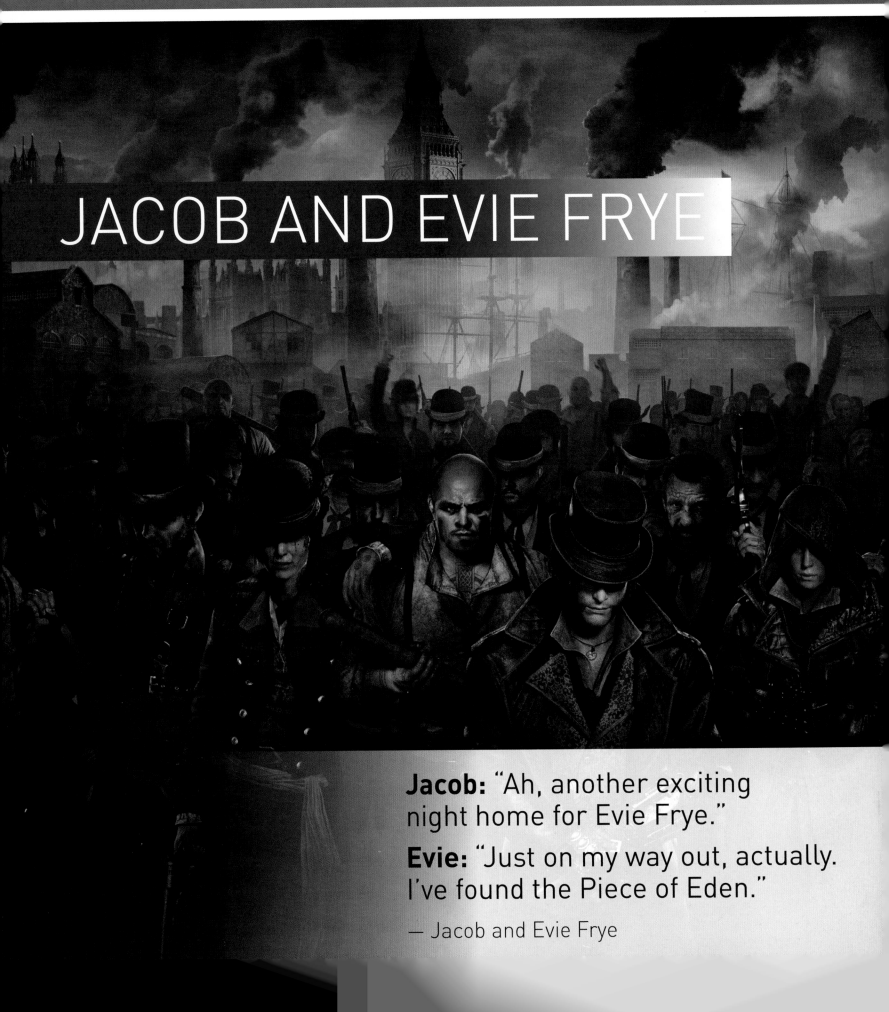

JACOB AND EVIE FRYE

Jacob: "Ah, another exciting night home for Evie Frye."

Evie: "Just on my way out, actually. I've found the Piece of Eden."

— Jacob and Evie Frye

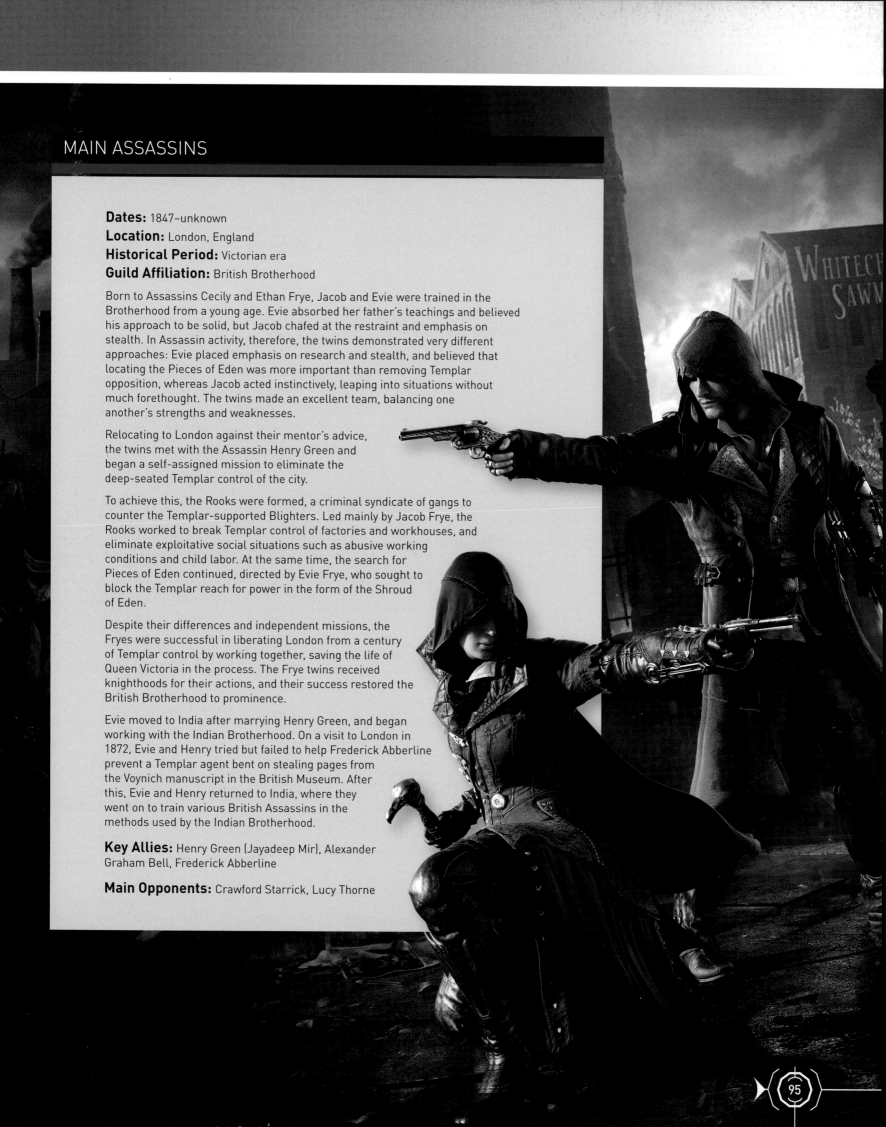

Dates: 1847–unknown

Location: London, England

Historical Period: Victorian era

Guild Affiliation: British Brotherhood

Born to Assassins Cecily and Ethan Frye, Jacob and Evie were trained in the Brotherhood from a young age. Evie absorbed her father's teachings and believed his approach to be solid, but Jacob chafed at the restraint and emphasis on stealth. In Assassin activity, therefore, the twins demonstrated very different approaches: Evie placed emphasis on research and stealth, and believed that locating the Pieces of Eden was more important than removing Templar opposition, whereas Jacob acted instinctively, leaping into situations without much forethought. The twins made an excellent team, balancing one another's strengths and weaknesses.

Relocating to London against their mentor's advice, the twins met with the Assassin Henry Green and began a self-assigned mission to eliminate the deep-seated Templar control of the city.

To achieve this, the Rooks were formed, a criminal syndicate of gangs to counter the Templar-supported Blighters. Led mainly by Jacob Frye, the Rooks worked to break Templar control of factories and workhouses, and eliminate exploitative social situations such as abusive working conditions and child labor. At the same time, the search for Pieces of Eden continued, directed by Evie Frye, who sought to block the Templar reach for power in the form of the Shroud of Eden.

Despite their differences and independent missions, the Fryes were successful in liberating London from a century of Templar control by working together, saving the life of Queen Victoria in the process. The Frye twins received knighthoods for their actions, and their success restored the British Brotherhood to prominence.

Evie moved to India after marrying Henry Green, and began working with the Indian Brotherhood. On a visit to London in 1872, Evie and Henry tried but failed to help Frederick Abberline prevent a Templar agent bent on stealing pages from the Voynich manuscript in the British Museum. After this, Evie and Henry returned to India, where they went on to train various British Assassins in the methods used by the Indian Brotherhood.

Key Allies: Henry Green (Jayadeep Mir), Alexander Graham Bell, Frederick Abberline

Main Opponents: Crawford Starrick, Lucy Thorne

NIKOLAÏ ORELOV

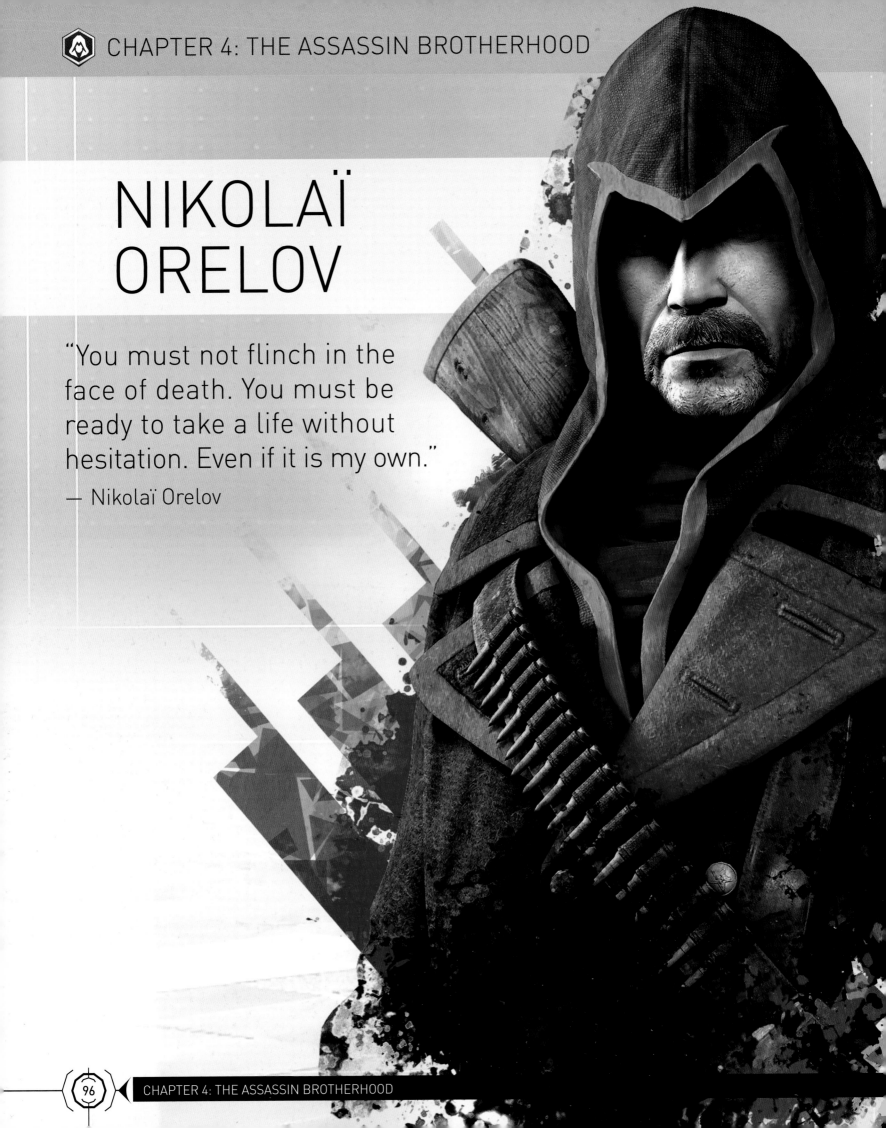

"You must not flinch in the face of death. You must be ready to take a life without hesitation. Even if it is my own."

— Nikolaï Orelov

Dates: Early twentieth century
Location: Russia
Historical Period: Imperial Russia, Russian Revolution
Guild Affiliation: Russian Brotherhood

OVERVIEW: Son of an Assassin who was a member of a left-wing terrorist offshoot of the Brotherhood, Nikolaï had a rough history as an Assassin. He failed in an attempt to assassinate Tsar Alexander III, who possessed a Staff of Eden.

In 1908, Nikolaï was dispatched to Siberia to obtain the Staff of Eden from Templar possession, where it was being tested with electric technology stolen from Nikola Tesla in an attempt to unlock its secrets. During Nikolaï's attack on the Tunguska facility, Nikola Tesla launched a teleforce attack from America, destroying the facility and the Staff of Eden. Nikolaï was the only survivor.

During the Russian Revolution, Nikolaï located a surviving fragment of the Staff of Eden in the grave of Rasputin, who had used the Shard of Eden to manipulate the individuals around him. Rasputin's body was exhumed and the fragment recovered in 1917.

In 1918 the Brotherhood sent Nikolaï on a mission to steal the Precursor box Ezio had given to Shao Jun. The box was in the possession of the Tsar's family; Nikolaï arrived just as they were executed by the Bolsheviks. Princess Anastasia was holding the Precursor box, and as Nikolaï touched it, it interacted with the Shard of Eden he wore around his neck. The box unlocked memories of Shao Jun, imprinting them upon Anastasia. Nikolaï escaped with Anastasia, who was overwhelmed by the Chinese Assassin's memories and physical training.

The Russian Brotherhood considered Anastasia to be a living Piece of Eden and planned to extract the memories from her, a process that would undoubtedly destroy her. Nikolaï chose to betray the Brotherhood and free Anastasia, helping her to escape Russia.

Nikolaï took his family across the Russian border and escaped to the United States, where in 1919 his wife and daughter were seized in the Palmer Raids and deported. Although he tried to live in isolation in the woods with his son, searching for the rest of his family, the Brotherhood tracked him down and demanded that he return.

Key Allies: Anastasia/Anna Anderson, Innokenti Orelov

Main Opponents: Tsar Alexander III

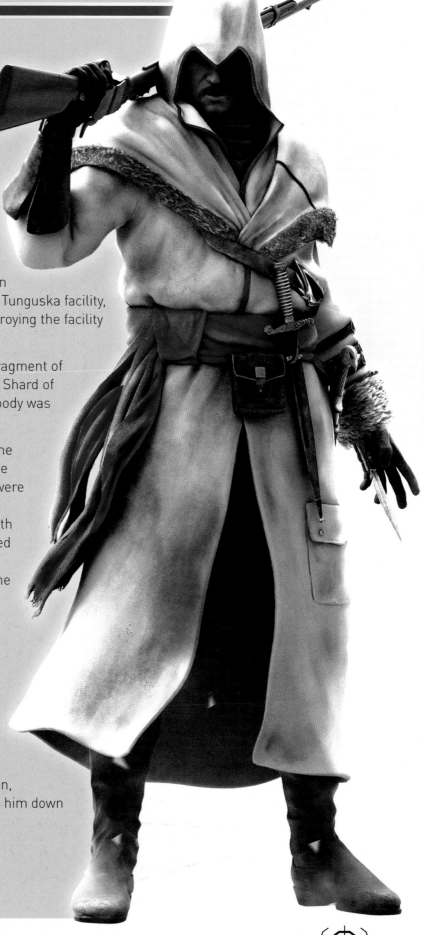

ASSASSINS AND ALLIES

MALIK AL-SAYF: (1165–1228)
A wise man who honoured the Three Tenets of the Creed, Malik was initially critical of Altaïr's actions, while Altaïr felt him to be too rigid. Eventually the two found common ground and Malik became Altaïr's second in command, helping him reform the Brotherhood, as well as one of Altaïr's closest friends. Framed by Abbas for the murder of Altaïr's youngest son, Malik was rescued from prison by Altaïr, but was assassinated by Abbas Sofian's spy.

BARTOLOMEO D'ALVIANO:
(1455–1515) A Venetian Assassin and a mercenary leader, Bartolomeo allied with Ezio on several occasions to free various districts from oppression and tyranny, and was present at Ezio's induction into the Brotherhood. Bartolomeo was an aggressive man known for his blunt approach and his disdain of nuanced strategy. He was also proud, reluctant to admit that he needed help, and placed great emphasis on honor.

MARIA THORPE: (1161–1228) Rebellious and strong-willed, Maria disguised herself as a man to join the Third Crusade. She distinguished herself and caught the attention of Templar Grand Master Robert de Sablé, who made her his personal steward. Altaïr met Maria when she acted as Robert's decoy in Jerusalem. After Robert's death at Altaïr's hand, Maria's position within the Templars destabilized; she established an uneasy alliance with Altaïr in order to revenge herself upon the Templars. Ultimately she chose to leave the Templar Order. Maria and Altaïr grew romantically involved; they married, and he admitted her into the Brotherhood, a move that shocked more conservative Assassins. Maria died in a confrontation between Altaïr and Abbas Sofian, who had usurped the leadership of the Levantine Brotherhood.

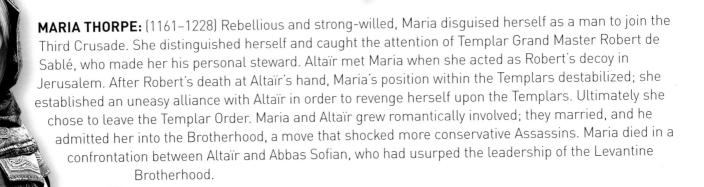

NICCOLÒ MACHIAVELLI: (1469–1527) A humanist, philosopher, and diplomat, Machiavelli was a member of the Italian Brotherhood who worked as a civil servant in the Florentine Republic. He led the Italian Brotherhood after the death of Mario Auditore, and fought against the Borgia family with Ezio.

DARIM AND SEF IBN-LA'AHAD:
(1195–unknown; 1197–1226) Altaïr and Maria's sons Darim and Sef were members of the Levantine Brotherhood. Darim traveled with his parents to Mongolia, where he assassinated Genghis Khan. Sef remained at Masyaf, where he was murdered as part of Abbas Sofian's coup d'état against the Brotherhood.

MARIO AUDITORE: (1434–1500) Leader of the Italian Brotherhood and a mercenary, Mario Auditore ruled the town of Monteriggioni. After his brother Giovanni's death in 1476 he took Ezio and his family under his wing, training Ezio in the ways of the Brotherhood. A boisterous man with a fondness for drinking and fighting, Mario cared deeply for his family, treating his nephew Ezio as a son, and was proud of his Assassin heritage. He died defending Monteriggioni during a Borgia attack.

CLAUDIA AUDITORE: (1461–unknown) Ezio's only sister, Claudia Auditore served as the bookkeeper for Monteriggioni until the Borgias attacked the town and killed her uncle Mario. She escaped to Rome to help Ezio fight the Borgias there, and became the Madame of a brothel called the *Rosa in Fiore*, using the network of courtesans to gather intelligence for the Brotherhood. She was inducted into the Brotherhood by Ezio in 1503, and given temporary command of the Italian Assassins when Ezio traveled to the Turkish Brotherhood in search of Altaïr's legendary library.

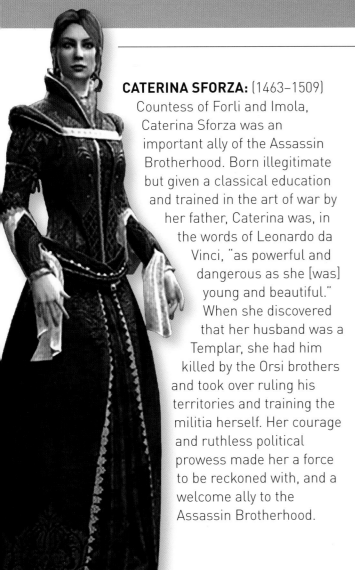

CATERINA SFORZA: (1463–1509) Countess of Forlì and Imola, Caterina Sforza was an important ally of the Assassin Brotherhood. Born illegitimate but given a classical education and trained in the art of war by her father, Caterina was, in the words of Leonardo da Vinci, "as powerful and dangerous as she [was] young and beautiful." When she discovered that her husband was a Templar, she had him killed by the Orsi brothers and took over ruling his territories and training the militia herself. Her courage and ruthless political prowess made her a force to be reckoned with, and a welcome ally to the Assassin Brotherhood.

LEONARDO DA VINCI: (1452–1519) A true Renaissance man, Leonardo was a sculptor, painter, engineer, architect, and mathematician. Although not an initiated member of either faction, Leonardo played a key role in the struggle between the Assassins and Templars. Curious, optimistic, and enthusiastic, his genius was an asset to the Brotherhood, helping them design and improve weapons and gear both with and without the information he gleaned from studying an Apple of Eden.

ASSASSINS AND ALLIES

PIRI REIS: (c. 1467–1553) A member of the Ottoman Brotherhood, Piri Reis was a sea captain and cartographer of reknown. A pirate with his uncle in his youth, Piri joined Sultan Bayezid's navy in the 1490s. After a distinguished career, he retired to Constantinople to concentrate on cartography. His Assassin specialty was bomb crafting, and he served as Ezio's main teacher of the craft.

LA VOLPE (GILBERTO): Leader of the Florentine thieves and a member of the Italian Brotherhood, La Volpe was the epitome of an Assassin, believed to be a mythical person with supernatural abilities who had accomplished impossible tasks. He was in charge of a sophisticated intelligence network, which, among other things, uncovered a plot to murder the Medici family to strengthen Templar control over Venice. A man of subtlety, he instructed and guided Ezio as part of his training. After the fall of Monteriggioni in 1500, La Volpe relocated to Rome and set up a new intelligence network in order to oppose the Borgias there, helping to restore the fragmented Italian Brotherhood.

YUSUF TAZIM: (c. 1467–1512) Leader of the Constantinople Assassins, Yusuf was a confident, charismatic man who lived life to the fullest. He devoted himself to keeping the Ottoman Brotherhood together, but his lack of experience with the Templars set them in a precarious position. He welcomed Ezio to his city with open arms, and with Ezio's help he forged an alliance with the Ottoman prince Suleiman and fought the Byzantine Templar threat to the Ottoman Empire.

SOFIA SARTOR: (1476–unknown) Proprietor of a bookshop in Constantinople, Sofia met Ezio when he determined the bookshop was built on the site of the trading post established by Marco and Niccolò Polo, founders of the Ottoman Brotherhood. Sofia helped Ezio locate the Masyaf keys out of intellectual curiosity, and used her knowledge of old manuscripts and cryptography to help him decipher clues, ultimately assisting him right to the door to Altaïr's secret library itself. When Ezio returned to Italy, Sofia went with him, and they married soon after.

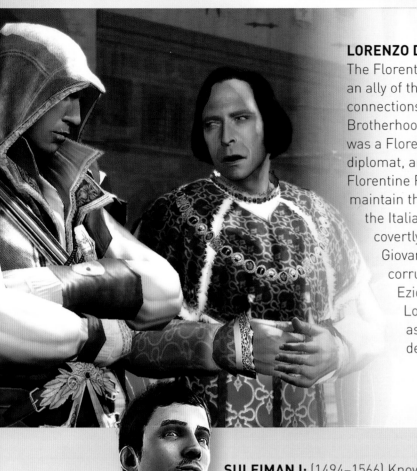

LORENZO DE' MEDICI: (1449–1492) The Florentine House of Medici was an ally of the Auditore family, with connections to the Assassin Brotherhood. Lorenzo de' Medici was a Florentine politican, diplomat, and de facto ruler of the Florentine Republic who worked to maintain the fragile peace between the Italian states. He worked covertly with the Assassin Giovanni Auditore against the corrupt Borgia family, and Ezio functioned as Lorenzo's personal assassin until Lorenzo's death on 1492.

GIOVANNI BORGIA: (1498–1548) Healed by the Shroud of Eden as an infant, Giovanni was forever changed by the Piece of Eden, dreaming about Assassins from the past and communicating with Consus, as well as having the Eagle Vision ability. Giovanni did much valuable research on Pieces of Eden and Precursor information.

SULEIMAN I: (1494–1566) Known as Suleiman the Magnificent, this sultan presided over what is considered the Golden Age of Constantinople. Drawn into the Templar-Assassin struggle in 1511 by a botched Templar assassination attempt, Suleiman asked Ezio and the Ottoman Brotherhood to look into the increasingly worrisome Templar activity. Made the crown prince in 1512, he became sultan in 1520. Suleiman's bureaucratic reforms improved the legal, bureaucratic, and judicial systems, and under his rule the Ottoman Empire expanded to the largest it would ever be. A kind and thoughtful man, he ensured that diverse cultures and religions would be honored within his empire.

ZHU JIUYUAN: (1473–1524) Chosen to succeed Wang Yangming as Mentor of the Chinese Brotherhood, Jiuyan trained Shao Jun after Wang's disappearance and tried to re-establish the Chinese Brotherhood's opposition of the Templar group the Eight Tigers. When the new Emperor Jiajing began a purge of the Chinese Assassins, Jiuyuan fled with Jun to Europe to ask Ezio for help. Jiuyuan was killed by Templar agents in Venice before they found Ezio, and Jun carried on alone.

ASSASSINS AND ALLIES

WANG YANGMING: (1472–1529)
Mentor of the Chinese Brotherhood, Wang was an Imperial general and the governor of Jiangxi province during the Ming dynasty. He recruited Shao Jun into the Brotherhood when she discovered his secret identity and alerted him to a Templar plot to destroy the Brotherhood. The surviving Assassins withdrew from the Forbidden City after a defeat and reassembled in Beijing, where Wang trained Jun. Wang was forced to disappear when his life was threatened by a political crisis surrounding the emperor. Upon Shao Jun's return from Italy, he helped her rebuild the Chinese Brotherhood before his death at the hands of the Eight Tigers.

THOMAS STODDARD:
A seventeenth-century Master Assassin, Thomas Stoddard was known as ruthless, talented tracker of Pieces of Eden. In 1692 his hunt led him to Salem in the time of the witch trials, where with fellow Assassin Jennifer Querry he determined that the girl Dorothy Osborne, who demonstrated signs of possession by Consus, was the Piece of Eden he sought.

JENNIFER QUERRY: A nurse and newly made Assassin, Jennifer Querry's first assignment was to aid Thomas Stoddard in locating a Piece of Eden in 1692 Salem during the time of the witch hunts. Her idealism clashed with Stoddard's more ruthless nature. Jennifer died after inadvertently leading the Templars to Stoddard and Dorothy.

BLACKBEARD (EDWARD THATCH): (c. 1680–1718) A privateer who turned to piracy after the War of the Spanish Succession ended, Blackbeard was one of the founders of the Pirate Republic in Nassau, along with Benjamin Hornigold, James Kidd, and Edward Kenway. Dressing all in black and featuring a huge black beard, captaining his ship the Queen Anne's Revenge, he used his imposing reputation and fear to intimidate his targets into surrender. One of Edward Kenway's closest allies, Blackbeard's reputation worked so successfully to his benefit that he never had to kill any of his captives. Blackbeard died during a naval battle in Ocracroke Bay, overcome by British attackers.

BARTHOLOMEW ROBERTS: (1682–1722)
Considered by many to be the most successful pirate of all time, Bartholomew Roberts was a Sage, an incarnation of the Precursor Aita. Pursued by both the Assassin Brotherhood and the Templar Order, Roberts used Edward Kenway to gain access to the Observatory and then turned on him. Edward killed Roberts two years later, and followed the pirate's final wish to have his body destroyed to prevent the Templars from gaining anything from it.

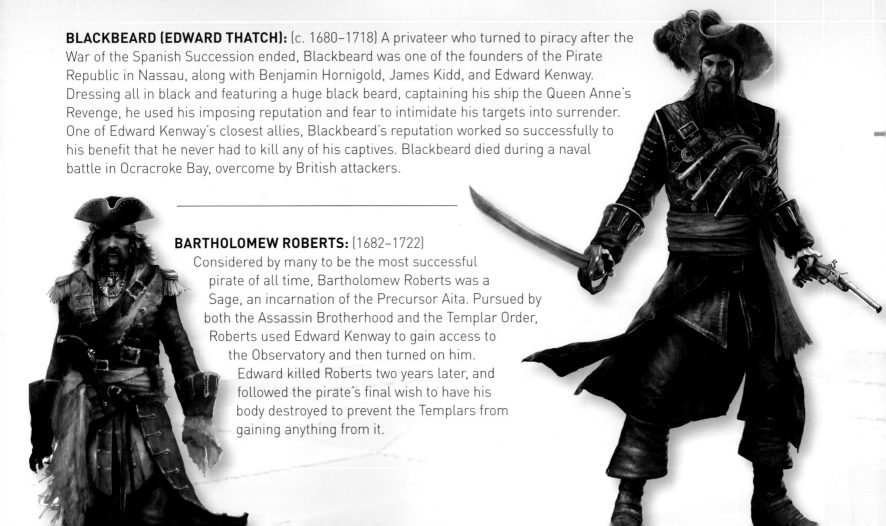

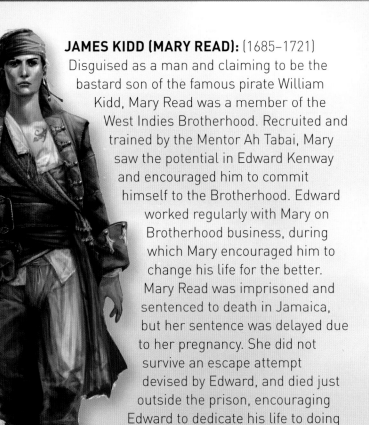

JAMES KIDD (MARY READ): (1685–1721)

Disguised as a man and claiming to be the bastard son of the famous pirate William Kidd, Mary Read was a member of the West Indies Brotherhood. Recruited and trained by the Mentor Ah Tabai, Mary saw the potential in Edward Kenway and encouraged him to commit himself to the Brotherhood. Edward worked regularly with Mary on Brotherhood business, during which Mary encouraged him to change his life for the better. Mary Read was imprisoned and sentenced to death in Jamaica, but her sentence was delayed due to her pregnancy. She did not survive an escape attempt devised by Edward, and died just outside the prison, encouraging Edward to dedicate his life to doing good. Edward honored her final wish, and to joined the Brotherhood.

DUNCAN WALPOLE: (1679–1715)

A British Assassin affiliated with the Caribbean Brotherhood and serving as the Mentor Ah Tabai's right-hand man, Duncan was in the process of betraying the Brotherhood, carrying sensitive Assassin information to the Templars of the Caribbean Rite, when his ship was attacked by pirates. Shipwrecked with Edward Kenway, one of the pirate crew, he was killed by Edward when the two fought. Edward discovered the secret struggle between the Brotherhood and the Templar Order by going through Duncan's possessions and reading the papers he carried. Motivated by greed and personal gain, Edward assumed Duncan's identity and carried through with the intended meeting with the Templars, who had promised Duncan a handsome reward.

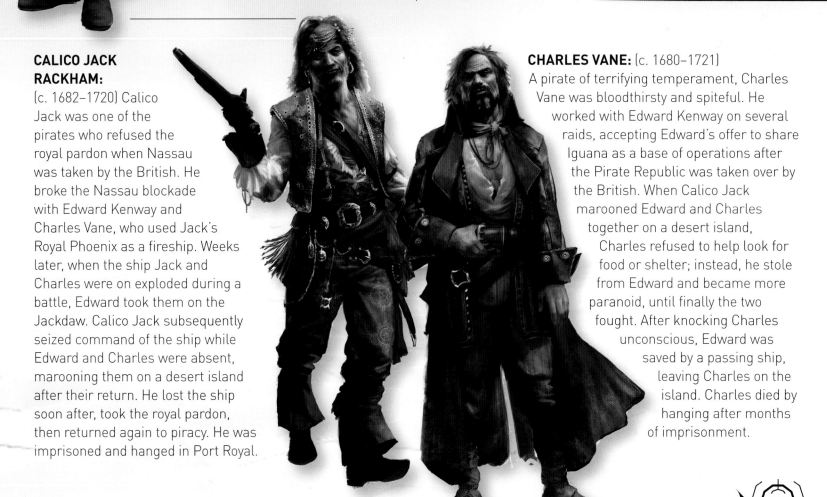

CALICO JACK RACKHAM:

(c. 1682–1720) Calico Jack was one of the pirates who refused the royal pardon when Nassau was taken by the British. He broke the Nassau blockade with Edward Kenway and Charles Vane, who used Jack's Royal Phoenix as a fireship. Weeks later, when the ship Jack and Charles were on exploded during a battle, Edward took them on the Jackdaw. Calico Jack subsequently seized command of the ship while Edward and Charles were absent, marooning them on a desert island after their return. He lost the ship soon after, took the royal pardon, then returned again to piracy. He was imprisoned and hanged in Port Royal.

CHARLES VANE: (c. 1680–1721)

A pirate of terrifying temperament, Charles Vane was bloodthirsty and spiteful. He worked with Edward Kenway on several raids, accepting Edward's offer to share Iguana as a base of operations after the Pirate Republic was taken over by the British. When Calico Jack marooned Edward and Charles together on a desert island, Charles refused to help look for food or shelter; instead, he stole from Edward and became more paranoid, until finally the two fought. After knocking Charles unconscious, Edward was saved by a passing ship, leaving Charles on the island. Charles died by hanging after months of imprisonment.

ASSASSINS AND ALLIES

AH TABAI: (c. 1660–c.1745) A Maya Assassin born into the Brotherhood, Ah Tabai trained several notable Assassins, including Adéwalé, Mary Read, and Achilles Davenport. A wise, serious man who honored the traditions of his people, he served as Mentor of the Caribbean Brotherhood, working to open the Brotherhood to men and women of all cultural descents. He believed that the role of the Caribbean Assassins was to protect the Precursor site called The Observatory. Originally distrustful of Edward Kenway, who had completed Duncan Walpole's betrayal of the Brotherhood and whose actions had set the Brotherhood's activity at risk, he slowly grew to trust him over time as Edward demonstrated personal growth and wisdom, and ultimately accepted him into the Brotherhood.

AUGUSTIN DIEUFORT: (c. 1701–unknown) An escaped slave and leader in the Maroon rebellion in the Port-au-Prince area, Augustin Dieufort was a humble man who had witnessed the cruelty of slavery from birth. Cunning, he knew plantation layouts and routines, and used them to his advantage. He convinced Adéwalé to stay when the Assassin planned to leave before the rebellion had finished, and suggested Adéwalé steal the Experto Crede, serving as Adéwalé's quartermaster. Together they attacked several slave ships, liberating hundreds of slaves.

BASTIENNE JOSÈPHE: (c. 1690–unknown) The madam of a Port-au-Prince brothel, Bastienne was an intelligent and educated woman who understood the political power her business could have. Her financial success allowed her to buy the freedom of slaves in Port-au-Prince, while her intelligence-gathering network aided the Maroon rebellion. During this time, Bastienne acted as a courier for the Templar Order, using the money they paid her to free more slaves. Upon meeting Adéwalé, she convinced him to support the Maroon rebellion against the French governor of Port-au-Prince, the Marquis de Fayet. Adéwalé and Bastienne had a son, Babatunde, who would become the father of Eseosa.

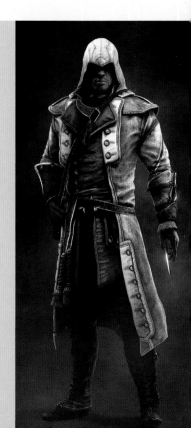

ACHILLES DAVENPORT: (c. 1710–1781) Achilles was born in the West Indies, and was the last Assassin recruited into the Caribbean Brotherhood by legendary Ah Tabai. When his training was complete, Achilles went north to establish a Brotherhood in the American Colonies. Templar activity during the Seven Years' War almost completely wiped out the Colonial Brotherhood; Achilles was the only Assassin to survive, going into retirement until Ratonhnhaké:ton convinced him to train again.

HOPE JENSEN: (1732–1759)
A Colonial Assassin who trained with Achilles Davenport, Hope oversaw much of New York's criminal underworld, which provided her with an excellent intelligence-gathering network. One of Shay Cormac's teachers, she was frustrated by his lack of discipline, and mourned his lost potential. When Shay quit the Brotherhood, citing irresponsible endangerment of lives associated with hunting for Precursor sites and Pieces of Eden, Hope stayed true to the Brotherhood's goal of locating Precursor artifacts in order to prevent them from falling into Templar hands.

AGATÉ: (c. 1722–1777) The founder and Mentor of the Louisiana Brotherhood, Agaté was trained by François Mackandal, Mentor of the Saint-Dominigue Brotherhood and a leader in the Maroon rebellion, who helped him and Baptiste escape from the plantation where they were enslaved, leaving his love Jeanne behind. Years later he began to train Jeanne's daughter Aveline as an Assassin. Agaté was secretive and controlling, and Aveline often clashed with him, disobeying his orders. Agaté began to suspect her of disloyalty; ashamed of his paranoia, Agaté chose to commit suicide after Aveline confronted him.

LIAM O'BRIEN: (1726–1760) Achilles Davenport's first student in the Colonial Brotherhood, Liam brought his childhood friend Shay Cormac into the Brotherhood as well as recruiting other students. Patient, thoughtful, and calm, Liam followed the Creed unwaveringly and respected his fellow Assassins. He was highly skilled and experienced, and remained a close friend of Shay until the latter turned his back on the Assassins over the use of Precursor artifacts.

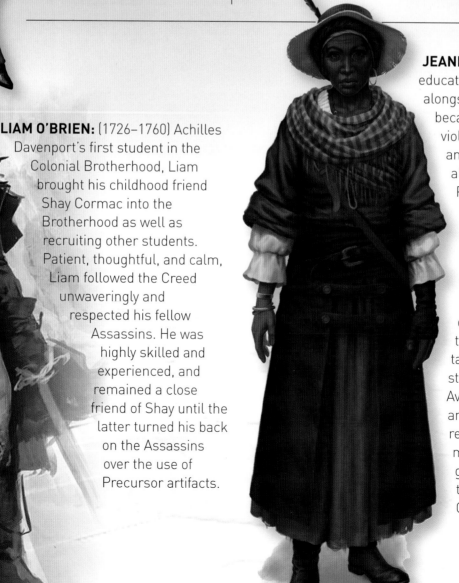

JEANNE: (c. 1722–1777) A slave educated by François Mackandal alongside Agaté and Baptiste, Jeanne became uncomfortable with the violent direction their training took and refused to join the Brotherhood, although she stole a fragment of a Precursor artifact from Mackandal before they left. Five years later she was purchased by the merchant Philippe Olivier de Grandpré and taken to New Orleans, where she became his placée bride and gave birth to a daughter, Aveline. Jeanne feared the Assassins would find her to take back the artifact she had stolen; she gave the artifact to Aveline disguised as a necklace, and accepted Madeleine's offer to relocate to Mexico. When Aveline met her there, Jeanne eventually gave her guidance regarding how to find the Precursor sites of Chichen Itza.

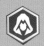

ASSASSINS AND ALLIES

BENJAMIN FRANKLIN:
(1706–1790) Political writer, scientist, author, inventor, diplomat, and Assassin ally, Benjamin Franklin helped the Colonies fight for their rights as citizens under British rule, proposed a unified government to better defend the colonies during the Seven Years' War, and contributed to the writing of the Declaration of Independence. He assisted the Brotherhood in their struggle against the Templars by experimenting on Pieces of Eden and designing new technology.

GILBERT DU MOTIER, MARQUIS DE LAFAYETTE: (1757–1834)
A sophisticated, cultured French aristocrat who traveled to America when the Colonies requested French aid in the Seven Years' War, Lafayette was dedicated to bringing about reform both in the Colonies and in France. He worked as George Washington's second in command for much of the War of Independence. An excellent leader and ally to the Brotherhood, Lafayette and Connor handled the Patriot retreat at the Battle of Monmouth together, saving many lives, and the two often offered aid to one another throughout the rest of the war.

SAMUEL ADAMS: (1722–1803)
A political philosopher and statesman, Samuel Adams was an ally of Colonial Brotherhood Mentor Achilles Davenport. He defended Connor after the latter was framed for the Boston Massacre, and was one of the key members of the Sons of Liberty. A shrewd man, he taught Connor the value of compromise.

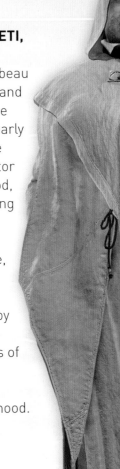

HONORÉ GABRIEL RIQUETI, COMTE DE MIRABEAU:
(1749–1791) Honoré Mirabeau was a French statesman and author, and a leader of the French Revolution in its early days, desiring to keep the revolution peaceful. Mentor of the French Brotherhood, Mirabeau was also working with the Templar Grand Master of the Parisian Rite, Francois de la Serre, to establish peace between the two groups. Mirabeau was poisoned by the Assassin Bellec, who felt that Mirabeau's goals of peaceful alliance were impossible to attain and endangered the Brotherhood.

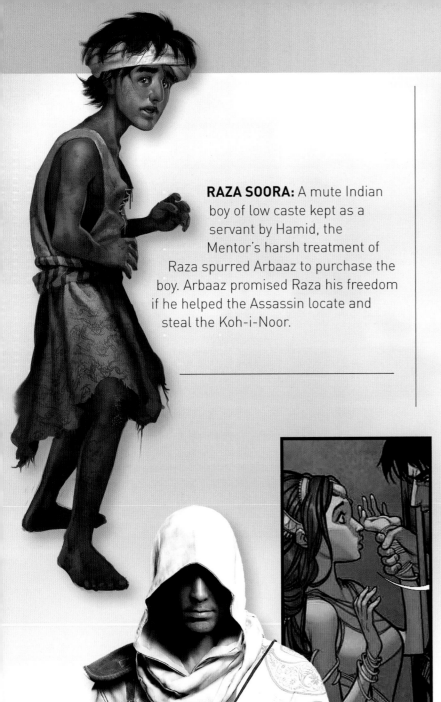

RAZA SOORA: A mute Indian boy of low caste kept as a servant by Hamid, the Mentor's harsh treatment of Raza spurred Arbaaz to purchase the boy. Arbaaz promised Raza his freedom if he helped the Assassin locate and steal the Koh-i-Noor.

HAMID: Mentor of the Indian Brotherhood, Hamid recruited and trained Arbaaz Mir. A strict man, Hamid ordered Jayadeep Mir's execution after a failed assassination, a sentence that was commuted to exile at the request of Ethan Frye. Hamid was a product of his society and era; while the Brotherhood theoretically taught that innocents should be protected, Hamid treated servants and lower-caste individuals harshly.

PYARA KAUR: Granddaughter of Maharaja Ranjit Singh, Pyara met the disguised Assassin Arbaaz Mir at a diplomatic function. Mir seduced her, and was later apprehended with the Koh-i-Noor diamond. Pyara was crushed, but allied with Mir when she learned that a Templar plot to murder her grandfather was in process. While escaping with the Koh-i-Noor, Pyara was possessed by the power of the Piece of Eden and communicated a message of hope from the Precursors. Pyara and Arbaaz had a son, Jayadeep, whom she encouraged after his relocation to England, giving him his first Hidden Blade.

JAYADEEP MIR (HENRY GREEN): (1843–unknown) Son of Arbaaz Mir, a Master Assassin of the Indian Brotherhood, and Pyara Kaur, the princess of the Sikh Empire, Jayadeep was a charismatic child with great potential. Trained by his father's friend Ethan Frye, Jayadeep preferred books to violence, and the Assassins soon realized that Jayadeep lacked a killer's instinct. Banished to London, England, after a humiliating mission failure, Jayadeep worked with the weakening British Brotherhood. Taking the name Henry Green, he developed a network of informants and struggled against the Templar control of the city, finding an ally in Frederick Abberline, a police officer. Sincere and hardworking, he served as the Frye twins' primary contact in the city, assuming they had been sent by another Assassin in response to his requests for aid. With the Fryes, he was inducted into the Order of the Sacred Garter by Queen Victoria for their services to the crown. He eventually married Evie Frye and returned to India with her.

ASSASSINS AND ALLIES

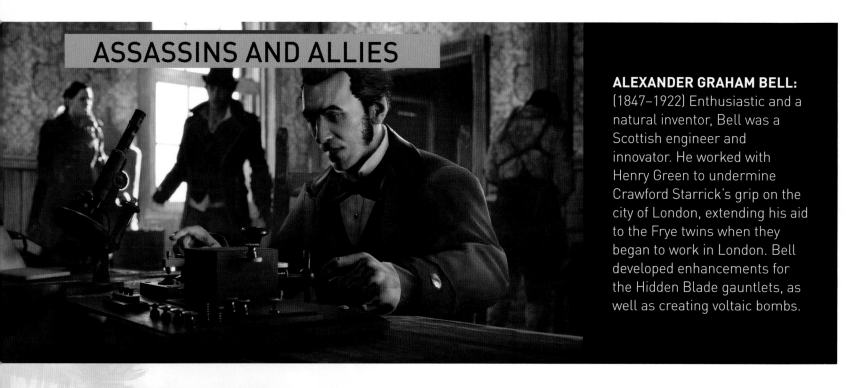

ALEXANDER GRAHAM BELL: (1847–1922) Enthusiastic and a natural inventor, Bell was a Scottish engineer and innovator. He worked with Henry Green to undermine Crawford Starrick's grip on the city of London, extending his aid to the Frye twins when they began to work in London. Bell developed enhancements for the Hidden Blade gauntlets, as well as creating voltaic bombs.

IGNACIO CARDONA: (active circa 1937) A prominent member of the Spanish Brotherhood of Assassins, who was active during the Spanish Civil War. Cardona was one of the few humans able to wield the Precursor artefact the Koh-i-Noor without being killed, as despite his gender (the artefact was created for Isu females), he still had a high enough level of Precursor genes to briefly handle its powers, albeit at a great cost to his health. Following an extraordinary collaboration with Templar and Black Cross Albie Bolden, Cardona and Bolden decided to leave the Koh-i-Noor buried in a mass grave under the ruins of a church.

ETHAN FRYE: (c. 1825–1868) An Assassin of the British Brotherhood, Ethan Frye trained Jayadeep Mir, as well as his own twin children. He was married to fellow Assassin Cecily Frye, who died in childbirth. Ethan had a strong sense of justice, but also enjoyed courting danger. A firm supporter of the Creed, he was also aware that an Assassin's individual strengths and character should shape their path and destiny, instead of a blind adherence to a teacher's direction.

FREDERICK ABBERLINE: (1843–1929) Sergeant Abberline enlisted the help of the Frye twins to help him arrest criminals associated with the Templar-run Blighters gang. With Jacob Frye, he foiled a plot to rob the Bank of England; however, Jacob's assassination of the Templar bank supervisor Philip Twopenny threw London's financial sector into chaos, and the banknote printing plates vanished at the same time. To help calm the turmoil, Abberline asked Evie Frye to help recover the missing plates and destroy any counterfeit notes. By 1888 he had been promoted to the rank of Inspector in Whitechapel, where he worked with the Frye twins to solve the Jack the Ripper case.

INNOKENTI (KENYA) ORELOV: Innokenti was born in the United States after his family emigrated from Russia in 1918. After his mother and sister were deported during the Palmer Raids, Innokenti lived with his father, who trained him to fight. Innokenti shot the Assassin who had found them through his own father, killing both of them.

LYDIA FRYE: (1893–unknown) An Assassin with the British Brotherhood, Lydia Frye was initially reluctant to join the Brotherhood, preferring to focus on her studies. When her education afforded her the insight into the injustices of the world, combined with the loss of family and friends to the Assassin-Templar struggle, she chose to finally join the Brotherhood, training with her great-aunt Evie Frye. Lydia worked in London during the First World War, notably infiltrating and eliminating a German Templar spy facility in Tower Bridge.

ANNA ANDERSON: (1901-unknown) Anastasia Romanova, the youngest daughter of Tsar Nicholas II, escaped the Bolshevik slaughter of her family when the memories of Chinese Assassin Shao Jun contained within the Precursor box she held bonded with her. Aided by Russian Assassin Nikolaï Orelov, she fled both Templar and Assassin pursuit, eventually relocating to Germany and taking a new name.

NIKOLA TESLA: (1856–1943) A brilliant Serbian-American inventor, engineer, and futurist, Nikola Tesla is seen as one of the most important contributors to the onset of commercial electricity. Tesla was only 18 when he found an Apple of Eden in the wilderness of Croatia. He moved to the United States, where he set up several laboratories to develop electrical and mechanical devices. The Templars and Tesla's rival Thomas Edison actively tarnished Tesla's reputation and discredited his ideas and inventions.

In 1908 the Assassins reached out to Tesla to ask him for aid in destroying a Templar facility in Tunguska, where a Staff of Eden was set up as a particle beam weapon. The Russian Assassin Nikolaï Orelov infiltrated the facility, and Tesla remotely controlled a detonation intended to destroy the facility. Unfortunately, this resulted in a massive explosion which destroyed the Staff of Eden, and killed multiple Assassins.

Years later, Templar and SS general Gero Kramer kidnapped Tesla in order for him to work on Die Glocke, a very early type of proto-Animus. Tesla reluctantly agreed to cooperate, while secretly sabotaging the devuce. Eventually the Assassins rescued Tesla and the Apple of Eden used for Die Glocke, but Tesla feared the Assassins would try to use the artefact themselves, resulting in more tragedy.

Eventually Tesla was convinced to aid in Project Rainbow, the collaboration between the Assassins and Templars intended to use Die Glocke to change the course of history and prevent the escalating atrocities of World War 2, but the project failed. Tesla was killed by Gorm, who subsequently took his own life.

EDDIE GORM: (died Oct. 1943) Eddie Gorm reluctantly agreed to help the Brotherhood when they reached out to him in 1940 to aid in a mission to infiltrate the Nazis' atomic program, the 'Uranprojekt'. Acting as a spy within the SS, Gorm discovered that the Uranprojekt, located in Norway, was a cover for a project which involved a device called 'Die Glocke'. Gorm formally joined the Assassins, and left for Norway where he confronted the Templar and SS general Gero Kramer, who revealed that Nikola Tesla himself was forced to engineer Die Glocke to work with an Apple of Eden, capable of exploring the genetic memories of its user.

In 1943, Gorm and fellow Assassin and lover Julia Dusk rescued Tesla and delivered Die Glocke, as well as the Apple of Eden, to the high-ranking Assassin and American army officer Borish Pash. When they found out that Pash had secretly made a deal with the Templars to use Die Glocke in order to change the historical events that lead to the Nazi atrocities, Gorm and Dusk turned on Pash, and Dusk was killed as she used a grenade. Disillusioned, Gorm later infiltrated the ship where Project Rainbow was taking place, and killed Tesla in the hopes of sabotaging the project, which he believed would only lead to more destruction and suffering. Soon after, Gorm took his own life.

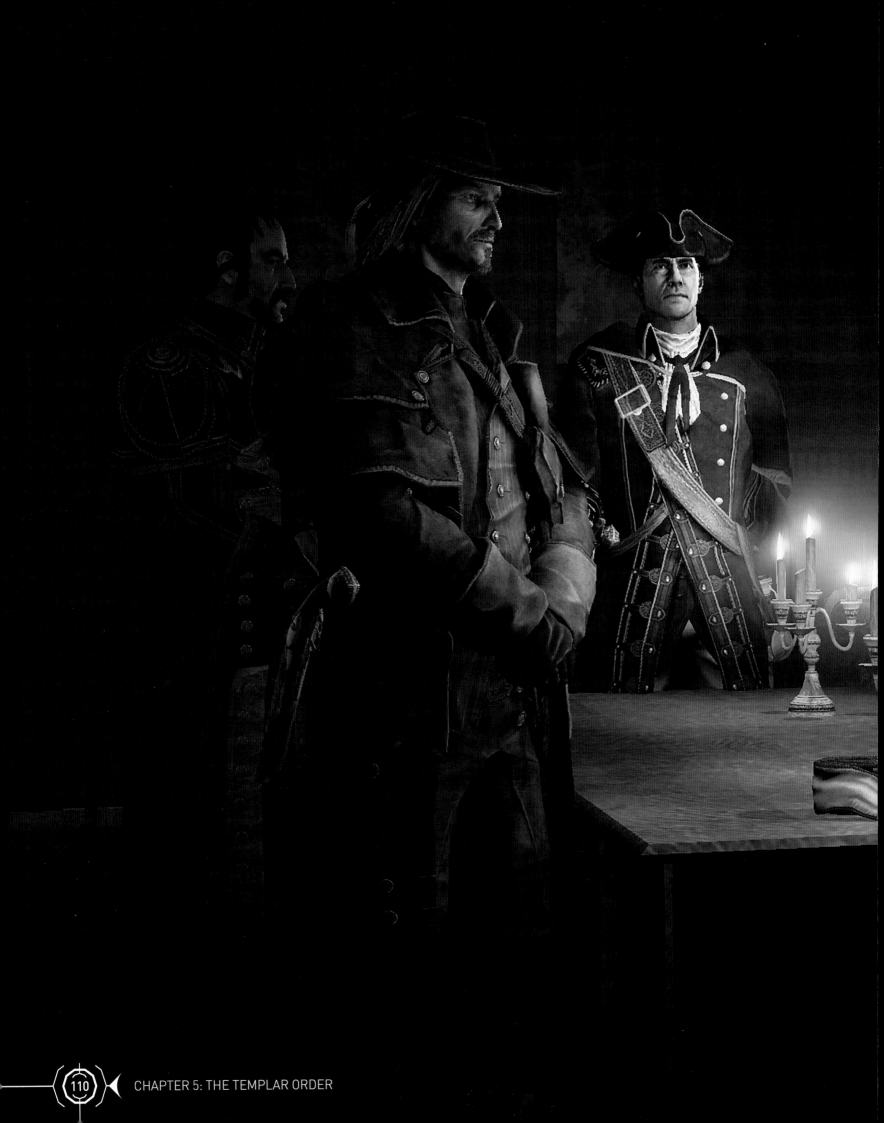

CHAPTER 5: THE TEMPLAR ORDER

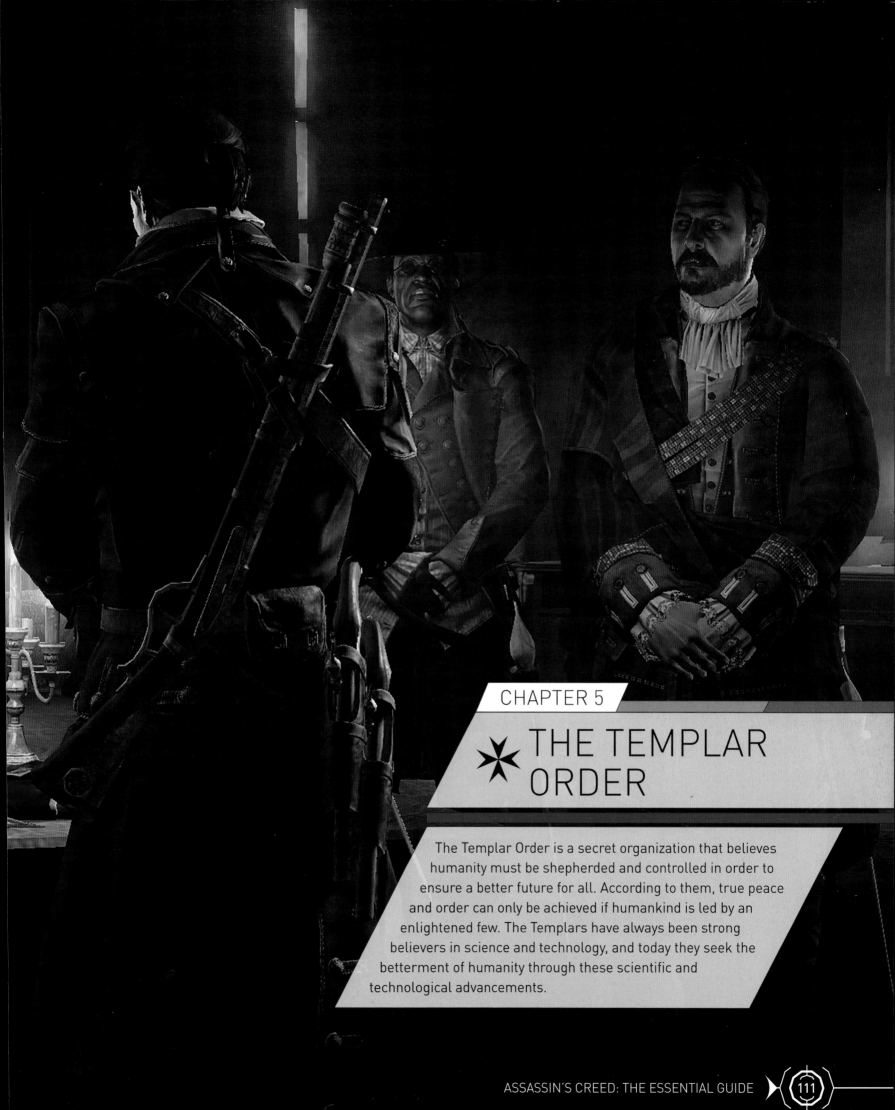

CHAPTER 5

✳ THE TEMPLAR ORDER

The Templar Order is a secret organization that believes humanity must be shepherded and controlled in order to ensure a better future for all. According to them, true peace and order can only be achieved if humankind is led by an enlightened few. The Templars have always been strong believers in science and technology, and today they seek the betterment of humanity through these scientific and technological advancements.

TEMPLAR HISTORY

Like the Brotherhood of Assassins, the origins of the Templar Order are shrouded in mystery. An origin legend has Cain, one of Adam and Eve's sons, as a forebearer, and says that he murdered his brother Abel not out of jealousy, but to acquire a Piece of Eden. Some refer to the symbol of the Templar Order, the red cross pattée, as the mark of Cain.

The Templar Order has its roots in previous secret organizations, one of which was the Order of the Ancients in Ancient Egypt and beyond. Before that, the downfall of the Cult of Kosmos in Ancient Greece was a catalyst for the ideas that would eventually lead to the formation of the Templar Order.

It is believed that an ancestor group of the Templars was behind Darius the Great, the fourth king of the Achaemenid Empire who overthrew a usurper and claimed the throne of Persia. They likewise supported his son Xerxes I in his conquering of Greece and suppression of revolts in Egypt and Babylon. Alexander the Great was supported by proto-Templars as he forged his empire. Thanks to them, Alexander carried multiple Pieces of Eden, which contributed to his massive success at a young age.

The Templar Order and its ancestor groups supported many of the great civilizations and empires throughout history, underscoring major projects such as the construction of the Great Wall of China. They were particularly active in the Roman Empire, supporting such individuals as Caesar and Caligula, as the Empire sought to unify Western Europe under one rule.

Throughout the ages, the Templars were, in general, highly educated individuals who were sometimes mistrusted simply for the amount of knowledge they possessed or the ideals they upheld. In 1118 Bernard de Clairvaux realized the Order needed a powerful ally to protect them; he reformed the Order and worked to have it confirmed as a religious entity by the Catholic Church in 1192, during the Council of Troyes, ostensibly to protect pilgrims to the Holy Land. This ensured the Order's safety and enabled it to function as a public enterprise, and it flourished over the next two centuries as the Knights Templar.

"But you are Templars now. The secret and true legislators of the world."

— Laureano Torres y Ayala

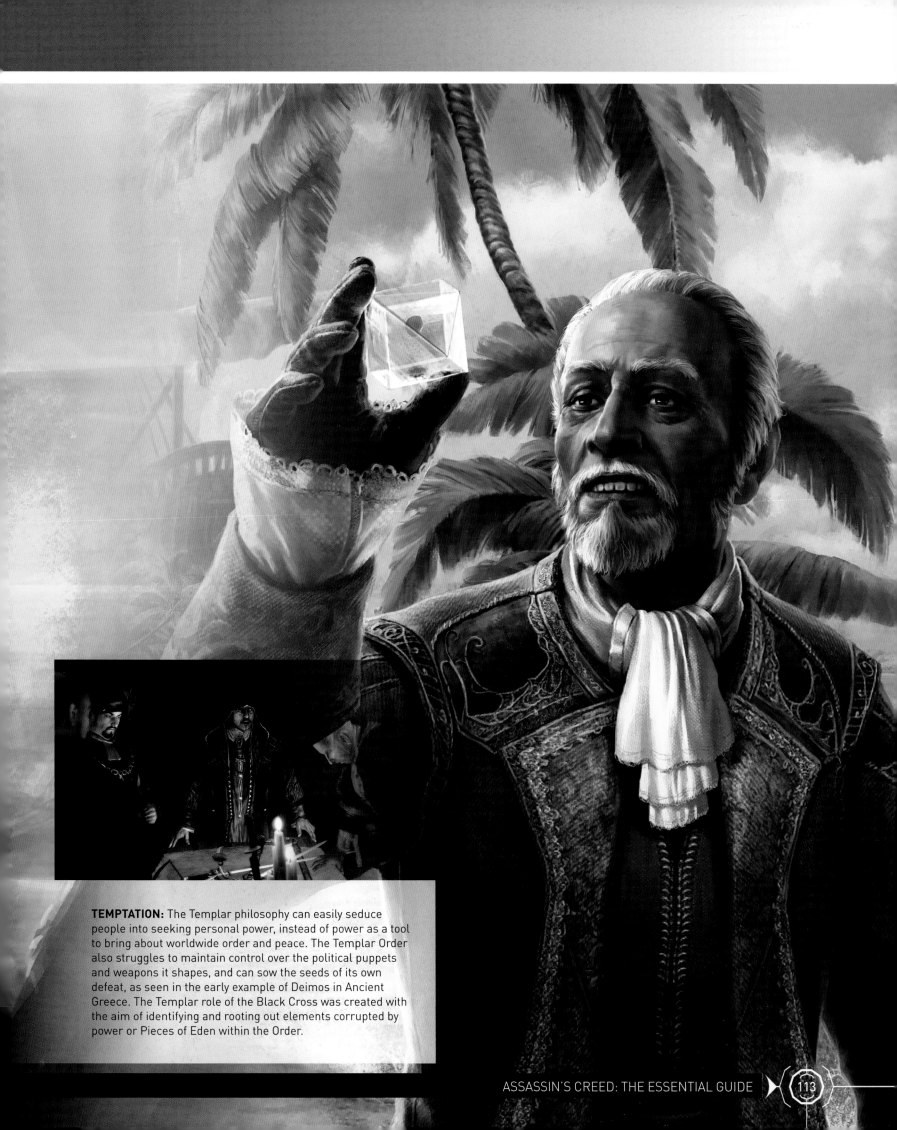

TEMPTATION: The Templar philosophy can easily seduce people into seeking personal power, instead of power as a tool to bring about worldwide order and peace. The Templar Order also struggles to maintain control over the political puppets and weapons it shapes, and can sow the seeds of its own defeat, as seen in the early example of Deimos in Ancient Greece. The Templar role of the Black Cross was created with the aim of identifying and rooting out elements corrupted by power or Pieces of Eden within the Order.

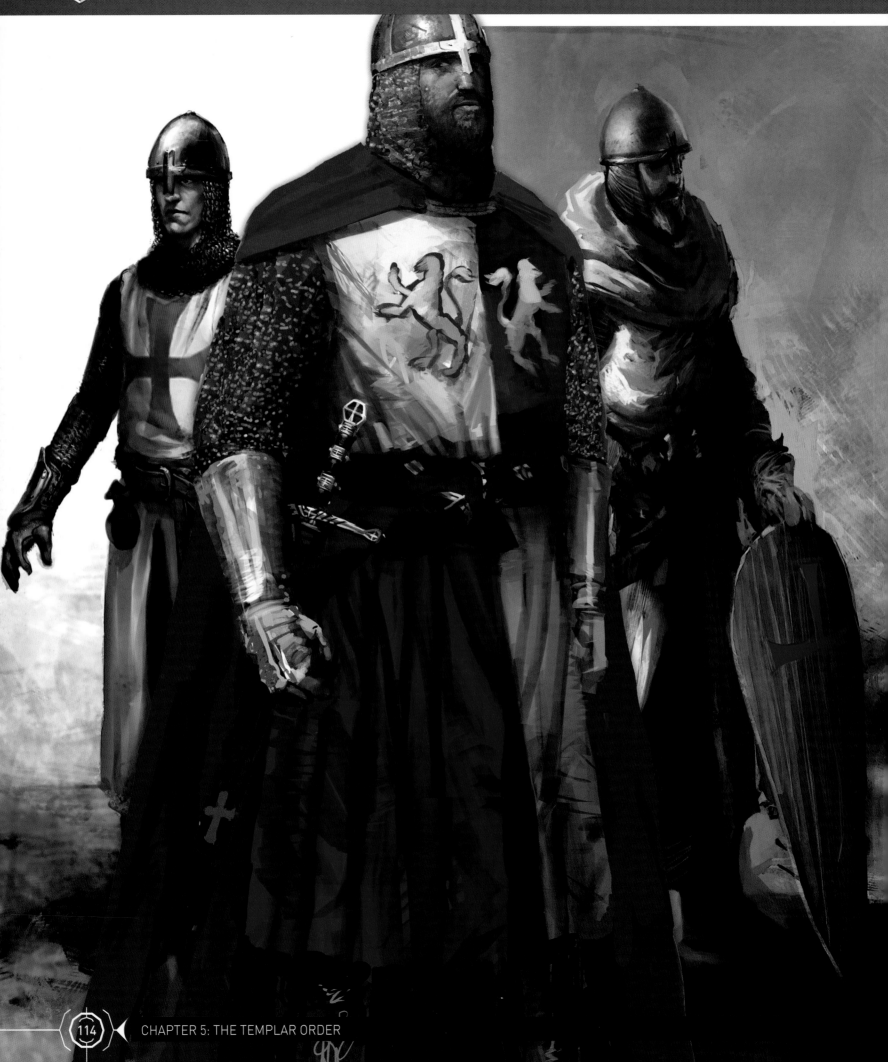

TEMPLAR HISTORY

The golden age of the Templar Order came to an end in the early fourteenth century when King Philip IV of France accused the Templars of heresy, and the Knights Templar were disbanded. Before being burned at the stake, Grand Master Jacques de Molay set a plan in motion that moved the Templars into secrecy again, their wisdom preserved. Over the next few centuries, Templars held powerful and influential positions in the Church, in various noble courts, and in numerous militaries, influencing how the world was shaped.

The Templar Order is particularly interested in the Pieces of Eden, as the original purpose of the most powerful of those artifacts was to control humanity. With these items, the Templars seek to reinforce their concept of imposed, designed world order.

A key point in the Templars' strategy was to realize that by funding and directing technological and industrial development, they could navigate the world's economy into emphasizing their ideals and goals. When London became the epicenter of the Industrial Revolution during the nineteenth century, the Templars controlled much of the city's infrastructures and manufactories. They also established a major foothold in American industry, with several key figures such as Thomas Edison and Henry Ford belonging to the Order.

Consequently, science and technology research has become the core of the Templars' operations in the 20th century. They created Abstergo Industries in the late 1930s and it became the public face of the Templar Order as well as one of the largest industrial conglomerates in the world. Abstergo's development of the Animus, a technology created to explore the genetic memories of a select subject, constituted a critical point in the Assassin-Templar conflict.

At the beginning of the twenty-first century the Templar Order had the upper hand in the age-old struggle with the Brotherhood of Assassins. In 2000, Templar sleeper agent Daniel Cross assassinated the global Mentor of the Brotherhood. This masterstroke lead to the Great Purge, with many Assassins being discovered and subsequently killed via the information Cross brought to the Templar Order. The Brotherhood was all but shattered by this event, and the surviving members went underground in isolation to remain safe. The Templar Order is confident that it possesses the upper hand in contemporary society.

STRUCTURE OF THE TEMPLAR ORDER

It is no surprise that the Templar Order is a highly structured and carefully controlled global organization.

At its most basic, the Templar Order can be divided into two parts: the Inner Sanctum and the Outer Temple. The Inner Sanctum of the modern Order consists of a select group of 9 Templars and is its governing body, actively ruling, making decisions, and implementing them. Members of the Inner Sanctum have direct knowledge of all Templar plans, make decisions and send out orders. The Inner Sanctum has their major decisions and policies reviewed by the Guardians, and ultimately the General of the Cross.

By contrast, the Outer Temple consists of Templars who do not have access to the full slate of Templar operations, and lack the degree of details the Inner Sanctum is privy to.

POSITIONS WITHIN THE TEMPLAR ORDER INCLUDE:

- **The Guardians** review major decisions made by the Inner Sanctum before passing them along to the General of the Cross for approval. There are three Guardian positions within the Order.

- **The General of the Cross** is responsible for the ultimate approval of decisions and plans. He has the power to veto important decisions made by the Inner Sanctum. His identity is kept secret, even from other Templars. Presumably, only the Guardians know who the General of the Cross is.

- **The Grand Master** is one of the highest ranks attainable within the Templar Order. There are several Grand Masters, each being responsible for a geographical region. Grand Masters are the leaders of a specific rite, and have control over all Templar members of that rite and their activity.

- **The Black Cross** is an inquisitorial and enforcer position meant to keep the Grand Masters of the different Rites and their subordinates in line with the Templar philosophy. The identity of the Black Cross is always secret, and a Black Cross could challenge even the Inner Sanctum, wielding their power to excise corrupted members of the Order. The concept of the Black Cross had reached almost legendary status among Templars throughout history, who admired and feared the mysterious inquisitor of their Order. The Black Cross mythos was presumed to have ended in the early twentieth century, although it was anonymously revived by Otso Berg in the early twenty-first century to address the Phoenix Project, among other issues.

- **The Master Templars** are mid to high-ranking Templars who hold various important positions within the Order. There are several Templars who hold the rank of Master.

The ranks within the Templar Order correspond roughly to those within the Assassin Brotherhood, beginning with a novice level and advancing through to a master level.

A faction or division of the Templar Order is referred to as a **Rite**. Rites are defined geographically, i.e. the Colonial Rite or the Parisian Rite.

THE INNER SANCTUM MEMBERS - 2018

- **Laetitia England:** Head of the Operations Division, Abstergo Industries

- **Mitsuko Nakamura:** Director of Research, Lineage and Acquisition, Abstergo Industries

- **Juhani Otso Berg:** Operations Specialist, Abstergo Industries

- **Simon Hathaway:** Head of Historical Research, Abstergo Industries

- **Agneta Reider:** Chief Executive Officer, Abstergo Financial Group

- **David Kilkerman:** Director of the Animus Project, Abstergo Industries

- **Alfred Stearns:** Retired (former Head of Operations Division, Abstergo Industries)

As of 2018, there are two seats believed to be unfilled in the Inner Sanctum. Alan Rikkin, CEO of Abstergo Industries, was assassinated by Callum Lynch in December 2016, and Álvaro Gramática died during the destruction of the Phoenix Project in 2018. The positions they held within Abstergo—CEO and Head of Director of Research and Future Technology—are also as of yet unfilled.

In 2016, Juhani Otso Berg independently resurrected the position of the **Black Cross** on his own initiative to bring modern Templars into line. In 2017, Otso Berg had formally taken on the position of the Black Cross himself. His identity was secret, and he was the first Black Cross to be an actual member of the Inner Sanctum. He worked with André Bolden, who acted as support, until the end of his mission in 2018.

The Council of Elders influences and guides the active governing bodies of the Templar Order such as the Inner Sanctum, but does not directly control them. The Council exists separately from the governing structure, and part of its function is to ensure the integrity of the Templar government, similar to the function of the Black Cross. The Council may have had significant impact on the Black Cross assignments in earlier years. The Council of Elders is currently led by Ellen Kaye.

THE INDUCTION CEREMONY

Records of Templar initiation ceremonies show that the ritual has changed through the years, and is often tailored to the particular Rite the inductee belongs to. A ceremony usually involves oaths to uphold the Order's philosophy, a vow of silence regarding the Order's activity and the identities of fellow Templars, and the bestowing of a Templar ring.

TEMPLAR RINGS
A Templar ring is bestowed during initiation, and identifies the wearer as a member of the Order. The design is usually very simple, and features the Templar symbol, the red cross pattée.

The use of rings began sometime before the eighteenth century. Rings belonging to deceased Templars are often passed down to new initiates, carrying the weight and symbolism of the previous owner's deeds with them.

By the end of the eighteenth century, the Parisian Rite had phased out the use of rings and bestowed silver pins in the shape of the Cross of the Templars surrounded by elaborate designs. The small blade extending down from the cross could be used as an actual weapon, as in the murder of Grand Master François de la Serre.

FATHER OF UNDERSTANDING
The Father of Understanding is often mentioned by Templars, especially during ritual ceremonies or as a form of greeting. The phrase refers to the sense of order and logic embraced by the Templars. Whether it refers to a specific deity or entity is unclear; what matters is that the Templars' appeal to an embodiment of logic itself in their work to reform the world. At times, Templars and proto-Templars have described certain individuals as the personification of the Father of Understanding. For instance, Lucius Septimius described Caesar as the Father of Understanding during his final battle with Aya.

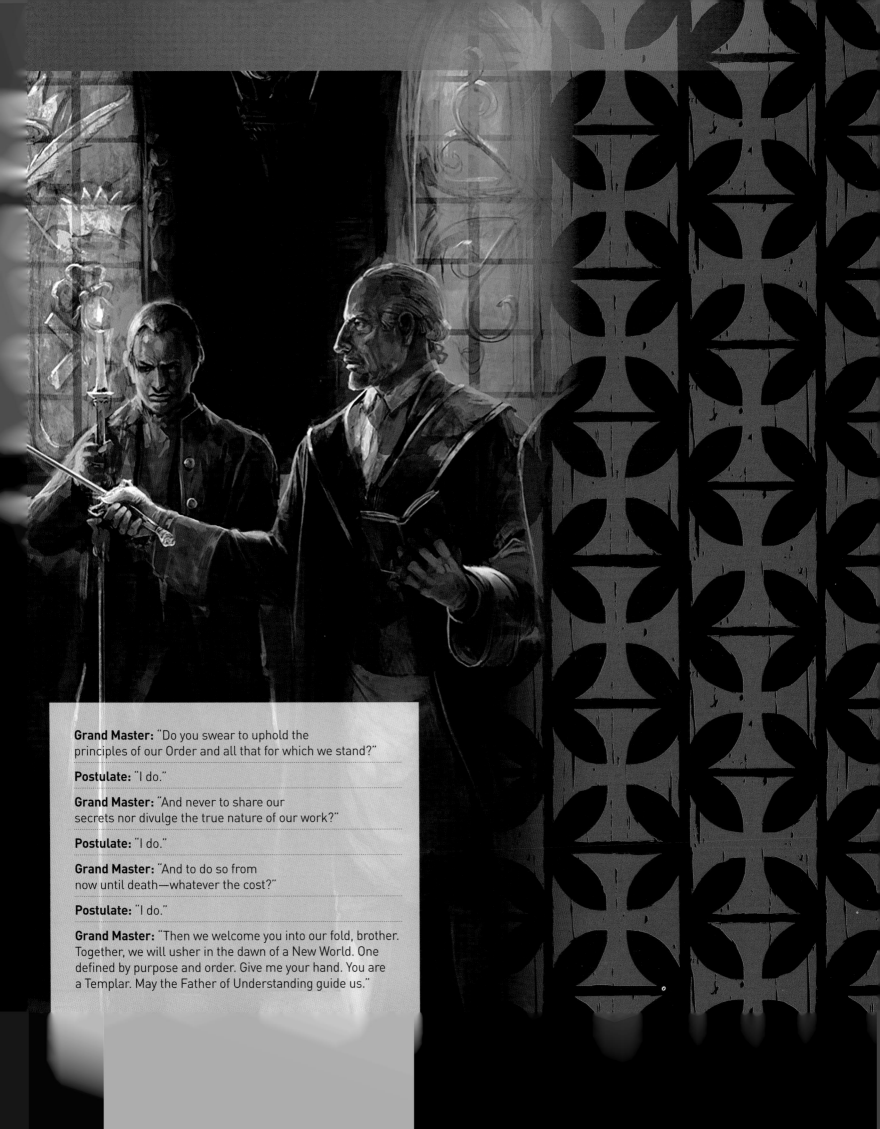

Grand Master: "Do you swear to uphold the principles of our Order and all that for which we stand?"

Postulate: "I do."

Grand Master: "And never to share our secrets nor divulge the true nature of our work?"

Postulate: "I do."

Grand Master: "And to do so from now until death—whatever the cost?"

Postulate: "I do."

Grand Master: "Then we welcome you into our fold, brother. Together, we will usher in the dawn of a New World. One defined by purpose and order. Give me your hand. You are a Templar. May the Father of Understanding guide us."

ROBERT DE SABLÉ

"You know not the things in which you meddle, Assassin. I spare you only that you may return to your Master and deliver a message: The Holy Land is lost to him and his. He should flee now, while he has the chance. Stay, and all of you will die."

— Robert de Sablé

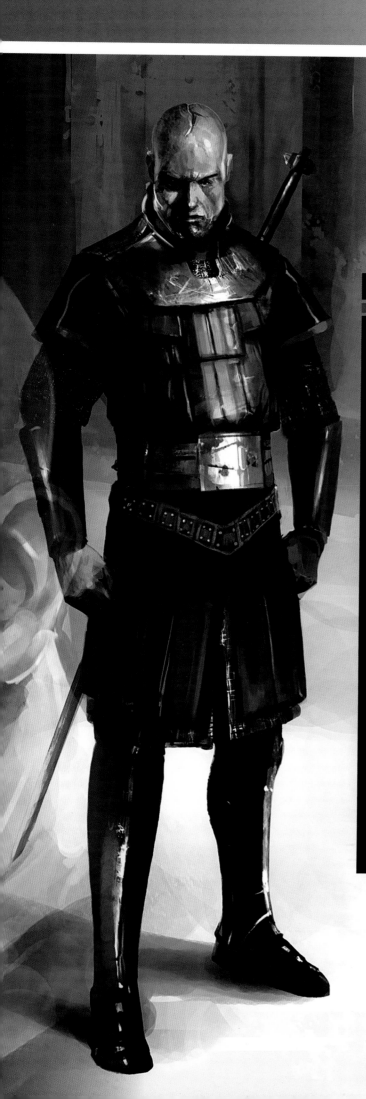

MAIN TEMPLARS & ANTAGONISTS

Dates: 1150–1191
Place of Birth: Angevin, France
Location: Jerusalem, Holy Land
Historical Period: Third Crusade
Rite Affiliation: Levantine Rite

Born into a noble family, Robert de Sablé ruled the Sarthe region of Anjou, France. In 1190 he was made Grand Master of the Order of the Knights Templar, while serving as a close advisor to King Richard I and his Crusader army. His goal in the Holy Land was to seize control of the heavily disputed area and bring it under the jurisdiction of the Templars. He recruited many Saracens and Crusaders to the Templar cause, working to unite them against the Brotherhood of Assassins.

Tracking the location of an Apple of Eden, de Sablé reached the vault below Solomon's Temple before Altaïr did, although he ultimately lost the Piece of Eden to the Assassins. He chased the Apple back to the Assassin stronghold of Masyaf, where a traitor gave him and his troops access to the city.

Robert de Sablé ultimately died in single combat with Altaïr, a fight decreed by King Richard to determine which side was in the right. Before he died, however, he revealed Al Mualim's treachery to Altaïr. De Sablé's death threw the Templar plans to seize control of the Holy Land into disarray.

Key Allies: King Richard, Saladin

Main Opponents: Altaïr Ibn-La'Ahad

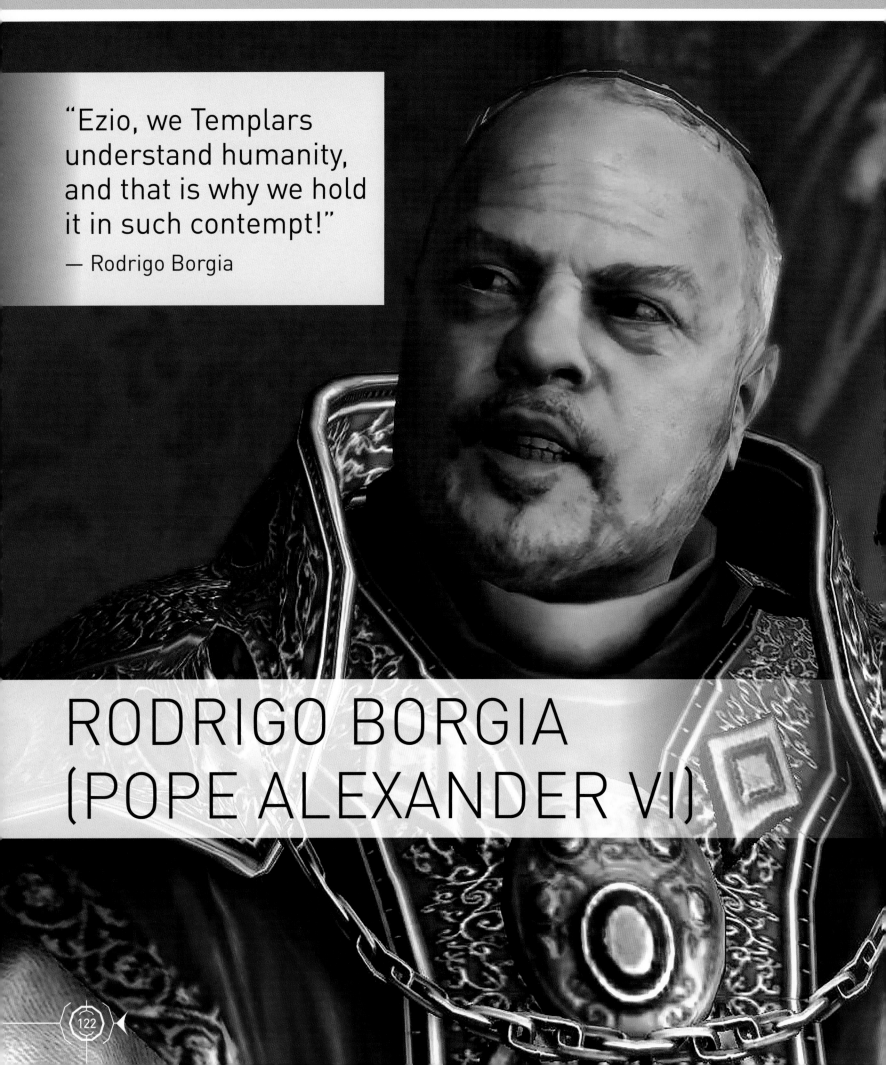

"Ezio, we Templars understand humanity, and that is why we hold it in such contempt!"
— Rodrigo Borgia

RODRIGO BORGIA (POPE ALEXANDER VI)

Dates: 1431-1503
Place of Birth: Spain
Location: Italy
Historical Period: Italian Renaissance
Rite Affiliation: Roman Rite

Made Grand Master of the Templar Order in Italy in 1476, Rodrigo used his influence in the Church to remove political leaders unsympathetic to the Templar philosophy, bringing Italy under Templar influence. His power grew until he was one of the most powerful Templars in Europe.

Through rigged voting and bribery, Rodrigo became the leader of the Catholic Church in 1492 as Pope Alexander VI. His papal election allowed him access to the Precursor Vault underneath the Vatican, as well as the Papal Staff, a Piece of Eden. For years he searched for an Apple of Eden to pair with it in order to acquire some kind of immense power from the Vault, falling prey to his desire for personal power instead of using his knowledge to strengthen the Templar Order.

Rodrigo confronted Ezio in the Sistine Chapel. Seizing the Apple Ezio had brought with him, he united the two Pieces of Eden and used them to unlock the Vatican Vault under the chapel. However, Rodrigo could not open the inner doors, and after another fight with Ezio he admitted that he had no respect for God or the Church; he had only taken this path to gain access to the Pieces of Eden and the Vault, and to realize what he believed was his destiny as the Prophet.

After Rodrigo's defeat in the Vault, his son Cesare began to work against him, ultimately taking over Rome. Rodrigo feared that Cesare would jeopardize his life's work and plotted to poison his son. Alerted to the plan, Cesare spat out the bite of poisoned apple he had taken and forced his father to eat the poisoned fruit instead, whereupon he died. In time, the Borgia era of Templar leadership would be known as "the Dark Age of the Order."

Key Allies: House of Pazzi, House of Barbarigo, Uberto Alberti

Main Opponents: Lorenzo de' Medici, Mario Auditore, Ezio Auditore

CESARE BORGIA

"Father, do you not see? I control all of this. If I want to live,
I live. If I want to take, I take! If I want you to die, you die!"

— Cesare Borgia

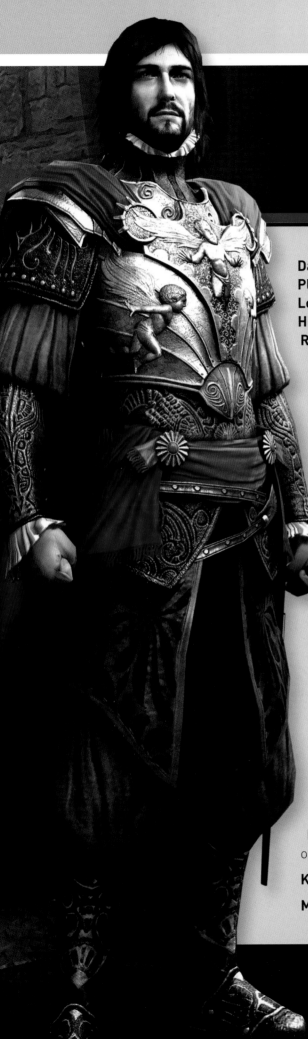

MAIN TEMPLARS & ANTAGONISTS

Dates: 1475-1507
Place of Birth: Rome
Location: Rome
Historical Period: Italian Renaissance
Rite Affiliation: Roman Rite

Cesare was born into the Templar Order as the illegitimate son of Rodrigo Borgia. An ambitious man, he had his elder brother Juan killed in 1497 in order to assume his position as Captain General of the Papal Armies, thereby becoming one of the most powerful men in Italy. In 1500 he mounted an assault on the Assassin stronghold of Monterrigioni, acquiring the Apple the Auditore family held, and killing Mario Auditore. It would take the Brotherhood several years to recuperate from this stroke.

An excellent leader and skilled swordsman, Cesare was also a talented manipulator with a ruthless drive for power. When his sister became pregnant after an intimate relationship with the Assassin Perotto Calderon in 1498, Cesare took the child from her and raised it himself.

By 1503, Assassin activity and interference had weakened Cesare's influence to the point where he confronted his father and demanded more support. The men argued over Cesare's lust for power, and he demanded his father's Apple of Eden so that he might wield it. His sister Lucrezia warned Cesare that Rodrigo was attempting to poison him, and Cesare murdered his father by forcing him to eat the poisoned fruit intended for Cesare himself. He then took up the position of Grand Master of the Templar Order in Italy.

Cesare subsequently attempted to obtain the Apple of Eden hidden under St. Peter's Basilica, but Ezio retrieved it first. Cesare's influence and power decreased even more, and he was finally arrested by the Papal Guard by the order of the new pope, Julius II, an enemy of the Borgias. Escaping his imprisonment, Cesare attempted to assemble a new army, eventually joining his brother-in-law King John III's militia in Navarre. Ezio fought him during the siege of Viana Castle, throwing him from the battlements to his death.

Key Allies: Ramiro d'Orco, Oliverotto da Fermo, Vitellozzo Vitelli

Main Opponents: Ezio Auditore

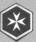
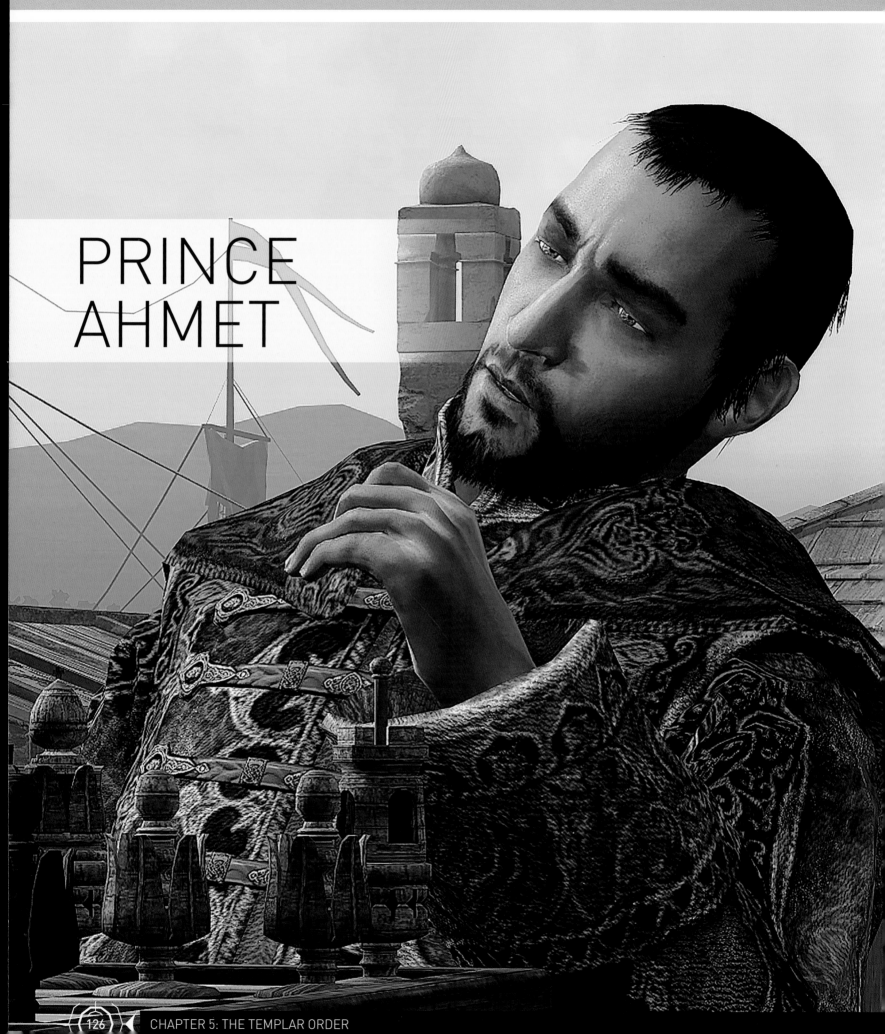

PRINCE AHMET

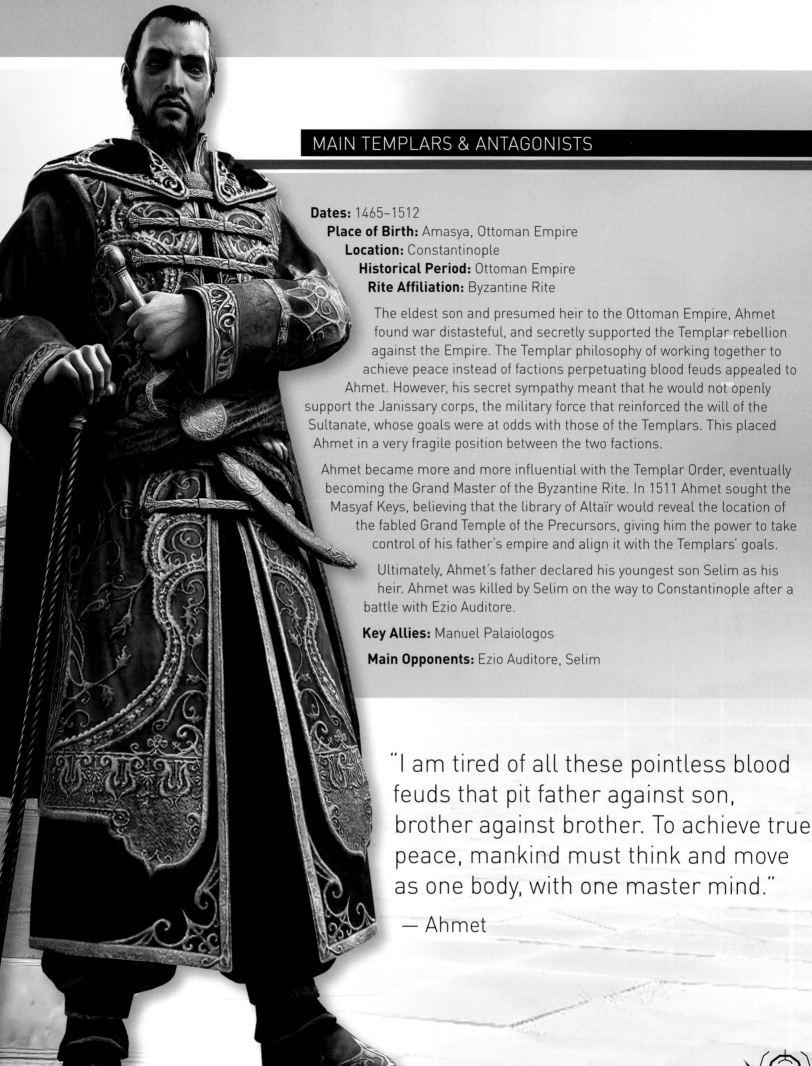

Dates: 1465–1512

Place of Birth: Amasya, Ottoman Empire

Location: Constantinople

Historical Period: Ottoman Empire

Rite Affiliation: Byzantine Rite

The eldest son and presumed heir to the Ottoman Empire, Ahmet found war distasteful, and secretly supported the Templar rebellion against the Empire. The Templar philosophy of working together to achieve peace instead of factions perpetuating blood feuds appealed to Ahmet. However, his secret sympathy meant that he would not openly support the Janissary corps, the military force that reinforced the will of the Sultanate, whose goals were at odds with those of the Templars. This placed Ahmet in a very fragile position between the two factions.

Ahmet became more and more influential with the Templar Order, eventually becoming the Grand Master of the Byzantine Rite. In 1511 Ahmet sought the Masyaf Keys, believing that the library of Altaïr would reveal the location of the fabled Grand Temple of the Precursors, giving him the power to take control of his father's empire and align it with the Templars' goals.

Ultimately, Ahmet's father declared his youngest son Selim as his heir. Ahmet was killed by Selim on the way to Constantinople after a battle with Ezio Auditore.

Key Allies: Manuel Palaiologos

Main Opponents: Ezio Auditore, Selim

"I am tired of all these pointless blood feuds that pit father against son, brother against brother. To achieve true peace, mankind must think and move as one body, with one master mind."

— Ahmet

LAUREANO DE TORRES Y AYALA

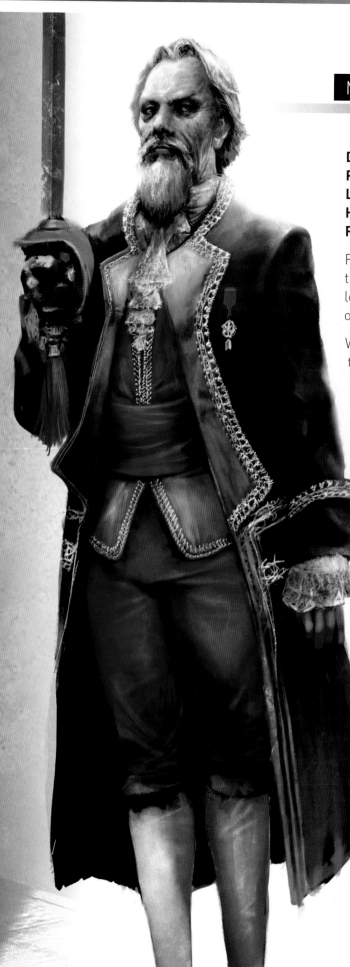

Dates: 1645-1722
Place of Birth: Havana, Cuba
Location: Florida; Cuba
Historical Period: Golden Age of Piracy
Rite Affiliation: West Indies Rite

Raised in Spain, Torres joined the Templars in his twenties, and founded the rite of the Templar Order in the West Indies. He was also tasked with locating the Precursor site known as the Observatory, a mission that occupied him for over twenty years.

With Templar support he was appointed the governor of the Spanish territories in Florida in 1693, and held the position until 1699. In 1708 he was appointed the governor of Cuba, and held the position until he was charged with corruption in 1711. He was acquitted and reinstated in 1713 and won a re-election for the position two years later, retiring in 1716.

Torres unknowingly inducted Edward Kenway into the Templar Order, believing him to be the turncoat Assassin Duncan Walpole. When the deception was finally discovered, Torres condemned Kenway to work as a galley slave.

In preparation for the Observatory, Torres had all the Templars under his control donate a drop of their blood so that they could be tracked and spied on via the Observatory.

Torres finally located the Observatory in 1722. After ordering his troops to massacre the native tribe of Guardians protecting the site, he reached the central location, but after triggering the Observatory's deadly defensive measures, he was killed there by Edward Kenway.

Key Allies: El Tiburón

Main Opponents: Edward Kenway, Adéwalé

> "A body enslaved inspires the mind to revolt. But enslave a man's mind and his body will follow on naturally. Efficiently."
>
> — Laureano de Torres y Ayala

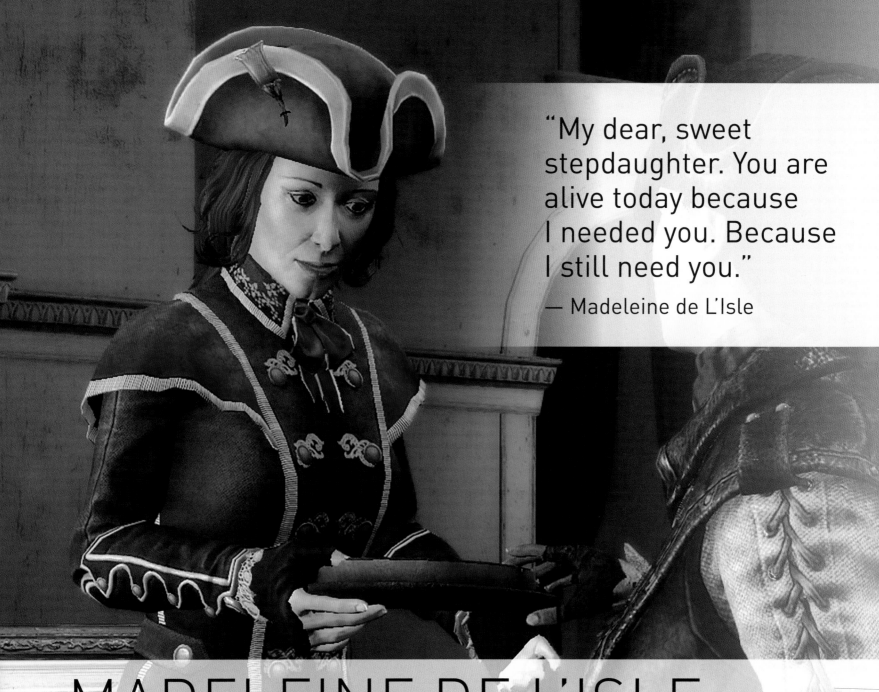

"My dear, sweet stepdaughter. You are alive today because I needed you. Because I still need you."

— Madeleine de L'Isle

MADELEINE DE L'ISLE

Dates: 1732–1777
Place of Birth: New Orleans, New France
Location: New Orleans
Historical Period: Louisiana Rebellion
Rite Affiliation: Louisiana Rite

Madeleine joined the Templars of the Southern Colonies in New Orleans in 1747 and was tasked with locating Precursor objects rumoured to be in the Yucatán Peninsula. When she heard that a slave called Jeanne had stolen a Precursor artifact from the Assassin Mentor of Saint-Domingue, she traced Jeanne to Philippe de Grandpré, a merchant who had purchased Jeanne and had made her his placée (or common-law) bride. She began to insinuate herself into the Grandpré household.

Made a Master Templar in 1751, Madeleine formally married Philippe de Grandpré in 1752. When she learned that a Precursor Prophecy Disk was in Chichén Itzá, Mexico, Madeleine began to divert slaves and vagrants from New Orleans and the West Indies to Yucatan work camps operating to unearth it. She trusted Rafael Joaquín de Ferrer to oversee this project for her. When Jeanne became concerned that the Assassin Brotherhood might come for her and the Precursor artifact she possessed, Madeleine subtly encouraged her paranoia; Jeanne accepted Madeleine's offer to relocate to Mexico, one of the first slaves redirected to the work camps there.

Madeleine had noted the potential of Jeanne's daughter Aveline, and promised Jeanne she would raise the girl as her own, and subtly groomed her to join the Templars. When she began to suspect Aveline had instead allied with the Assassin Brotherhood, she began to acquire information about the Brotherhood's activities by observing her. This intelligence helped Madeleine secure her position as the Templar leader of Louisiana. She slowly poisoned her husband when he uncovered evidence of Templar interference in his business.

When the slave trafficking system was discovered by Aveline in 1765, Madeleine's control over the Templar activity in the area began to erode. In 1777 Madeleine's identity was uncovered by Aveline. Madeleine invited her stepdaughter to join the Templars, and Aveline agreed. However, it was a ruse, and Aveline assassinated her stepmother at the close of her initiation ceremony.

Key Allies: Rafael Joaquín de Ferrer

Main Opponents: Aveline de Grandpré

BAPTISTE

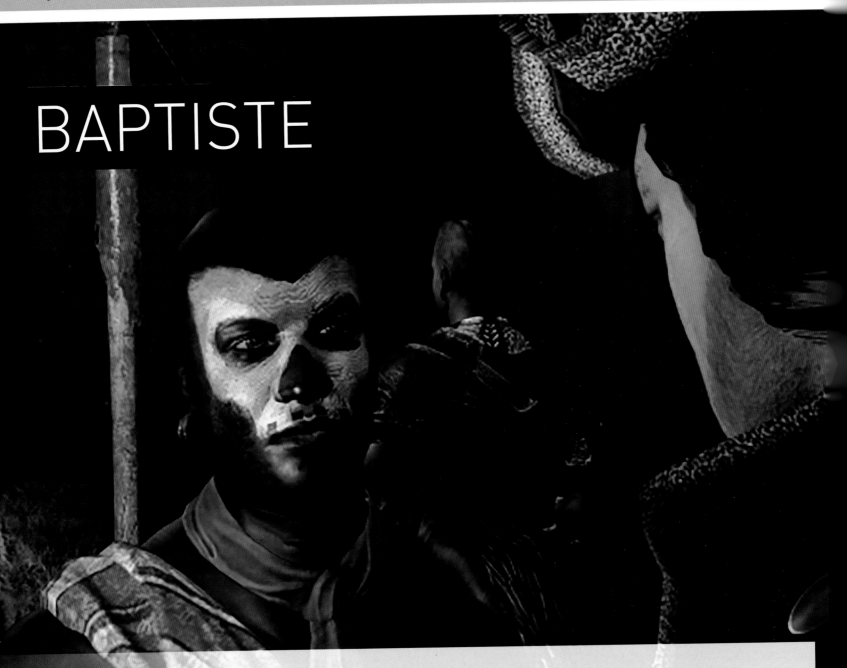

"Very well... François Mackandal was my mentor. And an Assassin. But he failed. She betrayed us and he died. I won't make that mistake before I carry out his life's destiny."

— Baptiste

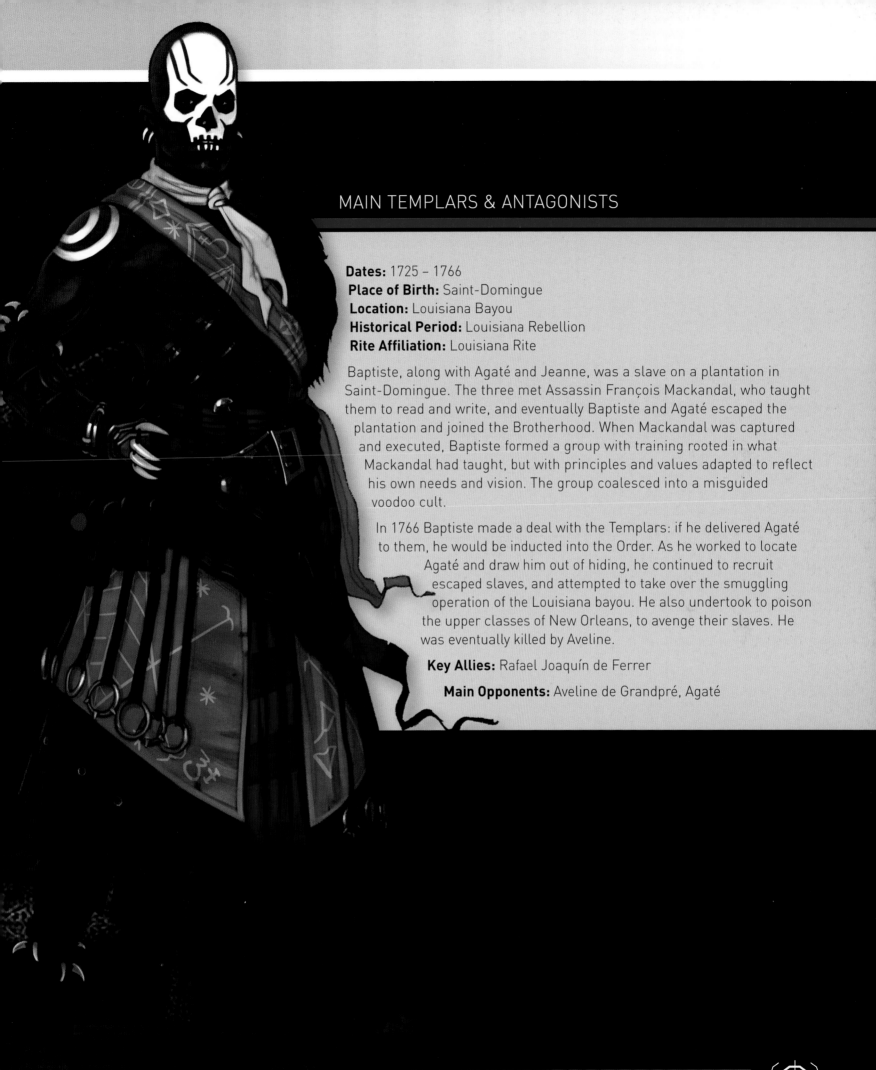

MAIN TEMPLARS & ANTAGONISTS

Dates: 1725 – 1766
Place of Birth: Saint-Domingue
Location: Louisiana Bayou
Historical Period: Louisiana Rebellion
Rite Affiliation: Louisiana Rite

Baptiste, along with Agaté and Jeanne, was a slave on a plantation in Saint-Domingue. The three met Assassin François Mackandal, who taught them to read and write, and eventually Baptiste and Agaté escaped the plantation and joined the Brotherhood. When Mackandal was captured and executed, Baptiste formed a group with training rooted in what Mackandal had taught, but with principles and values adapted to reflect his own needs and vision. The group coalesced into a misguided voodoo cult.

In 1766 Baptiste made a deal with the Templars: if he delivered Agaté to them, he would be inducted into the Order. As he worked to locate Agaté and draw him out of hiding, he continued to recruit escaped slaves, and attempted to take over the smuggling operation of the Louisiana bayou. He also undertook to poison the upper classes of New Orleans, to avenge their slaves. He was eventually killed by Aveline.

Key Allies: Rafael Joaquín de Ferrer

Main Opponents: Aveline de Grandpré, Agaté

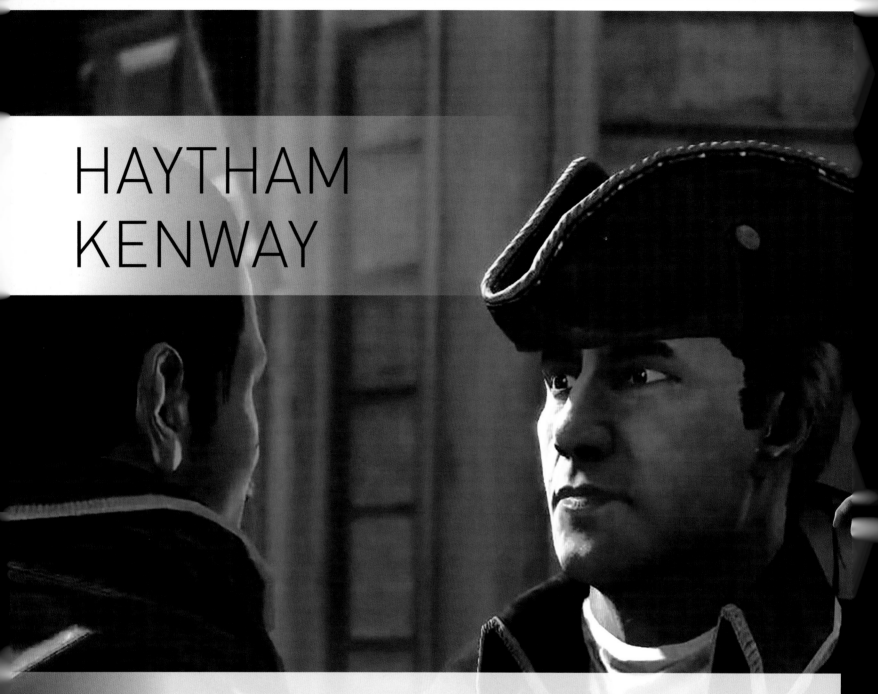

HAYTHAM KENWAY

"The people never have the power. Only the illusion of it. And here's the real secret: they don't want it. The responsibility is too great to bear. It's why they're so quick to fall in line as soon as someone takes charge. They WANT to be told what to do. They YEARN for it. Little wonder, that, since all mankind was BUILT to SERVE."

— Haytham Kenway

Dates: 1725–1781
Place of Birth: London
Location: British America
Historical Period: Colonial America, American Revolution
Rite Affiliation: Colonial Rite

Brought up by his Assassin father Edward Kenway to think independently and question others' opinions, Haytham's upbringing was completed by Reginald Birch, a close family friend who revealed himself to be a Templar after Edward's murder. Haytham immersed himself in the Templar teachings and found comfort in the ordered worldview, and was inducted into the Order in 1744.

In 1754 Haytham was sent to the British colonies in America to locate a suspected Precursor storehouse. While there he established the Templar Order's Colonial Rite, the first permanent, organized Templar presence in Colonial America. Haytham oversaw the development of a relationship with the local native population, which resulted in the location of the Precursor site being given to them by Kaniehtí:io, a Kanien'kehá:ka woman with whom Haytham eventually had a son. When Kaniehtí:io discovered he had lied to her about ensuring he had killed Edward Braddock at the end of his expedition in 1755, she repudiated him, keeping the knowledge of their child a secret.

Unable to gain access to the locked Precursor site and having lost the support of the native people, Haytham focused instead on strengthening the Templar presence in the Colonies. Under his leadership, the Colonial Rite grew exponentially, and the emerging Assassin guild was essentially eradicated.

In 1778 he met Ratonhnhaké:ton, also known as Connor, whom he recognized as his son. Over the following years, as the colonies struggled to gain independence from England, the two attempted to work together, realizing that their goals were aligned. Despite disagreements about tactics and leaders, Haytham and Connor worked together on several key missions during the War of Independence, each attempting to sway the other to his way of thinking. In the end, the fundamental philosophies of their respective paths prevented this, and the two battled at Fort George, where Haytham was slain by his son.

Key Allies: Reginald Birch, Charles Lee, Shay Cormac

Main Opponents: Achilles, Ratonhnhaké:ton (Connor)

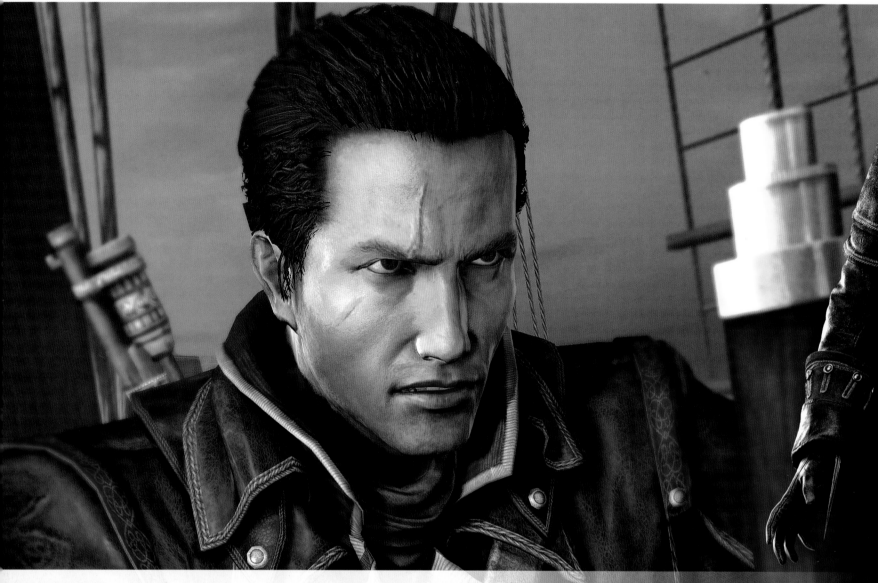

SHAY CORMAC

"The hunt has lead me to the forgotten edges of this world. Seasons pass, drawing me deeper into the darkness where I have found the truth; That my redemption is found in ashes; that I must burn away the past to set things right. Once an Assassin, now their pursuer. I must destroy those whom I once called 'brother.' The air is still...and I am a hunter."

— Shay Cormac

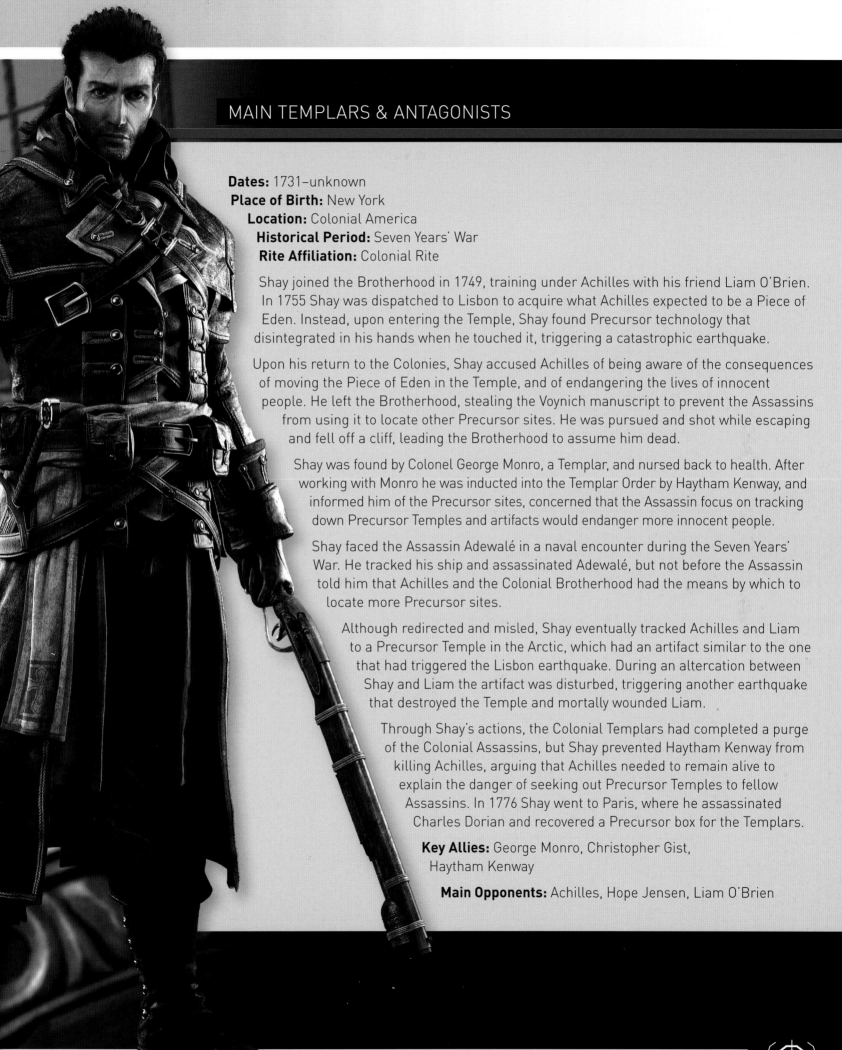

Dates: 1731–unknown
Place of Birth: New York
Location: Colonial America
Historical Period: Seven Years' War
Rite Affiliation: Colonial Rite

Shay joined the Brotherhood in 1749, training under Achilles with his friend Liam O'Brien. In 1755 Shay was dispatched to Lisbon to acquire what Achilles expected to be a Piece of Eden. Instead, upon entering the Temple, Shay found Precursor technology that disintegrated in his hands when he touched it, triggering a catastrophic earthquake.

Upon his return to the Colonies, Shay accused Achilles of being aware of the consequences of moving the Piece of Eden in the Temple, and of endangering the lives of innocent people. He left the Brotherhood, stealing the Voynich manuscript to prevent the Assassins from using it to locate other Precursor sites. He was pursued and shot while escaping and fell off a cliff, leading the Brotherhood to assume him dead.

Shay was found by Colonel George Monro, a Templar, and nursed back to health. After working with Monro he was inducted into the Templar Order by Haytham Kenway, and informed him of the Precursor sites, concerned that the Assassin focus on tracking down Precursor Temples and artifacts would endanger more innocent people.

Shay faced the Assassin Adewalé in a naval encounter during the Seven Years' War. He tracked his ship and assassinated Adewalé, but not before the Assassin told him that Achilles and the Colonial Brotherhood had the means by which to locate more Precursor sites.

Although redirected and misled, Shay eventually tracked Achilles and Liam to a Precursor Temple in the Arctic, which had an artifact similar to the one that had triggered the Lisbon earthquake. During an altercation between Shay and Liam the artifact was disturbed, triggering another earthquake that destroyed the Temple and mortally wounded Liam.

Through Shay's actions, the Colonial Templars had completed a purge of the Colonial Assassins, but Shay prevented Haytham Kenway from killing Achilles, arguing that Achilles needed to remain alive to explain the danger of seeking out Precursor Temples to fellow Assassins. In 1776 Shay went to Paris, where he assassinated Charles Dorian and recovered a Precursor box for the Templars.

Key Allies: George Monro, Christopher Gist, Haytham Kenway

Main Opponents: Achilles, Hope Jensen, Liam O'Brien

FRANÇOIS-THOMAS GERMAIN

"Think on this: the march of progress is slow, but it is inevitable as a glacier. All you have accomplished is to delay the inevitable. One death cannot stop the tide. Perhaps it will not be my hand that shepherds mankind back to its proper place — but it will be someone's."

— François-Thomas Germain

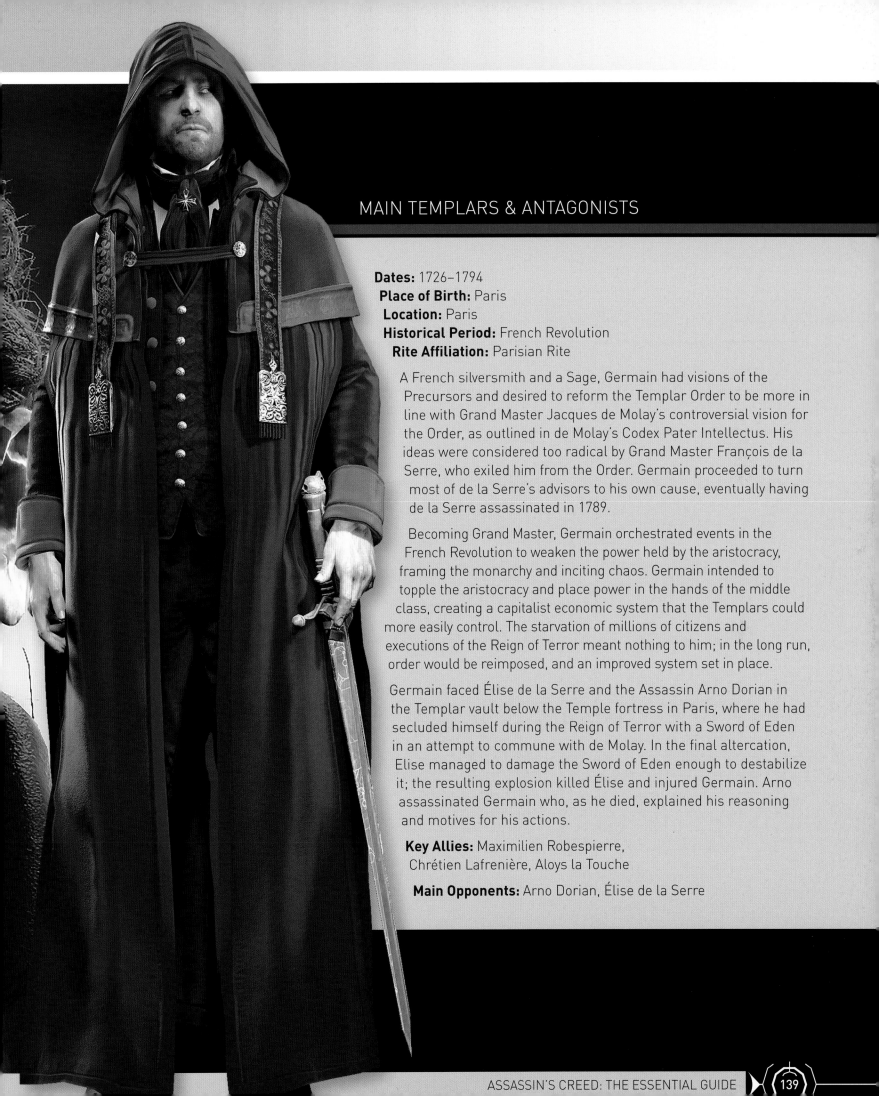

MAIN TEMPLARS & ANTAGONISTS

Dates: 1726–1794
Place of Birth: Paris
Location: Paris
Historical Period: French Revolution
Rite Affiliation: Parisian Rite

A French silversmith and a Sage, Germain had visions of the Precursors and desired to reform the Templar Order to be more in line with Grand Master Jacques de Molay's controversial vision for the Order, as outlined in de Molay's Codex Pater Intellectus. His ideas were considered too radical by Grand Master François de la Serre, who exiled him from the Order. Germain proceeded to turn most of de la Serre's advisors to his own cause, eventually having de la Serre assassinated in 1789.

Becoming Grand Master, Germain orchestrated events in the French Revolution to weaken the power held by the aristocracy, framing the monarchy and inciting chaos. Germain intended to topple the aristocracy and place power in the hands of the middle class, creating a capitalist economic system that the Templars could more easily control. The starvation of millions of citizens and executions of the Reign of Terror meant nothing to him; in the long run, order would be reimposed, and an improved system set in place.

Germain faced Élise de la Serre and the Assassin Arno Dorian in the Templar vault below the Temple fortress in Paris, where he had secluded himself during the Reign of Terror with a Sword of Eden in an attempt to commune with de Molay. In the final altercation, Elise managed to damage the Sword of Eden enough to destabilize it; the resulting explosion killed Élise and injured Germain. Arno assassinated Germain who, as he died, explained his reasoning and motives for his actions.

Key Allies: Maximilien Robespierre, Chrétien Lafrenière, Aloys la Touche

Main Opponents: Arno Dorian, Élise de la Serre

ÉLISE DE LA SERRE

''Assassin. Templar. Pah. They've got enough dogma for ten thousand churches and twice as much misguided belief. For centuries they've done nothing but squabble, and to what end, eh? Mankind carries on regardless.''

— Élise de la Serre

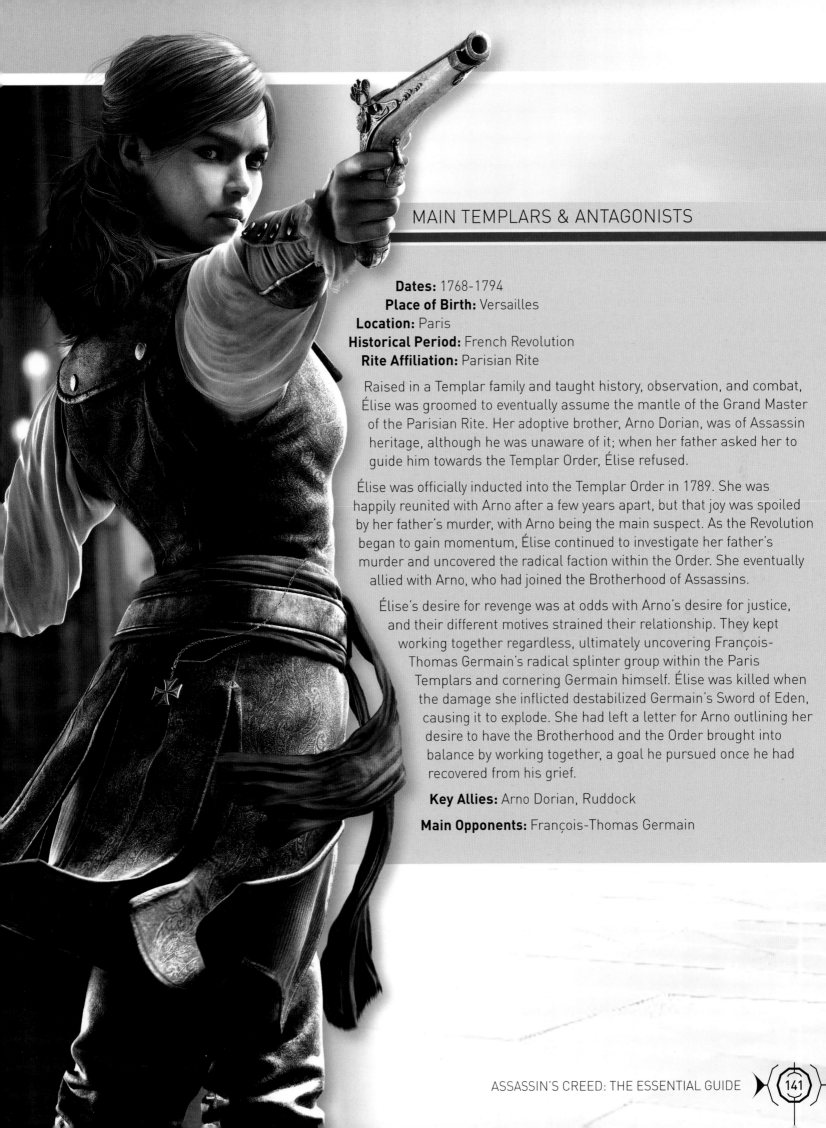

MAIN TEMPLARS & ANTAGONISTS

Dates: 1768-1794
Place of Birth: Versailles
Location: Paris
Historical Period: French Revolution
Rite Affiliation: Parisian Rite

Raised in a Templar family and taught history, observation, and combat, Élise was groomed to eventually assume the mantle of the Grand Master of the Parisian Rite. Her adoptive brother, Arno Dorian, was of Assassin heritage, although he was unaware of it; when her father asked her to guide him towards the Templar Order, Élise refused.

Élise was officially inducted into the Templar Order in 1789. She was happily reunited with Arno after a few years apart, but that joy was spoiled by her father's murder, with Arno being the main suspect. As the Revolution began to gain momentum, Élise continued to investigate her father's murder and uncovered the radical faction within the Order. She eventually allied with Arno, who had joined the Brotherhood of Assassins.

Élise's desire for revenge was at odds with Arno's desire for justice, and their different motives strained their relationship. They kept working together regardless, ultimately uncovering François-Thomas Germain's radical splinter group within the Paris Templars and cornering Germain himself. Élise was killed when the damage she inflicted destabilized Germain's Sword of Eden, causing it to explode. She had left a letter for Arno outlining her desire to have the Brotherhood and the Order brought into balance by working together, a goal he pursued once he had recovered from his grief.

Key Allies: Arno Dorian, Ruddock

Main Opponents: François-Thomas Germain

''Gentlemen! This tea was brought to me from India by a ship, then up from the harbor to a factory, where it was packaged and ferried by carriage to my door, unpacked in the larder and brought upstairs to me. All by men and women who work for me. Who are indebted to me, Crawford Starrick, for their jobs, their time, the very lives they lead. They will work in my factories and so too shall their children. ''

— Crawford Starrick

CRAWFORD STARRICK

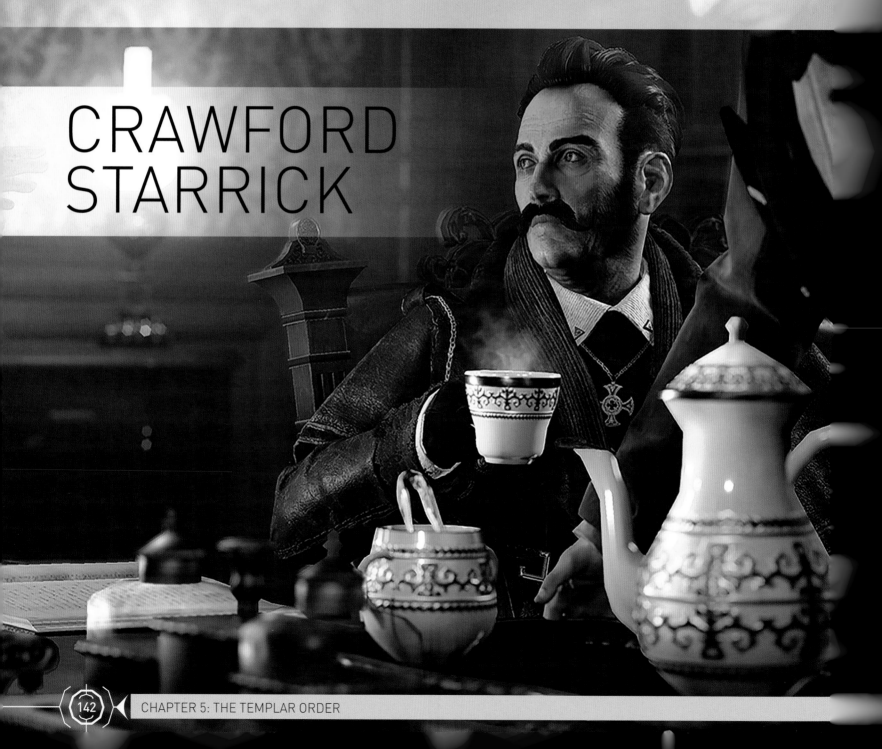

MAIN TEMPLARS & ANTAGONISTS

Dates: 1827-1868
Place of Birth: London
Location: London
Historical Period: Victorian Era
Rite Affiliation: British Rite

A deeply conservative man, order and control were Crawford Starrick's watchwords. He built an industrial empire of companies, ruthlessly controlling London by squeezing out or eliminating competition. His Templar network worked to keep the lower classes oppressed and too weak or dispirited to struggle against their unyielding masters.

Starrick dismissed the activity of the Assassins Jacob and Evie Frye, along with their colleague Henry Green, confident that it would be ineffective against the multi-layered control the British Templars had over all aspects of the city. However, when Jacob assassinated his cousin, Pearl Attaway, Starrick became determined to remove the twins from the equation. Shortly thereafter, Starrick's second in command, Lucy Thorne, was assassinated by Evie Frye, further cementing Starrick's decision to move against them and defend his grip on the city.

Starrick infiltrated Buckingham Palace during a party, intent on acquiring the Shroud of Eden from a crypt hidden underneath before assassinating the heads of church and state present. He reached the Shroud and wrapped himself in it, using the Shroud's powers against the Frye twins. It was not until Evie managed to remove the Shroud from Starrick's shoulders that the Assassins were able to overcome him, fatally wounding him at last.

Key Allies: Lucy Thorne

Main Opponents: Jacob and Evie Frye

"It shall happen in the shadows. Miss Frye will hang from the gallows and I will flay her brother as he comes to save her."

— Lucy Thorne

LUCY THORNE

Dates: 1837-1868
Place of Birth: London
Location: London
Historical Period: Victorian Era
Rite Affiliation: British Rite

From a young age, Lucy Thorne immersed herself in the study of occult philosophy, magic, and obscure religions. As she grew older she began collecting rare manuscripts, overspending on auctions of rare papers. At one such auction she met Crawford Starrick, who admired her passion and dedication. He introduced her to the Templar Order, and once inducted, she became his second in command.

Her knowledge of mystical and occult objects naturally led her to focus on the study of Pieces of Eden and other Precursor artifacts. She focused her efforts on locating the Shroud of Eden, and made her headquarters in the Kenway mansion.

Her pursuit of the Shroud led her to acquire a collection of historical Assassin papers and documents, which she had shipped to London. The Frye twins stole this delivery. Although they were forced to leave most of the valuable collection behind, Evie Frye managed to salvage a notebook, the loss of which frustrated Lucy Thorne. Evie used clues in the notebook to sneak into the Kenway mansion and locate a secret chamber containing Edward Kenway's memorabilia, and Lucy arrived too late to reach it before Evie sealed it.

Evie Frye was also one step ahead of her in obtaining the key to the vault that contained the Shroud, hidden atop St. Paul's Cathedral. Lucy wrested it from her, eventually taking the key to where she believed the Shroud to be located, the Tower of London. Evie Frye found her there, where the two battled and Lucy was assassinated.

Key Allies: Crawford Starrick

Main Opponents: Evie Frye

TEMPLARS AND ALLIES

SALADIN: [c. 1138–1193] Sultan of the Ayyubid dynasty, Saladin commanded the Muslim armies against Richard the Lionheart's invading European Crusaders. Known for his cunning, Saladin led an assault against the Brotherhood at Masyaf in 1176, but withdrew after the terms of a truce with the Assassins, which included the death of Umar Ibn-La'Ahad, Altaïr's father, were accepted.

HOUSE OF BARBARIGO: A Templar-affiliated Venetian noble family in the 15th century, the Barbarigo family was involved in a plot to seize control of Venice instigated by Rodrigo Borgia. Marco Barbarigo became Doge of Venice in 1485, securing the city for the Templars; however, he was assassinated that same year and replaced by Agostino Barbarigo, who was an Assassin ally. Regretfully, Agostino later fell under Templar sway, and was removed by the Brotherhood in 1501.

LUCREZIA BORGIA: (1480–1519) The illegitimate daughter of Rodrigo Borgia and the half-sister of Cesare Borgia, Lucrezia was like the rest of her family: ruthless, cruel, and violent when it served her purposes. However, she also had a kinder side, as seen in her affair with the Assassin Perotto Calderon and in her relationship with their son, Giovanni Borgia.

HOUSE OF PAZZI: A Templar-affiliated family of Tuscan nobles in the 15th century, the Pazzi family owned banks throughout Florence. With the support and assistance of Rodrigo Borgia, they conspired to overthrow and murder the Florentine rulers, the Medici family. This conspiracy failed thanks to the efforts of Lorenzo de' Medici and Ezio Auditore. Notable members of the family included Jacopo, Francesco, and Vieri de' Pazzi.

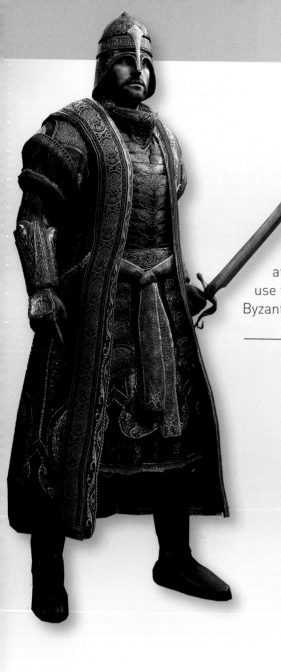

TARIK BARLETI: (1470–1511) Captain of the Janissaries, the elite Ottoman soldiers in charge of the Sultan's safety, Tarik was a man of honor, though arrogant and sometimes cruel. He committed to rooting out the Byzantine Templars in the city. By the order of Suleiman, he was assassinated by Ezio Auditore after being investigated for his failure to prevent an assassination attempt, even though the attempt had been unsuccessful. Ezio was later able to use the information given to him by Tarik to destroy the Byzantine Templars.

ABBAS SOFIAN: (1166–1247) Once Altaïr's childhood friend, Abbas eventually became an embittered rival. Strong-willed and quick-tempered, he staged a coup to seize the leadership of the Levantine Brotherhood while Altaïr was in Mongolia. He had Altaïr's youngest son, Sef, killed, and framed Malik Al-Sayf for the murder; he subsequently had Malik killed and accused Altaïr of the deed. Under his twenty-year Mentorship, Masyaf declined, the Brotherhood became corrupted, and respect for the Assassins ebbed.

MANUEL PALAIOLOGOS: (1455–1512) A Byzantine nobleman, Manuel was the heir to the Byzantine throne who planned to conquer Constantinople and restore the Byzantine Empire. He joined the Templar Order as a young man; in 1509, after living as a model Ottoman citizen for years, he brought in an army of Byzantine Templars and initiated the secret war with the Turkish Assassins. Manuel's position of power within the Byzantine Templars eroded as the younger, more charismatic Prince Ahmet joined the Templar Order and gradually took over as leader.

TEMPLARS AND ALLIES

BENJAMIN HORNIGOLD: (c. 1680–1719) A West Indies privateer, Benjamin Hornigold commanded a flotilla of ships and co-founded the Pirate Republic in Nassau. After Edward Kenway seized the ship that he renamed the Jackdaw, Benjamin was the one who taught him how to captain it. When the Pirate Republic degenerated into a slum, Hornigold felt that the British government could best impose order in the region. He sought a royal pardon, accepted the governor's offer to join the Templars, and became a pirate hunter, spending a year and a half hunting down his former allies. He was killed by Edward Kenway when his ship ran aground during a sea battle.

PIERRE, MARQUIS DE FAYET: (1675–1737) Under de Fayet's term as Governor General of Saint-Domingue, the slave population grew to three times the number of European colonists. Political instability accompanied these changes, leading de Fayet to secretly negotiate with the Maroon rebellion leader Auguste Dieufort. However, de Fayet abandoned negotiations and diplomacy, and he began dealing out harsher punishment and investing in ventures that would increase the slave trade. De Fayet was killed by the branding iron he sought to use on the Assassin Adéwalé.

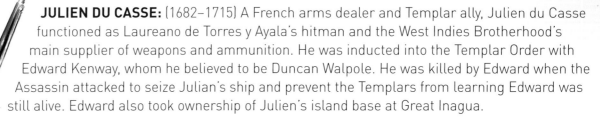

JULIEN DU CASSE: (1682–1715) A French arms dealer and Templar ally, Julien du Casse functioned as Laureano de Torres y Ayala's hitman and the West Indies Brotherhood's main supplier of weapons and ammunition. He was inducted into the Templar Order with Edward Kenway, whom he believed to be Duncan Walpole. He was killed by Edward when the Assassin attacked to seize Julian's ship and prevent the Templars from learning Edward was still alive. Edward also took ownership of Julien's island base at Great Inagua.

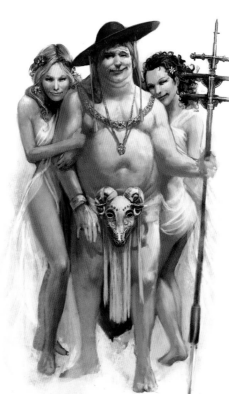

JUAN BORGIA THE ELDER: (1446–1503) A nephew of Rodrigo Borgia, Juan was a Templar and cardinal who handled Cesare's military funds, earning the nickname "The Banker." A cruel man with a capacious sexual appetite, Juan co-opted city funds to put on lavish entertainments. He was assassinated at one such party by Ezio Auditore.

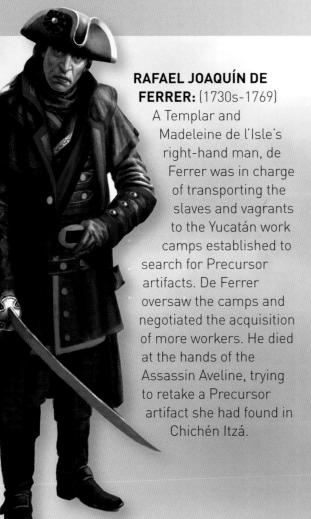

RAFAEL JOAQUÍN DE FERRER: (1730s-1769)
A Templar and Madeleine de l'Isle's right-hand man, de Ferrer was in charge of transporting the slaves and vagrants to the Yucatán work camps established to search for Precursor artifacts. De Ferrer oversaw the camps and negotiated the acquisition of more workers. He died at the hands of the Assassin Aveline, trying to retake a Precursor artifact she had found in Chichén Itzá.

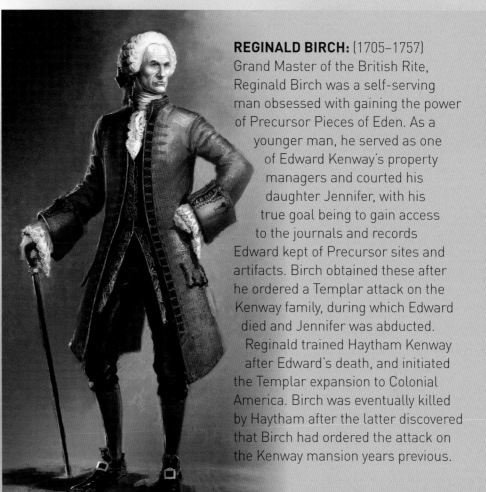

REGINALD BIRCH: (1705–1757)
Grand Master of the British Rite, Reginald Birch was a self-serving man obsessed with gaining the power of Precursor Pieces of Eden. As a younger man, he served as one of Edward Kenway's property managers and courted his daughter Jennifer, with his true goal being to gain access to the journals and records Edward kept of Precursor sites and artifacts. Birch obtained these after he ordered a Templar attack on the Kenway family, during which Edward died and Jennifer was abducted. Reginald trained Haytham Kenway after Edward's death, and initiated the Templar expansion to Colonial America. Birch was eventually killed by Haytham after the latter discovered that Birch had ordered the attack on the Kenway mansion years previous.

JIAJING EMPEROR (ZHU HOUCONG): (1507–1567) The eleventh emperor of the Ming dynasty, Jiajing ruled China from 1521 till his death in 1567. A puppet emperor placed in power by the Eight Tigers, a Chinese Templar faction, Jiajing was a pleasure seeker with a streak of sadistic cruelty. He was easily manipulated into hunting down political opponents and Assassin allies, resulting in the near elimination of the Chinese Brotherhood. He was killed by Assassins sent by Shao Jun in 1567.

EL TIBURÓN: (unknown–1722) The mute personal bodyguard of Grand Master of the Caribbean Templars and Governor of Cuba, Laureano de Torres y Ayala, El Tiburón was a menacing Templar ally who stood over six feet tall. He realized Edward Kenway was impersonating Duncan Walpole, and nearly overcame Edward at their final confrontation; only by shooting him did Edward overcome him.

TEMPLARS AND ALLIES

MAXIMILIEN DE ROBESPIERRE: (1758–1794) A charismatic but arrogant French lawyer and politician recruited into the Templar Order by Grand Master François-Thomas Germain, Robespierre was a key figure in the French Revolution and he set the Templar Order's goals ahead of his own personal ambition. Previously against the death penalty, Robespierre initiated the Reign of Terror, an enterprise that encouraged paranoia and sent thousands of accused counter-revolutionaries to their deaths. Robespierre was ultimately captured, shot, and interrogated by Arno Dorian and Élise de la Serre, informing them of the location of Grand Master François-Thomas Germain.

BERNARD RUDDOCK: (unknown–1794) A selfish, greedy, exiled Assassin of the British Brotherhood, Ruddock accepted a Templar-directed contract to kill Julie de la Serre, although the attempt failed. Years later Élise tracked him down to trace the identity of his employer at the time. Élise promised to help him regain his position within the Brotherhood by giving him letters from Haytham Kenway if he helped her. After her death, Ruddock attempted to take her maid hostage to coerce Élise's allies into giving him more than Élise had promised, but was killed.

WILLIAM SLEEMAN: A man with interest in the scientific community, Templar William Sleeman was assigned to be Francis Cotton's replacement. An active seeker of Pieces of Eden, he was especially interested in rumours that Alexander the Great wielded a Staff of Eden. The dossier Cotton had assembled on Arbaaz Mir and the Koh-i-Noor included a Precursor Box that Cotton had theorized required a power source to operate, motivating Sleeman to focus his attention on the Assassin Brotherhood in Amritsar.

JAMES COOK: (1728–1779) A British explorer and cartographer, James Cook was a Templar ally during the Seven Years' War. He allowed Shay Cormac to take command of his ship, the HMS Pembroke, during the siege of Louisbourg, to break the French fleet protecting the fort. Cook subsequently offered naval support and aid to Shay and the Templar cause. While Cook had no knowledge of the Templars, assuming Shay and his allies worked for the British crown, his knowledge and skills were valuable support to the Order's activity.

WILLIAM HAY MACNAGHTEN AND GENERAL FRANCIS COTTON: Templar ally Macnaghten (1793–1841), aide to the British Governor-General to India, and Cotton (unknown–1839), a Templar general assigned to Macnaghten, plotted together to poison Maharajah Ranjit Singh in 1839. When Cotton encountered Assassin Arbaaz Mir there in disguise, he became suspicious; and while spying on the Assassin, Cotton caught him stealing the Koh-i-Noor from catacombs beneath the palace. He had Arbaaz arrested and imprisoned. Arbaaz escaped, but was too late to prevent Cotton from poisoning Singh; Cotton attempted to flee, but encountered Pyara Kaur in possession of the Koh-i-Noor. Cotton shattered the Piece of Eden with a bullet, and the resulting energy blast killed him.

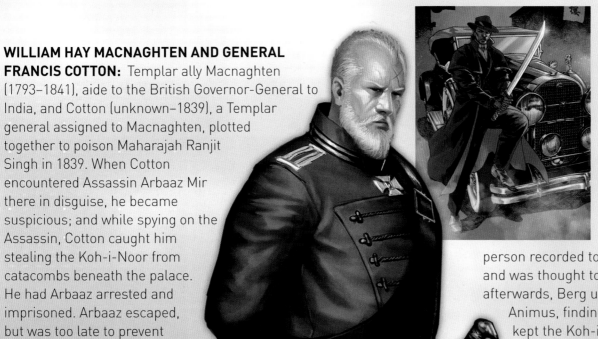

ALBERT (ALBIE) BOLDEN: (1893-unknown) Albie Bolden was a Templar agent operating in the 1920s. He assumed the position of the Black Cross for the Order, functioning as the secret inquisitor for the Inner Sanctum, tasked to take down any corrupt Templar members. In 2013 Otso Berg discovered that Albie Bolden was the last person recorded to encounter the Koh-i-Noor and was thought to have died. Sometimes afterwards, Berg used André's blood to go in the Animus, finding that Albie had survived and kept the Koh-i-Noor. This allowed Berg to continue the hunt for the Koh-i-Noor, which Albie had lost to Rufus Grosvenor. Albie then helped Assassin Ignacio Cardona seize the gem from him during the Spanish Civil War. Bolden and Cardona had left the artefact buried under the ruins of a church in 1937, and trained several young locals as guardians of the artefact before going their separate ways.

GEORGE MONRO: (1700–1757) Initially a member of the British Rite, then of the Colonial Rite, Templar George Monro was a colonel in the British Army during the Seven Years' War. His men rescued ex-Assassin Shay Cormac after the Colonial Assassins believed him dead. A gentle man who believed the Templar path was the ideal cause, Monro recognized Shay's potential and convinced him to join the Templars, passing his Templar ring to Shay as he died. Monro's honesty and honorable character did much to recommend the Templar cause to Shay, who ultimately accepted the Order's ideology.

TEMPLARS AND ALLIES

TSAR ALEXANDER III:

(1845–1894) Alexander III was a Templar ally, as his father had been. When his father was assassinated by the Russian Brotherhood in a bid to free Russia from Templar control, Alexander moved to arrest the Russian Assassins. A later Assassin plot to remove him from the throne was uncovered by the tsar's secret police; many of the conspirators were hanged. In 1888 Alexander was the target of another assassination attempt by Assassin Nikolaï Orelov while traveling to St. Petersburg by train; the tsar fought off the attack, but the train derailed, resulting in the Borki train disaster.

GERO KRAMER:

(unknown-1943) An SS General during World War II, Gero Kramer was a member of the Templar Order, working to deliver Germany to the Nazis. Secretly, Kramer was also one of the founding members of Abstergo Industries.

During World War II, Kramer oversaw the Uranprojekt, a Nazi operation aimed at developing atomic weapons for the Third Reich. This project was used as a cover to covertly finance Templar projects, such as the proto-Animus known as Die Glocke, and Josef Mengele's research on genetics in pursuit of the übermensch. Die Glocke was the first iteration of what would become the Animus. It was designed by Nikolas Tesla, who used an Apple of Eden to power it.

WILLIAM STOUGHTON & SAMUEL PARRIS:

Stoughton (1631–1701), a member of the Templar Order and a magistrate in Massachusetts, was in charge of the Salem witch trials. Learning that Assassins had come to Salem seeking a Piece of Eden, he encouraged citizens to seek them. Samuel Parris (1653–1720), a Puritan minister and member of the Templar Order, was a key accuser of witches during the trials. Although Parris objected to Stoughton's attempts to direct the witch trials toward hunting Assassins, he assisted in locating Thomas Stoddard and Jennifer Querry. Uncomfortable with Stoughton's cruel torture while interrogating the Assassins, Parrish shot Stoughton, then gave Stoddard the keys to the cells, telling him to free the prisoners and reminding him that not all Templars should be judged by the evils of one.

THOMAS EDISON: (1847 – 1931) The American inventor and scientist who became famous thanks to his life-changing inventions, like the lightbulb, and the phonograph, was also a member of the Templar Order. He successfully dedicated a lot of effort to discrediting the inventions of his rival, Nikola Tesla, who was able to use an Apple of Eden to aid his work. With the aid of the Templars, Edison took possession of Tesla's Apple of Eden, and went on to create inventions that garnered him widespread fame and success.

RUFUS GROSVENOR: (1895 - unknown) Before World War I, Grosvenor was a Templar and a member of a Juno-themed cult led by the Master Spy. Rufus escaped Lydia Frye's purge of the cult by being out of the country. For nine years he pursued ex-Black Cross Albie Boden to steal the Koh-i-Noor until he finally traced Bolden's family and slaughtered them. As Bolden grieved, Grosvenor stole the Piece of Eden and fled to Spain in order to pose as Assassin Norbert Clarke and persuade Ignacio Cardona, an Assassin with a high concentration of Isu DNA, to use the Koh-i-Noor. Bolden followed and helped Cardona fight Grosvenor, who fled to America. The Koh-i-Noor ended up buried in the ruins of a church used as a mass grave of victims of the Spanish Civil War.

ZHANG YONG: (1470–1532) Leader of the Eight Tigers, a Templar faction, Zhang Yong controlled much of the Chinese imperial court. The Eight Tigers masterminded the Great Rites Controversy to flush out Chinese Assassins in places of power within the imperial court, as well as arranging the ascension of a new puppet emperor, Jiajing. Zhang Yong was assassinated in 1532 by Shao Jun at the Great Wall of China, where he had planned to allow the Mongol forces into China.

CHARLES LEE: (1732–1782) Second in command to the Grand Master of the Colonial Rite, Haytham Kenway, Charles Lee was a violent, impulsive, and vengeful man. A former British officer, Lee joined the Continental Army, and was second only to Washington himself in rank. Lee chafed at this and, critical of Washington's leadership, he allowed himself to be captured by the British during Washington's retreat across New York and New Jersey in 1776, giving them critical information on the Continental forces. He briefly served as the Grand Master of the Colonial Rite after Haytham's death, but only until he was killed by the Assassin Connor.

CHAPTER 6: TECHNOLOGY AND WEAPONS

CHAPTER 6

TECHNOLOGY AND WEAPONS

The struggle between the Assassins and the Templars has evolved through the ages, and so have the technology and weapons used in their covert war. From the Animus to the iconic Hidden Blade, each faction seeks to make improvements to their weaponry and technological devices in an attempt to get the edge over their opponents.

THE ANIMUS

At the heart of the search for Precursor information and artifacts is the Animus.

INTRODUCTION

Partially inspired by Precursor technology, the Animus was developed by Abstergo Industries in the 1970s and 1980s under the guidance of Dr. Warren Vidic, who was one of the world's leading authorities on genetic memory. The goal of the Animus Project was to explore genetic memories via virtual reality simulations. The Templars were confident that the information obtained via these simulations would lead them to discover more information on Precursor artifacts and knowledge. As the Animus technology evolved to become more refined and sophisticated, it became a way for a user to actually interface with history.

The range of operations provided by the Animus soon became broader than initially envisioned. This virtual experience simulator technology has been used not only to examine genetic memories, but also to train Abstergo employees, and secretly collect genetic memories from the unknowing public under the guise of a video game. In addition, the Animus technology has served as a way to explore the nature of memory and the human mind; high-risk medical experiments have been conducted with the aim to erase memories, replace them, and 'reprogram' a person's impulses - with varying degrees of success.

The Animus has the ability to adapt the genetic memory it simulates to the user's level of experience and preference. If the user is new to the Animus, or wishes to have a seamless interactive experience, they can adjust the settings of the Animus in order to filter out more challenging or traumatic aspects of the memory. As a user improves their level of synchronization with the memory, the Animus allows them to move deeper into the simulation. In essence, the Animus uses intelligent algorithms that can adapt its functionality to the user's preferences and level of experience.

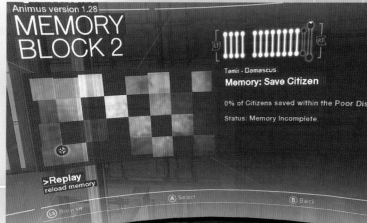

HOW DOES IT WORK?

Animus technology functions in much the way a simulator/ projector does. Your consciousness will tap into the genetic coding in such a way that everything will appear to all your senses as three-dimensional—putting you in the heart of the action. It's adaptive, so as the memories unfold, the 'program' you experience begins to change subtly. They will appear to you as glitches and let you explore a memory much more closely.

— The Abstergo Entertainment Employee Handbook, 2014.

SUBJECT 4:

Dr. Vidic achieved a huge scientific breakthrough during the testing on Subject 4, Daniel Cross. Reaching beyond simply viewing the genetic memories of his patient, Vidic managed to apply Animus technology in combination with brain surgery in order to erase parts of Daniel Cross' memories, and implant a sequence of uncontrollable impulses that would be activated by certain triggers. Subject 4's 'reprogramming' meant that Vidic had been able to exert control over the mind of a person, leading the Templars to their great victory over the Assassins during The Great Purge in 2000.

Officially, Abstergo and the Templars spearheaded the developments of the Animus and its technology. However, throughout the decades the Assassins have been able to obtain, build, and even improve Animus devices for their own use. Co-opting materials and software acquired from Abstergo through raids, espionage, and hacking, the Assassins have been able to hold their own against the vastly superior resources and facilities of the Templars.

Early Templar attempts at constructing a machine to explore ancestral memory began in the 1930s, using a design created by Nikola Tesla and incorporating technology stolen from the Allies as well as an Apple of Eden. Nicknamed Die Glocke for its bell shape, this device was based on an anti-gravity system that generated a wormhole to the genetic past of the user, through which the user viewed events. Although it would take decades for developments to advance, the scientific knowledge behind the invention of Die Glocke would become instrumental to the later development of the Animus.

During development at Abstergo, subjects were observed having difficulty interfacing with the Animus. When the interface design of Animus model 1.28 was modified to be more like videogame controls, the response rate improved drastically.

As the Assassins further improved their own Animus, the interface allowed the users to interact marginally with the environments they viewed via the memory. By the time Assassin Rebecca Crane developed the 2.0 model, the user could control the rate at which the memory progressed. Over-interference with the memory would bring about desynchronization, however, resetting the memory to an earlier point to be experienced again. In extreme cases of desynchronization, the Animus could eject the user entirely from the memory. Rebecca and other Assassins would continue to fine-tune and improve upon this model.

The Data Dump Scanner (DDS) was a software that allowed users to relive any prerecorded memory, without having to possess a genetic link to the memory being viewed. Created by Abstergo Industries for their Project Legacy initiative, the DDS was used in conjunction with the Animi Training Program to train Templar agents.

The Animus Omega, created in 2013, was used internally at Abstergo Entertainment during research and analysis for the Sample 17 Project, which had employees viewing memories harvested from Subject 17, Desmond Miles, supposedly to explore potential new settings for future games. In reality, the material was being mined for Precursor information.

The Animus console was a model of the Animus produced by Abstergo Entertainment, marketed to the public as an entertainment console in 2012. The Animus console offered the opportunity to experience edited memories marketed as educational, interactive, immersive games, intended to influence the public in a pro-Templar way.

In 2013, Abstergo Industries went on to produce another entertainment device with Mysore Tech called the **Brahman V.R.,** a mass-produced portable Animus machine that collected the genetic memory of players without their knowledge.

The Animus tech, in conjunction with the DDS software led to the development of **Helix** in 2014. Cloud-based software created by Álvaro Gramática, Helix framed memories of Assassins and Templars throughout history within a Templar-sympathetic, propaganda-like narrative. The Helix program also had Templar initiates run through genetic memories of individuals unrelated to them in order to seek information regarding the Precursors and their artifacts. Its cloud-based nature made Helix software vulnerable to hacking attempts by the Assassins and their sympathizers, who did not let any opportunity for interference go unused.

A classified experiment at Abstergo in 2016 used additional sources, such as the written accounts, letters, and DNA of eye-witnesses, in order to compliment the source DNA and generate algorithms of 'probable paths' – these were called the 'extrapolated memories'. They were reliable simulations of genetic memories that extended beyond the moment the subject procreated and passed on his or her genetic memories to a descendant.

The Abstergo Animus underwent a significant development around 2017 with the creation of **4.3** and **4.35**, full-immersion versions that suspended the user in a harness and allowed physical movement when synchronized. While the 4.3 allowed for immersion to the extent it actually trained the user, optimizing the quality of the simulations as well as the desired results of the Bleeding Effect, it was not at all user-friendly. The 4.35 was a more streamlined version, and with less chance of harm to its user, models of this kind were used at the Aerie facility, as well as by the Inner Sanctum quarters in London.

Also in 2017, Abstergo developed a method to use DNA to directly view the genetic memories of someone who was unrelated to the subject, without the need for processing and uploading time, although it was not fully refined.

In 2017 Abstergo employee Layla Hassan independently modified an HR-8, an Abstergo field Animus, and illegally tested it on a mission in Egypt. This model expanded upon the ability to immediately view unprocessed, non-biologically related memories, and also proved capable of separating two sets of DNA, and choosing one to follow; capabilities thought to be far beyond what a field Animus could achieve.

By 2018, Layla had joined the Assassins, and made advancements in using external objects to further reinforce the functionality of the HR-8 Animus and the quality of its simulations. In order to achieve this, Layla built on the existing technological innovations she had been exposed to while working at Abstergo. These improvements allowed a more accurate and immersive experience, even when using incomplete or ancient genetic material, with minimal to no chance of desynchronization. Layla named this version of the portable Animus the HR-8.5 Beta.

▶ 1459
EZIO AUDITORE

SEQUENCE 3

REQUIESCAT IN PACE
1476 - 1478

THE ANIMUS TIMELINE

1977: Assassin William Miles steals a copy of the Animus blueprints and passes them to an Assassin cell in Protvino, Russia, enabling the Assassin Brotherhood to use the blueprints as a basis for developing their own Animus. From this point, the Animus develops in two parallel streams, although the Assassins are slower to produce their model, as they lack Abstergo's access to previous research and cutting-edge technological development.

1952: A letter by Clinton B. Rosenburg informs Abstergo Chemicals of scientist Linus Pauling and his Triple Helix DNA model. Abstergo consequently start to focus on genetic research.

October 1943: Project Rainbow (also known as the Philadelphia Project, or Philadelphia Experiment), a joint venture between the Brotherhood and the Templar Order to alter the past in order to prevent the horrific events of World War II, fails. The USS Eldridge, the ship where the experiment took place, temporarily manifested in a future state for about 18 minutes, and the Apple of Eden was severely damaged in the process. The risks involved with any further attempts to manipulate time were deemed too high, and the project was classified a failure.

1976: Dr. Warren Vidic begins drafting blueprints for what would become the Animus, in response to the newly uncovered evidence of triple-helix DNA.

February 1943: Die Glocke, an early Animus ancestor powered by an Apple of Eden, among other things, is tested on Eddie Gorm, a British Assassin captured by the Templars.

1978: Abstergo builds the first Animus device, launching the discipline of DNA Memory Research.

THE ANIMUS TIMELINE

1985: The Animus Project is formally launched with the **Animus model 1.09.**

1980-81: Aileen Bock uses the Animus to test the possibility of viewing the memories of someone unrelated to the subject. The **Surrogate Project** is shut down in 1981 after Bock experiences damage during a self-testing session.

1983: Abstergo captures Daniel Cross, a young American boy of Assassin descent. His codename will be Subject 4.

1991: The Russian Brotherhood of Protvino finally builds an Animus prototype. However, the volunteers who use it emerge as madmen, so the Assassin in charge of the project, Medeya Voronina, decides that she will be the only test subject from this point on. She will fall into madness as well. 23 years later, her daughter, Galina Voronina, will kill her to end her suffering.

1980: Abstergo first uses the **Animus 1.0** model on a human subject, known simply as Subject 1 in the classified material. The procedure is recorded as being extremely painful and dangerous. Warren Vidic volunteers to become the next Animus subject (Subject 2) and explore his own genetic memories.

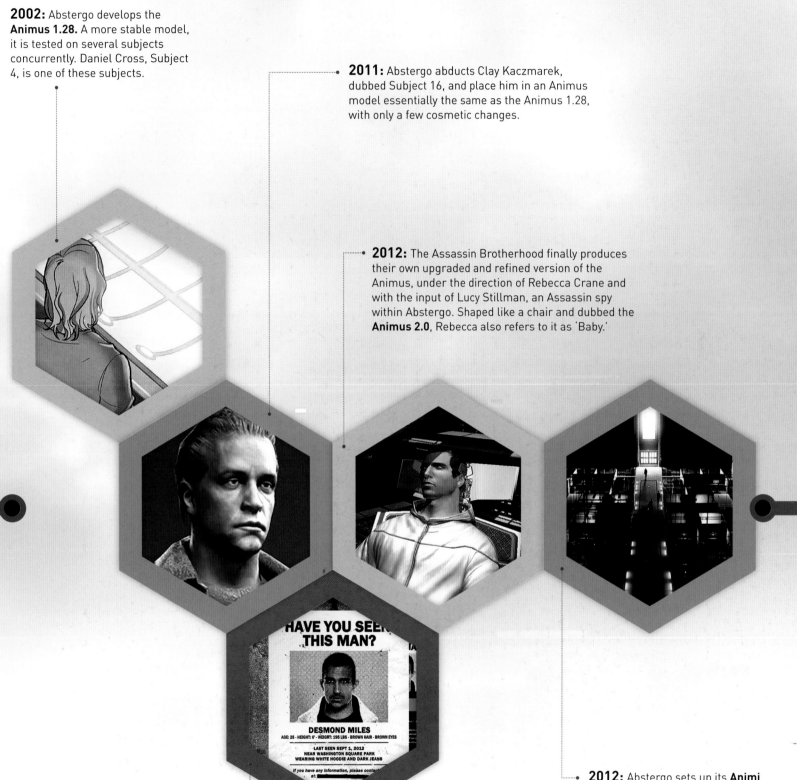

2002: Abstergo develops the **Animus 1.28.** A more stable model, it is tested on several subjects concurrently. Daniel Cross, Subject 4, is one of these subjects.

2011: Abstergo abducts Clay Kaczmarek, dubbed Subject 16, and place him in an Animus model essentially the same as the Animus 1.28, with only a few cosmetic changes.

2012: The Assassin Brotherhood finally produces their own upgraded and refined version of the Animus, under the direction of Rebecca Crane and with the input of Lucy Stillman, an Assassin spy within Abstergo. Shaped like a chair and dubbed the **Animus 2.0,** Rebecca also refers to it as 'Baby.'

2012: Abstergo sets up its **Animi Training** Program, using Animus technology to train employees in the skills required to fight the Assassin Brotherhood. In time, Abstergo will use this as a template for entertainment experiences.

2012: Desmond Miles is captured and becomes Subject 17, his bloodline being of specific interest to the Templars and the Animus Project.

HAVE YOU SEEN THIS MAN?

DESMOND MILES
AGE: 25 - HEIGHT: 6' - WEIGHT: 195 LBS - BROWN HAIR - BROWN EYES

LAST SEEN SEPT 1, 2012
NEAR WASHINGTON SQUARE PARK
WEARING WHITE HOODIE AND DARK JEANS

If you have any information, please contact at:

THE ANIMUS TIMELINE

December 2012: The Assassins upgrade and improve their Animus, renamed the **Animus 3.0.**

2013: Abstergo uses Animus and DDS tech to allow anybody to view genetic memories of individuals — the **Animus Omega** is created. It soon becomes available as a game console.

2014: The Helix Project is created, a cloud-based version of the Animus that enables public users to access specific edited and curated memories held within Abstergo's genetic memory servers without a console. Abstergo privately mines the user-uploaded genetic memories to locate memories of individuals who have come into contact with Pieces of Eden or whose bloodlines are associated with the Precursor civilization, the Assassins, or the Templars.

2014-15: The **Animus V.R.,** a version of the Brahman V.R. created for the North American market, is released. A widespread commercial success, the Animus V.R. is available in a range of models at different price points, from basic to highly sophisticated.

2013: The Abstergo Entertainment division head office, set up in Montréal, widely utilizes the Animus Omega to develop entertainment products. By late 2013, it makes a deal with Indian company Mysore Tech to release **Brahman V.R.** onto the Asian market. Unknown to the public, this device has the added functionality of uploading the genetic memories of the users into the Abstergo Cloud.

2014: The Helix Project is hacked by a group of Assassins in order to reach out to other potential sympathizers.

2016: Following research based on V.R. technology, Abstergo realizes it can maximize the efficiency of the Animus and even harness the Bleeding Effect when immersion and physicality are combined within the Animus technology. Several Abstergo facilities around the world develop new models based on this principle:

• With Animus versions 4.3 and 4.35 the user no longer sits on a chair but is suspended mid-air by harnesses. The subject's experience is quite smooth thanks to machine parameters adapting to each individual's neurometrics. These versions allow the user physical movement while synchronized.

• The Animus 4.3 used in the Madrid facility is extremely invasive, using a lumbar puncture to connect the user to the technology. The London version, 4.35, replaces the lumbar puncture with a helmet and exoskeleton. The Aerie, an American facility, used a 4.35 model for use with underaged research participants.

2017: Layla Hassan privately modifies a HR-8 model, building on the Abstergo-developed ability to view non-biologically related memories. Layla's modified Animus allows her to slip into the genetic memory of anyone she has a DNA sample from, not only an ancestor, achieving a hitherto unknown level of synchronization. Her prodigy-like modifications also allow for using damaged DNA, something that the standard Animus had been unable to handle up to this point. Her improved model also proves capable of following two sets of DNA, an ability far beyond the expected capability of a field Animus. Layla brings this Animus with her when she defects to the Brotherhood.

Early 2016: It appears that a former Abstergo employee named Sebastian Monroe has stolen a valuable piece of technology and the associated research. With that, Monroe developed a unique Animus which allows multiple users who have ancestors with 'memory concordance' to share the same simulation.

2015: In San Diego, a group of Assassins develops a new working version of the Animus dubbed the Red Rider. Mostly created from older Animus parts by Kody Adams with help from Rebecca Crane, this version of the Animus can be powered by long-lasting batteries, making it possible to use it while on the move.

2017: The newest model of the Animus, the portable HR-8, is developed by the Abstergo facility in Madrid under the direction of Dr. Sophia Rikkin. The HR-8, a sarcophagus shape, can be folded and carried as a suitcase. The epidural connection is replaced with a hematological link, through which information is sequenced and data sent to every organ of the user, instead of only the brain.

2018: Layla's further engineering modifications include using external objects to further reinforce the functionality of the Animus, such as books and weapons. These advancements create a more accurate and immersive experience, with minimal to no desynchronization. The interface is now even more compact, essentially a VR headset connected to the computers that process the data. Layla refers to this model as the HR-8.5 Beta.

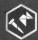
ANIMUS APPLICATIONS AND PROGRAMS

Since its creation, the Animus has been used for more than simply viewing genetic memories. A major application of the Animus has been its use as a virtual training environment.

THE ANIMI TRAINING PROGRAM

Not long after Desmond Miles escaped the Animus Project laboratory with the help of Lucy Stillman, Dr. Warren Vidic implemented the Animi Training Program at the Abstergo Campus in Rome. A secret Templar initiative, the Animi Training Program was designed to train selected Abstergo Industries employees in the skills they needed to fight the Assassin Brotherhood, such as freerunning and combat.

The first stage of the program had multiple subjects reliving the experiences of notable Templars and other non-Assassin individuals from the Renaissance era and training together in virtual combat. The second stage employed the same scheme, but with a simulation time period in the 15th century Ottoman Empire.

THE ANIMUS VIRTUAL TRAINING PROGRAM

Assassin Rebecca Crane created the Animus Virtual Training Program as a special feature in Animus 2.01. This series of tutorial missions allowed Desmond Miles to practice freerunning, combat, and assassination techniques in a neutral environment outside of the actual genetic memories simulation.

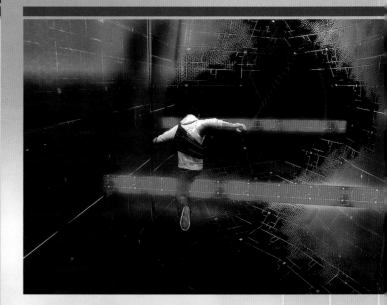

KNOWN ANIMUS SUBJECTS

Subject 0: Aileen Bock (via the Surrogate Initiative)

Subject 1: unidentified male descendent of Aveline de Grandpré; died of a seizure during testing, 1980

Subject 2: Warren Vidic (private use)

Subject 4: Daniel Cross, 1983

Subject 12: unidentified individual whose ancestor was involved in the 1943 Philadelphia Project experiment, a military experiment that attempted to change the past to modify the present.

Subject 15: unidentified pregnant female, 2010

Subject 16: Clay Kaczmarek, 2011

Subject 17: Desmond Miles, 2012

Abstergo Foundation Rehabilitation Center, Madrid, 2016: Several subjects coming from a lineage of Assassins were being used for extensive testing and experimentation. Among them was Callum Lynch, who led a collective breakout from the facility.

ANIMUS PROJECTS

Surrogate Initiative: The Surrogate Initiative explored the possibility of viewing a genetic memory via an unrelated individual. Led by Aileen Bock, the Initiative was suspended in 1981 after Bock suffered physical trauma in response to a memory during a viewing session. The Surrogate Initiative material would eventually serve as one of the inspirations for the Sample 17 Project.

There is evidence that Warren Vidic sabotaged the Surrogate Initiative to ensure that his own Animus Project remained properly funded.

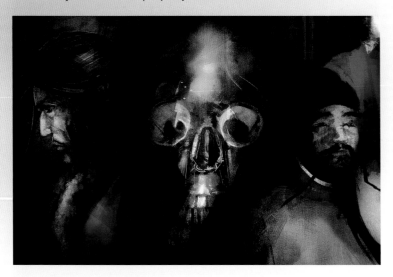

Project Legacy: Using the Data Dump Scanner, Abstergo agents analyzed the memories of specific individuals of interest to the Templar Order. Launched publicly in 2010 as a social media experience, Project Legacy allowed people to relive the experiences of historical figures. This project was placed on hold indefinitely in 2012 due to security concerns.

Sample 17 Project: Headed by Melanie Lemay and based heavily on the research of the Surrogate Initiative, this project was launched to examine the genetic memories contained within genetic material harvested from Desmond Miles after his death in 2012. This project proved that a direct biological link was not required to examine a memory. The stated goal was to locate material for future games and films; the life of Edward Kenway was located and explored via this project. However, the underlying motive of the Sample 17 Project was to locate more Pieces of Eden and other pieces of Precursor technology.

Sophia Project: An on-going Abstergo project that studies the information imprinted on human cells,

examining how information is passed biologically. By understanding this process, Abstergo could make revolutionary advancements in disease prevention.

Phoenix Project: A project originally designed to sequence triple-helix Precursor DNA, grow a Precursor body, and explore the genetic memories encoded in it via the Animus. The project was infiltrated by the Instruments of the First Will, who co-opted it in order to pursue their goal of bringing Juno's consciousness into a physical body. In 2018, the project's director Álvaro Gramática succeeded in creating a body for Juno, using the Precursor DNA-rich blood and bone marrow of Elijah, the son of Desmond Miles. Juno incarnated, but was killed almost immediately by Assassin Charlotte de la Cruz. The Phoenix Project lab was subsequently destroyed by Templar and Black Cross Otso Berg.

OTHER ABSTERGO PROJECTS

Project Rainbow: A joint venture between the Brotherhood and the Templar Order to alter the past using Die Glocke, an Animus prototype designed by Nikola Tesla and partially powered by an Apple of Eden, to transfer the *USS Eldridge* back in time to prevent the horrific events that would take place during World War II. The plan failed; the ship temporarily manifested in a future state for approximately 18 minutes, and the Apple of Eden was severely damaged in the process.

Akashic Satellite Plexus: This satellite network has been gathering a wide array of information for Abstergo Industries since 2008, through communication and observation technology.

Eye-Abstergo Project: A satellite containing an Apple of Eden, the Eye was to be the cornerstone of the Akashic Satellite Plexus, which would amplify the power of the Apple of Eden, as well as facilitate Abstergo's observation of humankind. Originally scheduled for September 2012, the launch was postponed to December 2012 when the Apple of Eden destined to be placed in the Eye was destroyed; a replacement Apple could not be obtained.

TERMS AND VOCABULARY

GENETIC MEMORY

Genetic memory is a theory of evolutionary biology hypothesizing that DNA, apart from its function as a genetic blueprint for growth and development of a species, can also be a repository of individual memory, skills, experiences, and information passed on to descendants. Genetic memory is thought to be passed from parent to child at the moment of conception.

MEMORY CORRIDOR

The Memory Corridor is an isolated virtual area that exists outside the simulation, generally presented as a blank, neutral field, allowing the user to acclimate to the virtual experience while the recorded memory loads. This virtual area can also be used as a training ground or a space in which to examine specific data collected from a memory.

BLEEDING EFFECT

Prolonged use of the Animus can cause the Bleeding Effect, a condition where the user's real-time experience would blend with genetic memories, with the ancestor's thoughts and skills "bleeding" through to the user's own personality when away from the Animus. Inability to distinguish between an ancestor's memories and one's own, experiencing auditory or visual hallucinations, and manifestation of skills or abilities outside the Animus are all symptoms of the Bleeding Effect. The degree of severity often corresponds to the overall length of exposure to the Animus.

BLACK ROOM

Also referred to as Animus Island, the Black Room functions as a safe mode within the virtual Animus. Clay Kaczmarek inserted an AI copy of his consciousness into the Black Room, where it remained even after his physical body died. When Desmond Miles's mental state was too crippled to interface with the regular Animus mode after he fell into a coma in October 2012, he was connected to the Black Room in order to be stabilized.

DANGERS AND SIDE EFFECTS

As the Animus is a full-immersion experience, viewing distressing experiences or traumatic memories can stress users mentally, emotionally, and physically as they relive the genetic memory. Use of the Animus at an early age was also discovered to be dangerous; side effects are quicker to manifest in younger subjects. Overuse of the Animus technology has been demonstrated to lead to various degrees of mental instability. This was especially true early in the project's development, when the dangers and side effects were not yet known. Extreme overuse of the Animus technology results in severe mental degradation, and can lead to psychological instability.

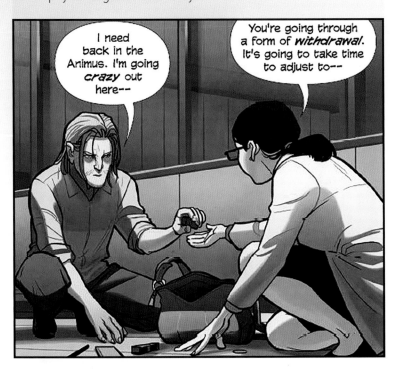

HARNESSING THE BLEEDING EFFECT

Some people have demonstrated the strength to harness the Bleeding Effect to improve their own skills without long-lasting negative impact. As Animus technology has been refined and improved, the dangers have been reduced. Otso Berg used the Animus to learn about the Black Cross techniques, and Charlotte de la Cruz spent considerable time in the Animus to trace clues about the whereabouts of the Koh-i-Noor, which also enabled her to successfully absorb Assassin techniques and skills in a comparatively brief period of time.

SYNCHRONIZATION

Synchronization is a method by which the user's experience in the Animus aligns with the memories of the ancestor. A subject is carefully eased into synchronization by brief sessions in the Animus; as exposure is gradually increased, the user's subconscious becomes acclimatized to the genetic memories and eventually accepts them as natural instead of foreign. Full synchronization occurs when the user is fully integrated with the genetic memory of the ancestor and follows the memory precisely as it originally happened, with no deviance. It allows full access to the memories available, possibly even repressed ones.

DESYNCHRONIZATION

Desynchronization occurs when a user deviates from the path of a memory in some way. This derails the memory, making it unstable. An unstable memory may manifest as the environment fading beyond the subject's immediate vicinity, or displaying audio or visual glitches. If destabilized enough, the user and the memory desynchronize completely and the memory restarts from an earlier, more stable point. A severe desynchronization may eject the user from the virtual experience completely.

There is speculation that certain psychological disorders or phenomena, such as past-life regression and multiple personality disorder, may be linked to a naturally occurring form of the Bleeding Effect.

THE HIDDEN BLADE

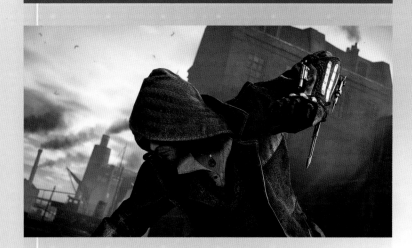

The Hidden Blade is the signature Assassin weapon. A three-part blade housed in a bracer, it is almost invisible when retracted. When the Assassin triggers the extension mechanism, the blade extends along the underside of the forearm, past the ends of the fingers. Discreet and versatile, the Hidden Blade is the hallmark of an initiate who has attained full Assassin status.

EARLY MODELS

Early models of the Hidden Blade featured a large leather bracer worn on the Assassin's forearm, into which was set a channel for a telescopic blade. The spring-loaded mechanism to extend the blade was triggered by a ring cuff on the Assassin's little finger, making the extension as easy as flicking the finger. This basic version of the Hidden Blade was very much a stealth weapon; using it in melee wasn't an option due to the size of the blade and the limitations of leather used for the bracer.

This early model of the Hidden Blade also required the Assassin to amputate the ring finger of the left hand, so that the blade could extend through the resulting gap when the hand made a fist. In this way, the Hidden Blade functioned as that missing finger, becoming an extension of the Assassin's own body. It also meant that only someone completely committed to its use could operate it.

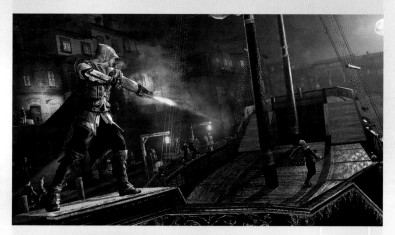

ALTAÏR'S REDESIGNS

In the thirteenth century Altaïr redesigned the Hidden Blade after examining information provided by an Apple of Eden, including his plans and vision for future blades in his Codex. The redesign included the elimination of the finger amputation and a new trigger mechanism, the initial versions of which had made it too easy to identify an Assassin by sight.

Altaïr's ideas regarding future adaptations of Hidden Blades also included a miniaturized firearm, known as the **Hidden Gun**, and a poison chamber for the blade, known as the **Poison Blade**. Altaïr also developed improvements to the use of the weapon, including the use of a second Hidden Blade on the other arm.

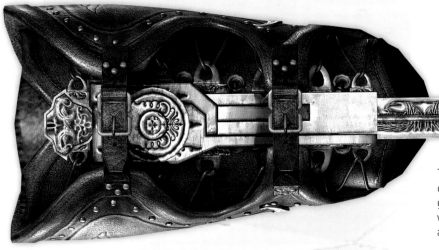

The first recorded use of the Hidden Blade was the 465 BCE assassination of King Xerxes I of Persia, by Darius. This Hidden Blade would go on to be given to Aya by Cleopatra in 48 BCE, and used by Bayek of Siwa. In this way the Hidden Blade became the weapon of choice for the Hidden Ones, and was later absorbed into the Brotherhood.

LEONARDO DA VINCI'S REDESIGNS

Altaïr's plans were eventually realized during the Italian Renaissance after Ezio Auditore had located all the pages of his Codex. Using Altaïr's information, Leonardo da Vinci repaired and modified the Hidden Blade that Ezio inherited from his father. Changes included the addition of a metal plate to the top side of the bracer to enable it to deflect attacks, and the use of a stronger metal for the blade. The metal plating and stronger blade meant the Hidden Blade assembly could now be used in melee combat. The launching mechanism was now a pressure switch inside the bracer, triggered by flexing the wrist to extend or retract the blade.

Leonardo da Vinci also designed several improvements and modifications of his own. The **Poison Dart** launcher enabled an assassination to take place at a distance, while the **Hidden Bolt** could fire small crossbow bolts.

HOOKBLADE

The **Hookblade** was developed by the Turkish Brotherhood, first noted by Ezio Auditore in the early sixteenth century. Designed to be worn as the secondary Hidden Blade, it featured a curved hook and a blade, and could be used while freerunning to travel ziplines or extend the Assassin's reach while climbing. The hook also enabled the Assassin to flip opponents or pull them closer, as well as attack and grab small objects.

HIDDEN FOOTBLADE

The Chinese Assassin Shao Jun used an adaptation of the Hidden Blade known as the **Hidden Footblade.** Well-hidden inside the sole of a boot and useful in an environment where weapons were restricted, the Footblade could be extended by flexing the foot.

PIVOT BLADE

The eighteenth century saw the development of the **Pivot Blade,** which the Assassin could rotate ninety degrees and use as a dagger. Colonial Assassin Ratonhnhaké:ton used a Pivot Blade for tasks ranging from combat to skinning game. His Pivot Blade was serrated along one edge, with a traditional edge on the other side.

NINETEENTH-CENTURY VARIANTS

Assassins during the French Revolution used a variant known as the **Phantom Blade,** a more advanced and sophisticated version of the earlier Poison Dart and Hidden Bolt models. Arno Dorian used one to launch poisoned or projectile blades.

Arbaaz Mir used a variant known as a **Trident Blade,** which had a three-pronged blade.

Jacob and Evie Frye used Hidden Blade gauntlets that had the blade on the underside and a **Rope Launcher** on the top, which launched a grappling hook

TWENTIETH- AND TWENTY-FIRST CENTURY VARIANTS

By the twentieth century, Hidden Blades had fallen out of regular use in a society where modes of dress were less hospitable to wearing bracers and weapons were less commonly carried.

Modifications continued to be made to reflect the times, however. Desmond Miles used a minimalist Hidden Blade that consisted only of the blade and the extension mechanism on a lightweight leather harness. Shaun Hastings used a **Shock Blade** variant, which had two electrified prongs in place of the blade.

Despite modern innovations, some Assassins have opted to equip traditional or basic Hidden Blades, to honor tradition while still benefiting from the simple ingenuity of the weapon. A former captive in Abstergo's Madrid facility, Callum Lynch equipped the Hidden Blades of his Assassin Ancestor Aguilar de Nerha while using the Animus. To assassinate Grand Master Templar and Abstergo CEO Alan Rikkin in 2016, he used a Hidden Blade that was designed to be disassembled and reassembled easily, with its components being hidden in common objects like a shoe, a wristwatch, a mobile phone case, a pen, a belt buckle, a necklace, and the spine of a book. In 2018, Assassin Charlotte de la Cruz used her Hidden Blade to kill the resurrected Isu entity Juno.

LEONARDO DA VINCI'S INVENTIONS

A close friend of Ezio Auditore, Leonardo da Vinci played a key role in the struggle between the Assassins and Templars of Renaissance Italy. Ezio provided him with pages from Altaïr's Codex, which, when decrypted, allowed Leonardo to repair and improve the Hidden Blade design. However, Leonardo's work extends beyond the Hidden Blade, and his technical ingenuity made him valuable to both the Assassins and the Templars.

Ezio used Leonardo's **Flying Machine** to gain access to the Palazzo Ducale in Venice, where he was unfortunately too late to save the Doge from being poisoned by the Templars.

BORGIA WAR MACHINES

At the end of the fifteenth century, the Templars forced da Vinci to design four war machines for Cesare Borgia.

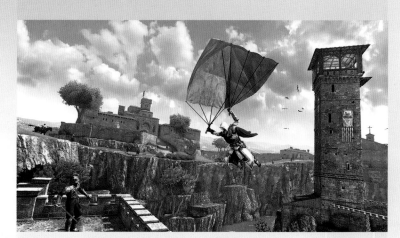

Leonardo also designed parachutes, bombs, and pistols.

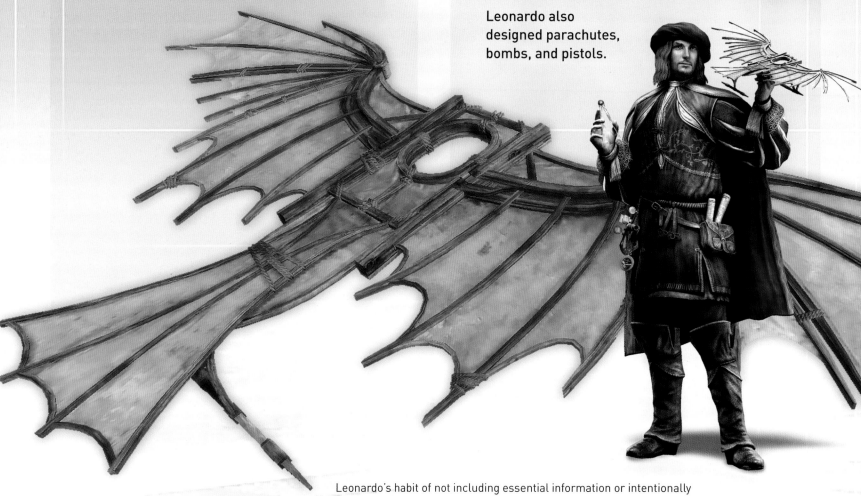

Leonardo's habit of not including essential information or intentionally including flaws to confound people trying to copy his designs had repercussions for the Assassins. When a woodworker in Colonial America tried to build a Flying Machine for Ratonhnhaké:ton based on a copy of the plans, the attempt failed because the knowledge of the heat required to keep the glider in the air was missing.

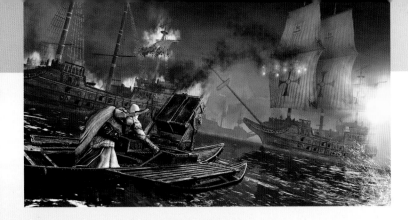

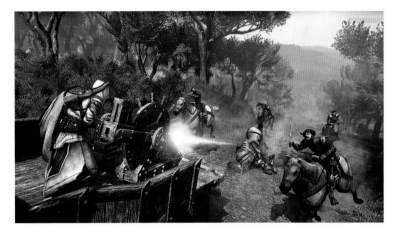

NAVAL CANNON

Consisting of a small cannon mounted on a small boat with outriggers for stability, the Naval Cannon launched fireballs. Two people were required to operate it, one to steer the craft and one to aim and fire the cannon.

TANK

The Tank was a mobile cannon platform with wooden armor. The cannon could shoot in all directions

AERIAL BOMBER

An expanded version of the Flying Machine, the Bomber was equipped with a fire cannon that could be used aggressively, as well as provide its own heat to power its flight.

MACHINE GUN

The Machine Gun was a rapid-fire cannon mounted in a horse-drawn chariot. Despite the name, it was not a fully automatic weapon; it simply required reloading less frequently than contemporary guns. It required two people to operate it, a driver and a gunman.

OTHER ICONIC WEAPONS AND GEAR

Assassins are not limited to the Hidden Blade. Cultural preferences and historical context provide an Assassin with a range of weaponry to supplement their gear.

BOMBS

An Assassin usually carries a small selection of bombs. Smoke bombs, stink bombs, blood bombs, and cherry bombs are used as distractions. Caltrop bombs and thunder bombs cause minor injuries. Splinter bombs and poison bombs are more lethal and can be used to eliminate groups of people in an area.

TOMAHAWK

A one-handed axe commonly used by Native Americans and European colonists, the tomahawk could be both a tool and a weapon. John de la Tour, the first Assassin in the British Colonies, carried a tomahawk that featured an axe head designed to echo the Assassin symbol. The very same tomahawk ended up in Ratonhnhaké:ton's hands.

A typical Assassin's kit would always include throwing knives or poison darts, and an assortment of bombs (such as smoke, poison, fear/hallucinogenic, or splinter bombs) to use as distractions or to attack.

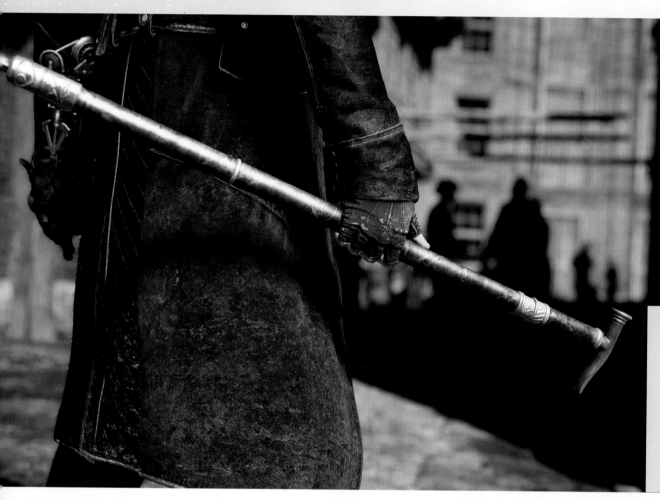

CANE-SWORD
Used by Evie and Jacob Frye, the cane-sword is a walking stick that conceals a sword and a button-triggered scythe blade.

CLIMB LEAP GLOVE
Ezio Auditore used a Metal Cestus, a leather glove lined with metal plates, to increase the damage he dealt while fist-fighting. Leonardo da Vinci improved it in such a way that it also enhanced the Assassin's ability to climb and leap during freerunning. The Climb Leap Glove, along with the secondary Hidden Blade, were later replaced by the Hookblade.

It's all right here.

PROPHET'S CODEX: Ezio Auditore wrote down many of the important events in his life in a collection called the Prophet's Codex. Among these events, Ezio recorded Minerva's communication to him in the Vatican Vault in detail for generations of Assassins to come. In 2002, Daniel Cross located this Codex in Russia, in the hidden library of Ivan the Terrible under the Bolshoi Theater, which served as an Assassin archive. The information contained within the Codex, specifically the Minerva communication with its references to Desmond, was a tremendous acquisition by the Templars.

ALTAÏR'S CODEX: An encrypted collection of Altaïr's observations, records of his study of the Apple of Eden, and other data, Altaïr's Codex has provided Assassins with clues, plans, and inspiration for technological development. While not a weapon in and of itself, the information it contains is critical, and has provided the Assassin Brotherhood with many important technical enhancements. Many decades later, Altaïr's Codex ended up in Domenico Auditore's possession. Hunted by pirates hired by the Templars, Domenico knew this sensitive information to be extremely valuable, and therefore separated the pages of the Codex and hid them in different boxes and chests in a ship in the Otranto harbor so that they would eventually be scattered across Italy. That way, if the Templars found any, they would still not have the entire set.

SHIPS

Statistics:
- Approximately 37 meters long
- 1 mast
- 1 sail

Armament:
- Naval ram
- Marines
- Archers

Ammunition:
- Spears
- Swords
- Arrows
- Fire arrows

ADRESTIA

Kassandra met Barnabas on the island of Kephallonia, where she rescued him from being tortured by a man called the Cyclops. Immensely grateful, and convinced Kassandra was sent by the gods, Barnabas offered her his services and the use of his ship, the *Adrestia*. With the trireme and Barnabas' crew, Kassandra was finally able to leave Kephallonia.

Barnabas explained he lost good men due to fighting with pirates, who had become more aggressive in the midst of the chaos caused by the war between Sparta and Athens. Kassandra agreed to help him find new recruits to crew the Adrestia, as well as find ways to upgrade the ship itself.

Named after the Greek goddess of retribution and equilibrium, the *Adrestia* was a relatively small but nimble trireme with an excellent crew, strong enough to engage in battle. While the crew was able to launch ranged attacks by throwing javelins and shooting flaming arrows, the ship itself was capable of ramming and sinking its opponents.

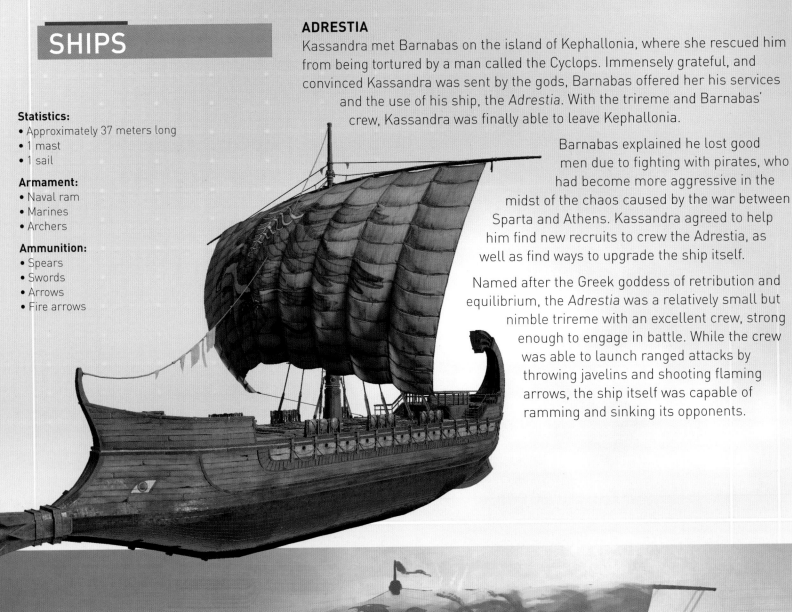

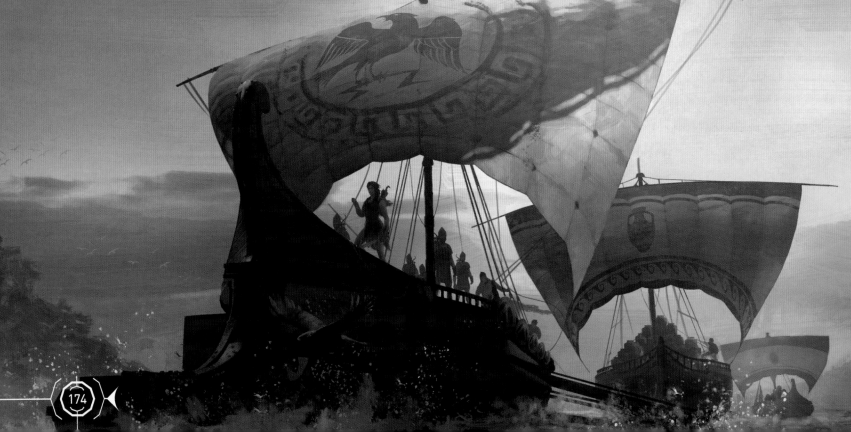

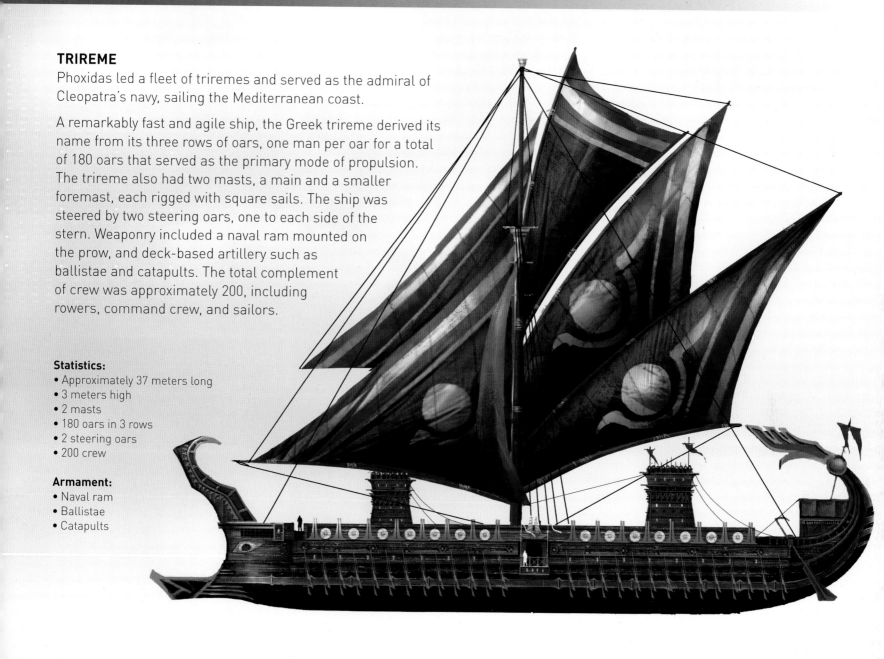

TRIREME

Phoxidas led a fleet of triremes and served as the admiral of Cleopatra's navy, sailing the Mediterranean coast.

A remarkably fast and agile ship, the Greek trireme derived its name from its three rows of oars, one man per oar for a total of 180 oars that served as the primary mode of propulsion. The trireme also had two masts, a main and a smaller foremast, each rigged with square sails. The ship was steered by two steering oars, one to each side of the stern. Weaponry included a naval ram mounted on the prow, and deck-based artillery such as ballistae and catapults. The total complement of crew was approximately 200, including rowers, command crew, and sailors.

Statistics:
- Approximately 37 meters long
- 3 meters high
- 2 masts
- 180 oars in 3 rows
- 2 steering oars
- 200 crew

Armament:
- Naval ram
- Ballistae
- Catapults

SHIPS

Ships were essential to long-distance travel and exploration, and also used in naval combat. Just as some Assassins are identifiable by their choice of weapon, others are forever associated with their vessels.

THE BLACK FLAG: The *Jackdaw* first flew a generic black flag, then a generic pirate flag. After Edward defended the Brotherhood from a Spanish raid, the pirate flag was altered to a skull set within a stylized Assassin insignia.

THE JACKDAW

A brigantine that was originally part of the Spanish treasure fleet traveling between the Caribbean and Spain, Edward Kenway and Adéwalé seized this ship and managed to sail it away before a fatal hurricane sank the rest of the fleet. Edward renamed it the *Jackdaw* after the small crow-like birds he had been fond of as a child. The name would later be a source of embarrassment when compared to the more typically terrifying names of pirate vessels.

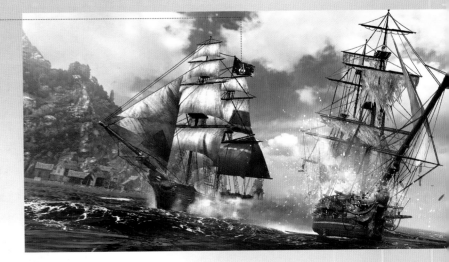

Statistics:
- 60 meters long
- 48.5 meters high
- 11.9 meters wide
- 26 sails
- Iron-plating reinforced hull

Armament:
- 46 broadside cannons
- 4 chaser cannons
- 2 swivel guns
- 1 naval ram

Ammunition:
- Fire barrels
- Heated shot
- Mortar rounds

Equipment:
- Diving bell
- Harpoons
- Whaling rowboat

Statistics:
- 48 meters long
- 49 meters high
- 11 meters wide

Armament:
- 4 Puckle guns
- 4 Carronades
- 34 Broadside cannons
- 2 Mortars
- 1 Ice ram

Ammunition:
- Burning oil
- Round shot
- Mortar rounds

THE MORRIGAN

Shay Cormac seized this modified sloop-of-war that originally served as a smuggler's vessel in the North Atlantic in 1752. The ship became part of the Assassin fleet, passing ownership after Shay's supposed death. Shay recaptured the *Morrigan* when it was moored in New York, and from that point on it was used by Shay for his Templar business and to support the British Royal Navy.

Templar funding enabled the *Morrigan* to become one of the most advanced warships of the era. The sleek design and advanced, state-of-the-art armament meant she was faster and more maneuverable than most other ships, while featuring above-average firepower.

The *Morrigan* is an Irish battle goddess strongly associated with crows and ravens.

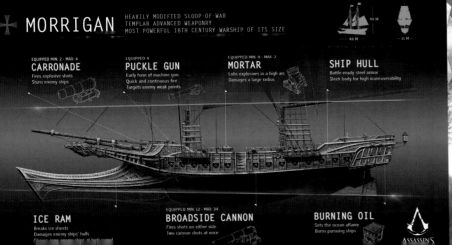

MORRIGAN — HEAVILY MODIFIED SLOOP-OF-WAR
TEMPLAR ADVANCED WEAPONRY
MOST POWERFUL 18TH CENTURY WARSHIP OF ITS SIZE

CARRONADE EQUIPPED MIN 2 · MAX 4
Fires explosive shots
Stuns enemy ships

PUCKLE GUN EQUIPPED 4
Early form of machine gun
Quick and continuous fire
Targets enemy weak points

MORTAR EQUIPPED MIN 0 · MAX 2
Lobs explosives in a high arc
Damages a large radius

SHIP HULL
Battle-ready steel armor
Sleek body for high maneuverability

ICE RAM
Breaks ice sheets
Damages enemy ships' hulls

BROADSIDE CANNON EQUIPPED MIN 12 · MAX 34
Fires shots on either side
Two cannon shots at once

BURNING OIL
Sets the ocean aflame
Burns pursuing ships

THE AQUILA

Commissioned and originally captained by Colonial Mentor Achilles, the *Aquila* was built in 1749 in Brest, France, under the supervision of the French Brotherhood. Later captained by Connor, the *Aquila* was small but fast, and served as the flagship of the Assassin fleet. The *Aquila* was used to defend trade routes and harry the British and Templar forces, and also engaged in the Battle of Chesapeake Bay.

Armament:
• 60 heavy cannons
• Swivel guns
• Naval ram

Ammunition:
• Round shot
• Chain-shot
• Grapeshot
• Heated shot

Aquila is Latin for 'eagle.'

ALTAÏR II

The modern Assassins operate a patrol boat, the *Altaïr II*, which they use as a mobile headquarters for the Brotherhood. Led by Gavin Banks, the ship is a key asset for the Assassins, allowing them to travel more discreetly around the world and move rapidly when necessary. Contact between the various Assassins cells is also maintained more easily.

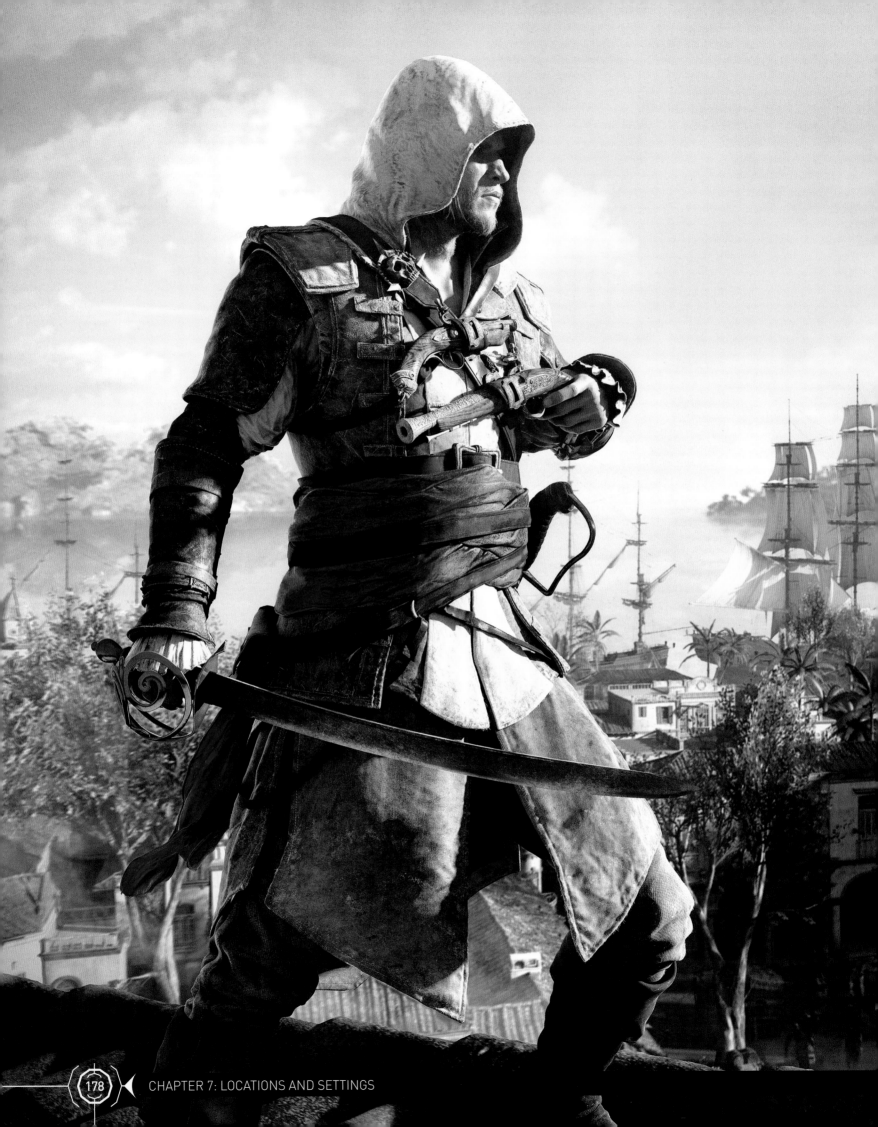

LOCATIONS
AND SETTINGS

The secret war between Assassins and Templars echoes
throughout every age of history, across many different
territories and locations.

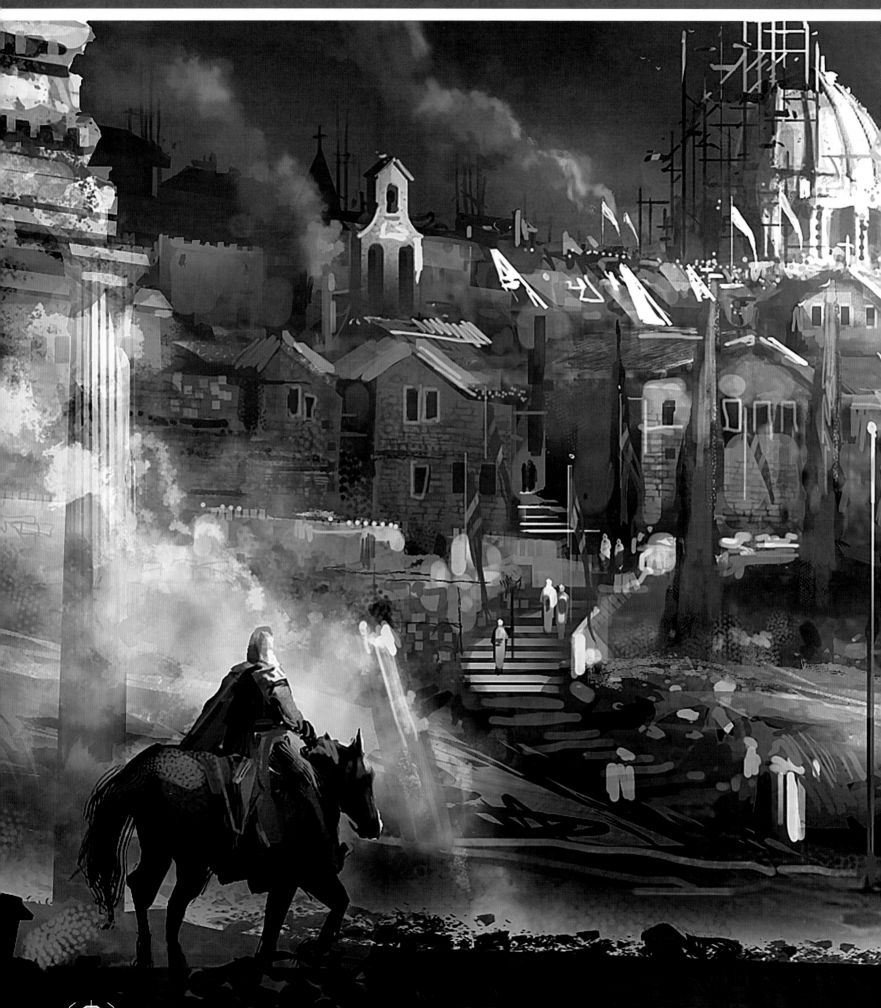

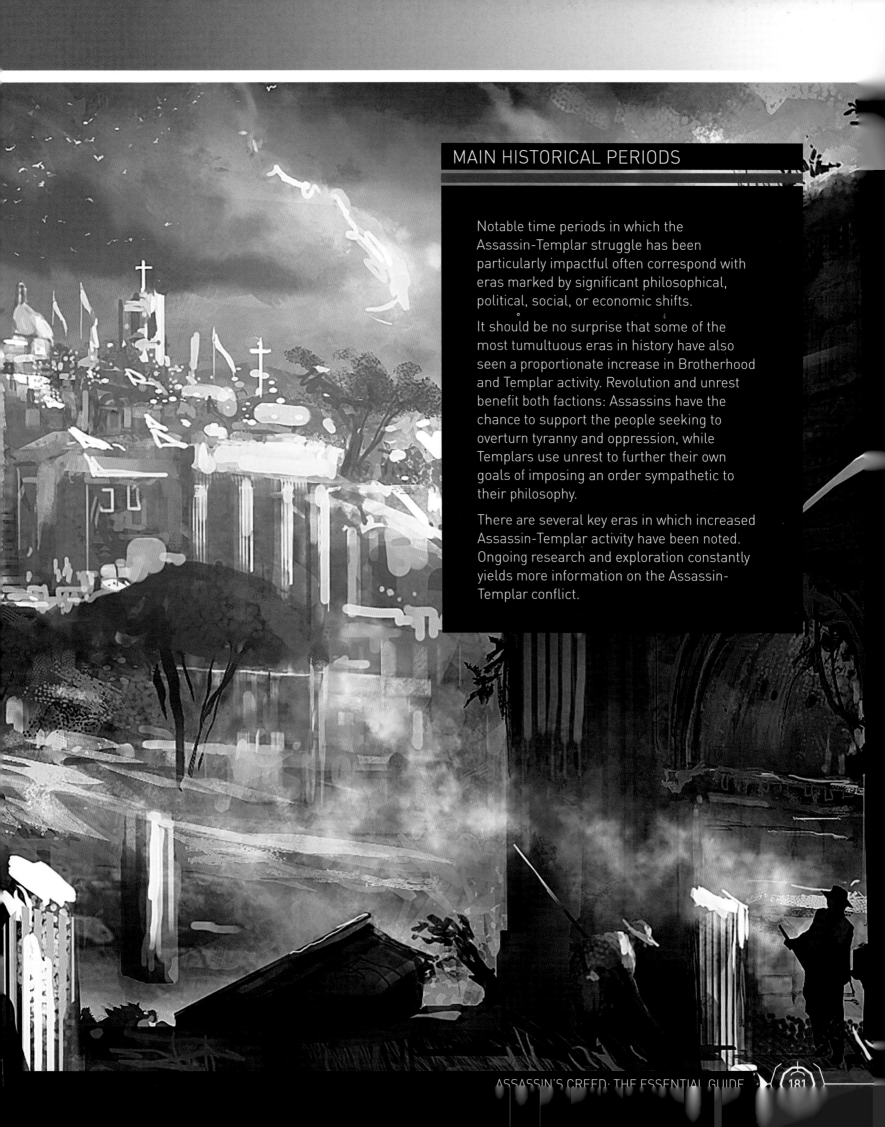

MAIN HISTORICAL PERIODS

Notable time periods in which the Assassin-Templar struggle has been particularly impactful often correspond with eras marked by significant philosophical, political, social, or economic shifts.

It should be no surprise that some of the most tumultuous eras in history have also seen a proportionate increase in Brotherhood and Templar activity. Revolution and unrest benefit both factions: Assassins have the chance to support the people seeking to overturn tyranny and oppression, while Templars use unrest to further their own goals of imposing an order sympathetic to their philosophy.

There are several key eras in which increased Assassin-Templar activity have been noted. Ongoing research and exploration constantly yields more information on the Assassin-Templar conflict.

MAIN TIME PERIODS

CHINA: sixteenth century — Fall of the Ming dynasty

FRANCE/ SWITZERLAND: early-sixteenth century– French Renaissance

GREECE: fifth century BCE — Late Archaic Period, Peloponnesian War

THE LEVANT: twelfth century — Third Crusade

PTOLEMAIC EGYPT: first century BCE — End of the Ptolemaic dynasty

ANCIENT ROME: first century BCE — End of the Roman Republic, foundation of the Roman Empire

ITALY: late fifteenth to early-sixteenth century — Italian Renaissance

CONSTANTINOPLE: sixteenth century — Ottoman Era

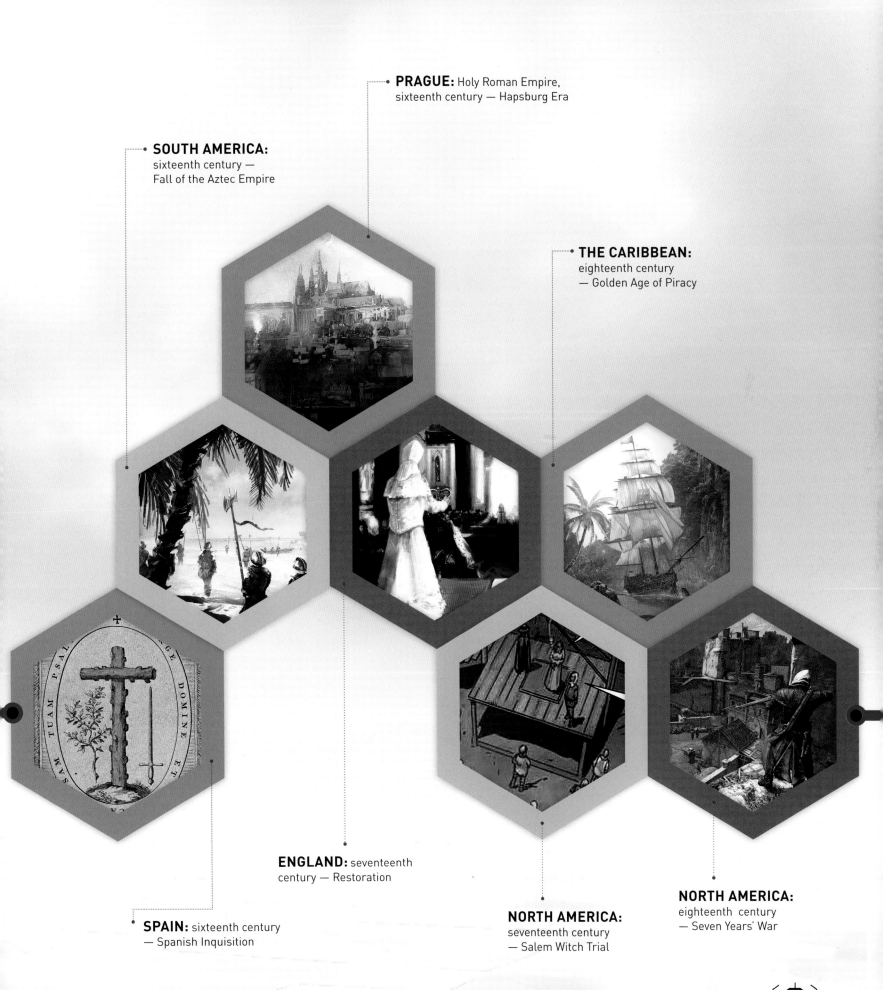

PRAGUE: Holy Roman Empire, sixteenth century — Hapsburg Era

SOUTH AMERICA: sixteenth century — Fall of the Aztec Empire

THE CARIBBEAN: eighteenth century — Golden Age of Piracy

ENGLAND: seventeenth century — Restoration

SPAIN: sixteenth century — Spanish Inquisition

NORTH AMERICA: seventeenth century — Salem Witch Trial

NORTH AMERICA: eighteenth century — Seven Years' War

MAIN TIME PERIODS

NEW YORK CITY: nineteenth century — Draft Riots

THE CARIBBEAN: nineteenth century — Slave Uprising

NORTH AMERICA: eighteenth century — American Revolution

NEW ORLEANS: eighteenth century — Louisiana Rebellion

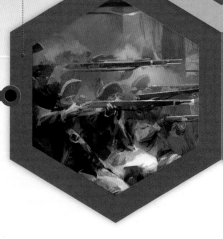

LONDON: nineteenth century — Industrial Revolution

FRANCE: eighteenth century — French Revolution

INDIA: nineteenth century — Sikh Empire

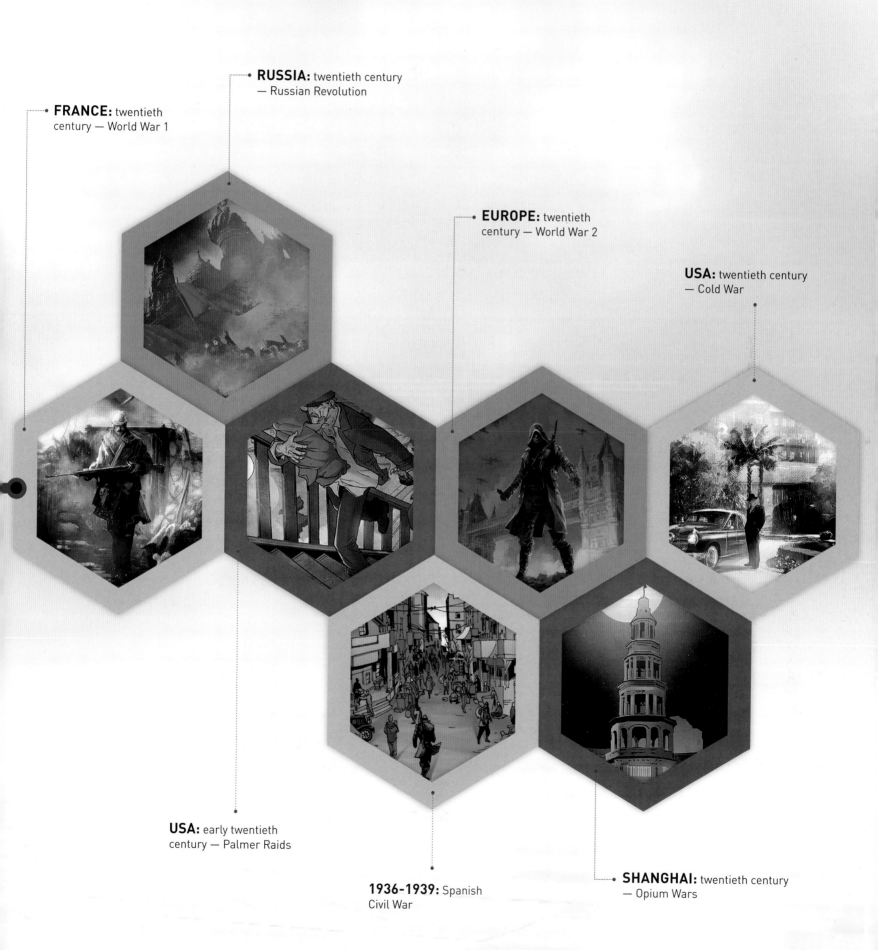

FRANCE: twentieth century — World War 1

RUSSIA: twentieth century — Russian Revolution

EUROPE: twentieth century — World War 2

USA: twentieth century — Cold War

USA: early twentieth century — Palmer Raids

1936-1939: Spanish Civil War

SHANGHAI: twentieth century — Opium Wars

ANCIENT GREECE

Classical Greek culture placed heavy emphasis on knowledge. Science and religion were inextricably entwined, and seeking truth meant getting closer to the gods and their divine knowledge. Mathematics was one method for approaching this divine truth and understanding the structure of the world and the nature of reality. Ancient Greek philosophy focused on the role of reason and inquiry, laying the foundation for modern philosophy and science. The era saw staggering advances in areas such as medicine, astronomy, and mathematics, and the civilization of ancient Greece would go on to influence modern languages, philosophy, and the arts.

Athens was the largest city in Ancient Greece, controlling fertile farmland and possessing the largest navy. It was a cultural center, visited by people from all over to study and engage in trade. Ruled as a democracy, classical Athens enjoyed great economic expansion and cultural richness that would endure, influencing Western civilization for centuries to come. By founding the Delian League, a loose association of city-states that paid tribute in exchange for defense, Athens expanded its influence until it effectively controlled all of Greece except Sparta and its allies.

Sparta was a military state with a permanent standing army. Its constitution focused on maximizing military adeptness. Led by a pair of kings, state-mandated physical training and fitness were an important part of every child's education. Thanks to the Peloponnesian War, Sparta eventually became a naval power to be reckoned with.

The **Peloponnesian War** transformed war from limited conflicts to all-out, large-scale war. The war wrought destruction on a previously unseen scale, and heralded the end of the Golden Age of Greece. Sparta's distrust of the powerful Athens led to friction between the two states. The walls of Athens kept the Spartans out while the Athenian fleet waged war on the seas. An outbreak of plague weakened Athens, killing roughly a third of the population, including Perikles and his sons.

Located on the southwest slope of Parnassus, the **Oracle at Delphi** was said to have been built on the location where Apollo slew the mighty Python. In part of the Sanctuary of Apollo and his temple, a priestess of Apollo served as the Pythia or sibyl who was consulted for prophecies regarding important decisions. The Cult of Kosmos seized control of the Oracle in order to manipulate the prophecies and direct events to their preferred outcomes.

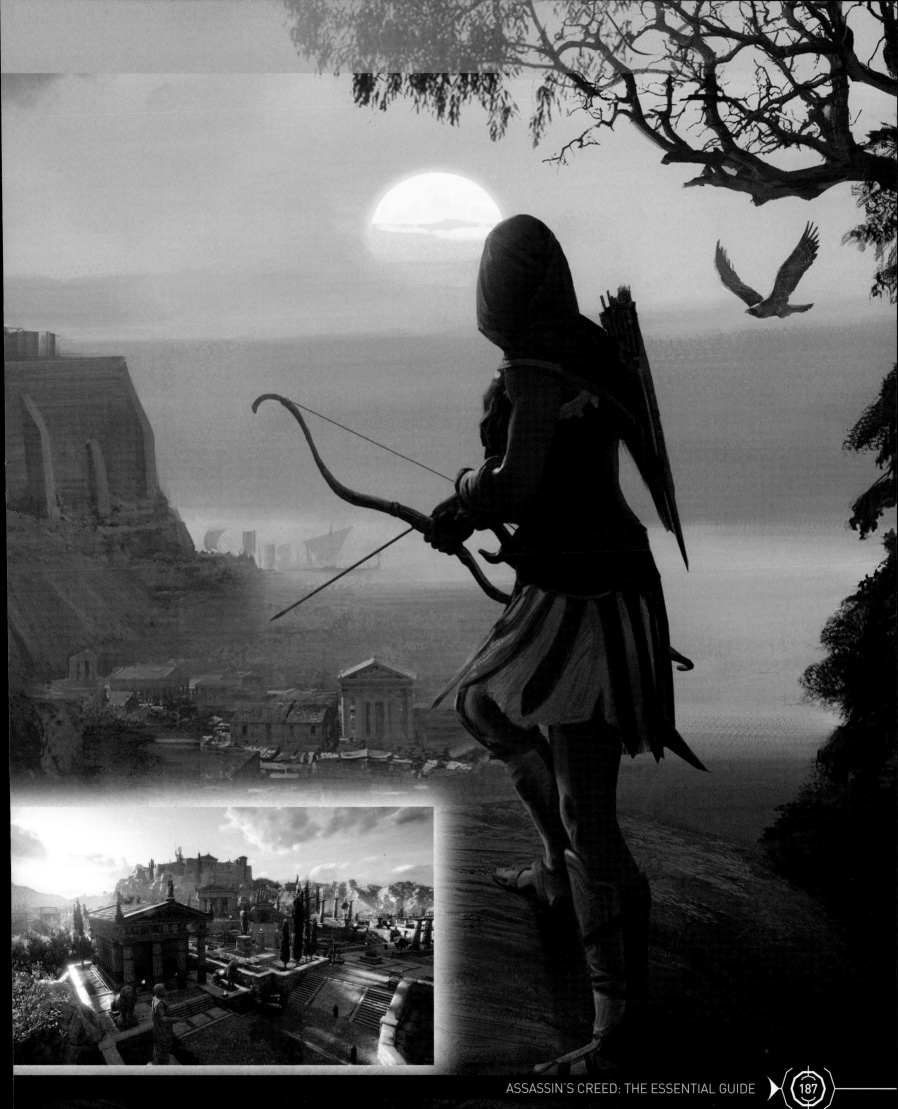

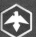

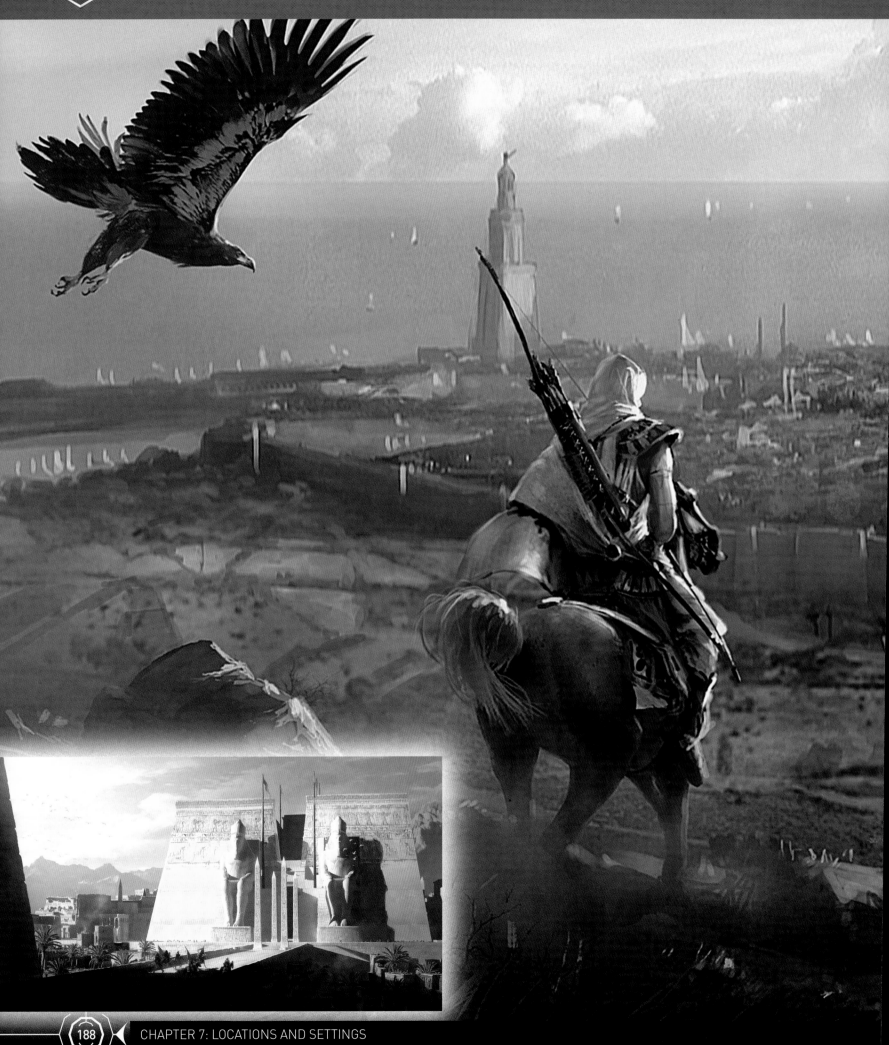

Egypt found itself in a time of transition circa 40 BCE. It was an era of rebellion and upheaval, when Cleopatra sought to reclaim the seat of the pharaoh, with the help of Caesar, who in turn sought to secure control of Egypt for Rome. Egyptians were suspicious of the Romans, who increasingly occupied and controlled areas of their land. Cleopatra would be the last Ptolemaic ruler of Egypt, a dynasty descended from the heir of Alexander the Great, who declared himself pharaoh in 333 BCE after defeating Darius of Persia.

Memphis was one of Egypt's most important cities between 2950 and 2180 BCE. During this time, it served as Egypt's capital, strategically located between Upper and Lower Egypt. Memphis was a site of sophisticated culture and great splendor, even after the capital was moved to Thebes, and later Alexandria. By Cleopatra's time, the most important political offices were located in Alexandria, but Memphis was still an important location for clergy and religion.

Alexandria was founded by Alexander the Great in 331 BCE on the northern coast of Egypt (known as Lower Egypt). The north coast had been the hub of sea travel between the Mediterranean Sea and the Nile Delta for over two thousand years, and Alexandria was designed to be a link between Greece and the Nile Valley. Alexandria became the seat of the Ptolemaic Kingdom, and quickly grew to be one of the greatest cities of the Hellenistic world, eclipsed only by Rome itself. Alexandria fell under Roman influence when Julius Caesar allied with Cleopatra.

Originally built to honor the ram-headed sun god Amun-Ra, the **Temple of the Oracle of Amun** at Siwa housed a famous divine oracle who consulted with many influential figures, including Alexander the Great. Deep within the temple lay a secret vault holding holograms and imagery depicting Isu history, safely locked behind a door that opened only to an Apple of Eden combined with a Staff of Eden. There, Bayek and Aya found the walls of the vault covered with images of a long-lost race.

The **Nile River** flows north through Upper Egypt and then Lower Egypt on its way to the Mediterranean Sea. The Nile provided transportation and was an essential source of food and materials for construction. Possibly the Nile's most valuable resource was the fertile land created by the yearly flood that made the Nile overflow its banks and cover the surrounding areas with mineral-rich water. Much of Egypt was arid, but the agricultural land along the Nile River nourished by this yearly flood was rich and ideal for growing crops such as flax, papyrus, and wheat.

The **Mediterranean Sea** was an important route for merchants and travellers that allowed for trade and cultural exchange between settlements of the region.

The countries with coastlines on the Mediterranean Sea include Croatia, Cyprus, Egypt, France, Greece, Israel, Italy, Lebanon, Libya, Malta, Morocco, Monaco, Montenegro, Slovenia, Spain, Syria, Tunisia, and Turkey.

THE LEVANT

The Levant is a large cultural and geographic area in the eastern Mediterranean, including Syria, Israel, Lebanon, Jordan, Palestine, Cyprus, and the southern part of Turkey. It is of major cultural and spiritual importance, being the religious center of Islam, Judaism, and Christianity. This has caused centuries of religious conflicts, including the Crusades.

The Levantine Assassins are one of the oldest branches of the Assassin Brotherhood. **Masyaf,** a large public Assassin fortress located in the Orontes Valley in western Syria, was the public headquarters of the Levantine Brotherhood. Its proximity to Jerusalem, Damascus, and Acre made it a natural location from which to oversee Assassin activity in the Levant region.

Altaïr Ibn-La'Ahad revitalized Masyaf, making it a place of learning and healing open to recruits from around the world. Eventually, however, Altaïr decided that the Assassins could best serve the people of the world by working among them; he disbanded the Masyaf Brotherhood and sent the Assassins out into the world to found new Guilds, secret once again.

In **Jerusalem**, the ruins of **Solomon's Temple** lie beneath the Temple Mount. The Temple was believed to have been built circa 950 BCE by King Solomon, on the site of an underground Precursor chamber.

Centuries later, Ezio located **Altaïr's hidden library** at Masyaf and unlocked it. Inside, he found Altaïr's remains and an Apple of Eden.

"Men must be free to do what they believe. It is not our right to punish one for thinking what they do, no matter how much we disagree."

— Altaïr Ibn-La'Ahad

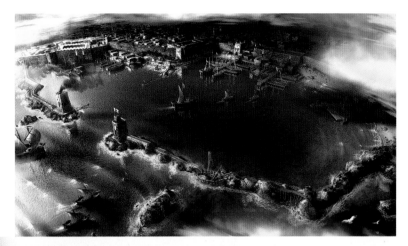

RENAISSANCE ITALY

The Renaissance was a time of great cultural change, and Italy was at the heart of it. New ideas challenged the old way of thinking, and the result was an explosion of art, music, literature, science, engineering, architecture, and philosophy. Italian politics were turbulent during this time of change.

Florence is a major Italian city, and the capital of Tuscany. The "da Firenze" suffix to Ezio's name translates to "of Florence." Under the rule of the Medici family, Florence enjoyed a golden age where art, science, and philosophy all thrived.

Located in Monteriggioni in Tuscany, Italy, **Villa Auditore** was purchased by Assassin Domenic Auditore in 1321 and redesigned to be a home, fortress, and a training ground. In 1476, Ezio and his remaining family came to live at Villa Auditore. With his uncle Mario, Ezio oversaw renovations and restored it to its original purpose as headquarters for the Italian Brotherhood by late 1499. By 2012, the Villa had been declared a World Preservation Site.

The Sanctuary was a hidden chamber beneath Villa Auditore, accessed via an entrance hidden in Mario Auditore's study. The Sanctuary was also used as a refuge by modern-day Assassins: in 2012, Desmond Miles and his team set up a base of operations there for a month after Abstergo raided their first hideout.

Assassins and Templars fought for control of **Venice** throughout the Renaissance. A city of cultural, political, and economic power, Venice went through a period of political instability as Templars and Assassins struggled to place Doges of their choosing in power. Leonardo da Vinci did much of his work for the Assassins in Venice.

Rome was the spiritual center of Italy, being the seat of Christian power. In 1492 the Templars seized control of the **Vatican** when the Templar Rodrigo Borgia became Pope Alexander VI. A **Precursor vault** was located beneath the **Sistine Chapel,** eventually successfully unlocked by Ezio Auditore using the Papal Staff and an Apple of Eden.

FEDERICO: "It is a good life we lead, brother."

EZIO: "The best. May it never change."

FEDERICO: "And may it never change us."

— Federico and Ezio Auditore

CONSTANTINOPLE

One of the wealthiest and most cultured cities in Europe, **Constantinople** was situated between the trade routes to Europe and Asia, and was considered a blend of the two cultures. The capital of the Byzantine Empire, Constantinople was famed for its architecture and its **port,** a hub of international trade and commerce. Constantinople featured formidable and complex defenses, both natural and manmade, but fell to Sultan Mehmet II of the Ottoman Empire in 1453. With this, it was transformed from a bastion of Christianity to Islamic rule, although all religions and cultural refugees were welcome. When the Templars were driven out of Italy by the Assassins, many relocated to Constantinople; some of these formed the Stewards of Byzantium faction and tried to take control of the city during the war between Sultan Bayezid and his son, Selim.

Hidden around the city of Constantinople were the **Masyaf Keys,** five Precursor Memory Seals created by Altaïr that were required to open the secret library of Masyaf. Under the leadership of Ezio Auditore, who had traveled to Constantinople to locate the Keys and research his Assassin heritage, the Ottoman Assassins were able to reclaim much of their territory from Templar control.

Sofia Sartor's bookshop was built on the site of the old trading post established by the Polo brothers, founders of the Ottoman Brotherhood. When Sofia and Ezio married, the bookshop became the cover for a Brotherhood archive.

Ezio spent time in **Piri Reis's workshop** learning the art of crafting bombs. Located in the Grand Bazaar, it also served as an operations base of sorts for Ezio.

The Byzantine Templars made their headquarters in the underground city of **Derinkuyu, Cappadocia.** Lit by natural openings that functioned as skylights, the underground city featured buildings carved from rock, as well as prisons and a weapons depot.

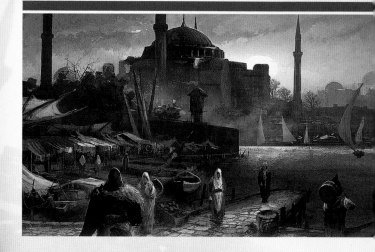

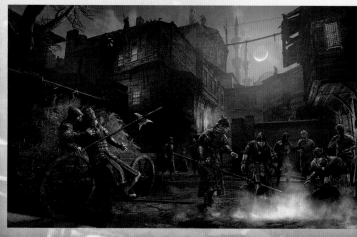

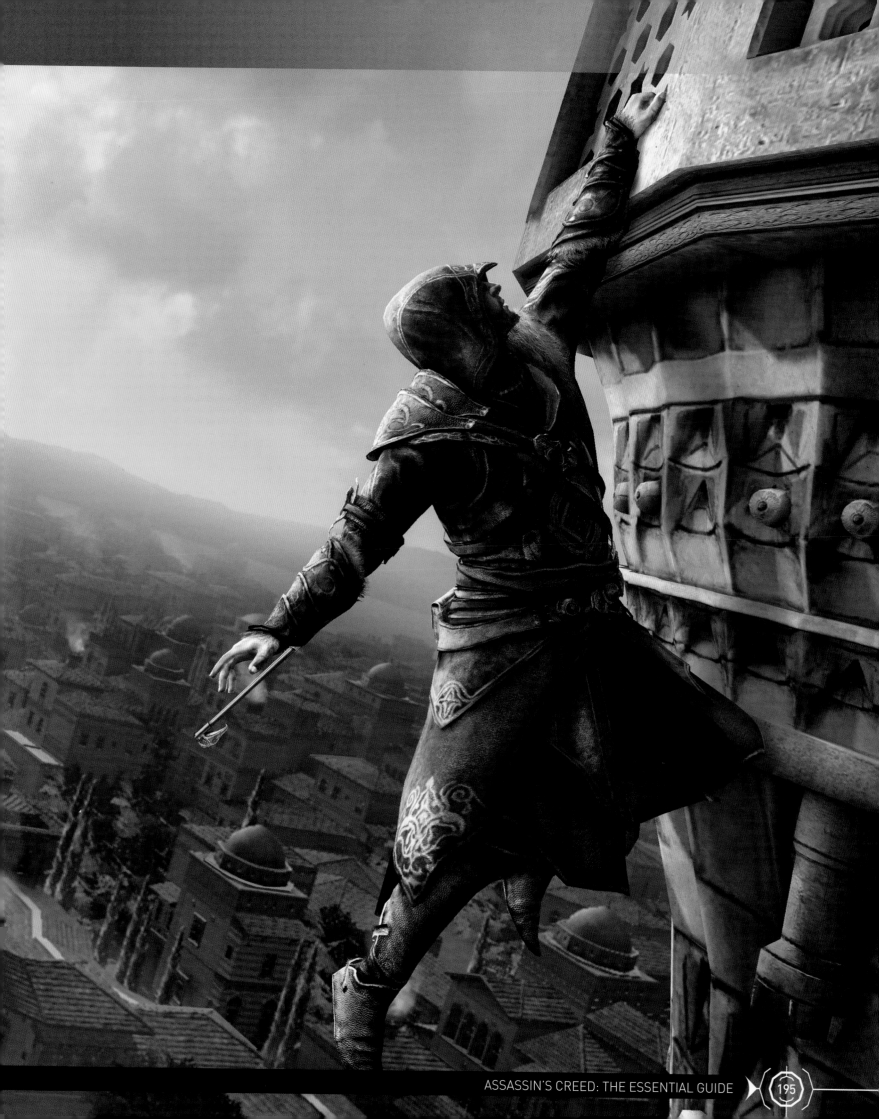

GOLDEN AGE OF PIRACY

Edward Kenway's maturation from a cocksure young man seizing any opportunity to his personal benefit into a wiser man promoting free will is reflected in the development of the Caribbean region throughout the 18th century.

A geographic region consisting of the Caribbean Sea, its islands, and coastal areas surrounding it, the **Caribbean** is located southeast of the Gulf of Mexico, east of Central America, and north of South America. Rich in natural resources such as gold, precious stones, and woods, it was favorable to the development of valuable trade crops such as sugar cane, tobacco, and coffee. The high amount of traffic produced by trading these resources and goods made it a magnet for pirates. The region had strong cultural and historical connections to slavery, European colonization, and the plantation system.

Havana, the capital of Cuba, was one of the largest and richest ports in the Caribbean. In 1750, it was the third largest city in the New World, larger even than Boston or New York.

Famed for its sugar plantations, **Jamaica,** an island south of Cuba, was located at the crossroads of regional trade routes. The island was under Spanish control until the mid-seventeenth century, when a British invasion force seized it. The Spanish released their slaves, who took refuge in the mountains and settled there; their descendants fought against the slave trade through the eighteenth century. Despite this, Jamaica became a hub of the slave trade; slaves who were brought from West Africa or the West Indies passed through its ports.

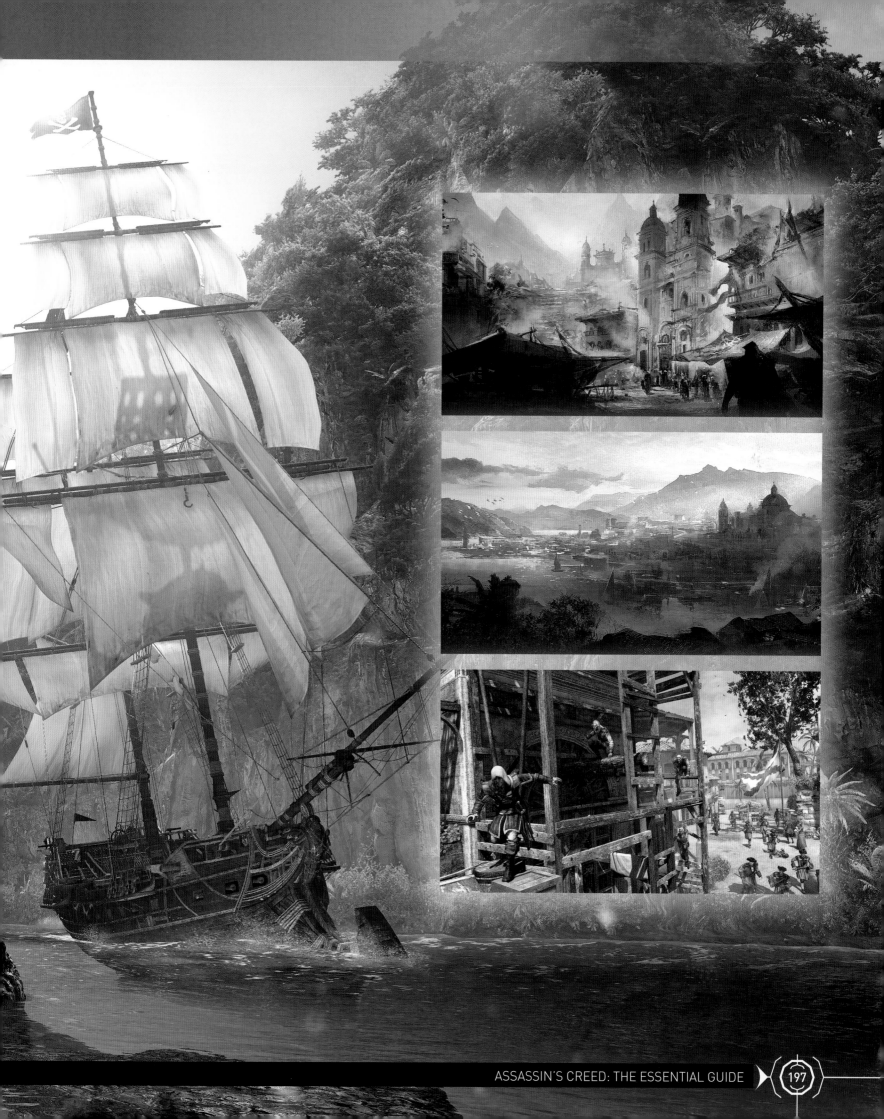

GOLDEN AGE OF PIRACY

Port Royal was a headquarters for buccaneers who held letters of marque, official permission from the British crown to attack and loot Spanish and French ships. In 1687 Jamaica passed anti-piracy laws, and pirates who had used it as a central location for their activity moved to Nassau. Once a utopia for pirates, Port Royal became more famous for pirate imprisonment and executions.

Kingston was founded by the British in 1692 after the destruction of Port Royal. The port city grew to become a major trade center, and served as a connection between the British Empire, the Caribbean, and West Africa. Slavery and sugar plantations were a central part of its economy.

Nassau, a British settlement in the Bahamas, became a beacon for pirates after the destruction of Port Royal, when a Spanish treasure fleet sank in the area. As the small city had no formal government, Benjamin Hornigold established the Pirates Republic there in 1713. Nassau also became an attractive haven for escaped slaves.

Great Inagua is the third largest island in the Bahamas. Originally owned by Templar Julien du Casse, it was seized by Edward Kenway, who established it as a base for the remaining pirates of the West Indies after Nassau was retaken by the British in 1718. Upon his return to Britain in 1722, Edward gifted the island to the region's Brotherhood, who abandoned their previous base in Tulum.

Tulum is an ancient Mayan city in the Yucatán peninsula, along the Caribbean Sea. The Mayan temple there was built on the site of a Precursor site known as the Observatory. A village of Mayan Assassins was established to protect the site and the Piece of Eden inside.

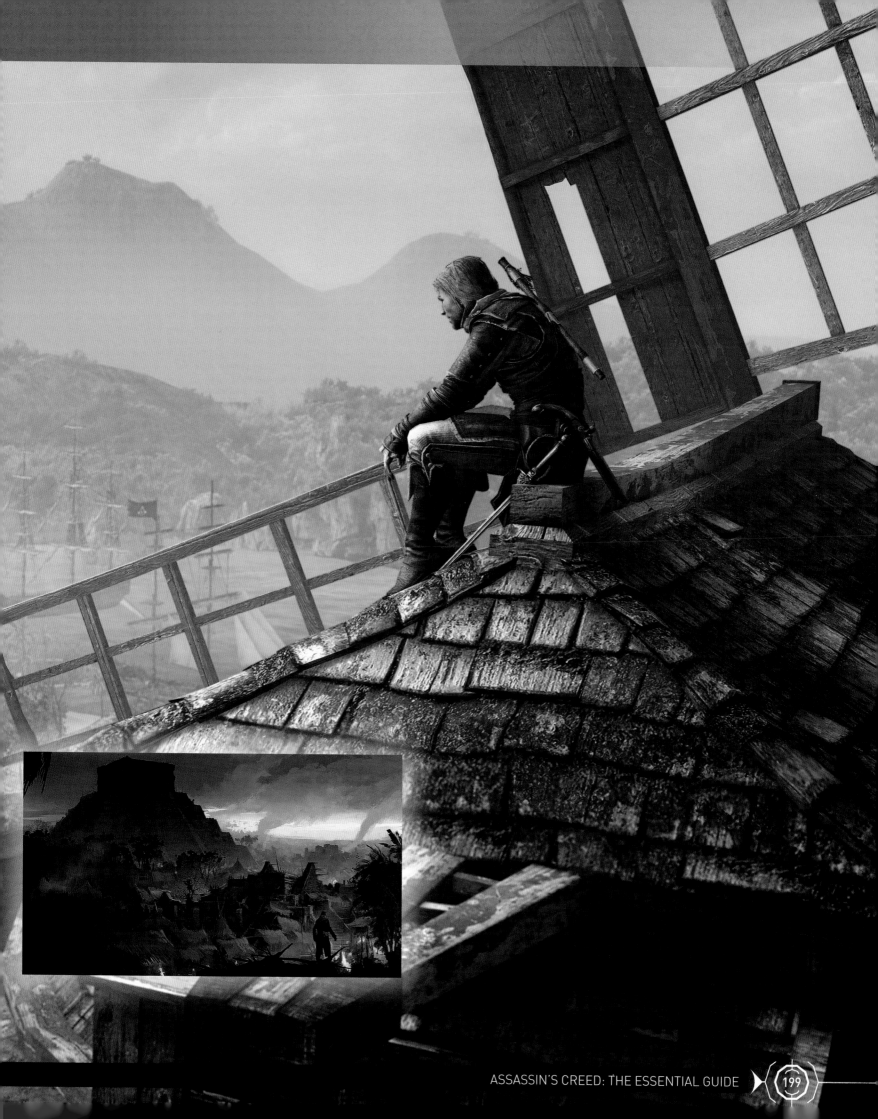

EN YEARS' WAR

Shay Cormac's early years as an Assassin, his disenchantment with the Brotherhood, and defection to the Templars takes place during the Seven Years' War. With the Assassins supporting the French and the Templars supporting the British, Shay's transfer of allegiance was echoed in the change of balance of power in the Seven Years' War itself.

Also known as the French-Indian War, the **Seven Years' War** took place between 1756 and 1763, though conflicts began in 1754. Britain and France struggled for power in North America; the French were aided by the Canadian militia and Native American allies. Early in the war, the French and their allies successfully fought off British attacks and captured a number of British forts. In 1758, the tide turned against the French when British forces captured Louisbourg in 1758, Quebec City in 1759, then Montreal in 1760. In 1763, France formally ceded Canada to the British in the Treaty of Paris, effectively withdrawing from North America.

On his ship the *Morrigan*, Shay explored the **North Atlantic,** specifically the Gulf of Saint Lawrence and the coast of Halifax. Halifax was settled by the British in 1759, violating a treaty and beginning a conflict between the British and New England colonists and the French and Native peoples.

The **Davenport Homestead** was a small community in the large forested grounds of the Davenport Manor, north of Boston near Rockport, Massachusetts. It served as the base of operations for the Colonial Brotherhood, led by the Mentor Achilles.

The French and the Native allies threatened the safety of **Fort William Henry** in August 1757. Shay's Templar ally Colonel George Monroe was injured by an Assassin during this siege; before dying he entrusted his Templar ring to Shay. Following this siege, Shay was inducted into the Colonial Rite of the Templar Order.

Shay was born to Irish immigrants in **New York,** a city originally settled by the Dutch in 1624, seized by the British in 1664. He returned there after joining the Templars to take back his ship, the *Morrigan*, and to help bring down the Assassin-controlled gangs of the city's underworld.

Shay was given permission to use the Royal Navy Man-o-War **HMS Pembroke,** under the command of James Cook, to help stop the French Navy. The Assassin Adéwalé and his ship, the *Experto Crede*, fought on the side of the French Navy. After the initial battle, Shay and Haytham Kenway tracked the *Experto Crede* to the Hudson River Valley, where Adéwalé eventually had to beach his ship before falling to Shay.

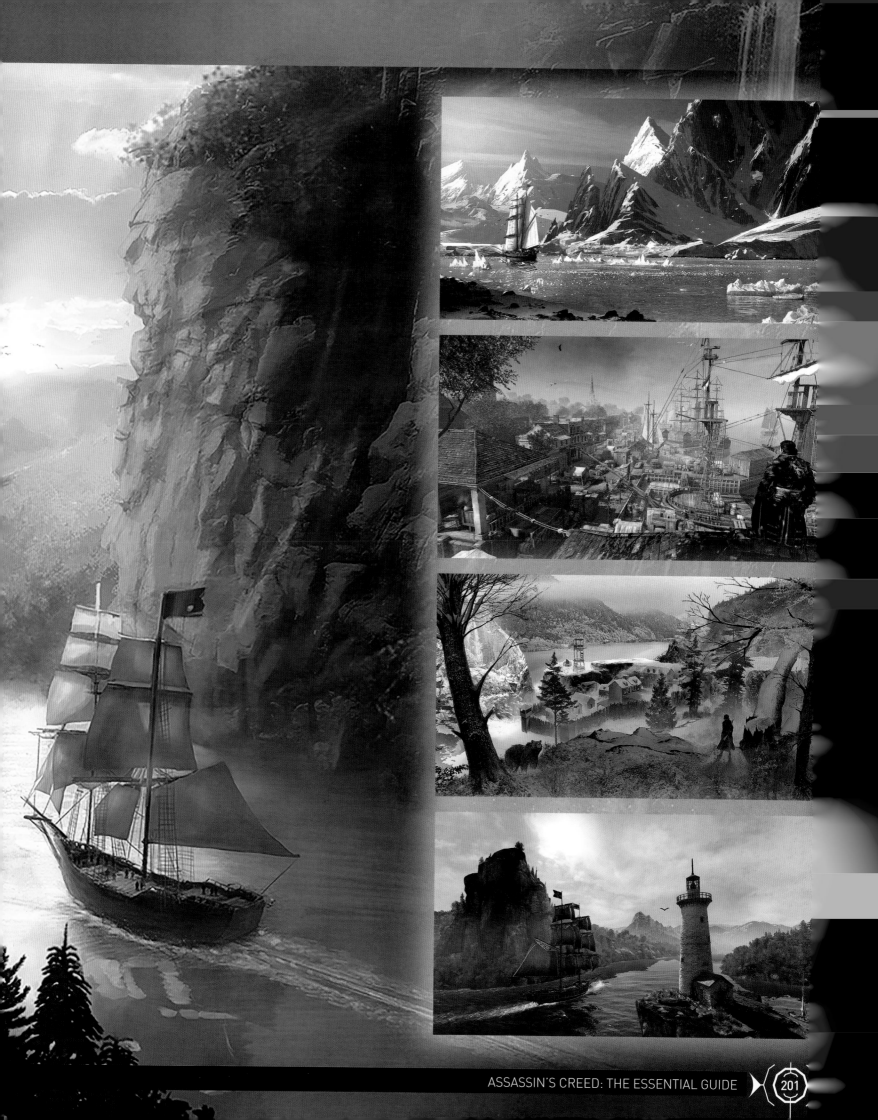

AMERICAN REVOLUTIONARY WAR

Connor's quest for revenge and his fight to secure liberty and rights for all men and women takes him from the wilderness of New England to the young city of New York, set against the backdrop of the American Revolution.

The Colonial Assassins had experienced great decimation during the Seven Years' War. After a Precursor vision, Ratonhnhaké:ton sought out the Colonial Brotherhood in order to defend his people and their land against the Templars, persuading Achilles, the last remaining Colonial Assassin, to train him. Ratonhnhaké:ton, renamed Connor, helped rebuild the Colonial Brotherhood and revitalize the **Davenport Homestead.**

Britain was heavily in debt after the Seven Years' War, and increased taxation in the thirteen colonies to help offset it. The colonists revolted against what they saw as unfair acts of governance. In 1773, the Sons of Liberty and the Colonial Assassins boarded British ships and threw nine hundred pounds of imported tea into the waters of **Boston Harbor** as a political protest against taxation without representation within the British government. The war officially began in 1775, and did not officially end until the Treaty of Paris in 1783. Connor was gradually drawn into the Patriots' cause, though his personal goal was to fight Templar control.

The **Battles of Lexington and Concord** in spring of 1775 were the first armed confrontations between the British forces and the colonists, and are considered the defining moments of the beginning of the war. Templar Major John Pitcairn and General Thomas Gage ordered British troops to arrest Patriot leaders in Lexington, Massachusetts, and to destroy a stockpile of weapons and ammunition in Concord. Both efforts failed thanks to advance warning; the Patriot leaders were removed to a safe place, and colonists in Lexington fell back to Concord, where they successfully defended the ammunition supply. These encounters led the colonists to officially form a national army to counter the British military.

The **Battle of Bunker Hill** took place soon after, where both Patriot and British forces attempted to take possession of the unoccupied hills overlooking Boston. Again, the colonists had advance notice, and quickly took a defensive position against the British forces.

"I'm proud of you in a way. You have shown great conviction. Strength. Courage. All noble qualities...I should have killed you long ago."

— Haytham Kenway

AMERICAN REVOLUTIONARY WAR

During the war Connor met with Haytham Kenway, his father and the Grand Master of the Colonial Rite, who told him that the Templars were not in fact supporting the British cause. Working together to confound the British commanders, Connor was hopeful that perhaps the Assassin and Templar causes could be brought into a united partnership.

The **Battle of Monmouth** in 1778 took place as the British troops marched from Philadelphia to New York. Charles Lee led the Patriot forces to attack the British, but quickly lost control of the situation, appearing to sabotage the Patriot attempt.

While working with Haytham, Connor learned that his **Kanien'kehá:ka village** had been burned by George Washington, not Charles Lee as he had believed since he was a child. Disillusioned, he nonetheless continued to support the Revolutionaries in order to use them in his quest to destroy Templar control of the colonies, and to protect Washington from the Templar threat against his life.

In the fall of 1775, the **Continental Navy** was officially formed to counter the might of the British Royal Navy; however, it was underfunded, as shipbuilding was expensive. The Continental Navy was therefore made up of small private vessels encouraged to harry and disturb British communication and commerce. Eventually France agreed to join the war to support the Patriots, and sent naval support capable of countering the British naval presence. In 1781 the French Navy forced the British ships into retreat from Chesapeake Bay and the British forces surrendered Yorktown; after this, the British Parliament refused to further finance the war in America.

Near the end of the war, Connor realized the Templar leadership would have to be eliminated to allow the Patriots to remain free to determine their own futures. During the attack on **Fort George** in southern New York City, the headquarters of the Colonial Rite of the Templar Order, Connor confronted his father. They dueled for the first and last time as the cannons roared and the battle raged below them.

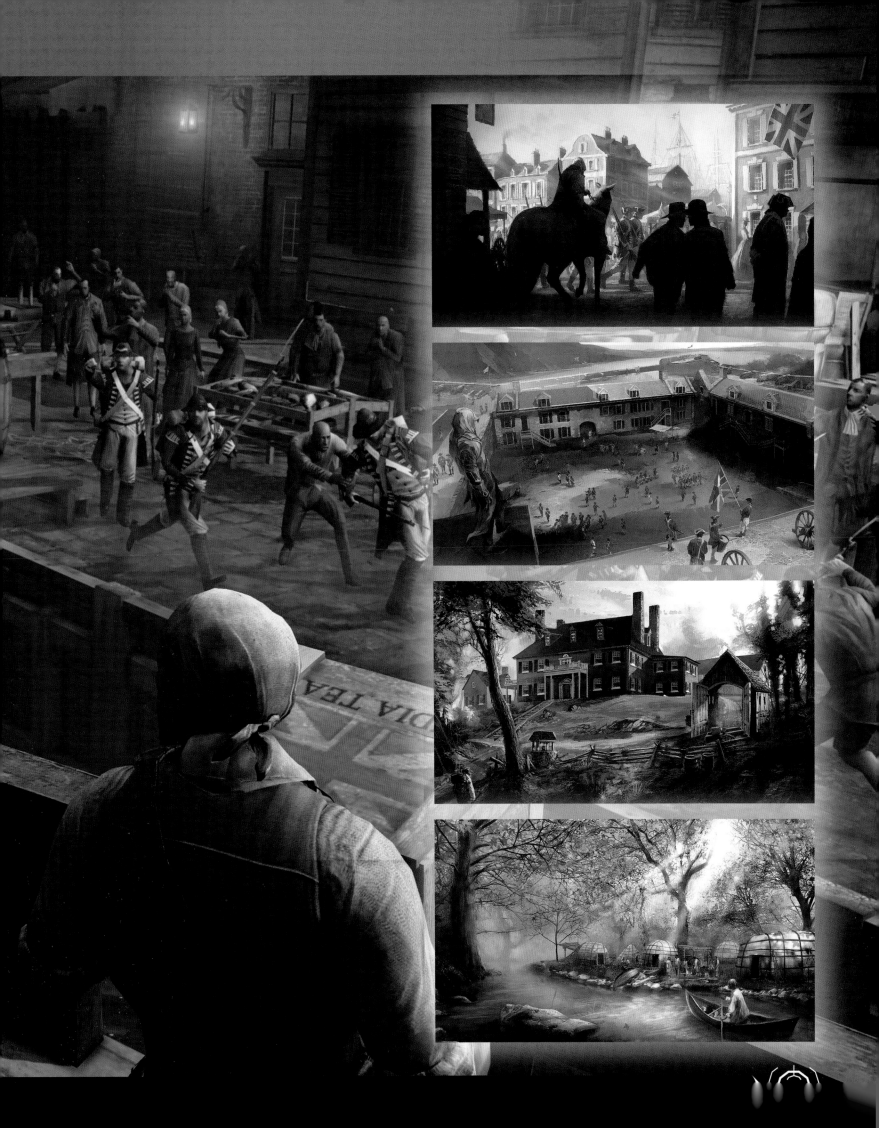

LOUISIANA REBELLION

The Louisiana Rebellion of 1768 was an unsuccessful attempt to block the transfer of power in Louisiana from France to Spain. The defeat of France in the Seven Years' War had repercussions beyond the northern part of the colonies; the French had to cede Louisiana to Spain under the 1762 Treaty of Fontainebleau, although it was not announced until 1764. The citizenry was unhappy about the transfer of ownership and the Spanish occupation of the city, which led to opposition.

New Orleans was situated along an important trade route connecting the Mississippi River with the Gulf of Mexico, and had grown into a key economic, cultural, and political center. Spanish political control of Louisiana was weak, making New Orleans a prime target for Templars to seize control. In 1765, the existing French governor made a deal with the Templars that allowed him to stay in power for a time, supervising the transfer of power.

Disguising herself as a slave, Aveline traveled to a Templar work camp in **Chichén Itzá** in 1769. Following clues, she explored a cave system and discovered an ancient chamber filled with ruins of a Precursor site and one piece of an artifact known as the Prophecy Disk. She later returned in 1772 and located a second Precursor site and the missing piece of the artifact.

Following clues about people working with the individual in charge of the Templars in New Orleans, Aveline traveled north in 1777 and met Connor, who helped her gain entrance to a fort where her quarry rested. From her target, she learned that her stepmother was the Templar she sought.

When confronted, Madeleine revealed that she had directed Aveline's education and life with the goal of inducting her into the Templars, believing that they had a common goal. When sharing this information with Agaté, her Mentor in the **bayou,** Aveline had to defend herself from her Mentor's attack; he believed she had already turned to the Templar cause. Unable to live with his failure to uncover the identity of the Templar himself, Agaté threw himself to his death.

Aveline agreed to Madeleine's invitation to join the Templars in order to finally eradicate the Templar threat from within, and gave her stepmother the two pieces of the Prophecy Disk to signal her good faith. In **St. Louis Cathedral** at her induction, while Madeleine was occupied in trying to make sense of the Piece of Eden, Aveline assassinated the Templars present, including Madeline herself.

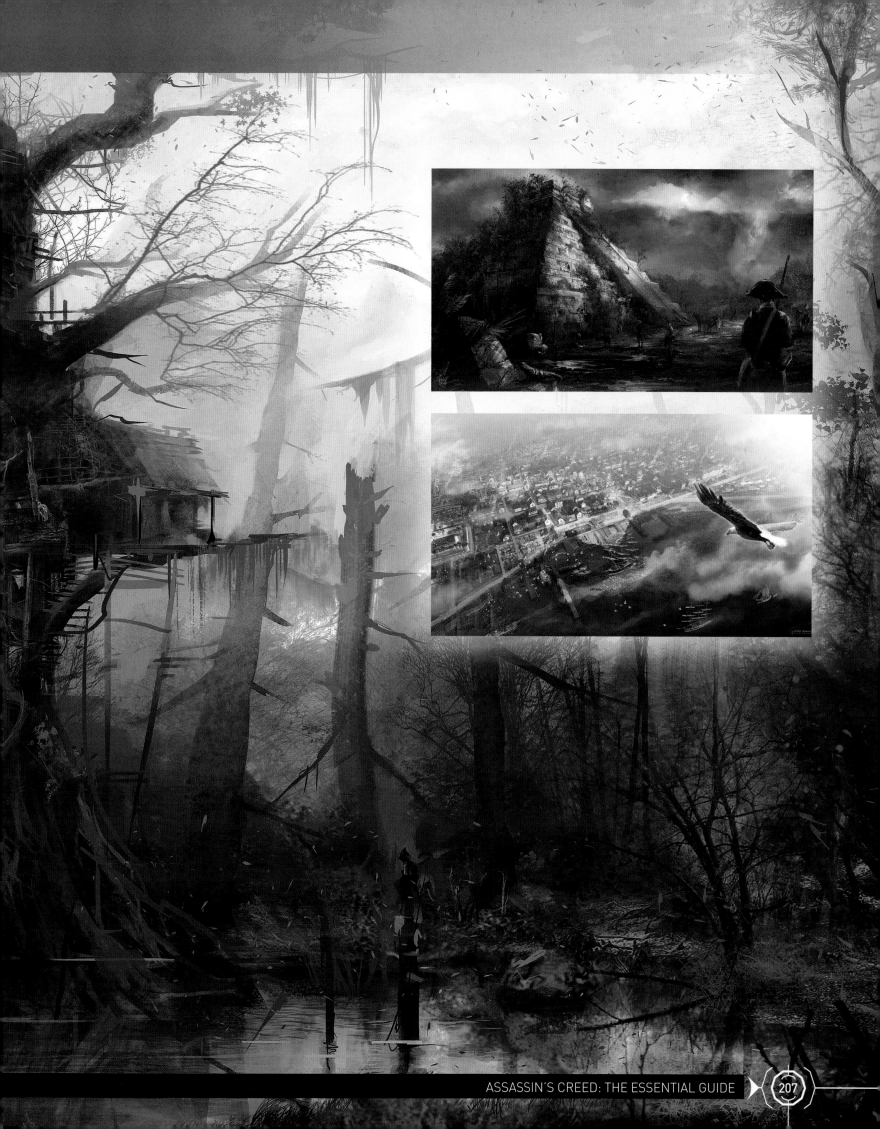

FRENCH REVOLUTION

Arno Dorian's quest for redemption takes place in Paris during the French Revolution, a tumultuous time that impacted the entire world. The revolution was a period of political and economic turmoil, commandeered by the Templars to benefit their own agenda. The social and political upheaval had its roots in the excesses of the aristocracy contrasted with the famine and economic crisis of the lower classes.

The Templars, lead by François-Thomas Germain after his assassination of Grand Master François de la Serre, fueled the revolution at large, which sought to remove aristocratic control of the country's social, economic, and political identity, and to replace it with a middle-class leadership, directed by the Templars. The chaos of the Revolution was meant to demonstrate the dangers inherent in the Assassin-championed free will, and lead the people to accept imposed control willingly.

Versailles was more than just a palace; it was a small city, and the capital of France at the time. The Palace of Versailles was the royal residence, and it was here that Assassin Charles Dorian met his death at the hands of Templar Shay Cormac. Templar Grand Master François de la Serre was assassinated in the courtyard of the same palace.

While imprisoned in the **Bastille** for the murder of his guardian, Arno learned of his family's Assassin heritage from Pierre Bellec, and started on a journey of self-redemption, joining the Brotherhood and working to discover the instigators of the Revolution.

Bellec objected to the Parisian Mentor Honoré Mirabeau's willingness to compromise and make a deal with the Templars, something that Grand Master de la Serre had also been working on when he died. He poisoned the Mentor; Arno subsequently assassinated Bellec in **Notre-Dame Cathedral.**

Working together, Élise and Arno discovered that François-Thomas Germain had ordered de la Serre killed and was manipulating the Revolution to the advantage of the Templars. They tracked him to the Temple, where he had shut himself away with a Sword of Eden. During their final confrontation, Germain's Sword of Eden overloaded during a fierce battle with Élise and was destabilized; the resulting discharge of energy killed Élise, who died in Arno's arms.

In 1794, in the **catacombs under Paris,** Napoleon ordered the excavation of a **Precursor temple** under the commune de Saint-Denis. Arno managed to retrieve the Apple of Eden from the temple first, preventing Napoleon from using it to defeat his enemies. Despite this, Arno later worked with Napoleon, saving him from Royalist attacks.

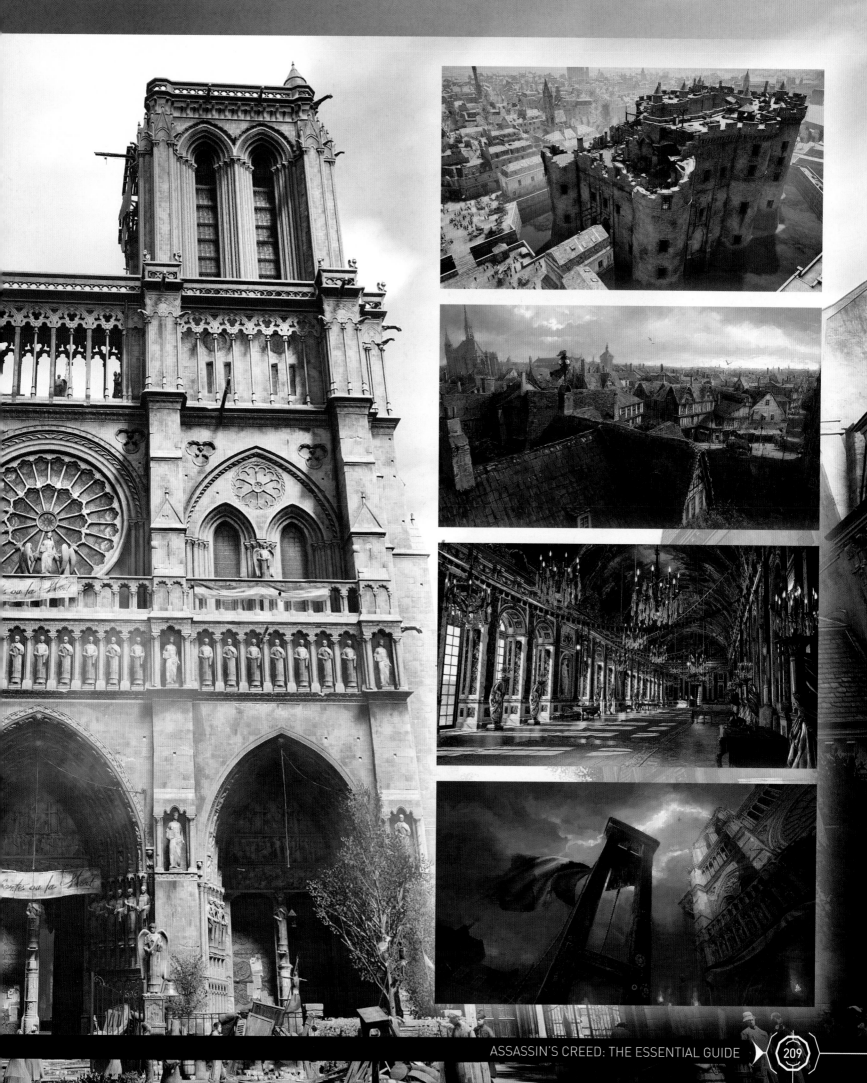

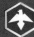

INDUSTRIAL REVOLUTION

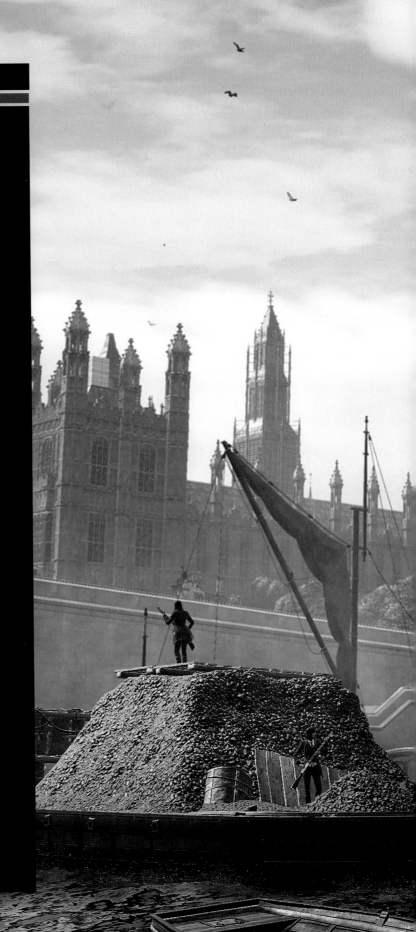

Originating in England, the Industrial Revolution transformed manufacturing processes with the introduction of faster and more efficient machine-based production. In turn, this facilitated the rise of a capitalist economy. In the long run, the Industrial Revolution improved the standard of living, but industrialization also made factory workers out of necessity, as many of the populace's previous jobs no longer existed. Poverty, crime, and exploitation were all too common in this new system. As people moved from the country in to the city seeking employment, the city saw a sudden increase in population, and wages decreased correspondingly. Working conditions were usually appalling, and wages unfair.

The Templars were at the helm of much of the Industrial Revolution, influencing and developing many of the technological advances and the economic shifts that resulted. In line with the Templar plan, the Industrial Revolution led to an economic revision that placed power in the hands of the middle-class business owners, instead of the landed gentry where it had rested for so long. Crawford Starrick benefitted from directing a small corporate empire based on these principles.

London was divided into seven boroughs: the City of London, Lambeth, The Strand, Westminster, Southwark, Whitechapel, and the River Thames.

Evie Frye and Henry Green tracked clues to **Edward Kenway's mansion**, in Templar hands since his death, and located a secret vault. The mansion held several pieces of Assassin memorabilia, but the arrival of Lucy Thorne and other Templars forced Evie and Henry to escape before being able to do more than grab a map and an engraved disk, which were clues to locating the Shroud of Eden.

Evie's use of the Kenway map and disk lead her to **St. Paul's Cathedral**, where a key to the Shroud's hiding place was hidden in a secret room at the top of the cathedral. Lucy Thorne arrived just as Evie had found the key, and took it from her after combat.

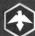

INDUSTRIAL REVOLUTION

In their pursuit of the next clue to the location of the Shroud of Eden, Evie Frye confronted Lucy Thorne in the Tower of London, where she assassinated Lucy in **St. John's Chapel.**

The **Bank of England** was one of the Templar-controlled enterprises in London. Philip Twopenny, who oversaw the running of the bank, was having the bank robbed every few months, using the money to fund Templar activities. Jacob Frye assassinated Twopenny in the bank vaults; however, the bank's printing plates were stolen in the confusion that followed, leading to an influx of counterfeit currency. The citizens' loss of faith in the currency led to riots, rapid inflation, and an increasingly destabilized economy. Evie Frye located and returned these plates.

Maxwell Roth, formerly a Templar ally and a link to the criminal underworld, struck up a partnership with Jacob Frye. Together they worked to undermine Templar activity, sabotaging shipments of explosives and kidnapping Templar agents. However, Jacob drew the line at destroying a workhouse with children inside it. Angered at Jacob's betrayal, Roth set his own **Alhambra Music Hall** on fire while it was filled with people, including Jacob. Roth's death by Jacob's hand ended the Templars' control of the criminal underworld.

Tracking the Shroud of Eden led the Fryes to **Buckingham Palace,** where Starrick was planning a massive coup to take place at a formal ball. Underneath the palace was a vault that contained the Shroud. Ultimately the Shroud was left in the vault after Starrick's defeat there, as the Frye twins considered it much too powerful and dangerous to be brought into the world

STERGO FACILITIES

Being a multinational corporate conglomerate, Abstergo Industries has several facilities in major city centers where work is undertaken. Among those facilities, there are a few key locations that house major Templar initiatives operating under the Abstergo name.

ROME

The Abstergo Campus in Rome was the original location of the Animus Project. A Laboratory in a special lab on the fourth floor within the research wing of Abstergo's Rome facility was built specifically for the launch of the Animus Project.

PARIS

The original home of the Phoenix Project was located in Paris. In 2014, Gavin Banks led an Assassin team to destroy the Phoenix lab. This assault also destroyed a Shroud of Eden and the Precursor DNA samples stored onsite, constituting a major setback for the project.

LONDON

The Abstergo head office in London is an important meeting place for Templars. Alan Rikkin, Abstergo's CEO and one of the members of the Inner Sanctum of the Templar Order, has a permanent office there.

THE AERIE

An Abstergo facility located in North America, the Aerie houses a version of the Animus that has been approved for underage users.

PHILADELPHIA

The Abstergo facility in Philadelphia is known to house an Animus. Daniel Cross returned to this facility after assassinating the Mentor of the Assassin Brotherhood in late 2000.

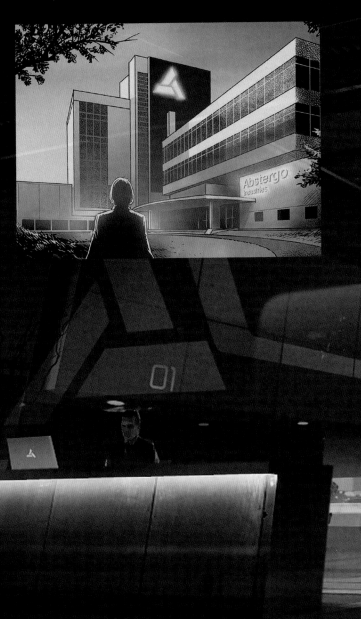

AUSTRALIA

After the destruction of the Paris Phoenix lab in 2014, the Brotherhood searched fruitlessly for the new location of Álvaro Gramática's project to create an Isu body via cloning technology, high-concentration Isu DNA, and a Shroud of Eden. The search intensified when the race to locate the Koh-i-Noor, the Piece of Eden that could unite the powers of other Pieces of Eden, became critical to stopping Juno from taking control of the world. The alliance between Juhani Otso Berg and Charlotte de la Cruz's Assassin team enabled them to learn that Project Phoenix now occupied a secret underground lab in the Australian desert. Gramática died and the lab was completely destroyed by Otso Berg after Juno incarnated into the finished Isu body and was killed by Charlotte de la Cruz.

MADRID

The Abstergo Foundation Rehabilitation Center (often referred to as simply the Abstergo Foundation) was established in Madrid to allegedly pursue genetic research to isolate a genetic solution to violence. Built on the site of a twelfth-century chapel and headed by Dr. Sofia Rikkin, the Foundation actually imprisoned several individuals connected to the Assassin Brotherhood and experimented on them in order to aid in the search for an Apple of Eden. Abstergo CEO Alan Rikkin planned to use the Apple of Eden to remove humanity's will to oppose the Templars' plan for the New World Order. The research at the facility was suspended indefinitely when the inmates rebelled and overcame the guards, escaping the property.

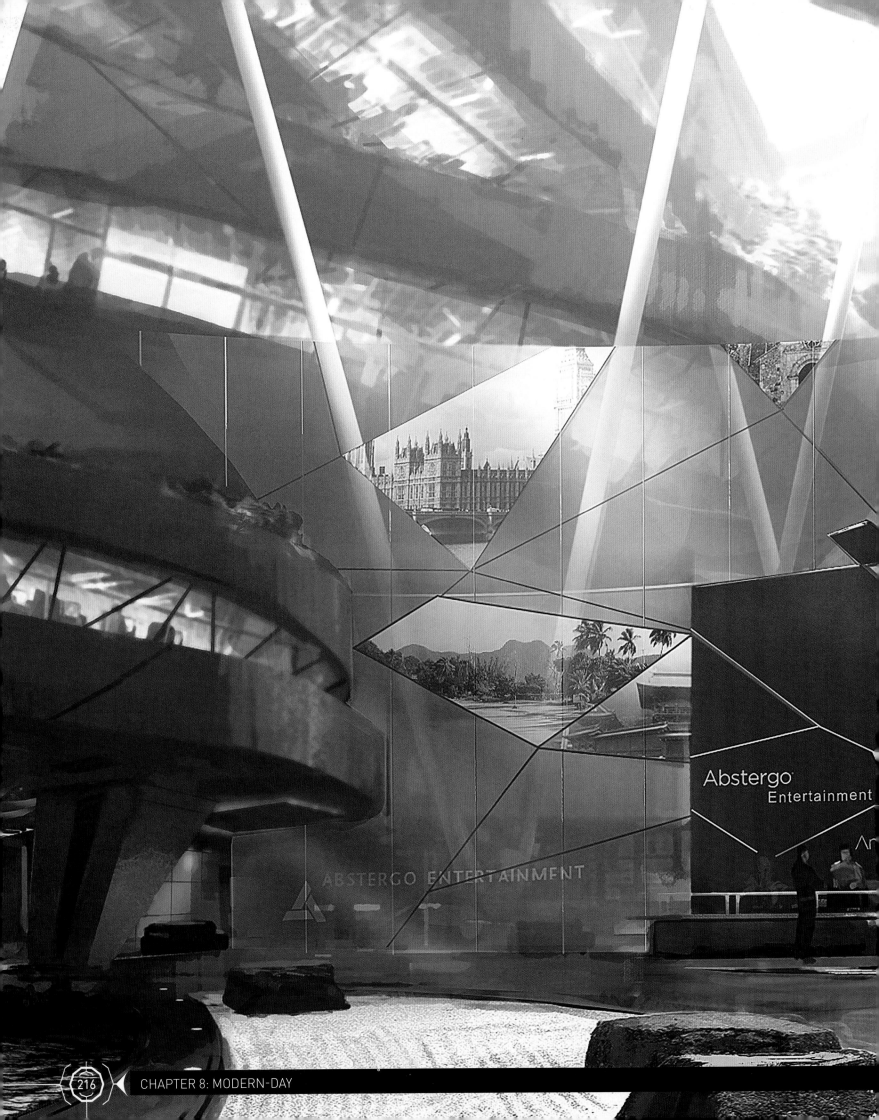

CHAPTER 8: MODERN-DAY

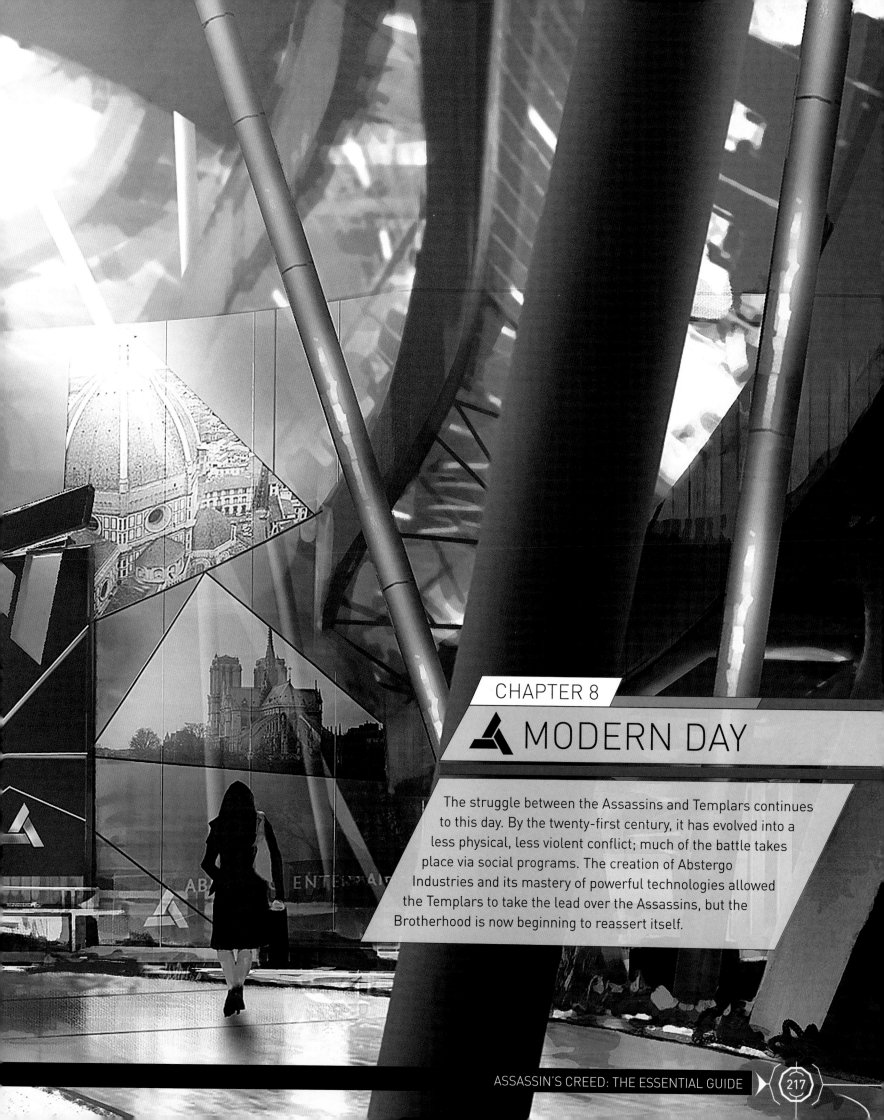

CHAPTER 8

MODERN DAY

The struggle between the Assassins and Templars continues to this day. By the twenty-first century, it has evolved into a less physical, less violent conflict; much of the battle takes place via social programs. The creation of Abstergo Industries and its mastery of powerful technologies allowed the Templars to take the lead over the Assassins, but the Brotherhood is now beginning to reassert itself.

THE ASSASSIN BROTHERHOOD

The Great Purge of 2000 was a defining event of the modern Assassin-Templar struggle. Initiated by the assassination of the Brotherhood's Mentor by sleeper agent Daniel Cross, the Great Purge was an Abstergo Industries operation that used information unwittingly gathered for them by Daniel to send Templar strike teams to destroy Assassin cells and safe houses. The Great Purge shattered the modern Brotherhood, decimating the Assassins and placing the Templar Order in a position of vastly increased power and influence.

As a result, the Brotherhood scrambled to stabilize itself. The Assassins recruited new people and sought new ways to reform its membership and modus operandi. Assassin cells became more mobile, which helped reduce the risk of being tracked by the Templar Order. Recruiting and training people from the Initiates group and Erudito Collective has been invaluable, as has the Brotherhood's determination to focus on significant Abstergo projects, such as the Phoenix Project, and their hunt for the powerful Koh-i-Noor.

MINERVA'S MESSAGE

The message from Minerva, recorded both in the genetic memories passed from Ezio to his descendants and in Ezio's Prophet's Codex, told the story of the Toba Catastrophe and warned of the upcoming Second Disaster, due in December 2012. This information gave the Assassins renewed purpose over the next few centuries, hunting for the Pieces of Eden that lead to the location of the Grand Temple and the key to unlock its inner chamber. Here, Desmond would be faced with a difficult choice between Minerva and Juno. Saving the world from the disaster would release Juno to once again threaten the earth; allowing the solar flare to wipe out most of the life on earth would allow for a fresh start, although Desmond's motivations and the Assassin philosophy would be warped over time and the cycle of struggle between the factions would reinitialize. Desmond chose to save the world and release Juno, giving his life in the process.

ALLIANCE

In 2018, Charlotte de la Cruz's Assassin team had formed an alliance with Juhani Otso Berg, as both parties understood the need to bring down the Phoenix Project and stop Juno once and for all. With Otso Berg functioning as the Black Cross and bringing his Abstergo knowledge to the undertaking, Charlotte and her team were able to track down the Koh-i-Noor, the Piece of Eden Juno required to secure her control over the world once she had incarnated in the Isu body the Phoenix Project was creating for her.

Despite their common goal, this alliance was fraught with tension. Otso Berg and Galina Voronina had personal, bitter history, and both sides made it clear that as soon as their objective had been realized, the alliance would instantaneously be over, their enmity restored.

TOWARD THE FUTURE

As of 2017 William Miles returned as the Mentor, taking up the duties he had previously shared with Gavin Banks, although without formally taking on the title. Now he operates formally under the name of Mentor as well as handling the responsibilities.

William Miles has personally recruited an ex-Abstergo employee called Layla Hassan, extracting her from a Sigma Team attack in Egypt after she illegally modified and used an Animus during a mission. A brilliant engineer, Layla's genius with the Animus has made her one of the most valuable additions to the modern Brotherhood and has given the Assassins a healthy boost in their fight to match Abstergo's new developments in Animus technology. Her ability to make intuitive leaps and her willingness to take risks, combined with her technological prowess, make her a force to be reckoned with, and a bright hope for the Brotherhood.

THE TEMPLAR ORDER

The Great Purge of 2000 set the Templar Order in a secure position. Their incapacitating strike against the Brotherhood removed all but a minimum of resistance. This event proved the validity of the Templar Order's decision to invest in science and technologies research as of the end of the nineteenth century. The Templars are aware their relentless push for scientific progress to further their cause does have risks, as in 2016 a rebellion took place in the Madrid facility, and in 2018 the Phoenix Project had to be destroyed. Nevertheless, the advancement of groundbreaking scientific and technological innovations through Abstergo's projects remains at the heart of the Order's strategy.

ABSTERGO INDUSTRIES

Created in 1937, Abstergo Industries serves as a front for the Templars, carrying out Templar-directed projects as well as acquiring information for the Order. However, Abstergo Industries is not synonymous with the Templar Order; while the Order may direct it from behind the scenes, Abstergo has a life of its own. The majority of Abstergo employees are regular people who are unaware of the Templar-Assassin conflict, and the majority of Abstergo's subsidiaries and companies are commonplace businesses.

SUBJECT 17

The other critical success in modern times for the Templar Order has been the September 2012 abduction of Desmond Miles, known as Subject 17 in the Animus Project. A descendent of several key bloodlines that carry Precursor DNA, his genetic memories have provided Abstergo Industries with a rich source of information about the Precursors and their legacy.

THE ANIMUS PROJECT IN THE TWENTY-FIRST CENTURY

The secret Templar core of Abstergo remains focused on gathering as much information as possible concerning the Precursor race and their artifacts, mainly via collecting and exploring genetic memories. With the introduction of technology that has enabled individuals to willingly explore and upload their personal genetic memories (as well as the unauthorized collection of genetic memory via various processes), Abstergo has access to countless resources for this purpose. Currently, the Animus Project's developments are moving forward in several directions at the same time, with some departments focusing on user experience and synchronization, others on mobility, and others on multi-user interfaces, among other avenues. The latest innovations are aiming to increase the quality of simulations based on damaged or incomplete DNA, as well as the input of other material sources to improve the accuracy of those simulations.

ABSTERGO AND THE PUBLIC

Abstergo Industries has access to the public via health centers, pharmaceutical trials, entertainment technology, and other widespread social programs. The discovery of Desmond Miles' unknown son Elijah was made as a result of a visit he and his mother made to an Abstergo health clinic, where his blood was scanned. Abstergo Industries is deeply committed to improving the life of citizens around the world, funding several initiatives that underscore issues like clean water and optimized health.

SIGMA TEAM

Sigma Team is the most important unit in the Templars operations task force. Led by Juhani Otso Berg, the team was originally created to hunt down Assassins who had survived the Great Purge. Sigma Team has been instrumental in other missions as well, acquiring Pieces of Eden or providing support for other initiatives. Sigma Team's most recent notable mission was blowing up the secret underground lab that housed the Phoenix Project in Australia.

ABSTERGO INDUSTRIES

Created to be a public front for the Templar Order and an economic force in the twentieth century, Abstergo Industries is a massive multinational corporate conglomerate with offices in major cities around the globe. It has been involved in the majority of technological development since its creation in 1937, and is the major source of funding for secret Templar projects. The last CEO of Abstergo Industries was Alan Rikkin, who died at the hands of Assassin Callum Lynch in December 2016 after Lynch's escape from the Madrid Abstergo Foundation. The position of CEO appears to be as of yet unfilled, with an interim management in place until a replacement for Rikkin is found.

ABSTERGO INDUSTRIES MISSION STATEMENT
"We are committed to researching, developing, and providing high-quality products that enrich, entertain, and shape the lives of our customers. We build programs that re-examine the past, improve the present, and define the future."

GOALS
With the motto "For a Better Life and a Brighter Future," Abstergo takes its mission very seriously. It is genuinely committed to advancing the human condition, developing technology and processes that improve life for millions of people. While many of its initiatives are

technological or consumer-based, Abstergo Industries also exerts power in other fields. For example, Abstergo helped develop and establish the World Bank and NASA, among other high-profile initiatives.

Abstergo Industries also works indirectly to affect international affairs, such as by owning controlling shares on the boards of other companies and private funding of specific political parties in various countries. By investing in foreign governments and funding particular key corporations, Abstergo has quietly strengthened its influence over the dissemination of knowledge and the collection of data that supports the Templar Order's goals.

ABSTERGO AND THE TEMPLAR ORDER
Abstergo has a secret, three-part, Templar-directed initiative that non-Templar Abstergo employees are not privy to: to destroy the Assassin Brotherhood; to acquire Precursor technology; and to establish a New World Order.

NEW WORLD ORDER
The Templar vision of the New World Order is a utopian ideal. Under complete Templar control, this new world would be directed by a small ruling elite managing all aspects of human civilization, including agriculture, education, military, and politics. This utopian ideal would feature the absence of racism, bigotry, and chaos. Warlords, guerilla uprisings, and despotic nations would no longer exist, as the Templar Order would be managing and directing a united, peaceful society with all aspects functioning in harmony with one another.

Abstergo Industries proudly states that their employees are well cared for: they have access to excellent benefits, including health care, and hiring practices emphasize diversity and gender equality.

The Eye-Abstergo project of 2012 was designed to initiate this New World Order, by placing an Apple of Eden in a key position within the Akashic Satellite Plexus array.

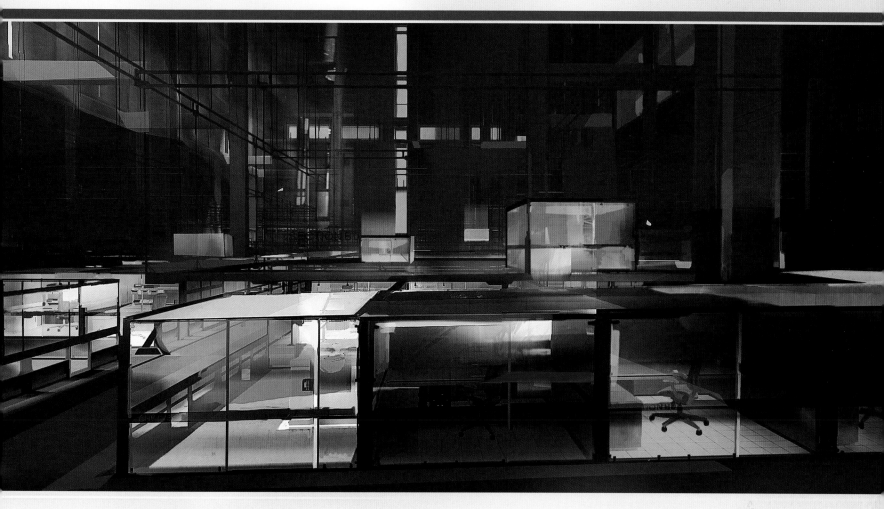

Present Day
Logo

1976 Logo

1969 Logo

Abstergo
Industries

Abstergo
Industries

THE ABSTERGO CONGLOMERATE

Abstergo Industries is a collective name for a corporate entity encompassing a wide variety of companies in various fields. These are only a few of the many divisions, companies, and subsidiaries that make up the conglomerate.

ABSTERGO PHARMACEUTICALS

Abstergo Pharmaceuticals produces medicines for use in various treatments such as cancer and diabetes, and is constantly engaging in new research for drug therapy, biotechnology, and pharmacology. In 2016, André Bolden, a Vietnam War veteran, was offered free experimental treatment for his Post-Traumatic Stress Disorder at the Philadelphia facility. While Abstergo Pharmaceuticals does indeed offer and develop treatments for PTSD, the offer extended to Bolden was a way for Otso Berg to get access to his genetic memories, which had links with the last known Black Cross.

ABSTERGO FITNESS

The Abstergo Fitness division develops products and programs that emphasize excellent health, responding to a popular concern in the twenty-first century. Products created in this division have included the Herne+ line, the Bodyband fitness tracker, and the Angelus monitor based on the Bodyband technology. When Layla Hassan started working for Abstergo, she initially joined the Abstergo Fitness department, although she soon became bored and skeptical, and applied to work elsewhere within the organization.

SKUNKWORKS

An Abstergo company devoted to designing and producing cutting-edge military technology and gear, Abstergo Skunkworks operates within measures of extreme secrecy and confidentiality. Experimental weapons and equipment are generally field-tested by select agents and members of the Sigma Team. New innovations and developments are classified to the extent that only very few Templars are aware of their existence.

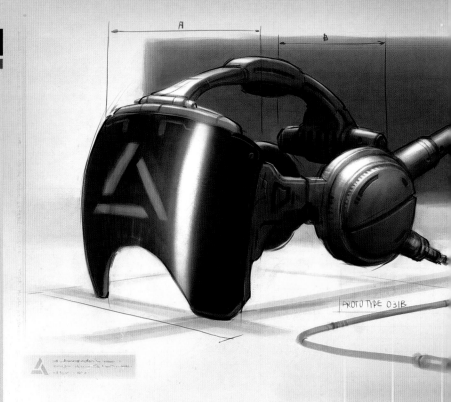

PROTOTYPE 031B

Market Penetration: It's estimated that there are approximately three dozen Abstergo products in the average North American household at any given time. In addition to this, while the Abstergo name may not be on the product itself, Abstergo produces elements or supplies companies with materials for manufacture or production.

In January 2017, Otso Berg investigated the aftermath of a mysterious raid that had taken place at an abandoned Abstergo facility in Hong Kong when he found a prototype of advanced military goggles belonging to the Skunkworks department. The discovery eventually led him to discover the Instruments of the First Will had managed to infiltrate the Templar Order at a very high level.

MYSORETECH

An Abstergo-owned technology company based in Bangalore, India, MysoreTech was the distributor of the Brahman V.R. device, a portable, commercial version of the Animus console.

ABSTERGO ENTERTAINMENT

Headed by Chief Creative Officer Melanie Lemay, Abstergo Entertainment creates multimedia entertainment products such as games and films. Founded in 2010, its main offices are located in Montréal, Canada.

Charlotte de la Cruz was an avid user of Abstergo Entertainment's Helix products. As all players' behaviors are tracked by Abstergo, her exceptional skills within the games led Charlotte to be noticed by the Templars, who intended to use her as a subject for the Animus in order to explore her potentially valuable genetic memories.

ABSTERGO FINANCIAL GROUP

Abstergo Financial provides a wide range of economic services that help consumers and corporations manage their money, including banks, credit unions, credit-card companies, insurance services, investment services, and accountancy services, among others. The Malta Banking Corporation is one such bank within the Abstergo Financial division. In 2015, Charlotte de la Cruz, who would later become one of the most important modern day Assassins, was working at a Malta Banking Corporation branch in San Diego, California.

HISTORICAL RESEARCH

The public mission of the Historical Research division is to research history and document as many events as possible, delving into the details of previously obscure incidents and learning more about historical personages. The applications of the material uncovered by Abstergo's Historical Research division has tremendous and exciting potential for many academic disciplines, including archaeology, anthropology, environmental history, and political science. The current head of the Historical Research Division is Simon Hathaway, although he is not trusted by all his fellow Inner Sanctum members. Former Abstergo employee Layla Hassan was working for the department when she was sent to Egypt for research.

LINEAGE DISCOVERY AND ACQUISITION

Sometimes referred to as Lineage Research and Acquisition, this department is a private Abstergo division responsible for locating individuals whose lineage is of interest to Abstergo. Acquiring the genetic memories of these individuals allows the Templars to do further research, and sources include internal projects such as Project Legacy. Led by Inner Sanctum member Mitsuko Nakamura, the Lineage Discovery and Acquisition department has been responsible for identifying and locating important individuals, such as Daniel Cross, Desmond Miles, Charlotte de la Cruz, André Bolden, Callum Lynch, and many others.

THE AERIE

A remote Abstergo facility located in the United States, the Aerie is a multidisciplinary research centre with a focus on subjects related to Lineage Discovery and Acquisition, the Animus Project, and the identification and search for Precursor artefacts.

Until 2017, the Aerie was headed by Isaiah, a Templar focused on exploring what he called an Ascendance Event, which brought together five teenagers whose ancestors interacted over and over again, in order to seek pieces of the Trident of Eden.

ABSTERGO FOUNDATION REHABILITATION CENTER

A subsidiary company of Abstergo Industries, the Abstergo Foundation presented its mission as researching a way to terminate the human penchant for violence via isolating the gene associated with it. Alan Rikkin was covertly using the project, headed by his daughter Sofia, to research the location of an Apple of Eden. Several individuals with Assassin ancestry, among them Callum Lynch, were 'treated' as subjects at the facility in Madrid, until their uprising and escape in 2016.

FUTURE TECHNOLOGY

Abstergo is highly invested in technology research and development, as it supports much of their activity in other divisions. Sofia Rikkin's drafting of Layla Hassan from the Department of Electrical Engineering and Computer Sciences at Berkeley during an Abstergo Industries Young Innovators recruitment event was one such investment, securing her high-tech genius and unconventional, innovative approach to be used unwittingly to further Animus development.

ABSTERGO INDUSTRIES PROJECTS

Abstergo Industries is behind several admirable public initiatives that underscore health and safety, focusing on the well-being of citizens. A line of public medical clinics has recently been launched, offering affordable health care to individuals who otherwise may not be able to access much-needed care.

NEW FLUORIDE

New Fluoride is a synthetic drug developed to improve the quality of drinking water. The New Fluoride project was suspended pending an allegation that Abstergo Pharmaceuticals was secretly testing their product on the water supply of citizens without approval. Abstergo Pharmaceuticals underwent a rigorous investigation, and as of 2014 was cooperating with the Food and Drug Administration to organize an approved launch of the New Fluoride project.

BODYBAND

A portable fitness tracker, the Bodyband exercise wristband monitors motion and heart rate, and can prompt the wearer to take breaks or engage in physical activity, like many other fitness trackers on the market. The Bodyband goes beyond the capability of many other trackers, however, also tracking brainwaves, hydration levels, hormone levels, sleep patterns, oxygen levels, and more. It is also capable of creating personalized exercise routines, offering the wearer a truly bespoke experience.

HERNE+ LINE

A line of energy supplements and food replacements that features twenty-seven "superfoods" in a variety of flavors, all optimized for peak nutrition. Among other things the Herne+ line offers consumers the choice between an easy-to-mix shake or meal replacements in a convenient pill form. All Herne+ products provide long-lasting energy and time-released nutrition.

ANGELUS

The Angelus implant relies on the most cutting-edge nanotechnology to monitor and communicate a child's state to a parent or guardian wearing the paired wristband. Designed to monitor heart rate, oxygen saturation, hormone levels, and brain function from birth, the Angelus monitor provides complete peace of mind for a parent caring for a child.

MAIN MODERN-DAY TEMPLARS

THE INNER SANCTUM

As in days past, the modern Templar Order is directed by the Inner Sanctum, a nine-member council (sometimes referred to as The Nine). Unlike lower-ranking Templars, every member of the Inner Sanctum is in full possession of the plans for the Templar creation of the New World Order, the imposition of a Templar-designed plan to control humankind in order to impose world peace. The Inner Sanctum members are also all fully aware of the private Abstergo projects and initiatives.

The Inner Sanctum of the Templar Order is an extremely private, highly secret group. Only the members know of the matters discussed among them, and the identity of The Nine is not known to most Templars.

The Inner Sanctum is outranked only by the three **Guardians of the Cross**, who review the Inner Sanctum's decisions before passing them to the **General of the Cross**, who has final approval on those decisions. The identity of the individuals holding these positions is presently unknown, although it is known that Alan Rikkin functioned as one of the Guardians in 2014. A separate entity, **the Council of Elders**, influences and guides the active governing bodies of the Templar Order such as the Inner Sanctum, but not directly controlling them.

The **Black Cross** was an inquisitorial and enforcer position meant to keep the Grand Masters of the different Rites and their subordinates in line with the Templar philosophy. The identity of the Black Cross was always secret, and they answered only to the Inner Sanctum, wielding their power to excise corrupted members of the Order. The concept of the Black Cross had reached almost legendary status among Templars throughout history, who admired and feared the mysterious inquisitor of their Order.

The Black Cross mythos was presumed to have ended in 1927 with what was believed to be the death of the last known Black Cross, Albert Bolden. In 2016, Juhani Otso Berg independently resurrected the position to bring modern Templars into line, including the members of the Inner Sanctum. Otso Berg personally took on the position of the Black Cross, with his identity kept secret. He was the first Black Cross to be an actual member of the Inner Sanctum. As of the destruction of the Phoenix Project in 2018, Otso Berg has retired the Black Cross persona... for now.

AT THIS TIME, MEMBERS OF THE INNER SANCTUM INCLUDE:

MITSUKO NAKAMURA

A research executive in the Lineage Discovery and Acquisitions division of Abstergo located in Philadelphia, Mitsuko Nakamura oversees the research done on genetic memories. She supervises the search for, location of, and acquisition of individuals with lineage of interest to Abstergo's programs.

ALFRED STEARNS

Alfred Stearns is a former high-ranking Abstergo Industries executive who personally oversaw the Great Purge of 2000, supervising the extraction of the Daniel Cross's memories and sending strike teams to the Assassin safe houses and operating locations Daniel had visited during his search for the Mentor. Although he has retired from his position, he remains a member of the Inner Sanctum today.

AGNETA REIDER

Originally from Austria, Agneta Reider was recently appointed as the new chief executive officer of the Abstergo Financial Group, where she served as a highly regarded chief financial officer for several years.

LAETITIA ENGLAND

A high-ranking executive in the Operations division of Abstergo and based in Philadelphia, Laetitia England's activity is shrouded in mystery, like many other Inner Sanctum members.

DAVID KILKERMAN

David Kilkerman's previous position within Abstergo Industries is unknown, although his activity suggests he has been peripherally involved with the Animus Project. He was informed of Daniel Cross's return after killing the Assassin Mentor in 2000, and visited the Animus lab in 2012 with Alan Rikkin after Desmond Miles finished reliving the genetic memories of Altaïr Ibn-La'Ahad. He has replaced Warren Vidic as the head of the ongoing Animus Project.

SIMON HATHAWAY

Following the death of his former boss, Isabelle Ardant, Simon Hathaway was promoted as the Director of Historical Research. He is the newest member of the Inner Sanctum member as of November 2016. Sharp and very cerebral, animated by an insatiable curiosity, Simon has a 'knowledge for the sake of knowledge' approach to the department, having used the Animus to explore history for its own sake. This led to his discovery of the missing Heart, a stone that, when joined with Jacques de Molay's Sword of Eden, enhanced its power.

ALAN RIKKIN

CEO of Abstergo Industries 2012 until his death in 2016, Alan Rikkin held the position of Guardian within the Templar Order, answering only to the General of the Cross, as well has holding a seat in the Inner Sanctum. Intelligent and charismatic, Rikkin was often brusque when dealing with inferiors, and could also be vulgar and disrespectful when impatient. He died in December 2016 at the hands of Callum Lynch.

ÁLVARO GRAMÁTICA

A genius with a background in mechanical engineering, biology, physics, and computer science, Gramática was recruited by Abstergo in 2008 for the Akashic Satellite Plexus project. He went on to create the Data Dump Scanner in 2009. As of 2014, Gramática headed the Phoenix Project with the goal of sequencing the Precursor genome in order to create an artificial body to house Juno's consciousness. He was successful in 2018, using Isu-rich DNA extracted from the bone marrow of Elijah, the son of Desmond Miles, and fibres from the Shroud of Eden to grow an Isu body for Juno to occupy. He died in the subsequent destruction of the secret underground Phoenix lab.

N MODERN-DAY TEMPLARS

Juhani Otso Berg
(1985–)

A man of integrity and honor, Otso Berg is the embodiment of the perfect modern-day Templar, and one of the most respected members of the Templar Order. Sworn to hunt down the Order's enemies, he has great respect for the Assassins' dedication and ingenuity. That respect does not temper his ruthlessness, however, as he is the Order's deadliest field operative, experienced in several forms of combat.

Originally a member of the Utti Jaeger regiment of the Finnish Special Forces, Otso Berg chose to work as a mercenary in order to make more money to pay for his daughter Elina's cystic fibrosis treatments. This decision led his wife to divorce him. He was recruited by Warren Vidic, who used the lure of a new cystic fibrosis treatment that he claimed would cure his daughter.

In October 2012, Otso Berg began training in the second level of the Animi Training Program; his work was impressive enough to earn him promotion within the Templar Order. Soon after he was tapped as a potential candidate for the Inner Sanctum. One month later, he was given command of Sigma Team, a special strike force created to hunt and kill Assassins after the Great Purge. After tracking down an Assassin who had murdered hackers at the Abstergo Campus in Rome, Berg and Sigma Team stormed an Assassin hideout in Florence. The Assassin leader blew up the hideout, killing everyone but Otso Berg, whose face was badly burnt.

Otso Berg was made a Master Templar and inducted into the Inner Sanctum of the Templar Order in early December 2012. A few days later, he was tasked with capturing William Miles. Otso Berg reformed Sigma Team and captured the veteran Assassin in Cairo, an accomplishment which earned him a great deal of respect within the Order.

Otso Berg spent most of 2013 and 2014 monitoring Assassin activity and hunting down the Order's enemies around the globe, as well as gathering information and tracking down Pieces of Eden. In 2015 Otso Berg lost half of Sigma Team to an Assassin attack during an attempt to secure a Shroud of Eden, and was almost killed by Galina Voronina.

In 2016 Otso Berg revived the position of the Black Cross of his own initiative, secretly taking on the role to root out corruption within the Templar Order. While investigating he discovered that the Instruments of the First Will had become a significant threat. In order to effectively eliminate them and stop Juno in her attempt to seize control of the world, Otso Berg proposed a temporary alliance between himself and Charlotte de la Cruz's Assassin cell, sharing intelligence and plans. The alliance ended abruptly once Charlotte had killed the newly incarnated Juno and Otso Berg blew up the Phoenix lab.

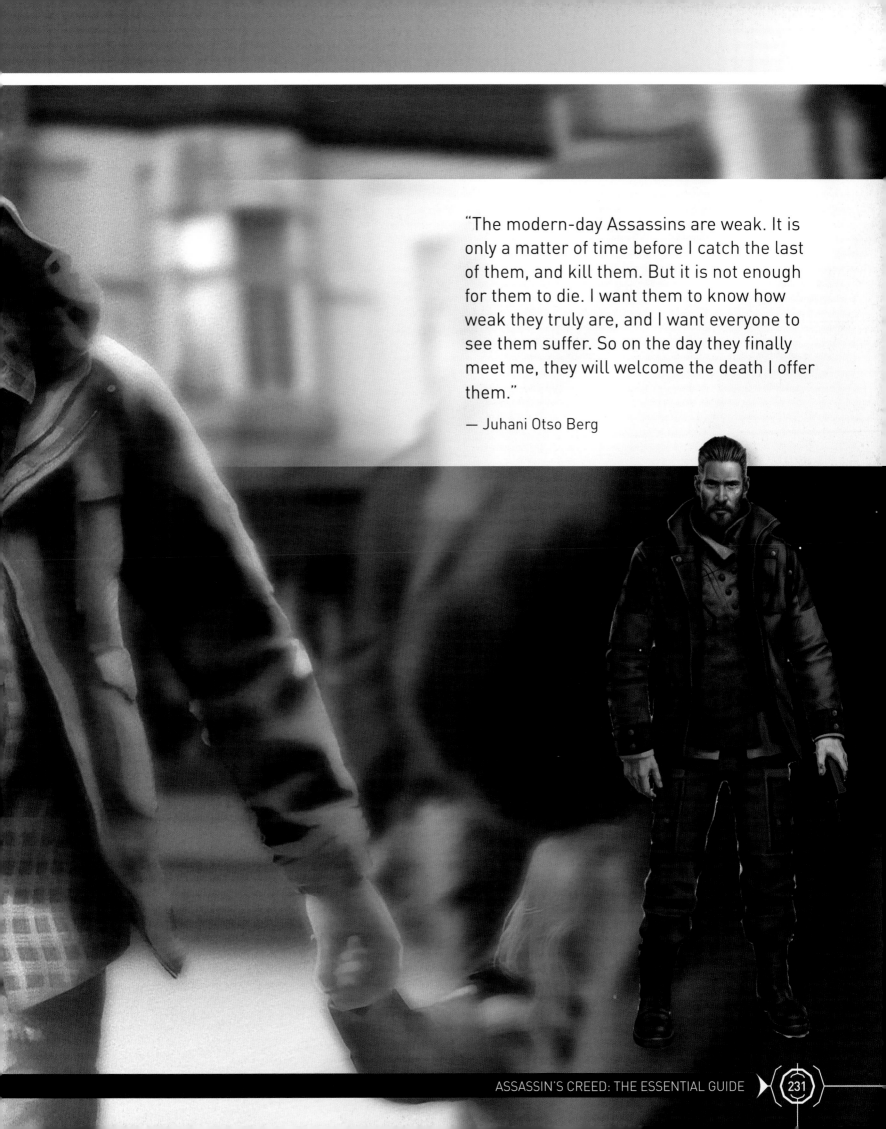

"The modern-day Assassins are weak. It is only a matter of time before I catch the last of them, and kill them. But it is not enough for them to die. I want them to know how weak they truly are, and I want everyone to see them suffer. So on the day they finally meet me, they will welcome the death I offer them."

— Juhani Otso Berg

Daniel Cross (1974–2012)

The great-grandson of Assassin Nicolaï Orelov, Daniel Cross was kidnapped by Abstergo to be used as a subject in early Animus experimentation. Warren Vidic then implanted a false identity and its associated memories into the boy's mind, as well as a subconscious directive to locate the Mentor of the Assassin Brotherhood, with the further directive to kill him hidden even deeper in his mind. Vidic then abandoned the child.

In the years that followed, Daniel suffered hallucinations that were actually the genetic memories of his Russian ancestor, and sought escape in drugs and alcohol. When Assassin Hannah Mueller noticed Daniel menacing a bystander and accusing him of being a Templar, she intervened and took him to an Assassin training camp, where they researched Daniel's identity.

After suffering from a severe Bleeding Effect episode, Daniel "remembered" who he was and became determined to find the Assassins Mentor. When he finally met him after years of searching, the Templar dormant directive was triggered and he assassinated the Mentor.

Daniel escaped and found his way to Abstergo, looking for help. Abstergo extracted the information on the Assassin cells that Daniel had acquired during his search, and used it to initiate the Great Purge, wiping out almost every Assassin cell in the world. Daniel eventually became a Templar, finding in the Order the family he lacked. His Assassin knowledge was useful in training new recruits and Abstergo managed his hallucinations and instability with therapy, medication, and periods in the Animus.

He was instrumental in retrieving Ezio Auditore's Prophet's Codex, which contained Minerva's information regarding the Second Disaster and the name Desmond — a valuable clue for Abstergo. Daniel would later be responsible for locating Desmond Miles after his escape from Abstergo. He became obsessed with Desmond, tracking him and expressing frustration for blocking his attempts to capture or kill him.

Daniel was eventually killed by Desmond at the Abstergo facility in Rome. The Apple Desmond carried triggered a Bleeding Effect reaction in an already unstable Daniel, and in the ensuing fight Desmond killed him with his Hidden Blade.

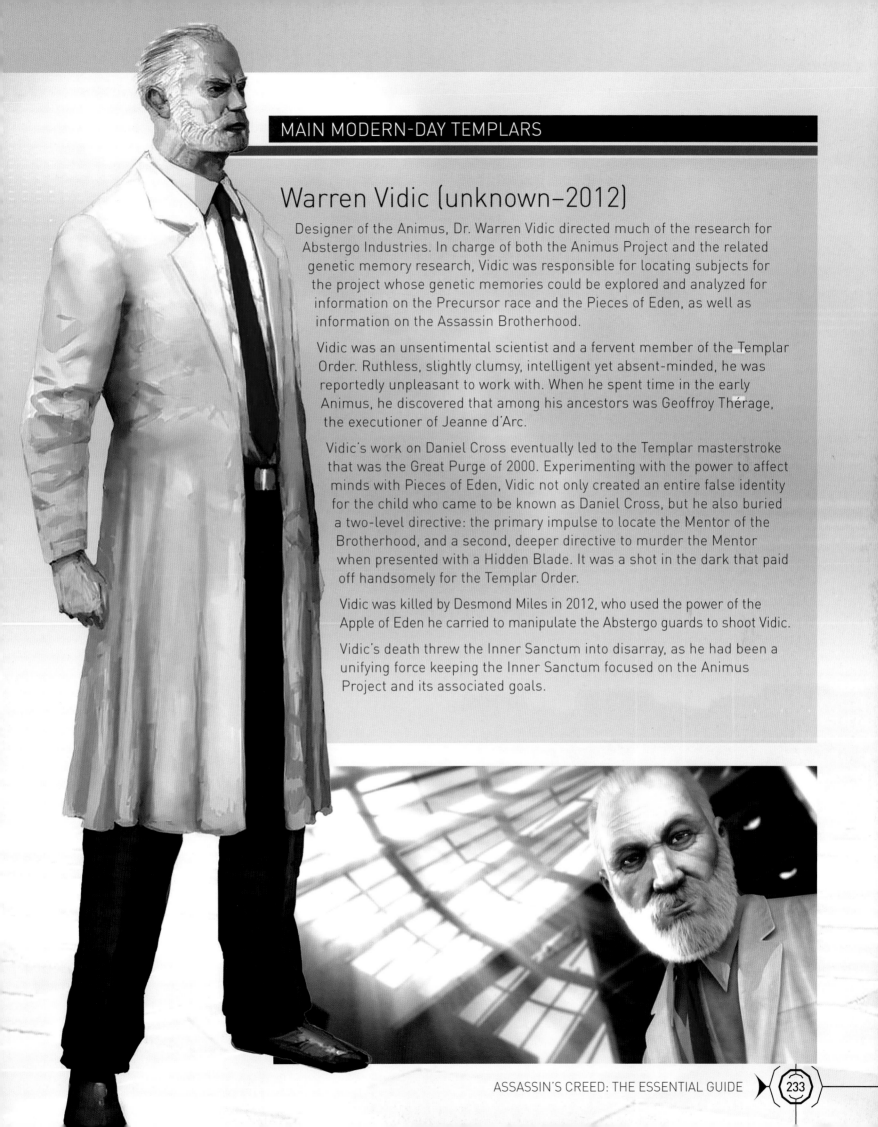

Warren Vidic (unknown–2012)

Designer of the Animus, Dr. Warren Vidic directed much of the research for Abstergo Industries. In charge of both the Animus Project and the related genetic memory research, Vidic was responsible for locating subjects for the project whose genetic memories could be explored and analyzed for information on the Precursor race and the Pieces of Eden, as well as information on the Assassin Brotherhood.

Vidic was an unsentimental scientist and a fervent member of the Templar Order. Ruthless, slightly clumsy, intelligent yet absent-minded, he was reportedly unpleasant to work with. When he spent time in the early Animus, he discovered that among his ancestors was Geoffroy Thérage, the executioner of Jeanne d'Arc.

Vidic's work on Daniel Cross eventually led to the Templar masterstroke that was the Great Purge of 2000. Experimenting with the power to affect minds with Pieces of Eden, Vidic not only created an entire false identity for the child who came to be known as Daniel Cross, but he also buried a two-level directive: the primary impulse to locate the Mentor of the Brotherhood, and a second, deeper directive to murder the Mentor when presented with a Hidden Blade. It was a shot in the dark that paid off handsomely for the Templar Order.

Vidic was killed by Desmond Miles in 2012, who used the power of the Apple of Eden he carried to manipulate the Abstergo guards to shoot Vidic.

Vidic's death threw the Inner Sanctum into disarray, as he had been a unifying force keeping the Inner Sanctum focused on the Animus Project and its associated goals.

MAIN MODERN-DAY TEMPLARS

Isabelle Ardant (1969–2015)

Born in Hong Kong and educated at the University of Cambridge in the UK, Isabelle Ardant specialized in computer science. Recruited via Abstergo's Young Innovators program, Ardant began her career as a digital archivist.

She worked through the ranks to become the Director of Historical Research, responsible for managing and archiving the genetic memories gathered by various divisions of the company. Being exposed to the many different branches of the company and the various projects underway, and being scrupulous and guarded by nature, she was a natural choice to be inducted into the Inner Sanctum.

Ardant headed the project to repair the damaged Shroud of Eden that had been in Templar possession since World War II, bringing it to Álvaro Gramática. That Shroud was destroyed in an Assassin attack on the Paris facility in 2014. In 2015 Abstergo learned that a second Shroud was hidden under Buckingham Palace. Ardant, Juhani Otso Berg, and Violet da Costa were ambushed by Assassins when they tried to retrieve it; during the attack Ardant was killed by Shaun Hastings.

VIOLET DA COSTA (1988–)

A blunt woman with a mean-spirited sense of humor, Violet da Costa was outstanding at handling tactical support. She excelled with security systems, both in maintaining network security and intrusion detection. Originally a field technician with Sigma Team and Juhani Otso Berg's second in command, in 2012 she was temporarily reassigned to work for six months with Álvaro Gramática on his research into the Shroud of Eden, willingly being shot on several occasions while wearing the Shroud in order to enable Gramática to speak with the consciousness of the Precursor Consus, which possessed da Costa while it revived her.

Da Costa witnessed Juno's escape from imprisonment in the Grand Temple in December 2012, and became a member of the Instruments of the First Will, a secret faction that sought to restore Juno as an embodied being and return the Precursor race to prominence. Violet was fully committed to the restoration of Juno, taking over the secret Phoenix lab with the Instruments to control the incarnation of the disembodied Isu. Violet was shot for her disloyalty to the Templar Order by Juhani Otso Berg during his incursion into the lab to end the Phoenix Project with Charlotte and her Assassin team.

MELANIE LEMAY

Originally the lead of the Sample 17 project, Melanie Lemay was inducted into the Templar Order and made the new Chief Creative Officer of Abstergo Entertainment after the disappearance of Olivier Garneau. Melanie has demonstrated genuine concern for her employees, and has been described as a "super-chipper overachiever" by Violet da Costa.

OLIVIER GARNEAU

The original head of Abstergo Entertainment, Olivier Garneau went missing while traveling to a shareholder's meeting with Laetitia England. It is possible that he was terminated by external forces before he could report news regarding Abstergo Entertainment's attempts to locate the Observatory via examining the memories of Edward Kenway; alternatively, it is possible that he was uncomfortable once the Templar Order had revealed their ultimate plan to him, and was removed before he could publicly communicate their intentions.

SOFIA RIKKIN

Daughter of Abstergo CEO Alan Rikkin, Sofia was the head of the Abstergo Foundation Rehabilitation Centre in Madrid, and a Templar like her father. Her mother was killed by an Assassin when Sofia was a child, an event that affected her deeply, as did the cold, unemotional relationship with her father.

While promising her protegee Layla Hassan a place on the Animus R&D team, Sofia exploited Layla's intelligence and ambition by presenting her with apparently hypothetical Animus challenges, then implementing them with the Animus team without crediting Layla. Layla finally realized that Sofia Rikkin was using her and her ideas, and had little to no intention of supporting Layla's research or rewarding her for her contributions. Sofia told Layla that her ideas were good but that she was too unreliable to bring onto the Animus project, officially ending their relationship.

Sofia deeply believed that humankind's violent impulses could be cured via research with the Animus, and that she could help bring about a peaceful society through her work. Bitter at her father's attempt to take credit for all her work at the Madrid facility that had netted the Templar Order an Apple of Eden, she was nonetheless upset by his death, and committed herself to tracking down his killer, Callum Lynch.

MODERN-DAY ASSASSINS: A CHALLENGING SITUATION

With the death of the Mentor in 2000, the Brotherhood lost its guiding hand. Fragmented and disconnected, Assassin cells floundered and were taken down by Templar teams.

For a time it was difficult to know precisely how many Assassin cells currently existed and where they were located. The Templar Order forced existing cells to go dark, cut off from the rest of the Brotherhood. Indeed, it was often the case that awareness of an Assassin cell only emerged after the Templars had already neutralized it. Trust is dangerous in these times, and reaching out could be an Assassin's undoing.

The state of high emergency meant there was no active way to document how many Assassins were currently alive or operative in the chaotic decade following the Great Purge. Gavin Banks and his crew on the *Altaïr II* served as a mobile headquarters, travelling worldwide to make contact with and offer support to various cells as they struggled to re-establish themselves.

Now nearing the end of the second decade post-Purge, the Brotherhood has found its footing again and is stable, if not yet thriving. New recruits from such organizations as the Initiates and Erudito have proven beneficial in enriching the modern Brotherhood as it adapts to life in the twenty-first century.

The Mentor

Originally a title bestowed upon an Assassin of a certain rank who had assumed leadership, during the twentieth century the title had come to be official and singular, given to one Assassin who curated the accumulated knowledge of predecessors in the position, passing it to the next Mentor. By the late twentieth century, the position of Mentor was so isolated that many Assassins wondered if a Mentor even existed.

In 2000, the Mentor was overseeing the activity of the Brotherhood from Dubai. He followed the case of Daniel Cross with interest, believing him to be unique and valuable to the Brotherhood, and a potential candidate to become the next Mentor. When Daniel was brought to him, the Mentor shared the inner workings of the Brotherhood with him and gave him his own ceremonial Hidden Blade. This act triggered Daniel's subconscious directive to kill the Mentor, and all the information on the Assassins Daniel had gathered over the previous years soon passed to the Templars.

Following the Great Purge, William Miles took on the role and assumed leadership of various cells, but did not assume the title of Mentor. Since then, William, Gavin Banks, and a few others have worked together to oversee Assassin activities around the world, sharing the Mentor's responsibilities. Recently, William Miles has officially become the Mentor of the Assassin Brotherhood.

William Miles (1948–)

Born into the Assassin Brotherhood, William Miles is a level and emotionally distant man.

After an active early career with the Brotherhood—most notably as the Assassin who stole the blueprints of the original Animus design in 1977—by 1987 he had become the leader of an Assassin compound known as "The Farm," a community of about thirty people in South Dakota. He trained many young recruits, including Clay Kaczmarek, Lucy Stillman, and his son Desmond.

With the death of the Mentor in 2000, much of the management of the Brotherhood fell to William. He began to supervise much of the Brotherhood's activity, though without formally stepping into the Mentor's position.

William's treatment of his son Desmond after his abduction by and rescue from the Templar Order in 2012 seemed heartless to some, but William's relentless and detached handling of the situation looked past the familial bond to the importance of the information Desmond obtained in the Animus. He was able to see the larger picture beyond the fundamental Assassin-Templar struggle to see that Desmond's choice would either save or essentially reboot the entire world. Desmond and William eventually saw past their differences to work together, with William helping Desmond understand the import of his upcoming role in the Grand Temple.

William was captured in Cairo by Templars in early December 2012 and taken to the Rome facility to serve as bait. Desmond left off his search for elements essential to opening the Grand Temple and traveled to rescue him, as the Templars had planned. Desmond killed both Warren Vidic and Daniel Cross while freeing his father.

In the end, at the Grand Temple, William had a change of heart and pleaded with Desmond to leave with him; Desmond chose to stay and give his life to protect the planet from a second destructive solar flare.

William resigned his position and went into hiding to process his grief, passing his duties to Gavin Banks. By 2014 he had recovered enough to return to active duty, facilitating the recruitment of the Initiates.

In 2017 William recruited Layla Hassan as an Assassin ally via an extraction from a situation in Egypt where Sigma Team appeared to be making a strike against her. Layla did not agree to join the Brotherhood but she accepted their protection from Abstergo's retaliation after she illegally modified the field Animus assigned to her. This was a coup for the modern Brotherhood, acquiring both Layla's genius-level technical knowhow and her highly modified HR-8 Abstergo field Animus.

Gavin Banks

A former member of the Osaka Brotherhood, where he trained under Kenichi Mochizuki, Gavin is now stationed onboard the *Altaïr II*, a mobile Assassin base traveling around the world to maintain contact between the various Assassin cells.

In 2012 Gavin and his team worked to draw Templar attention away from William and his group of Assassins as they sought to open the Grand Temple. After the events of December 2012 and the loss of Desmond, William disappeared. Soon after, Gavin was contacted by Shaun and Rebecca, who gave him a book from William containing everything he needed to know about directing the Brotherhood. With it came a letter, wherein William apologized for leaving and for burdening Gavin with this responsibility of overseeing the Brotherhood.

Gavin thus supervised the Brotherhood's activity while William Miles was missing, monitoring Assassin activity and communicating with the various cells. After months of operating on his own, Gavin located William in Norway. The two men began working together again when it was discovered that one of the crew members aboard the *Altaïr II* was a spy, and the Initiates were offered the opportunity to work with the Brotherhood.

Since then, Gavin has travelled the world on the *Altaïr II*, which serves as a mobile headquarters for the Brotherhood.

The Altaïr II is a mobile Assassin headquarters, under the command of Gavin Banks and Susan Drayton.

Desmond Miles (1987–2012)

Born into the Assassin Brotherhood, Desmond grew up on "the Farm," an Assassin compound in South Dakota with a population of about thirty. He trained with other Assassin children under his father, William Miles, but grew cynical of the intense party line that stressed the importance of battling the Templar threat. At the age of sixteen he ran away, using the skills he had learned from his father to evade capture. He ended up in New York, where he became a bartender.

Desmond came from a bloodline Abstergo wished to exploit for its genetic memories of Assassins, Templars, and Precursor sites and artifacts, and in September 2012, Desmond was abducted. He was placed in the Animus to have his genetic memories explored. After Abstergo had extracted the map identifying the location of Precursor sites and Pieces of Eden from his memories of Altaïr, they ordered Desmond terminated.

Desmond escaped with the help of Lucy Stillman. She brought him to the Assassins, where he voluntarily continued his work in an Animus to harness the Bleeding Effect, learning as much as possible about his Assassin ancestor Ezio Auditore in order to improve his newly awakened skills. In the process he received a message from Minerva via a vision Ezio had experienced: Minerva warned him about an upcoming repeat of the Toba Catastrophe that had decimated life on Earth, and gave him the task of finding the other Precursor Temples.

With the Bleeding Effect growing stronger and stronger, Desmond found an Apple of Eden in a Precursor Vault in Rome. After being controlled by Juno to kill Lucy, Desmond fell into a coma from the severe stress of recent events, and was placed into the Animus running in a safe mode to stabilize his condition. While there Desmond interacted with Clay Kaczmarek, the previous subject in the Abstergo

Animus Project, who had encoded a copy of his consciousness within the Animus operating system before committing suicide. With his help, Desmond regained consciousness, and the Assassins moved to the Precursor Grand Temple in New York.

To fully unlock the Temple and prevent a devastating solar flare the Precursors called the Second Disaster, Desmond returned to the Animus to explore the memories of his ancestors Haytham Kenway and Ratonhnhaké:ton, searching for a key. After the key was found and the inner chamber of the Grand Temple unlocked, the Assassins discovered that the device inside could indeed save the world from the Second Disaster, but it would also unleash Juno, who had been imprisoned in the Grand Temple by her fellow Precursors. If the device was not activated, the Second Disaster would wipe out most of the life on Earth, but the few people left could rebuild, honoring Desmond as a martyr and inspiration. Reasoning that humanity could fight Juno if they had the chance, Desmond made the difficult choice to activate the device, sacrificing himself to save the world.

Desmond's body was located by Abstergo, who arrived not long afterward. DNA samples were taken and his genetic memories were uploaded for further analysis and research.

QUICK FACTS:

Due to the higher than usual concentration of Precursor genes in his DNA, Desmond was able to correctly wield and control Pieces of Eden.

Desmond is a descendent of Assassins Altaïr Ibn-La'Ahad, Ezio Auditore, Edward Kenway, and Ratonhnhaké:ton, as well as of Templar Haytham Kenway.

Desmond performed a Leap of Faith in Monteriggioni after he experienced a vision of Ezio doing the same via the Bleeding Effect. This was a rare act in the modern Brotherhood.

"In a few short months my life changed forever. I know my easiest days are behind me, but I don't want them back — not now. My name is Desmond Miles, and I am an Assassin. I am an Assassin." — Desmond Miles

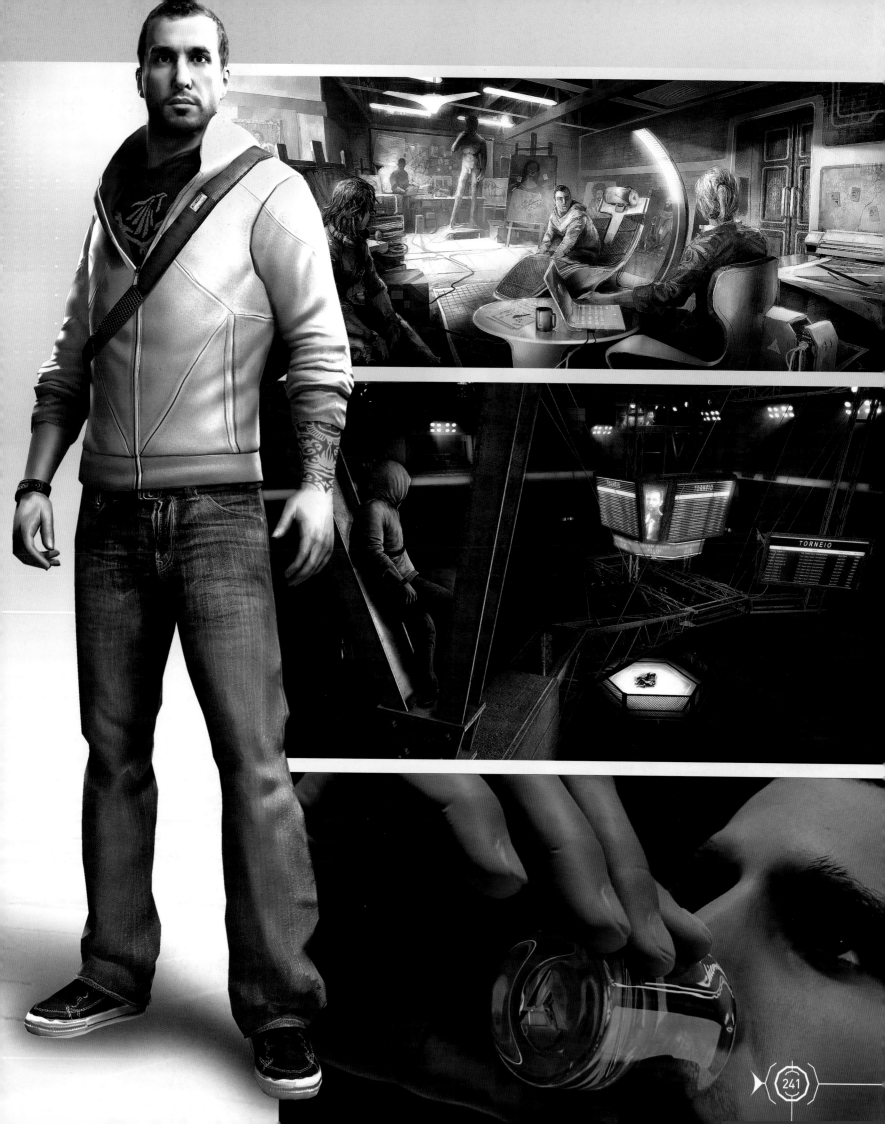

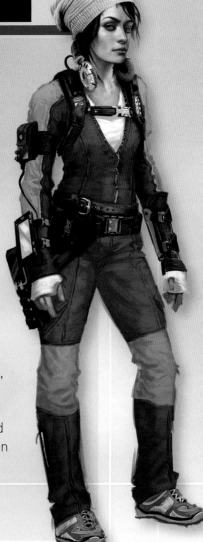

Rebecca Crane (1984–)

A lover of extreme sports who turned to computers during recuperation after an accident, Rebecca built the improved version of the Brotherhood's Animus 2.0 and serves as its technician. Optimistic and energetic, she is justifiably proud of her technical work within the Brotherhood.

Rebecca worked as Clay Kaczmarek's teammate, and was also friends with Lucy Stillman before she went undercover at Abstergo. She now works with Shaun Hastings.

Rebecca discovered the Initiate spy network while performing maintenance on the Brotherhood's communication network in 2014, appreciating its efficiency and construction. William and Gavin assigned Rebecca and Shaun to recruit the Initiates instead of punishing them, and she began working with them later that year.

In 2015, Rebecca and Shaun were charged with infiltrating Isabelle Ardant's office in London to acquire data on Abstergo's search for the Pieces of Eden. They disobeyed orders and waited for Ardant to arrive only to be ambushed by Abstergo's Sigma Team, narrowly escaping. After the data was analyzed and the Shroud of Eden traced to Buckingham Palace, the Assassins clashed with the Templars there. While attempting to recover the Shroud, Rebecca was shot by Violet Da Costa while trying to protect Shaun. Although Rebecca was severely wounded, she survived and made a full recovery. In 2016, she built an Animus based on the stolen designs of the models used at the Abstergo Foundation in Madrid. The Assassin Griffin and teenagers Owen and Javier, who were desperately looking for the location of the prongs of the Trident of Eden used this Animus at an Assassin hideout in North America. Rebecca helped them set up before leaving them to aid a different mission.

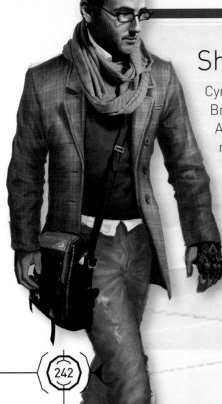

Shaun Hastings (1985–)

Cynical, sarcastic, and confident, Shaun serves as historian and analyst for the Assassin Brotherhood. His knowledge of history is a source of valuable information for the modern Assassins as they track Pieces of Eden and other Precursor intelligence through the memories of various historical figures. Although often rude, impatient, and critical, Shaun values the abilities and input of his teammates.

As a teenager, Shaun's interest in conspiracy theories led him to investigate Abstergo Industries and post information to WikiLeaks. He was contacted by Rebecca Crane, who warned him of the danger he was in, then recruited him after rescuing him from being abducted by Templars in December 2010.

Shaun trained with William Miles and eventually proved himself a capable field agent, though he prefers not to use weapons; however, by 2015 he had equipped himself with an electro-shock version of a Hidden Blade, with which he killed Isabelle Ardant.

Lucy Stillman (1988–2012)

Born into the Brotherhood and trained by William Miles, Lucy's ties to the Assassins were cut when she turned seventeen and infiltrated Abstergo Industries. Her studies in neuroscience were noticed by Warren Vidic, who offered her a job working with him on the Animus Project. Lucy was responsible for many of the early designs of Animus hardware and operating systems, and she oversaw the assembly process. Vidic was good to her, and this, combined with her many years of isolation, shifted her loyalties.

Lucy's shift of allegiance was discovered by her Assassin teammate Clay Kaczmarek during his time of imprisonment and experimentation within the Templar Animus. His suicide haunted Lucy, as she knew her defection made Clay's escape impossible, and also that following Vidic's order to keep Clay in the Animus for extended periods of time had fragmented his grip on reality, ultimately driving him to kill himself.

When Desmond was abducted and brought to the Rome facility, Lucy gained his trust between sessions in the Animus, and presented herself as a fellow captive and undercover ally. When his genetic memories of Altaïr revealed a map marking the position of Precursor sites and artifacts for the Animus Project, Abstergo executives ordered Desmond to be terminated, but Lucy helped him escape and took him to an Assassin hideout. Despite being a double agent, Lucy genuinely formed an affection for Desmond.

Under the control of Juno and the Apple of Eden, Desmond was forced to kill Lucy in the Colosseum Vault, stabbing her with his hidden blade.

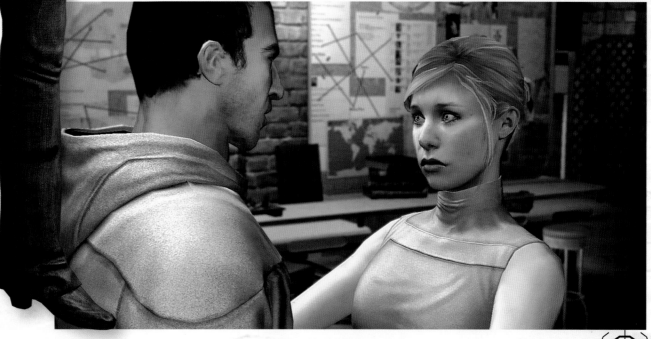

MAIN MODERN-DAY ASSASSINS

Charlotte de la Cruz (1993–2018)

Charlotte de la Cruz was recruited by the Brotherhood in 2015 for her ancestral connections, and the priceless information they might contain. Understanding that her DNA could be the key to revealing valuable secrets of the past, Charlotte decided to help the Assassins by accessing her genetic memories in the Animus. Charlotte's experiences in and outside of the Animus, and the influence of the Bleeding Effect, put her on the fast track to becoming a seasoned Assassin.

Opinionated and stubborn, Charlotte's principles aligned with the Brotherhood's general philosophy. As she settled into the Brotherhood, she also forced her fellow Assassins to review their ideals and to push back against the status quo. Although events forced her to grow into a rougher, more cynical version of her former idealistic self, Charlotte was determined to hold to her personal ethical system, which valued family, social justice, and equality, and made her reluctant to kill.

Charlotte demonstrated an impressive ability to cope with extended time in the Animus, and resilience to the negative aspects of the Bleeding Effect. Despite this, her intense use of the Animus to track the Koh-i-Noor finally stretched her constitution and ability to remain synchronized to the point where Juhani Otso Berg took over the search for her.

Charlotte seemed to have a special relationship with Consus, the Isu responsible for the design of the Shrouds of Eden. While it had been established that Consus could communicate directly with an individual if they were wrapped in the Shroud of Eden, the modern Brotherhood also theorized that he was capable of direct communication with humans carrying a high percentage of Precursor DNA in their genes. This possibility seems supported by Charlotte's interaction with him while reviewing genetic memories of her ancestors, as Consus left clues and guideposts for her to aid her in her quest to stop Juno.

Charlotte and her Assassin cell allied with Juhani Otso Berg, a Templar working as the Black Cross, to counter the Instruments of the First Will and their usurpation of the Phoenix Project to create an Isu body for Juno so that she could incarnate and finally seize control of the world with the use of the Koh-i-Noor, the immensely powerful Piece of Eden that could control other Pieces of Eden. Charlotte used the Koh-i-Noor to distract the newly incarnated Juno, then used her Hidden Blade to assassinate her, thereby preventing Juno from threatening the human race ever again.

Wounded and weak, Charlotte is assumed to have died in the ensuing demolition of the underground Phoenix lab by Otso Berg, although the rest of her Assassin team evacuated in time. Charlotte's determination enabled her to finally put a stop to Juno's interference in human affairs, and her death was a sacrifice that the entire Brotherhood will honor.

"I'm Tom Stoddard, Master Assassin. I'm **Hiram** Stoddard, creedbreaker. I'm **Quila**, the fastest damn Chasqui in the Inca Empire. I'm twenty-three going on six hundred, which means I've learned a few things." — Charlotte de la Cruz

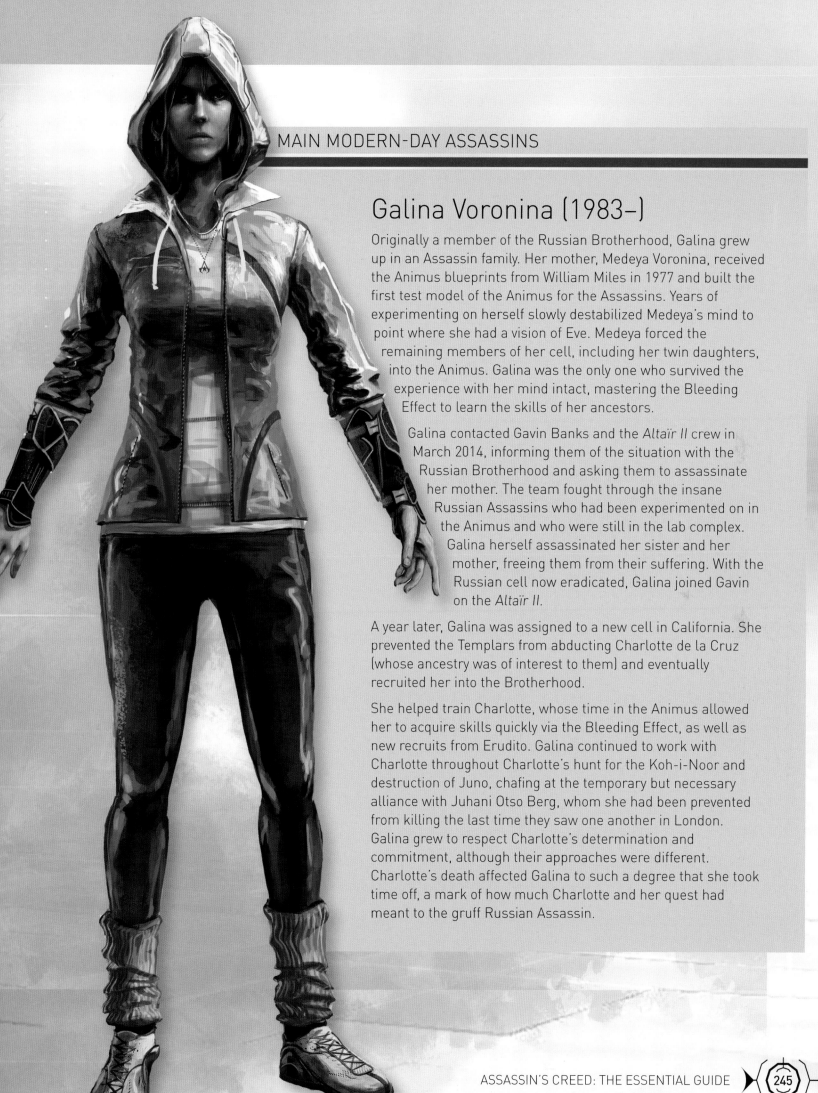

Galina Voronina (1983–)

Originally a member of the Russian Brotherhood, Galina grew up in an Assassin family. Her mother, Medeya Voronina, received the Animus blueprints from William Miles in 1977 and built the first test model of the Animus for the Assassins. Years of experimenting on herself slowly destabilized Medeya's mind to point where she had a vision of Eve. Medeya forced the remaining members of her cell, including her twin daughters, into the Animus. Galina was the only one who survived the experience with her mind intact, mastering the Bleeding Effect to learn the skills of her ancestors.

Galina contacted Gavin Banks and the *Altaïr II* crew in March 2014, informing them of the situation with the Russian Brotherhood and asking them to assassinate her mother. The team fought through the insane Russian Assassins who had been experimented on in the Animus and who were still in the lab complex. Galina herself assassinated her sister and her mother, freeing them from their suffering. With the Russian cell now eradicated, Galina joined Gavin on the *Altaïr II*.

A year later, Galina was assigned to a new cell in California. She prevented the Templars from abducting Charlotte de la Cruz (whose ancestry was of interest to them) and eventually recruited her into the Brotherhood.

She helped train Charlotte, whose time in the Animus allowed her to acquire skills quickly via the Bleeding Effect, as well as new recruits from Erudito. Galina continued to work with Charlotte throughout Charlotte's hunt for the Koh-i-Noor and destruction of Juno, chafing at the temporary but necessary alliance with Juhani Otso Berg, whom she had been prevented from killing the last time they saw one another in London. Galina grew to respect Charlotte's determination and commitment, although their approaches were different. Charlotte's death affected Galina to such a degree that she took time off, a mark of how much Charlotte and her quest had meant to the gruff Russian Assassin.

MAIN MODERN DAY ASSASSINS

Layla Hassan

Born into a wealthy Egyptian family that immigrated to New York when she was a toddler, Layla Hassan rebelled against structure, teamwork, and the confines of traditional academic environment. She was on on the verge of abandoning school entirely when her brilliance in engineering was noted by Sofia Rikkin during a Young Innovators recruitment event at Layla's university in 2006. Lured by the promise of eventually joining the Animus Project, Layla worked at Abstergo, first in an R&D division and then doing field work in the Historical Records division. She became more and more disillusioned as Sofia repeatedly brushed her off while taking advantage of her ideas.

A leave of absence during the Egyptian revolution beginning in 2011 led to her questioning how meaningful revolution could be and the lasting value of its effects. Newly determined to show Abstergo her value and secure the position on the main Animus Project that Sofia had promised her, Layla secretly began work on a modification of the Animus that would allow a person to access the genetic memories of anyone, not only bloodline ancestors, even using damaged or incomplete DNA samples.

Her assignment to investigate a burial chamber in Egypt, theorized to be the location of an Isu artifact, offered Layla the opportunity to secretly test the nearly complete prototype unit during a field op. With it, she could uncover information that could positively impact her career and bring her glory. While using her new Animus, Layla's high-level Isu DNA allowed her to easily handle the Bleeding Effect. William Miles arrived and offered her support and safety with the Brotherhood as Sigma Team attacked Layla's location in retaliation for her unauthorized modification and use of the Animus. Layla accepted his offer of safety, and subsequently joined the Assassins.

Her further development and refinement of the HR-8 model of the portable Animus was brilliant, allowing the Brotherhood to use not only damaged DNA, but external historical objects to further reinforce a simulation. Layla's advances and her determination to pursue the secrets of the Lost Book of Herodotus have the potential to drastically change the world for the better.

Abstergo isn't going to win this time. If what the book says is true, and we do actually find the artifact, the Assassins will finally have a chance to rise again.

— Layla Hassan

ALTAÏR II CREW

The *Altaïr II* is a mobile Assassin headquarters.

GAVIN BANKS: ASSASSIN LEADER

Leader of the Assassin cell aboard the *Altaïr II*, Gavin recruited every member of his crew for their unique skills. He helped William and his team during their mission to open the Grand Temple by providing him with transport and distracting the Templars' attention. After Desmond's death, Gavin's cell took on a more active role in rebuilding the scattered Brotherhood.

SUSAN DRAYTON: CAPTAIN

An environmental activist when she was younger, Susan was arrested after taking a sample of New Fluoride from the Prince George water supply. She was bailed out and recruited into the Brotherhood by a fellow conservationist. She met Gavin when they both tried to steal the same boat; they decided to work together, as Susan had the practical boating experience Gavin lacked.

EMMANUEL (MANNY) BARRAZA: ARMORER, WEAPONS INSTRUCTOR

After having to break the first tenet of the Creed in order to kill a schoolbus full of children wearing bombs intended to disrupt peace talks, Emmanuel swore to never again kill anyone. Of a military background, Emmanuel was assigned to the *Altaïr II* to arm the team and train them in weapons use.

EMMETT LEARY: COMPUTER EXPERT

A software engineer on the Abstergo Surrogate Initiative, Leary worked on the technology that read genetic memories. When the Surrogate Initiative was suspended, Warren Vidic tried to recruit Leary onto the Animus Project, but he refused, uneasy with the concept. Leary was apprehensive about his safety, and with reason; Abstergo came to abduct him, but Gavin extracted him before he could be taken.

MAIN MODERN-DAY ASSASSINS

NODAR NINIDZE: CHIEF STEWARD

Once a sumo wrestler, Nodar was recruited into the Brotherhood after surmising there was a larger entity behind the Russian and Chechen rebels whom his brother was fighting. Nodar oversees the daily running of the ship, preparing meals, making sure the ship is tidy, and managing supplies.

AKAKI NINIDZE: CHIEF ENGINEER

Creator of a false Brotherhood in Georgia to protect the weak and oppressed, Akaki was recruited into the real Brotherhood along with his brother Nodar by Gavin after the false Brotherhood was targeted by the Templars.

DR. STEPHANIE CHIU: MEDIC

Stephanie's parents worked for an Abstergo pharmaceutical company in Beijing; her father was one of the scientists who created New Fluoride. She attended an Abstergo-funded university, completing degrees in medicine, biomedical engineering, chemical engineering, and membrane technology. A member of the Initiates, she was uploading Eric Cooper's reports.

ERIC COOPER: NAVIGATOR, SUPERVISOR

Eric was recruited into the Brotherhood by Gavin after what he called "a carefully executed plan of revenge against the hate group that killed the love of my life." A transgender Scotsman, Cooper was a member of the Initiates, and the creator of the spy reports being sent out by Dr. Stephanie Chiu.

GALINA VORONINA: FIELD AGENT

Galina joined the *Altaïr II* crew in early 2014 after terminating the lives of the Russian Brotherhood, who had all been driven insane by their time in the Animus they had constructed. She was present for the discovery and recruiting of the Initiates, as well as working with Gavin on the attack on the Abstergo facilty in Paris. She served on the ship for a year before being assigned to a new cell in California in 2015.

MODERN-DAY ASSASSINS

CLAY KACZMAREK (1982–2012)
Clay came from a neglectful family. When he was recruited into the Brotherhood, he found the supportive environment he had previously lacked.

In 2010 Clay was assigned the task of accessing the personal computer of Alan Rikkin, the CEO of Abstergo Industries, to uncover as much information as possible about the Animus Project. After his success, the Brotherhood sent him to infiltrate Abstergo Industries as a test subject in the Animus Project; Lucy Stillman, an Assassin contact, was already functioning as a mole within the Animus Project, and would be able to help him escape. According to plan, Clay was abducted by Abstergo's Lineage Discovery and Acquisition department in February 2011 to explore the genetic memories of his ancestor Ezio Auditore, becoming Subject 16.

When he discovered the true purpose of the Animus Project was to locate Pieces of Eden he made the decision to leave; however, his teammate Lucy Stillman had switched allegiance to the Templars. With no one to help him escape, he spent days in the Animus at a time, his mind breaking down under the strain. Clay knew he was losing his grip on reality, and planned his death minutely. He made a copy of his consciousness, hiding it deep within hacked Animus files, before slitting his wrists and using his blood to paint messages on the walls to make sure the next Animus subject would receive the information he had gathered from his time in the Animus.

BISHOP
Responsible for managing worldwide Assassin activity, functioning as a central dispatcher, Bishop's identity and past are secret; various theories and rumors circulate among the Assassins as to her origins. She has been instrumental in contacting operatives with missions and dispatching Assassins to various places around the globe.

AREND SCHUT-CUNNINGHAM AND KIYOSHI TAKAKURA
Arend, a mixed-martial artist from the Netherlands, was recruited into the Brotherhood by his partner, Harlan Cunningham. Kiyoshi was a member of a Japanese yakuza faction in Osaka until it was taken over by the Japanese Brotherhood. They first worked together in 2014 when Bishop sent them to search for the newly moved Phoenix Project lab. Part of the extraction team that rescued Charlotte, Galina, and their Assassin cell from the Erudito island off the coast of Argentina, Arend and Kiyoshi remained with the team through the continuing search for the Instruments of the First Will, the Koh-i-Noor, and the destruction of the Phoenix Project. While Arendt then took time off to grieve and recover from the mission, Kiyoshi threw himself into work to cope with the emotion instead, working with Layla Hassan on her mission to locate Atlantis.

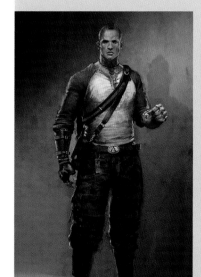
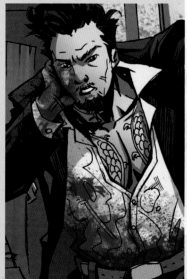

MY'SHELL LEMAIR

A member of the hacker collective Erudito, My'shell collaborated with Charlotte de la Cruz's cell when the Assassins needed help to investigate the Templar's Phoenix Project, and the plans of the Instruments of the First Will to resurrect Juno. Although My'shell expressed her disdain over the way the Assassins seem to have a form of genetic hierarchy when it came to abilities and skills, she eventually agreed to be trained as an Assassin by Galina. When her fellow Erudito member and close friend Guernica was exposed as a traitor and Instrument, My'shell was devastated. Her resolve was put to the test once more when she had to guard Guernica at a safehouse in London while the Assassins continued their mission. When the Instruments attacked the safehouse, My'shell was able to escape with the severely wounded Guernica. Realizing the events hadn't changed his mind, she continued her own path as an Assassin, leaving her former friend to die alone on a London rooftop.

VICTORIA BIBEAU

Formerly a Templar psychiatrist employed at Abstergo Entertainment in Montréal, Victoria Bibeau was one of the people responsible for psychological evaluation of employees, including monitoring them for side effects arising from research in the Animus, such as the Bleeding Effect. During her Abstergo career, she closely monitored Robert Fraser, the analyst who was researching Arno Dorian's memories via the Animus. It was then discovered that Fraser and Bibeau destroyed documentation pertaining to the associated research, including computer files. Together, they leaked the unsequenced memories to the Assassin Brotherhood, unhappy with how Abstergo was handling subjects suffering from the Bleeding Effect. Despite this action, Alan Rikkin kept Victoria on his team, although under very close surveillance. One of the sensitive subject evaluations she was called to do concerned Simon Hathaway, the new head of the Department of Historical Research at Abstergo.

Victoria then worked at the Aerie, an Abstergo facility where a group of teenagers was being observed in connection to what the project's head, Isaiah, referred to as an Ascension Event. Victoria struggled with severe ethical concerns about the adolescents' physical and mental welfare and the repercussions of Animus overuse. She also struggled with Isaiah's monomaniacal obsession with acquiring the Trident of Eden and using its power to become a god among men.

Having personally witnessed Animus use that proved the Templar's brute force information extraction techniques were severely detrimental to Animus users, her personal ethical system could no longer allow her to participate in their methods. With the help of William Miles, she formally defected to the Brotherhood, and now supervises the psychological wellbeing of Assassins, as well as working as Layla Hassan's Animus operator and medical tech.

ALANNAH RYAN

An enthusiastic young historian, Alannah functions as support for Layla in her search for the Spear of Leonidas, providing guidance and information via video chat when Layla needs it. Alannah has a passion for travel and adventure and the opportunities those bring for discovering new historical information, citing the chance to experience history firsthand as her main motivation for joining the Brotherhood.

OTHER FACTIONS AND UNAFFILIATED INDIVIDUALS

Not everyone taking part in the Assassin and Templar feud are members of either of the factions.

ERUDITO

A hacker collective that works to oppose Abstergo Industries, Erudito (sometimes referred to as the Erudito Collective) uses a range of communication methods to distribute the truths they unearth about Abstergo and the Templar Order. While not affiliated with the Assassin Brotherhood, Erudito has contacted Assassins on occasion, as well as participants in Abstergo initiatives such as Project Legacy. Erudito's interference in Project Legacy led to the program being suspended indefinitely due to security concerns.

Erudito invited Charlotte and her team for a conference to discuss alliance, at which time Charlotte discovered that her grandmother Florencia, who had vanished when she was a child, was a leader of Erudito. As the two teams shared information, an Abstergo strike team attacked the secret island off the coast of Argentina on which Erudito had constructed their complex. With most of Erudito shattered, Charlotte's team absorbed two of the Erudito members, My'Shell and the Animus tech Guernica. While My'Shell joined the Brotherhood, training with Galina, Guernica was eventually revealed to be a member of the Instruments of the First Will, working to sabotage Charlotte and her team.

THE INITIATES

Originally a secret unaffiliated group funded by private citizens, the Initiates were devoted to discovering the truth about Assassins and Templars. The information was posted to a secret network called the Outernet.

Two Initiates infiltrated the crew of the *Altaïr II*, but when discovered, William Miles and Gavin Banks chose to offer them an alliance with the Brotherhood. Since then, the Initiates have been trainees and support operatives for the Assassins, with Bishop serving as their contact and handler.

The Initiates have been essential in working with the Project Helix data, expanding the research into Arno Dorian's memories, and in locating the Shroud of Eden previously found by the Frye twins. There are some Assassins who are uncomfortable with the Initiates being called on by the Brotherhood.

THE ASCENDANCE EVENT

Ex-Abstergo employee **Sebastian Monroe** left with various pieces of equipment that he cobbled together in an old bus, creating an Animus that was able to run a simulation for several people at the same time, as long as their ancestors had shared the events. **Owen Meyers**, **Javier Mondragon**, **Natalya Aliyev**, **Sean Molloy**, **Grace Collins** and **David Collins** began working with him, until the group fragmented by Brotherhood and Templar incursions. The team split up, with some following the Brotherhood and the others going to the Abstergo facility known as the Aerie with Isaiah. The two sides raced independently to locate the three prongs of the Trident of Eden, with Minerva connecting all the adolescents via mental link, using the synergy created by their ancestral resonance to render the Trident devoid of power.

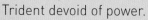

THE INSTRUMENTS OF THE FIRST WILL

The Instruments of the First Will, sometimes referred to as the Juno cult, was a secret group drawn from Templars, Assassins, and civilians devoted to Juno and her quest to re-establish the Isu race and return humanity to a slave race. Led by Violet da Costa, a Templar double agent and Otso Berg's trusted right hand, the Instruments were able to operate as an undetected fifth column within the Templar Order for years.

It recently became apparent that the cult had also drawn on people from the Brotherhood, as well as from Erudito. When an Assassin raid in Hong Kong went horribly wrong, one attacker in particular stood out due to his use of advanced Abstergo tech and Assassin fighting skills. He was later revealed to be Jasdip Dhami, a former Assassin who was recruited by the Instruments after first being assigned to hunt for the Koh-i-Noor, then to investigate the Phoenix Project. Jasdip's access to advanced weaponry created by Abstergo, his Assassin training, and his fanaticism made him a formidable opponent to the modern Brotherhood. Guernica, a recruit from Erudito, was also revealed to be a member of the Instruments, and was only just barely prevented from killing Charlotte de la Cruz while she was trapped in the Animus seeking the location of the Koh-i-Noor.

The Instruments of the First Will came close to accomplishing their goal of restoring Juno to a physical body and giving her the Koh-i-Noor, taking over Álvaro Gramática's secret lab and his Phoenix Project, as well as seizing the Koh-i-Noor from Charlotte once she and her team had located it in Spain. The Instruments were defeated along with Juno moments after she had incarnated in the cloned and grown Isu body Gramática had created for her with the help of the Shroud of Eden, when Charlotte stabbed her in the throat with a hidden blade. Juhani Otso Berg proceeded to utterly destroy the Phoenix lab with powerful Abstergo munitions, leaving no trace of Juno, the Koh-i-Noor, or Elijah. The cult was finally dead.

ELIJAH

Elijah, the son of Desmond Miles, hails from a bloodline rich in Isu DNA. Aside from his unique ancestral bloodline, Elijah is also a Sage: a human reincarnation of Aita, Juno's husband, who died during an experiment prior to the Toba catastrophe. Abducted by the Instruments of the First Will, who located the boy using Abstergo's information, Elijah was teh unwilling donor of bone marrow from which Álvaro Gramática created a body for Juno.

Elijah, along with Charlotte de la Cruz, is presumed dead by both the Assassins and the Templars as a result of the complete destruction of the Phoenix lab. However, the young Sage was able to escape the facility in time and, holding the Koh-i-Noor, vanished into the Australian desert.

THE ASSASSIN'S CREED COMMUNITY

For more than 10 years, Assassin's Creed has brought people together from all over the world: Fans who share their passion for our games, extensive lore and beloved characters.

Players unite both in and out of the games via online forums, fan sites and groups, art hubs, video sharing portals as well as live events, to form a profound and lasting bond of friendship that persists over miles and decades. All of this is the result of a shared love for *Assassin's Creed*.

COSPLAY

One of the most powerful community moments occurs when fans unite to show their creativity and passion for Assassin's Cred through cosplay. It is always an eye-catching spectacle at any convention or event to see a group of fans in Assassin's Creed costumes on their way to their destination. These fans spend months before any convention researching characters, designing, gathering materials and putting their creations together. They're eagle-eyed too, as their attention to detail is remarkable and is yet another prime example of how passionate and creative the Assassin's Creed community can be.

Ryu Cosplay

Just Yeliz (Yeliz Akyildiz)

VIDEOS

Video content-creation and live-streaming is incredibly prominent and one of the main media through which the community shares their passion for Assassin's Creed online. The range of video content avaible online is incredible; from game-guides and walkthroughs for challenging quests, montages, tributes to specific games or characters, to hours-long livestreams showcasing every tiny aspect of the games.

TAXAL3X, Assassin'sCreedSeries (https://www.youtube.com/assassinscreedseries)

Jordan van Andel, JorRaptor (https://www.youtube.com/jorraptor)

LIVE EVENTS

Conventions and live events are a great opportunity for the Assassin's Creed development and community teams to interact with fans face-to-face. These events provide the Assassin's Creed teams with a destination to showcase their latest products and a chance to have more intimate discussions about the franchise with dedicated fans and attendees. Having these opportunities for personal interaction are incredibly valuable and inspiring to us.

FAN ART

The art of Assassin's Creed is renowned for its visual edge when it comes to its immersive environments and charismastic characters. Members of the fan art and digital photography communities use the iconic style elements for their inspiration, and show their appreciation and artistic skills by recreating their beloved characters and scenes in artworks with their own unique touch. Over the decade, the immense talent of our creative community has continously surpassed all expecations with every new piece of art, offering a source of joy and inspiration to the developers of the games.

Shinosaaaaaang

Shinosaaaaaang

Hellstern (Elena Bespalova)

Muratgul (Murat Gül)

Zhong Yang

TITAN BOOKS

144 Southwark Street, London SE1 0UP
www.titanbooks.com

First UK edition, 2019. Printed in China.
10 9 8 7 6 5 4 3 2 1

ISBN: 9781789093612

HACHETTE
Content Director : Catherine Saunier-Talec
Project Director : Antoine Béon
Project Manager : Jean-Baptiste Roux
Layout : Servei Gràfic NJR, SLU
Production : Amélie Latsch

UBISOFT
Writing: Arin Hiscock-Murphy
Additional writing: Anouk Bachman
Additional editing: Antoine Ceszynski, Daniel Bingham, Melissa MacCoubrey, Susan Patrick, Alissa Ralph

UBISOFT CREDITS
SPECIAL THANKS:

Étienne Allonier
Aymar Azaïzia
Eve Berthelette
Daniel Bingham
Étienne Bouvier
Antoine Ceszynski
Clémence Deleuze
Jonathan Dumont
Patrick Dufresne
Richard Farrese
Andrien Gbinigie
Raphaël Lacoste
Caroline Lamache

Vincent Le Jamtel
Gabrielle Lévy Delaveau
Melissa MacCoubrey
Jean-Paul Mageren
Anthony Marcantonio
Susan Patrick
Alissa Ralph
Jesse Scoble
Sain Sain Thao
Fabien Troncal
Salambo Vende
Justine Villeneuve
Dominik Voigt

A huge thank you to all the past, present, and future developers of the Assassin's Creed universe. You rock!

Artists: Fernando Acosta, David Alvarez, Daniel Atanasov, Andy Belanger, Gilles Beloeil, Eddie Bennun, Gabriel Blain, Patrick Boutin-Gagné, Nicolas Bouvier, Ognyan Bozhilov, Dennis Calero, Martin Deschambault Patrick Desgreniers, Thierry Doizon, Olivier Donato, Guillaume Dorison, Christopher Dormoy, Neil Edward, Encho Enchev, Vincent Gaigneux, GREE AERIA artists, HELIX, Grant Hillier, Ian Herring, Tyson Hesse, Jose Holder, Jean-Baptiste Hostache, Diana Kalugina, Karl Kerschl, Ivan Koritarev, Konstantin Kostadinov, Raphaël Lacoste, Patrick Lambert, Serge LaPointe, Marco Lesko, David Lévy, Yan Li, Studio Lounak, Borislav Mitkov, Tri Nguyen, Namwoo Noh, Ivan Nunes, Nicolas Oroc, Hugo Puzzuoli, Frédéric Rambaud, John Rauch, Ludovic Ribardière, Joël Séguin, Jeff Simpson, Caroline Soucy, Adam Steeves, Cameron Stewart, Nadine Thomas, Remko Troost, Stéphane Turgeon, Two Dots, Nacho Yagüe, Donglu Yu, William Wu

A Very Special Thanks:
This Essential Guide is also the result of a collaboration with some of the most dedicated Assassin's Creed fans, and their Eagle Vision when it comes to our lore helped us create this book. Thank you for your help, your contributions were invaluable:

Access the Animus: Marco Chiacchiera, Serenika Sorrosyss, Giuseppe Distefano
The Assassin's Creed Wiki: Philip Schotte